LANGUAGE, LOGIC & EXPERIENCE

LANGUAGE, LOGIC & EXPERIENCE

the case for anti-realism

MICHAEL LUNTLEY

Open ❋ Court
La Salle, Illinois

OPEN COURT and the above logo are registered in the U.S. Patent and Trademark Office.

Published by arrangement with Gerald Duckworth & Co. Ltd., London.

Printed and bound in Great Britain.

Library of Congress Cataloging-in-Publication Data

Luntley, Michael.
 Language, logic & experience: the case for anti-realism/Michael Luntley.
 p. cm.
 Includes index.
 ISBN 0-8126-9061-3. ISBN 0-8126-9062-1 (pbk.)
 1. Realism. 2. Dummett, Michael A. E. I. Title. II. Title:
Language, logic, and experience.
B835.L87 1987
149'.2—dc19 87–16017
 CIP

Contents

For Dee

Preface

This book is about an issue that is almost as old as philosophy: the tenability of realism. Realism is the belief in the existence of a world that is independent of our enquiries about it. This looks to be a very reasonable belief. Nevertheless it has long attracted the sceptical gaze of philosophers. In recent years, due to pioneering work by Michael Dummett, it has seemed that techniques derived from the toolbag of contemporary philosophy of language might provide the opportunity to tackle the issue in a novel and forthright manner. This book is my attempt to show that this can be done and how it can be done.

I first became interested in the subject when, in 1979 as a research student fresh to Oxford, I had the good fortune to study under Michael Dummett. I have been pursuing the arguments and ideas on offer here ever since. The book has been a long time in the writing, but I hope it has improved for the time taken. If nothing else, I hope that it may serve to clear some of the air surrounding the blossoming debate instigated by Dummett's writings. This debate has resounded around the halls of many diverse topics and not always with a resulting clarification. I have tried to focus it on what I take to be the main issue and to treat this issue in isolation from other matters. In doing this I have spun out a position in a way that may well leave me too far exposed above the customary parapets and defences of philosophical debate. But such raids beyond the confines of a grittier trench warfare can sometimes result in valuable ground gained. It is in such a spirit that I offer the present work.

Regardless of whether I heeded the advice offered, I remember in particular thinking about matters raised by John Campbell, Michael Dummett, Tony Grayling, Rom Harré, Dan Isaacson, and David Wiggins. During a year profitably spent teaching at the University of St. Andrews I also recall numerous conversations with Peter Clark which, if not directly concerned with the material on

offer here, circumnavigated it in a way that offered much general illumination. I am conscious also of an enormous benefit derived from the work of John McDowell who, both in his lectures when at Oxford, and in his writings, has been a continual source of stimulation. More recently I have similarly benefited from Chris Peacocke's work.

My main debt is, not surprisingly, to Michael Dummett who, when supervisor for my doctoral thesis, gave up large portions of his time to discuss my fledgling views. I am grateful for the generosity with which he received my ideas then and since, for the tide of inspiration which invariably swept me from our meetings and for his having raised the bundle of ideas and issues of which I treat. Countless thoughts and suggestions have doubtless been lost along the way, but his influence is probably apparent on every page, and I thank him for it.

An early draft of this work was written during my tenure of a Junior Research Fellowship at Linacre College, Oxford and I am grateful to the Principal and Fellows for the support given. More recently, I have been fortunate to be one of the first recipients of a new series of British Academy post-doctoral Research Fellowships which has made possible the final drafting of the book. At a time when the government seems committed to the relentless destruction of the British university system, I know I have been most privileged to have been thrown a life line by the Academy.

Finally, to my wife, Dee, and our children I owe the fact that I was able to undertake such abstract work at a time of a cruel and fading economic order.

September 1987 M.L.
University College, Oxford

Introduction

Realism is the belief that the world exists independently of our knowledge of it. What this means is that for any proposition P, to the question 'Is P true or false?' the world has a determinate answer irrespective of our ability to calculate the answer. Despite the seemingly intuitive obviousness of this belief, realism is a myth. It is an unnecessary and untenable myth which has overshadowed our grasp of the concepts of objectivity and truth. In this book I show how we can develop the means to discuss the feasibility of realism and the alternative; why it turns out that realism is an untenable myth; and how we can learn to live with the recognition that it is unnecessary.

My argument is part of a debate that has grown in recent years within the philosophy of language due to the pioneering work of Michael Dummett.[1] Dummett has suggested that a long-standing metaphysical issue about realism can be approached through considerations about meaning. In the course of the debate that has followed in the wake of Dummett's voluminous, densely packed and richly suggestive writings much confusion has occurred. This confusion has been centred on two related topics:

(1) What exactly is the metaphysical issue Dummett thinks can be approached in the way he suggests?

and

(2) What is the way of connecting metaphysics and meaning that Dummett is supposed to have suggested?

Putting the confusion like that may make it seem that I think little progress has been made in the literature spawned by Dummett's

[1] The principal papers are collected in *Truth and Other Enigmas* (London 1978).

work. That would be wrong. Much progress has been made, but most of it has been up blind alleys. For with regard to what I take to be the core metaphysical issue, usefully labelled 'the realism question', the literature has been addressing the wrong question. Because of this, it has taken the connection between metaphysics and meaning wrongly also. Let me expand on these claims.

What made Dummett's proposals about realism so exciting was the claim that the metaphysics of realism stood or fell along with the validity of classical logic. Drawing upon his study of the dispute between intuitionism and platonism in the philosophy of mathematics, Dummett suggested, in effect, that in place of the obscure 'Does the world exist independently of our knowledge of it?', we should ask instead, 'Are the laws of classical logic valid?' This proposal offered to clear away a long-standing obscurity and replace it with an issue that looks a good deal more tractable. There is considerable initial plausibility to the identification on offer here. The realist idea of reality as fixed with facts independently of our knowledge of them seems well expressed by the semantic claim that for any proposition P it is determinately either true or false, otherwise known as the principle of bivalence. The connection with logic is then made by insisting that the validity of those inferences that distinguish classical from intuitionistic logic depends on there being a semantic justification of the inferences, one that will require the semantic principle of bivalence. The confusion sets in when we turn to see how Dummett suggested we tackle this latter semantic point. The suggestion seemed to go as follows.

The question which laws of inference are valid turns, in part, on the nature of our concept of truth. What our concept of truth is like turns in part on what our grasp of meaning is. Dummett's suggestion, as standardly construed, is that for the classical laws of inference to be valid it would have to be shown that our concept of truth was a *recognition-transcendent* one. Yet our grasp of meaning must be a case of possessing knowledge that is *manifestable*. However, grasp of meaning in terms of knowledge of recognition-transcendent truth conditions is not manifestable, and so our grasp of meaning reveals, because of the requirement of manifestability, that our concept of truth is not a grasp of a recognition-transcendent concept. But then realism and the validity of classical logic fall.

Now it seems reasonable to think that the argument structure just sketched breaks down into two main components. First, there

is the claim that for classical logic to be valid our concept of truth must be a concept of recognition-transcendent truth. Secondly, there is the issue about whether our grasp of meaning manifests our possession of such a concept of truth. On the relation between the two components all commentators, I believe, and frequently Dummett himself, have matters wrong. For what has happened in the debate so far is this. With regard to the first component a consensus has arisen that the validity of classical logic is *not* to be identified with our possession of a recognition-transcendent concept of truth. With this much I agree, but the point drawn from this consensus has been that realism is not to do with the validity of classical logic but with whether our concept of truth is a recognition-transcendent one. Indeed this severing of the issue about logic and concentration on the second component as the focus of the debate about realism has become something of an orthodoxy.[2]

The orthodoxy is mistaken. There is an issue addressed by asking whether our concept of truth is a recognition-transcendent one and it is an interesting issue. I call it the *objectivity-of-content* issue. It is a question about whether we grasp contents the characterisation of which requires our possessing a conception of a world beyond that which is experienced. But this is not the metaphysical issue about realism. For in contrast to this there is a separable issue that I call the *objectivity-of-truth* issue. This, or so it seems to me, is the metaphysical issue about realism, for it is the question about whether the contents we grasp (however we may think they should be characterised) are contents that correspond to a determinate reality fixed beyond our investigation of it; that is, whether the contents have a recognition-transcendent truth *value*. The first issue asks whether we have a conception of a world beyond that which experienced, the second whether we have any right to think that that world exists and is determinate in all respects. *That*, surely, just is the metaphysical idea central to realism. The two theses involved here are these. First there is a thesis about the kind of contents we are able to grasp. I shall not contend the thesis involved here, so let me simply call the thesis the objectivity-of-content thesis:

[2] The orthodoxy springs from John McDowell's 'Truth conditions, bivalence and verificationism' in *Truth and Meaning*, eds. J. H. McDowell & G. Evans (Oxford 1976).

Objectivity of content: The characterisation of content requires the subject's possession of a conception of a world beyond that which is experienced.

Secondly, there is an issue about what the objectivity of truth consists in. Now this *is* contentious and is the subject of the present book. Anti-realism must have *some* thesis about the objectivity of truth, but not the following, which I shall call the realist thesis of the objectivity of truth, or Thesis R:

Thesis R: The contents we grasp are contents that have a determinate truth value independent of our knowledge of that value.

Anti-realism, as I develop it, accepts the former thesis and denies only the latter, although, as I have said, it will have to offer *some* account of objective truth. This comes in Chapter 2 where I give an account of the independence of truth which is not realist. The viability of the distinction I am drawing and the identification of realism in the manner just stated is argued for in Chapter 1.[3]

For those who have reacted to Dummett over the issue of whether or not we possess a recognition-transcendent concept of truth it may well seem that I am proposing, in an unfair manner, to move

[3] Crispin Wright in the introduction to *Realism, Meaning and Truth* (Oxford 1987) distinguishes three questions about objectivity: objectivity of truth, objectivity of meaning, and objectivity of judgement. However, the former does not capture what I mean by this label, for Wright does not distinguish between the theses above, *both* of which are covered by his label 'objectivity of truth'. Under what he calls the objectivity-oftruth question, he discusses, e.g., 'the possibility of [sentences] being undetectably true or false' (p. 7) and says that 'for the platonist it is perfectly *coherent* to entertain the idea of a mathematical statement's being undetectably true' (p. 10). But both these points are to do with my objectivity-of-content thesis. In not separating the theses that I distinguish, Wright continually entangles his account of anti-realism with reductionist claims about the specification of content that I take to be extraneous to the core metaphysical issue. Nor is his objectivity of meaning the same as my objectivity of content. His point here is to do with whether or not there are determinate meanings for our utterances, and this is not something I question at all. His last point, the objectivity of judgement, is also something I do not tackle. This is concerned with such questions as 'Are moral utterances apt for the expression of facts?' Such matters are, again, wholly distinct from the core metaphysical concerns of the present book, which is focussed on the issue of what our notion of an objective fact is, irrespective of whether some domain of discourse is suitably seen as expressive of the facts. My whole point is to provide a focus on a central metaphysical issue, so that some progress may be made before turning to the broader issues covered by Wright's third notion of objectivity. Of course there are connections to be drawn, but I shall not draw them here.

the goalposts for the anti-realist attack. Now I need not be committed to the claim that the realist objectivity of truth thesis captures *the* traditional metaphysical issue about realism, for it would be ludicrous to suppose that there has been to date a clear consensus on what *the* issue is. What I am committed to is the claim that, among the various issues that have been addressed by Dummett and his opponents and sympathisers, there is the issue about what I call the objectivity of truth. I am also committed to the claim that this issue can be isolated from the rest of the debate, specifically the objectivity-of-content issue, and, further, when once so isolated provides a precise focus for most of what seems to be at stake in the question about the metaphysics of realism. This is not moving the goalposts. It is merely trying to lift the fog which has surrounded the playing field so far. When this is done, I believe it is readily seen that there is such an isolatable issue and that addressing it allows us to capture the core metaphysical idea constitutive of realism.

The debate about realism, as instigated by Dummett, has taken on something of the air of a gladiatorial combat with sympathisers and critics assured of what they are arguing about and convinced of the entrenchments in which they have embedded themselves. The debate has also become caught up in a host of diverse issues about the interpretation of Wittgenstein on rules and private languages, moral realism and the refutation of idealism. I ignore these wider issues in the present work. My concern is only to articulate one central line of argument, unadorned by complications connected with the various offshoots of the debate as it has proceeded to date. It may be that some will think that the anti-realist position I develop is hardly *anti*-realist. If so, all well and good. What I have tried to do is to develop a line of argument suggested by some of Dummett's work that provides a critique of the issue that I take to be at the core of the metaphysical image of realism. This is the objectivity-of-truth issue, a question concerned with the validity of rules of inference. But if my argument is right, at least this follows: We are not entitled to pursue unrestrictedly classical rules of inference in our enquiries about the world. And in so far as the question of the validity of classical logic is the only non-metaphorical way of capturing the realist metaphysical image, this is to give up that image. We do not replace it with another; we simply refuse to

indulge in the false gods of the realist myth of what makes for objective truth.

I separate the objectivity-of-content and objectivity-of-truth issues in Chapter 1 and there argue that the latter captures the core metaphysical point at issue. For the moment we need note only this: If the orthodox characterisation of the realism debate is wrong, as I think it is, we do well to separate the two issues about the validity of classical logic and our possession of a recognition-transcendent concept of truth as distinguished above. Furthermore, if what I call the objectivity-of-truth issue is the key concern, it is the issue about the validity of classical logic that must concern us. That is, we may agree that the validity of classical logic is not implicated in the question of whether or not we possess a recognition-transcendent concept of truth (the objectivity-of-content issue), but we deny the orthodox construal that it is on the latter issue that the metaphysics of realism stands or falls.

I shall be arguing then that the justification of realism stands or falls with the question of the validity of classical logic. However, I accept that *this* question is distinct from the question of whether we possess a recognition-transcendent concept of truth. Before I sketch the way my argument will proceed, let me note one further consequence of the refinement of the realism debate implicated in the above.

If I am right in separating what I have called the objectivity-of-content and objectivity-of-truth issues, one very important consequence is this: *Anti-realism need not engage in a theory of meaning that offers novel specifications of content.* What I mean here is this. Dummett, like his many critics and sympathisers, has seemed to assume that the debate between realism and anti-realism is a debate between two competing theories of meaning, where the competition comes out in the idea that the two sides offer different *specifications of content.* This is the issue that has been addressed in the literature on the question of whether we possess a recognition-transcendent concept of truth. Essentially this idea has the issue one such as:

Should we specify content in terms of truth-conditions or in terms of *e*-conditions?

where '*e*-conditions' are some weaker evidential conditions for the

correctness of a sentence (assertibility-conditions, criteria, etc.).[4] Pursuing this sort of debate obviously leaves the anti-realist on the defensive, as he has to justify novel reductionist accounts of content.[5] This sort of debate places the realism/anti-realism question as part of a general concern with the problems of *interpretation*. It sees Dummett's argument as an argument about whether we have any justification for interpreting the utterances of others in such a way that we construe the contents of their utterances as specifiable only with some recognition-transcendent concept of truth instead of some weaker evidential concept. That is *not* the way the anti-realism position is developed in this book. Because I take the metaphysical issue to be separable from the objectivity-of-content issue, anti-realism, as I develop it, offers no novelty in content specification *other than in the limited case of the logical constants and the concepts of truth and knowledge*. What it offers is a *constraint on the employment of contents*. It leaves the specification of content much as it is but seeks only to constrain content in a way that questions the assumption that contents have determinate truth values independent of our knowledge of them. Content is specified in terms of truth *conditions*, and the anti-realist may agree with the specifications of contents that have been pursued against some of the reductionist tendencies to which Dummett has been attracted. However, even if so agreeing, the anti-realist may still constrain content by rejecting the idea that of any given content it has a determinate recognition-transcendent truth *value*.

Another way of putting this point about the anti-realist's ability

[4] Crispin Wright has been the most forthright exponent of a construal of anti-realism which interprets it as offering novel content specifications in terms of 'criteria' understood along the lines of Wittgenstein's use of the term. See his 'Truth-conditions and criteria', *Proceedings of the Aristotelian Society*, supplementary volume (1976); 'Anti-realist semantics: the role of criteria' in *Idealism: Past and Present*, ed. G. Vesey (Cambridge 1982). More recently he has taken a more guarded attitude to the viability of content specifications employing criteria in 'Second thoughts about criteria', *Synthese* 1984. Wright's attempts to construe anti-realism as offering content specifications have, in my view, been fundamentally mistaken, regardless of the difficulties he now acknowledges in the notion of criteria.

[5] It also leaves the anti-realist case well separated from issues about logical validity. See Dorothy Edgington's useful 'Meaning, bivalence and realism', *Proceedings of the Aristotelian Society* 1980/81, pp. 153–73, in which she argues, correctly I believe, that on an assertibility-conditions account of meaning there will be no revision in logic. I agree, but then I do not think that the anti-realist should engage in revisionist accounts of content specification whether employing criteria, assertibility conditions or whatever.

to accept the specifications of content suggested by the objectivity-of-content thesis is this. Whether or not the anti-realist will offer novel content specifications turns on what is meant by the requirement of manifestability. Too often in Dummett and others the requirement that knowledge of meaning be manifestable has been construed as a demand that meaning be revealable in overt behaviour in a manner that seems to amount almost to a reductionist specification of content in terms of behaviour.[6] This is why such accounts of Dummett see his anti-realism as part of a larger project of a theory of interpretation after a style familiar from Quine. Clearly, given what I have said so far, I do not accept this account of the manifestation requirement. However, if I am right to focus the metaphysical issue of realism on the question of the justification of logic, I have to offer some account of manifestation if I am to preserve the idea that, at root, this issue is connected with our grasp of meaning. In Chapter 2 I distinguish three types of manifestation requirement and defend the one that connects the logical issue with the theory of meaning. This is achieved without indulging in reductionist or novel content specifications.

The plan of the argument proceeds like this. In Chapter 1 I argue that there is an isolatable metaphysical issue, distinct from problems of interpretation, which is properly seen as *the* issue about realism. This issue is concerned with the objectivity of truth and is an issue approached through questions about the validity of logic. What is involved here is an argument about how to characterise the sense of the logical constants. This is the domain in which anti-realism offers a novel account of content although it has certain consequences for the concepts of truth and knowledge but no more than that.

From the basis of the refinement of the realism question in Chapter 1 the argument then develops a critique of classical logic. The idea is this: There is an account of the sense of the logical constants that is necessary in order to develop a coherent notion of experience. This account is weaker than that offered in the semantics of classical logic; indeed it delivers an intuitionistic logic. That this account is also sufficient is due to its meeting the manifestability constraint on grasp of meaning. The underlying thesis involved in the argument about logic is a thesis about what it is for something

[6] Wright's criterialist analyses again being the obvious example here.

to be a logical constant. The worry with the classical account of negation is that grasp of its sense involves acceptance of a certain metaphysical picture for which there is no independent rationale.[7] The concept of truth involved is a metaphysically 'loaded' concept. In place of this I offer an account of negation the acceptance of which requires only what I call a concept of *experienceable truth*. The whole point to the anti-realist challenge being the observation that only a logic that is experienceable-truth-preserving can be justified because, as it turns out, experienceable truth is what lies at the base of all matters of knowledge justification. This leads me to claim that classical negation is not a logical constant. In general a logical constant is defined as such:

c is a logical constant iff the meaning of *c* can be explained by logical laws which are experienceably justifiable.

The idea is that logical constants that meet this requirement will be ones such that their meaning is *pure*, or devoid of metaphysical commitments. This then captures well Brouwer's important insight that what is wrong with classical mathematics is that its results are not derived mathematically. The very logic that is characteristic of classical mathematics imports metaphysical assumptions the entitlement to which needs to be made good. Just so in the general case. A logic which is experienceable-truth-preserving is one our entitlement to which cannot be questioned. Indeed it embodies the minimal notions of logical complexity required to make sense of experience. But further, such a logic is the most that can be justified, for it captures the very structure of experience to which all knowledge claims must conform. It is, we might say, the logic of experience. This latter, stronger, result comes from my account of the manifestation constraint. I develop that in Chapter 2, as also the idea of a logic of experienceable truth, an experienceable use of the logical constants; indeed the only purely *logical* account of the constants.[8]

[7] Negation is *the* crucial constant in formulating the anti-realist challenge.

[8] I am enormously indebted to Michael Dummett at this point for ideas which suggested this way of putting the point about the logical constants. In recent lectures in Oxford he has been developing a proof-theoretic account of justification of logic which aims to outline the logic which is justifiable by reference to self-justifying laws. Very recently (summer 1987) he made the startling claim that negation is not a logical constant because its sense cannot be explained in terms of laws that are

In Chapter 3 I answer a challenge, due to McDowell, about the identification of realism and logic. In Chapter 4 I develop the argument begun in Chapter 2 for an experienceable account of the constants and show how to develop an experienceable account of negation. Chapter 5 pursues the difficult issue of how the full generalisation of a quasi-intuitionistic account of the constants is to be deployed for empirical discourse. The effects of the generalisation for our concept of the objects of experience is then noted and defended. An outline sketch of the ensuing falsificationist account of the sense of the constants is given in Appendix 1. Chapter 6 continues themes from Chapter 5 and defends the anti-realist concept of an empirical object that arises given the falsificationist semantics and shows that the anti-realist has a concept of objects that is robust enough for all intelligible concerns. The argument here draws upon issues central to a proper account of Frege's notion of sense.

The effect of the argument up to the end of Chapter 6 is to suggest that anti-realism is a thesis about a constraint on our concept of truth. A constraint that serves to legitimate an account of the logical constants weaker than classical logic and proof-theoretically intuitionistic. Then the only concepts whose content is altered by the anti-realist are our concepts of truth, objectivity and knowledge and the logical constants themselves. The issue is wholly non-reductionist. At heart it is an issue about the *structure* of our concepts of truth and objectivity, their logical structure. It is an issue about what is logically implicated in our concepts of truth and objectivity when they are made to conform to a general constraint on knowledge ascriptions, the manifestability requirement. In Chapters 7 to 9 the non-reductionism of the enterprise is revealed.

In Chapter 7 I show how the anti-realist thus far characterised is entitled to what would, in terms of the philosophy of perception, be called a 'realist' theory of perception, and one in which percep-

self-justifying. I disagree with this, although I am of course sympathetic to the general idea that there is something very odd about negation. It is because I believe that, at bottom, logic stands in need of a semantic justification that I disagree with Dummett's claim about negation. And it is because I believe that semantic justification must result in a justification in terms of experienceable-truth preservation that I believe that *classical* negation is not a logical constant. However, a negation operator which is proof-theoretically intuitionistic *is* a logical constant. Indeed it is *the* negation constant. This result derives from the account I give of the manifestation requirement in Chapter 2. The account of negation is developed in Chapter 4.

tual content is representational. This allows that the range of experience, the range of effective decidability for my non-reductionist anti-realist, will depend only on what representational contents we can plausibly take to be present in experience. In Chapters 8 and 9 I consider two examples to illustrate the range of an anti-realist account of experience: other minds and theoretical entities in science. The point of these concluding chapters is that if the earlier argument about logic and meaning shows realism to be untenable, the arguments about the range of experience show it to be unnecessary. Given the non-reductionism of the enterprise, the anti-realist can avail himself of almost everything that could be wished for in an account of our experience of the world. At the end all that is missing is a metaphysical image or metaphor: the myth of realism, a philosophical myth that serves no useful purpose in our enquiries about the world. Moreover this myth has infected and been responsible for debates in disciplines other than philosophy; debates concerning the possibility of construing disciplines as objective cognitive enquiries. The social sciences are an obvious example, but the myth goes deeper, reaching into a widespread nihilism prompted by what is seen as the thwarting of scientific objectivity by what Camus called the 'unreasonable silence of the world'.[9] If the arguments in this book are correct, many of these broader problems can be solved and we will find that, far from being confronted by an unreasonable silence, we are bombarded with an excess of noise when we come to see our concepts of truth and objectivity aright. I do not pursue these larger themes here, although I believe that there are important consequences for questions about objectivity in the social sciences and in moral and political philosophy that may be drawn.[10] For the moment the important task is to clarify the issues and make plain the argument for anti-realism.

Dummett's work on anti-realism has, by and large, been grossly misinterpreted. A recent critic concluded that the anti-realist case,

> rests on a linguistic theory of metaphysics, a behaviourist theory of the mind, a positivistic epistemology, and a descriptive theory of reference.[11]

[9] A. Camus, *The Myth of Sisyphus*.

[10] But see my *The Meaning of Socialism* (forthcoming) for some of these consequences.

[11] M. Devitt, 'Dummett's anti-realism', *Journal of Philosophy* 1983. The confusions which vitiate Devitt's argument continue in his *Realism and Truth* (Oxford 1984).

In so far as the first charge is meant as an attack on the idea that metaphysical issues are best approached through considerations about meaning, it is here shown to be wrong at least in the sense, discussed in Chapter 9, that metaphysical issues in the philosophy of science are subservient to resolutions in the philosophy of language. There are no readymade realist conceptions of object and truth with which the scientific realist can bolster his position without tackling the fundamental issues in the philosophy of language. In this book Devitt's second and third charge are attacked and shown to be illusory. And in so far as, a 'descriptive theory of reference', misleadingly means a thesis that names have sense, this thesis is accepted in Chapter 6, but it is also shown to be necessary whether one is a realist or not. If this book serves to alleviate such gross misunderstanding and confusion it will have served some purpose. If it also reveals something of the richness unearthed by Dummett, it will supply one reason for writing it.

Realism and the Justification of Logic

We have to begin our argument by clarifying what realism is and how the issue is to be tackled. I proceed in this chapter with an indirect strategy emulating arguments that have become popular in recent years in the wake of Dummett's onslaught on realism. The point of my strategy is to reveal how little is achieved even if we accept the points made in the arguments in question. This turns out to be so because the arguments I have in mind are designed to press what I called the objectivity-of-content thesis. My point in this chapter is to show that what is left undone by such arguments is reason for believing in the realist objectivity-of-truth thesis, and that it is *this* which is required to sustain the metaphysics of realism.

1. An opening contrast

Consider the situation of a pure solipsist. Consider, that is, the situation of a subject whose experiences are characterised wholly in terms of how things *seem*. Call this subject S. Not only is S's experience characterised wholly in terms of how things seem, but how things seem is construed as how things seem here and now. S has no conception of a world beyond that which is experienced by him, and let us take the 'beyond' here to cover both space and time. So S has no conception of spaces other than *here* or of times other than *now*. On being confronted with an experience of F-ness, S may think 'F-ness here' and 'F-ness now'; but he has no conception of its being F anywhere else, or its having been F previously, or of the possibility of its being F at some time yet to come. According to S, the world stretches no further than the limits of his experience within the specious present.

We can contrast S's situation with that of another subject, R. R shares with S a *disbelief* in the existence of a world that stretches beyond the limits of his experience, and again the 'beyond' includes both space and time. However, unlike S, R *understands* the idea of a

world that exists beyond experience. It is just that he does not believe in it. Like *S*, *R*'s experience is characterised in terms of how things *seem*, but he is able to grasp more complex thoughts than *S*; thoughts like,

'*F*-ness again'

and

'It is *F* somewhere else'.

Either his ability to grasp this latter thought will require that seemings can exist unowned, or we grant *R* an unexplained grasp of other minds to own the seemings of *F*-ness elsewhere.

I am not suggesting that either of these positions is tenable, or indeed coherent. For the moment I am laying out options that may prove to be incoherent but from which we may start in an attempt to see just how much is required in our characterisation of content to defeat the pure solipsist *S*. Of both *S* and *R* we may say that their thoughts are characterisable in an internalist manner; this is to capture the idea that their thoughts are characterised in terms of how things seem. Neither of these subjects has thoughts the characterisation of which requires mention of external objects. What differentiates them is that *R* has an ability that *S* lacks, the ability to conceive of himself as an object within an objective spatio-temporal order. Let us call this the *objectifying ability*. We must be clear what this is. It is the ability to *understand* the idea of places and times other than here and now. To possess the objectifying ability is to possess an understanding of oneself as an object within a spatial and temporal order that stretches away from the here and now. It is not necessary that in order to possess this ability we place a metric upon the conception of space and time, although that is a common way in which we articulate the ability. It would be enough if the subject merely had the notions of 'before' and 'after', and of 'over there'. The subject might also have the idea of iterating 'before' and so have the thought '*F*-ness before before *G*-ness', where *G*-ness is how things are with him now and there was some intervening way things were, and he may not now recall what that was, since his experience was as of *F*-ness.

There are a number of arguments that we may want to put to *S*

and *R*, and I will consider what they are and how much they prove. But first let us consider the exact nature of the difference between the two positions. One thing that seems right is that the concept of truth that *S* possesses is much weaker than that which *R* possesses. Of course it might be objected that *S* lacks the resources to have any credible concept of truth. I am sympathetic to this idea, but for the moment I withhold criticism in order to clarify the nature of the difference.

We might describe this difference between *S* and *R* by saying that the latter has a concept of truth that allows him to consider the possibility that a thought be true or false even though he is not presently able to verify that it is true or false. But then that is to say that, measured against *S*, *R* has a concept of *recognition-transcendent truth*. This ought to be surprising, for according to much of the work on realism by Dummett and by many of his critics, that should be enough to make *R* a realist.[1] But that is implausible on two counts. First, *R* does not believe in the existence of a world beyond his experience: he merely understands the possibility of there being one. Secondly, the characterisation of *R*'s experiences is wholly internalist: it is not dependent on the existence of objects. Of course, given his disbelief in the existence of a world beyond experience, the fact that the characterisation of his experience is internalist is hardly surprising. However, these are separate issues, for they indicate two distinct lines of argument that one may propose against *R*. The first would be an argument against his disbelief in the possibility of an experience-independent world. The second would be a more complex argument against the possibility of an adequate characterisation of his experience that was not object-dependent.

The fact that so much work still seems to be required against *R*'s position suggests that the idea that his possession of a concept of recognition-transcendent truth makes him a realist is misguided. After all we know of subjects who have taken up positions just like

[1] See the papers in Michael Dummett's *Truth and Other Enigmas* (London 1978), especially essays 10, 14, 21 and the preface. The critics that I have in mind who take realism to be identified with the thesis that we possess a recognition-transcendent concept of truth are: John McDowell, 'Truth-conditions, bivalence and verificationism', in *Truth and Meaning*, eds. J. McDowell and G. Evans (Oxford 1976); Colin McGinn, 'Truth and use' in *Reference, Truth and Reality*, ed. M. Platts (London 1980); Christopher Peacocke, *Thoughts: An Essay on Content* (Oxford 1986). See also S. Blackburn, *Spreading the Word* (Oxford 1984), especially ch. 2, section 4; and M. Platts, *Ways of Meaning* (London 1979), ch. 9 for further discussion of this point.

those of S and R. Berkeley, or so it seems to me, has a position much like that of S, and phenomenalism is an instance of an R-type position. Berkeley differs from phenomenalism just in his refusal to countenance the *intelligibility* of unperceived existence. A phenomenalism which characterises objects in terms of constructions of possible experiences rather than collections of actual experiences is a position which allows the intelligibility of unperceived existence but refuses to believe in it. And *that* surely is not yet realism.

We might at this stage simply conclude that Dummett was wrong to identify realism with the question whether we possess a concept of recognition-transcendent truth, for unless my candidate R has taken up an impossible option he is a realist by this standard. Perhaps it could be argued that it is the internalist nature of R's position that makes it non-realist. This is a plausible line of attack; it is the second argument I identified above as a response to R. I shall consider it below. For the moment we should note that, if this line fails, to conclude that the identification of realism with the issue about recognition-transcendence is mistaken is to run against a tide of argument levelled against Dummett that amounts to something of an orthodoxy. This new orthodoxy simply has it that realism *is* to do with the question about recognition-transcendence.[2] That being so, much is at stake in the issue of what differentiates S from R. I believe that the difference *is* to do with R's possession of a concept of recognition-transcendent truth and, as I do not believe that R is a realist, I conclude that what I have called the new orthodoxy is mistaken in thinking that the metaphysical issue of realism could be identified with recognition transcendence and pulled apart from questions about the justification of logic, issues that until recently Dummett ran together.[3]

The question here is this: Dummett has suggested that realism, which he allowed to be the issue about whether our concept of truth was a recognition-transcendent one, could be approached through

[2] For example, see Peacocke's *Thoughts*, p. 86, where he defines realism as follows: 'Contents can be true without our being able to verify that they are true.' The new orthodoxy that I am identifying originates with McDowell's 'Truth-conditions, bivalence and verificationism', op. cit. It is now firmly established in many writers other than Peacocke. See Blackburn, op. cit.; McGinn, op. cit.; E. J. Craig, 'Meaning, use and privacy', *Mind* 1982; S. D. Guttenplan, 'Meaning and metaphysics' in *Meaning and Interpretation*, ed. C. Travis (Oxford 1986).

[3] See Dummett's *The Interpretation of Frege's Philosophy* (London 1981), ch. 20 for reservations about whether logic, in particular the principle of bivalence, can be employed in providing a benchmark for the metaphysical thesis of realism.

questions about the validity of inference. Specifically, the tenability of realism was to be identified with the validity of classical logic; acceptance of the principle of bivalence was suggested as the benchmark for realism. Since McDowell's 'Truth conditions, bivalence and verificationism'[4] it has become definitive of the new orthodoxy that, if we allow the connection between realism and the recognition-transcendence issue, the connection with logic is severed. Further, the new orthodoxy holds that realism *is* to do with recognition transcendence. But if the new orthodoxy is mistaken on *that*, this leaves the original and, I believe, central insight connecting realism with the validity of inference intact. That suggestion carried an enormous bonus. Instead of asking whether the world exists independently of us with all the unclarity and confusion occasioned by that form of words, we could raise a long-standing metaphysical issue by asking whether classical logic was valid. I think that bonus can be retrieved and to do so is to take issue with the new orthodoxy. The first step is to consider the possibility that it is recognition transcendence that separates R from S.

2. Arguments against the solipsist

We must reconsider the situation of S. I want to consider the kind of arguments that would be appropriate against S. I allowed that S could have thoughts like

(1) F-ness here

and

(2) F-ness now,

but surely this is allowing too much. If S does not grasp the possibility of unperceived existence, how can he grasp the concept of 'here' as opposed to 'there', of 'now' as opposed to 'then'? Time would seem to be the more fundamental dimension here.

I acknowledged that both S and R employ an internalist characterisation of their experience. That being so, there would seem to be no direct way in which they could acquire the concepts of

[4] Op. cit.

'here' and 'there'. There is nothing about the content of experience internalistically conceived to provide a here-ness to the way things seem. Of course there is a sense in which all experience exhibits here-ness, but that is not the appropriate sense that contrasts with there-ness. The sense in which all experience exhibits here-ness is the sense in which all experience is owned, where to be owned is for the experience to be enjoyed from some particular point of view. All my experiences are mine in just the sense that they are all *here*, *where I am*, wherever that may be. This notion of here-ness is the primitive notion of point of view that demarcates the subject, the 'I' that accompanies all experience. It is this notion of here-ness which, as Bernard Williams notes,[5] licenses Descartes' use of the first-personal pronoun in his statement of the *cogito*. It is not a substantial notion of 'I' but a formal place-holder for the subject from whose perspective the experience is had. It does no more than mark a place, *here*, where the experiences are had. As such, this formal notion of 'here' is not the familiar notion to be contrasted with 'there', for it is not a 'here' located within a spatial framework that provides the contrast with 'there'. It is like the 'here' of the lost traveller who does not know where he is but nevertheless knows that, wherever it is, it is *here*. It is then difficult to see how there could be a way things seem, construed internalistically, that provided the subject with a notion of 'here'. From within the subjective character of experience there is only *here*, and that is just to say that there is no here/there distinction.

This is why it is plausible to see time as the fundamental dimension in the ordering of a solipsist's experience. Perhaps, we may ask, he might be able to come to grasp some notion of the here/there distinction in terms of the now/then distinction. The thought would be that in noticing that some experience as of *F*-ness was new, while previously it had all been *G*, the subject might have the idea that the change had come about because the *G*-ness had 'gone away' as the *F*-ness had approached. This will not do. The proposal merely begs the question by invoking the notion that the *G*-ness has 'gone away', rather than merely *stopped*. The attempt to derive spatiality from temporality in this manner is surely as doomed as Hume's notorious attempt in the *Treatise* to derive the notion of an object from an interrupted succession of experiences.[6] Nevertheless

⁵ B. Williams, *Descartes: The Project of Pure Enquiry* (London 1978), pp. 95f.
⁶ *Treatise On Human Nature*, bk. 1, part IV, section 2.

it remains the case that temporality will be fundamental to our solipsist for the ordering of his experience, if not the only way in which his experience may be ordered.

But now it might still seem that, in granting S the ability to grasp thoughts like (2), I have still given him too much. For how can he have a concept of 'now' if his inability to comprehend the notion of unperceived existence employs 'unperceived' to stretch beyond experience in both space and time as allowed in section 1? Just as with 'here', there may be a primitive notion of 'now' that accompanies all experience, but if so that is not yet the notion of 'now' to be contrasted with 'then'.[7]

These familiar thoughts suggest the following two-pronged attack on S. (a) Without the ability to grasp thoughts about other times and places S lacks the resources to locate himself as a persisting object; indeed, he lacks the resources to grasp the concept of himself as an object at all. (b) However, once he has the ability to grasp other times and places, his position collapses into that of R, for there is no half-way house between solipsism and phenomenalism. For example, once a conception of 'just a moment ago' is admitted, the subject will have the resources to construct a concept of as long ago in time as he wishes. Similarly with space.

I shall not pursue argument (a), for I shall simply take it that in some form or another it is correct. I do not accept that a pure solipsist with no grasp of the concepts of space and time other than the primitive ones of the specious present and specious here could have an adequate notion of the self. Besides, it is not my purpose to argue against S, only to note what follows from accepting plausible and familiar lines of critique. It is argument (b) that is worth further attention, for it is just this argument type that would be employed in arguing for a recognition-transcendent concept of truth.

[7] Consider the problem often put to Berkeley's notorious 'tree in the quad' argument: What if Hylas had said, 'I can conceive of the tree existing unperceived in ten minutes time'? Philonous can no longer respond that Hylas' act of conception involves him perceiving the relevant idea of the tree that renders impossible the conception of unperceived existence. For although he has an idea of the tree now, his understanding is of the tree existing ten minutes from now when he may well be thinking of something else. Short of taking the heroic course and concluding that we cannot properly understand times other than the specious now Philonous is put in a sticky position by this challenge. For sure, given Berkeley's theory of mental activity and understanding, he would probably take the heroic course, and this only points up the extent to which his position is solipsistic not phenomenalistic.

3. Arguments against a revised solipsism

Suppose then that we amend S's position to allow him the resources to entertain thoughts such as

(3) F-ness a moment ago.

That is, suppose we provide S with a conceptual repertoire rich enough to generate some grasp of the notion of the self as an object persisting through time. S now has a grasp of a notion of truth that suffices to grasp the conditions for the above thought to be true. S knows what it would be for (3) to be true and for it to be false. It would be true if it was F-ness with him a moment ago and it would be false if was not. It is the notion of 'a moment ago' that I am granting S as given. His grasp of the truth conditions of (3) is still internalist. It is still a grasp of the truth conditions of this thought in terms of how things seem to him, with this notion extended to cover how things seemed and, perhaps, will seem.

Even thus extended, it is unclear that S has sufficient resources to have an adequate grasp of himself as a persisting object precisely because of the internalist conception of the truth conditions of thoughts like (3). Once again it might be argued plausibly that S therefore still lacks a concept of *truth* at all. For the sake of argument let us suppose that *with regard to thoughts concerning his experiences* he has some rudimentary concept of truth just because we have allowed him some grasp of the temporal order. I do not think that this *is* enough, but the point is irrelevant to the issue I wish to pursue. For what really matters about S, even so modified, is that he is unable to grasp the most rudimentary thought about objects other than himself. It may be, and I have said that I think so, that S will need more than the rudimentary grasp of the temporal order so far allowed to grasp thoughts about himself. That is, he will require some grasp of the spatial order and so, perhaps, a grasp of thoughts characterisable only in an externalist manner. But we can ignore this, for it is certainly true that in order to grasp very simple thoughts about objects S will require some of these resources. And any adequate theory of content will have to be able to characterise thoughts about objects.

So, we have the possibility that, contrasted with the original suggestion about S, our revised S has a grasp of a concept of truth

that is, in a minimal degree, a concept of recognition-transcendent truth. He has a conception of states of affairs beyond that which is immediately verifiable, namely the state of affairs of his experience being as of *F*-ness a moment ago. If this is not recognisably a recognition-transcendent concept of truth, that, I suspect, is because we have not so far granted *S* sufficient resources to construct even an adequate concept of self.

With regard to thoughts about objects, *S*'s position is still far from satisfactory. To see this, and to see how in arguing away from the position occupied by *S* we are arguing for ever richer accounts of a recognition-transcendent concept of truth, consider the following thought:[8]

(4) That block is cubic.

There is no real surprise, I think, in observing that such a thought is not available to *S*. But the kind of arguments employed to argue for that conclusion are worth inspecting, for this reveals that what one is arguing for in such a case is the adoption of the position of *R*. This is important because Peacocke for one seems to think that the arguments in question are arguments for realism.

One would argue that *S* lacks the resources to grasp the thought in (4) in the following way. The argument is an argument about how best to *interpret* the thought, what content to ascribe to *S*. As a first attempt to list the options available we might cite:

Option 1: The thought expressed in (4) is specifiable in terms of *S*'s experiences

and

Option 2: The thought expressed in (4) is only specifiable in terms of the way the world is.

Now if we stick with these options, although it is clear that option 2 introduces a notion of recognition-transcendent truth conditions into the specification of content, it does so by way of also expanding the content specification to an externalist one. However, I suggested

[8] I take the example from Peacocke, op. cit., pp. 14f.

in section 1 that *R* had *a* notion of recognition-transcendent truth but without an externalist account of content. If this suggestion is correct, option 2 above is not the only alternative required to bring out the deficiencies in the solipsistic *S*. So I shall ignore the issue of the role played by an externalist account of content for the moment, for I think that it is insignificant. I shall argue this in section 6 below. But the thought that we are too hasty in seeing option 2 as the only alternative to option 1 is a valuable insight, for it helps explain why the new orthodoxy has rested content with the sort of arguments I now wish to consider. For the arguments I have in mind, although effective against option 1 do not suffice to provide option 2: they only give the position of our phenomenalist *R*. The option on offer is something more like this:

Option 1*: The thought expressed in (4) is specifiable in terms of possible experiences.

We can construct this weaker alternative to option 1 by investigating the arguments employed against it.

The obvious line of argument against option 1 would be a transcendental argument. Option 1 claims that we could characterise the content of (4) in terms of *S*'s experiences. If we were dealing with the *S* of section 1 this would amount to the claim that the content of (4) could be specified in terms of how things were with *S* at the present moment. There would be no room for any account in terms of any other than actual experiences. Moving to *S* as modified to include a grasp of the temporal order, option 1 would then allow the inclusion of non-actual experiences into the clauses specifying the content of (4). I shall work with this latter version of option 1, for it is still insufficient to generate a plausible account of (4) and the points which tell against *it* tell with even stronger force against the simple *S*. (From now on when I speak of *S* I refer to the solipsist with the grasp of the temporal order.)

Against *S* it would be argued that in order to grasp a content such as (4) he would need to acquire nothing less than the *objectifying ability R* was said to possess (cf.section 1). This amounts to the claim that as well as his grasp of the temporal order extending beyond his immediately experienced specious present, *S* will need to grasp the conception of a spatial framework extending beyond the immediately experienced specious here. The argument proceeds

like this: In order to grasp the notion of a *block*, we need more than the conception of the way things seem right here and now. We also need the conception of the way things would seem under certain counterfactual situations. For example, we need the conception of how things would seem if we were to move to one side. Without this, our conception of the 'block' amounts to no more than an ability to entertain thoughts about a two-dimensional *surface* rather than a *solid* block. For our concept of a block just is a concept of an object that persists through space and time: something we understand to exist when we are not experiencing it. We cannot begin to approach this notion unless we have the conception *at least* of how things would seem, as well as of how they presently seem.

Space is required here as well as time, for the following reason. It might be thought that because S has a grip on the notion of a temporal order beyond the specious present he could acquire the conception required in terms of the way in which his experiences would modulate over time alone. That is to say, he would distinguish between (4) and

(5) That is an *F*-shaped surface

in terms of the expected modulation of experience over time. But that will not do. It is not enough that we separate these thoughts in terms of changes of experience over time, although that does employ a limited notion of recognition transcendence. On this option S's concept of a block amounts to a grasp of how his experience would be were it not now but some time in the future. But to separate thoughts (4) and (5) we need, rather than this notion of changes in experience over time, the notion of changes in experience over time *because of movement through space*. It is the grasp of the spatial order as well as the temporal one that enables us to grasp the notion of an *object*: something, for example, that we can walk around.[9]

The argument canvassed above suggests that S lacks the resources to grasp even simple object-directed thoughts like (4). What is

[9] If we think of our presentation of the block as from a position straight in front of one of the surfaces, the need for a grasp of spatiality might not strike us as immediately apparent. But if we started viewing the block from any other angle the need for the grasp of spatiality is immediate. For without the notion of parts of the presented object receding *in space* from other parts we would not even be able to characterise such an alternative presentation of the block.

revealed by this is that in order to grasp even such basic thoughts we must be possessed of a concept of truth that is recognition-transcendent. Otherwise it would be impossible to interpret S as entertaining a thought we would take as elementary to any thinking subject. What is revealed by such arguments is the way in which thinking about an object is more than having experiences as of a certain kind where the kind is described in terms of the actual occurrent qualities of the experience. What is required is that the subject take on certain *expectations of possibilia*. To think of an object, like a cubic block, just is to have certain expectations about the way our experience would go under certain conditions, for example, if we were to move to one side. And in characterising these expectations the subject needs a grasp of the spatial order, for the conditions of the modulation of the experiences are conditions to do with movement of the object or the subject through space. If this were not so, the modulations would be no more than subjective change of experiences and that, as we have seen, is not enough.

This kind of argument is all to do with the requirement that a subject possess what I called (section 1) the *objectifying ability*. This was the ability to conceive of oneself as an object within an objective spatio-temporal framework, and 'objective' here means no more than a conception of space and time that transcends the specious here and now.

However, acceptance of these arguments does not seem to have much to do with realism, and yet these arguments are precisely the arguments employed in discussion of whether we possess a concept of recognition-transcendent truth. I shall now go on to show how the above sorts of arguments may be extended so that, once extended to enable thoughts like (4), S's position collapses into R's position. I shall then show how this falls short of an argument for realism despite the fact that the arguments employed are precisely those of Dummett's critics. I shall conclude by showing what kind of argument *is* required to go any further and support realism. It turns out that the kind of argument required is an argument about the justification of logic. But first, let me put S and R in a little more focus by drawing out what I shall call Idealism's two mistakes.[10]

[10] 'Idealism' is too often used generically for a position which makes either of these mistakes. I propose to restrict the label to a position which commits both.

4. Idealism's two mistakes

The two I have in mind are:

(a) Idealism treats objects privately in terms of ideas; it treats of the world of inner sense without reference to the world of outer sense, defining the latter in terms of the former,

and

(b) Idealism treats objects as collections of actual experiences; it misses the generality in our concept of an object that involves reference to *possibilia*.

Idealism in Berkeley's version commits both (a) and (b). Phenomenalism, commonly understood, commits only (a) but not-(b). There is a position that would be characterised as (b) and not-(a). This would be like Moore's phenomenalism in holding sense-data to be physical, but unlike Moore in giving only collections of such things for objects rather than logical constructions. The position of *S* as he started out was that of (a) and (b). The position of *R* was that of (a) and not-(b). *R* is a phenomenalist. Both commit mistake (a), for both provide internalist accounts of content. *That* I have said, so far without argument, is irrelevant to the question of what is to be learnt from considering how to argue out of these positions for the tenability of realism. I shall redeem this silence on the internalist/externalist question in section 6 below. For the moment I shall first show how one argues to the effect that once *S*'s position is modified to allow some notion of possible experiences because *S* then has *a* grip on the temporal order, his position collapses into that of *R*. Having done that, I shall show that we have done all that can be done on the issue of the recognition transcendence of truth, but that we have fallen far short of realism.

What is clear so far is that, in arguing against *S* and in arguing for the need that a subject of experience have some grasp of a recognition-transcendent concept of truth, the argument is all about possessing the *objectifying ability*. The argument is concerned with what I call the *objectivity-of-content* issue. For the argument against Idealism's mistake (a) is an argument that such an idealist does not have the resources to grasp certain kinds of content, namely

thoughts with an objective content – thoughts that are about more than his subjective experiences. The argument, and I think it is an important one, is to the effect that the notion of a subject of experience requires that the subject be able to grasp thoughts with an objective content. This issue, the objectivity of content, is the issue raised by asking whether we have a recognition-transcendent concept of truth. It is, in short, an issue about *whether or not concepts have a coherent content*. It is the appropriate issue to raise in a refutation of Idealism, but it is not the issue to raise in defending realism. Let us then see how to proceed against S as he has been modified by the argument of section 3.

5. Objectivity of content/objectivity of truth

We have allowed S a modest grasp of the temporal order. However, we have seen that this is still insufficient to enable him to grasp the most elementary thoughts about objects. A grasp of the spatial framework extending from the specious here is also required on pain of disallowing that thoughts like (4) make sense. But in allowing S that much, his position collapses into R and he will now have the ability to entertain thoughts about any region of space and time. That is, he will already have the resources to grasp thoughts involving universal quantification and those about distant times.

Consider these two examples:

(6) All F's are G

and

(7) It was raining in Los Angeles on 28 January 1887.

In order to capture what I called the subject's expectations of *possibilia*, any plausible account of the thoughts expressed by (6) and (7) will be of the form

(8) If some condition *c* is met then result *r* obtains.

For example, Peacocke's account of unrestricted universal quantification fits this general form. It is:[11]

11 Op. cit., p. 34.

(9) If there is an *F* at the place bearing R to pi, it is *G*,

where 'pi' denotes a place already in the domain of places thought of. An analogous account of (7) might run by first characterising a content about a time just past as a thought true just in case at time *t-n* it is raining where '*n*' is the increment of time that distinguishes now from a moment ago. We would then employ the notion of the relation of the predecessor of a time *t* as the time *n* before *t*. The thought expressed by (7) would then be the thought that is true just in case it was raining at a time standing in the relation of predecessor to a time that stands in that relation to further times that are so related to now. By employing the notion of the temporal increment *n* which gives us the notion of a moment ago we can avail ourselves of times other than now which are within the domain of our thought and in terms of which we can inductively extend our thought to more distant times.

Now there are a number of points to be noted about these proposals. First, as the proposal for an account of (7) makes plain, it offers a way of characterising our ability to think about distant times which sees that ability as firmly located within an overall grasp of an objective temporal order stretching away from the specious present. Similar thoughts apply to the importance of our grasp of ourselves as objects within an objective spatial order stretching away from *here* in the account of universal quantification offered by Peacocke. The importance of the conception one has of oneself as an object located within such a spatio-temporal framework is fundamental to the attempt to provide a coherent content to thoughts like (6) and (7).

Secondly, such a way of providing a coherent content to these thoughts clearly fits within the scheme of the provision of transcendental arguments of a kind with those already discussed. The ability to think of distant times is explained by an induction on our ability to think of the nearest time from now – one moment ago. This means that if someone were to challenge our ability to entertain thoughts about the distant past they would be in danger of challenging too much. For on the account on offer if we can think of one moment ago we can also think of as many moments ago as we like. This suggests that the defence of such a characterisation of our ability to think of distant times would best proceed via a transcendental argument to the effect that in order to have any conception

of oneself as subject we need to have a conception of ourselves as embedded within an objective spatio-temporal order. But once we have got *that* we have all that is required to be able to think about distant times just as easily as times more recent, such as a moment ago. This, in turn, suggests that the challenger will have to fall back to an impossibly restrictive solipsism in order to sustain his challenge, for he will have to argue that we cannot even have thoughts about times as near to the present as one moment ago. This is why he will be susceptible to a transcendental argument to the effect that, so restricted, no viable, let alone recognisable, concept of the self as subject can be constructed. The challenger would have fallen back to the opening position of *S*. Failing that, we have to conclude that the arguments sketched have succeeded in collapsing *S*'s position as successively modified into *R*'s.

Anyone familiar with Strawson's work on the self will recognise the kind of argument canvassed above. It is a style of argument that has been employed in the defence of realism with great aplomb, but it misses the point. It is successful in the task of refuting Idealism, that is, in rejecting the idea that the concept of unperceived existence makes no sense, but it does not suffice to prove realism for, so far, we have only reached a proof of *R*. That is, we have only so far proved that the idea of unperceived existence *makes sense*. We have not yet proved that there *is* such a thing, or given any reason for believing in such a thing. This is why the refutation of Idealism is far less than a proof of realism.

Take the accounts of (6) and (7) suggested. We might agree with these as specifications of what it is to grasp the thoughts (6) and (7). To grasp (6) *is* to be committed to the idea that if there is an *F* at a place spatially related to here it is *G*. Similarly, to grasp (7) *is* to be committed to the idea that rain occurred at a point in time related to now by successive applications of the notion of one moment ago. But to be so committed is not yet to have reason to think that it is determinately either true or false that an unverified *F is G*. It is not yet to have reason for thinking that at an unverified time removed from now by *x* number of applications of 'one moment ago' it is determinately fixed that either it is raining or it is not. It is not yet to have reason to believe that, as it were, the *facts are settled* in advance of our verification of them. So far it is only to be committed to the idea that *what we would count* as a relevant fact, if discovered, is settled in advance. It is to agree that grasp of contents

like (6) and (7) involves commitment to conditionals of the form of (8), but not yet to have reason to discharge the relevant antecedent. It is as if we are committed to a particular mould for the facts, if there are any, but not yet to the idea that the facts are determined thus or not waiting to drop into our mould. That latter idea is the core metaphysical issue of realism. It is concerned with what I call the objectivity-of-truth issue, in contrast to the objectivity-of-content issue. The objectivity-of-truth issue is a genuinely separate matter left untouched by the objectivity-of-content issue which deals only with the coherence of content and not with what we might call the applicability of content. The objectivity-of-truth issue is an issue best expressed, as here, employing the principle of bivalence. Most succinctly the difference between the two is this:

> *The objectivity of content for some thought P commits one to the idea that if there is a fact of the matter it is of such and such kind; the realist objectivity-of-truth thesis commits one to the idea that there is a determinate fact of the matter.*

Put like that, I do not think that it can plausibly be denied that there is an isolatable issue addressed in the realist objectivity-of-truth thesis, nor that it captures what has long been central to the metaphysics of realism.

Idealism is a thesis about what sorts of content are possible for, or may be grasped by, creatures like ourselves. It is not *directly* a thesis about whether the world exists independently of our verification of it, for in Idealism this matter is approached only through a semantic thesis that rules out the possibility of grasping the kinds of content needed to frame the realist position. However, if we reject Idealism's two mistakes and thereby allow the possibility of grasping the kinds of contents required for stating the realist option, we have still to argue that that option is viable: we still have to argue that the option can be shown to obtain. And this is the objectivity-of-truth issue.

At its simplest it comes to this: It may well be correct to say that a grasp of (6) consists in a commitment to believe that *if* there is an F at a place bearing R to pi it is G, but with what right do we assume that this unverified conditional represents a state of affairs already there, such that it is determinately either true or false? Similarly, it may well be right to say that a grasp of (7) consists in

a commitment to believe that at the time reached by x applications of 'one moment ago' it is raining, but with what right do we assume that there is a past back there fixed before our investigation of it? Most generally: Entertaining a thought about more than the content of our experience here and now involves expectations of *possibilia*, but with what right do we assume these expectations fulfilled?

Peacocke takes realism to be the following:[12]

Contents can be true without our being able to verify that they are true.

This, of course, is just the objectivity-of-content issue about the recognition transcendence of truth. The claim is that in specifying content we need to appeal to a recognition-transcendent concept of truth, one that allows for the *possibility* that a thought be true when not verified as true. Employing the objectivity-of-truth issue we require more than the above as a characterisation of realism for we require not only that contents *can* be true unverified, but that *they actually have a determinate truth value unverified*:

Contents have a determinate truth value independently of our being able to verify them.

But that, of course, just is the principle of bivalence; a content is determinately either true or false independently of our ability to verify its truth value.

That there is a distinction between the objectivity-of-content thesis and the realist objectivity-of-truth thesis is seen if we consider the following analogous situation. In the philosophy of religion it is usual to distinguish between showing that the concept of God is coherent and showing that the concept has application.[13] The former task is one of showing how it is possible that finite beings like ourselves could come to grasp the concept of a being with the traditional attributes of God. The latter task is, *having already grasped the concept*, showing that we have reason to think that the concept *applies*. It is this distinction between grasping a concept and having reason for thinking that a concept has application that is important.

[12] Op. cit., p. 86.

[13] E.g. see Swinburne's *The Coherence of Theism* (Oxford 1977) and *The Existence of God* (Oxford 1979) in contrast to the work of writers like D. Z. Philips, *Faith and Philosophical Enquiry* (London 1970).

Just as we can distinguish between these tasks in the philosophy of religion, so too should we distinguish them in semantics. Doing so provides the demarcation between the objectivity-of-content thesis and the issue about the objectivity of truth.

Just as we raise the question whether the concept of God is coherent, so we can raise the question whether the concept of a world persisting beyond our ability to experience it makes sense. This task is the one that the new orthodoxy takes Dummett to have questioned, for it is this task that is performed by the supply of transcendental arguments as outlined above. Indeed such arguments not only show that we *can* make sense of a world beyond that which is given in immediate sense experience but, further, that we *must* make sense of such a conception if we are to be able to grasp concepts as elementary as those employed in grasping the thought expressed by (4). But having once convinced ourselves that we do grasp such a conception, as when we convince ourselves that we *understand* the concept of God, we have to ask whether we have any reason to think that this conception applies, just as we have to ask whether we have reason to think that the concept of God applies. If this were not so, the *existence* of God would be proved by our understanding of the concept of God. That is not plausible, although some would argue in its favour.[14] But *that* is precisely what the new orthodoxy asks us to accept in its response to Dummett's critique of realism: that realism is vindicated by showing that we *understand* the possibility of the world's unperceived determinate existence. That is not enough. After all, I assume that Dummett knew all along what was *meant* by this idea how else could he have called it into question? The only way out is to conclude that the new orthodoxy is innocent of the implausibly short-circuited argument just canvassed because guilty of having missed the point of what the metaphysical issue of realism was about.

I think the last thought is probably right. Dummett's critics have seized on the semantic question about how to *interpret* utterances, and have ignored the metaphysical issue about the determinacy of the application of the concept of the world that they have argued that we possess. I am suggesting that we might agree with them that we possess the sort of concept of the world they argue for. We agree with the sorts of transcendental arguments canvassed so far,

14 Cf. Philips, op. cit.

but this leaves the metaphysical issue of the application of this concept open.

What more is required to achieve realism? So far the kinds of arguments that I have been pursuing have delivered us only the position of *R*, the phenomenalist. As I noted above (section 1), there are two lines of argument that may be made against *R*. One attacks the coherence of his position by attacking the idea that the position can be established on only an internalist account of content. The other accepts the coherence of the position but attacks *R* simply for not believing in the existence of the external world. If the first argument worked it would show that, contrary to what I have just claimed, we *have* considered arguments rich enough to generate realism, for if the externalist account of content is necessary then adding *that* to what we already have will deliver realism. I shall counter this thought in the next section and, in the process, develop *R* into an anti-realist of the kind to be developed and defended throughout this book. I shall then show how the argument required for realism is to do with giving *reasons* for *R* to believe in what he understands and such an argument has to be concerned with issues about logical validity.

6. Externalism is not enough

It might be thought that my claim that so far we still lack realism in our pursuit away from the corruptions of *S*'s position is due to the fact that I have allowed *S* and *R* to get away with only an internalist account of content. This thought does not work. We need to distinguish between two ways in which we might talk of an externalist account of content. An externalist account is one in which thoughts are object-dependent, but it is this notion of object-dependence that allows us to mark a distinction here.

We need to distinguish between the object-dependence of thought and object-dependent thoughts. The latter are thoughts the entertaining of which is not possible if the object does not exist. For such thoughts, if there is no object there is no thought. The former claim is weaker. The object-dependence of thought is the general thesis that thought would not be possible if there were no objects. This thesis claims a general dependency on the existence of external objects for the very ability to entertain thoughts. Such a thesis might be most plausibly held because it is held that the capacity for

thought requires that the thinker possess a conception of self; that would not be possible without a conception of the self as spatially locatable, which would not be possible without the thinker's ability to think about external objects in order to triangulate his position. Therefore there would have to be some objects for this self-location to take place. But note that this does not require that there be any thought that is object-dependent.[15] What is required is that the subject's general capacity for thought requires that there be *some* objects which serve for self-location.

With this distinction at hand we can now modify the position of *R* so as to meet the objection about the internalist character of content as so far described without affecting the argument for realism. Let us suppose that, of the beliefs which *R* possesses that are involved in location of the self as an object within the spatial order, some are true. Indeed let us suppose that some of these central beliefs must be true for the concept of self to get off the ground. All that is required is that not too many of *R*'s basic spatially directed thoughts be false. In this respect *R* has something like an externalist account of content, but only in so far as the external spatial order is required, *not* any particular external objects. That is, a characterisation of his thoughts requires that he be *embedded*, but it does not require that any particular thoughts of the embedding thoughts be true, only that enough of them be true. That is, *R* has a grasp of the spatial order and, further, some of his elementary thoughts about objects are true.

But we have now amended *R* to a position where he can no longer claim to disbelieve in the existence of the external world, for under the present modification he must believe in *some* of the object-directed thoughts he has, and furthermore some of these must be true. Thus amended, *R* is no longer a phenomenalist, but neither is he a realist. For want of any other label, let us call him an anti-realist. He understands the possibility of an external world beyond that which is experienced; he has a recognition-transcendent concept of truth. Further he believes in the truth of some of the object-directed thoughts he has, and is right to do so. But so far he

[15] John Campbell appears to argue for the object-dependence of thoughts in this manner. See his 'Possession of concepts', *Proceedings of the Aristotelian Society* LXXXV 1985 and also, 'Conceptual structure' in *Meaning and Interpretation*, ed. C. Travis (Oxford 1986). He has made the argument more explicit in unpublished material on the reality of the past.

has no reason for thinking that all the thoughts about objects that he has possess a determinate truth value. They have a coherent content, the objectivity-of-content issue, but that is not to say that the facts they represent are settled in advance of the anti-realist's verification of them.[16] Clearly the anti-realist believes in the objectivity of truth for those thoughts about objects which triangulate his position in the world. Further, he has no reason for not believing that verifiable thoughts have determinate truth values. But, from what has been said so far, he lacks any reason to believe that the objectivity of truth for non-verifiable thoughts renders them determinately either true or false. And although it will naturally be objected that he has no reason for not believing in this either, *that* matter will be remedied in chapter 2 with my account of the manifestation challenge.[17]

[16] Even if we took the stronger internalist line that would not be enough as an argument for realism. For the stronger line of object-dependent thoughts would not be plausible as an account of *all* thoughts. We only need to consider those thoughts that are not object-dependent in order to raise the position of the anti-realist, for of *such* thoughts he may doubt that they have an objective determinate truth value. I do not believe in this stronger version of object-dependence, but that is another matter peculiar to an adequate account of sense and reference. Nevertheless, even if it were viable, it would not aid the argument in question.

[17] This last objection discarded to the next chapter is a serious one. The only person I know who has sympathised with Dummett's critiques of realism *and* made something like my distinction between objectivity of content and objectivity of truth falls on just this objection. Neil Tennant in 'Is this a proof I see before me?', *Analysis* 1981, pp. 115–19, not only distinguished between the recognition transcendence of truth conditions and the recognition transcendence of truth values, but also insisted that the latter was what was at issue in the realism/anti-realism debate. Like me, Tennant wants to keep the debate tied to the issue about logic. However, as a debate between Tennant and Weir developed in the pages of *Analysis*, it became clear that Tennant never really kept the focus where he claimed to have put it, the chief problem being that he never gave any reason for accepting the intuitionistic account of validity rather than the classical account. Without doing that, Tennant has no leverage against the realist who, offered the recognition transcendence of truth conditions, can see no good reason for not taking the recognition transcendence of truth values too. It seems to me that such leverage can only be obtained by grounding the notion of validity in terms of the preservation of experienceable truth, and we are lead to do *that* through the account we give of the manifestation challenge. This matter is dealt with in Chapters 2 and 4. Without it, Tennant for one, is open to the complaint voiced by Alan Weir against his refusal to accept double negation elimination when, on objecting to Tennant's disallowing the use of fundamental logical principles in justifying inferences like DNE, he says: 'Such a procedure is only viciously circular from the absurd perspective of one trying to derive fundamental principles from independent ones', A. Weir, 'Truth conditions and truth values', *Analysis* 1983, p. 178. What is required to anchor the anti-realist employment of the objectivity-of-truth issue is just the kind of *semantic* base for justifying rules of inference that emerges in Chapters 2 and 4. The Tennant/Weir debate proceeded

7. Where the argument lies

I have argued away from the restrictions of the solipsist *S* and the phenomenalist *R*. I have arrived at a position that is no longer restricted to the specious here and now and is no longer straightforwardly internalist. In doing all this I have employed arguments that are becoming familiar in much contemporary discussion of realism and yet we have not arrived at realism. Far from it. The position is still anti-realist. This is because what has been revealed is that realism is *not* to do with the issue about whether we possess a recognition-transcendent concept of truth, *contra* the new orthodoxy; it is not to do with the objectivity-of-content issue but with the objectivity-of-truth issue. *That* is the straightforward metaphysical issue that lies at the core of the realist position.

In focussing the matter thus it might be objected that on the position I have described the anti-realist has no concept of the categorical object; he has only a counterfactual theory. Peacocke raises the idea that we might capture the thought that there is something spherical at some inaccessible place as the thought that, if suitable conditions for perception are met, properly functioning humans would perceive something spherical there.[18] There are two points to be made against this charge.

First, Peacocke considers such a counterfactual theory and says it is incompatible with a point Dummett has frequently emphasised: namely, that counterfactuals cannot be barely true, for we think of them as being true in virtue of there *being* something spherical there. But on the counterfactual theory this condition in turn receives a counterfactual explanation. This misses the point. Peacocke cites Dummett's 'What is a theory of meaning?ll' for the issue about counterfactuals not being barely true. But there, in considering the example of so-and-so being good at learning languages, Dummett says that there are three possibilities with regard to such a sentence if we have no evidence for it. Option (ii), in not liking the idea of

with, Tennant, 'Were those disproofs I saw before me?', *Analysis* 1984, 'Weir and those 'disproofs' I saw before me', *Analysis* 1985; Weir, 'Rejoinder to Tennant', *Analysis* 1985; also, 'Dummett on Meaning and classical logic', *Mind* 1986. Unfortunately Tennant's *Anti-realism and Logic* (Oxford 1987) came to hand too late for me to take as full an account of it in the final drafting of the present book as I would have liked. Nevertheless Tennant does not overcome this fault; for further details on this see Chapter 4 below.

[18] Op. cit., p. 42.

counterfactuals being barely true, takes a reductionist strategy and makes the claim true in virtue of, e.g., some brain state. Option (iii), in not liking the reductionist strategy but, as in option (ii), adhering to bivalence, accepts that the claim is barely true or false, and thereby accepts the bare truth or falsity of counterfactuals. On option (i) however Dummett says the following:[19]

> The upholder of position (i) shares with the proponent of (iii) the conviction that there need be nothing which would enable us to determine the categorical statements as true or false . . . but, since he also shares with the proponent of (ii) a distaste for allowing as a possibility the bare truth of a counterfactual, he escapes the dilemma by rejecting the law of bivalence.

That is, on the proposed counterfactual theory we need not accept counterfactuals as barely true. We give up realism instead. That this possibility is overlooked by Peacocke is, I suspect, because he is misdirecting his energy on the objectivity of content while his official target ought to be the objectivity of truth.

But matters are worse. For it is not the case that such a counterfactual theory need be seen as offering a *reductive* account of our notion of the categorical object. There is no question of there being a priority one way or another between

Object at position R to pi is spherical

and

If a subject were at R to pi he would have an experience as of a spherical object.

Only someone engaged in providing novel content *specifications* need take that line the line of the objectivity-of-content issue. The objectivity-of-truth issue is concerned rather with our notion of the categorical object being *constrained* by our notion of the determinacy of truth-value of such counterfactuals; as also those employed in specifying our dispositions to expect certain modulations of experience as we move around the cubic object in the earlier example. The anti-realist is not employing these devices to *specify* content,

19 'What is a theory of meaning? ll' in *Truth and Meaning*, eds. J. McDowell & G. Evans (Oxford 1976), p. 91.

but to *constrain* it. The anti-realist might agree with Peacocke's specifications of contents about universal quantification and the others, and he will not be without a notion of the categorical object. He will however be suspicious about thinking that contents concerning such things are to be understood as determinately either true or false independently of our ability to determine which. He will be suspicious about the objectivity of truth for contents other than those for which he has already determined their truth.

If our anti-realist has a coherent position, the only argument that could amend his position further to adopt realism would be the kind of argument noted in section 1: an argument against *R*, or our anti-realist, for not believing in the external world. Now we have argued against *R* by way of the requirement that he accept *some* external objects, and that has given us our anti-realist. But against the anti-realist the argument must proceed against his disbelief in the existence of the categorical object in cases of sentences for which he is requiring some reason to think that they are determinately either true or false; that is, cases where he is refusing to believe that the object exists already before our verification of it. But what kind of argument could do this job? I can see only one candidate. It is to argue indirectly that, with regard to the relevant sentence *P*, if *P* were false it would follow that *C* where '*C*' is some contradiction. But *that* assumes bivalence for '*P*'. Otherwise the intended double negation elimination on *P* would not be justified. But that then assumes just that for which the anti-realist is waiting for a justification. And that is to say that there is no argument for realism that does not beg the question. It leaves the argument for realism, if there is any, firmly located in the issue about the validity of classical logic and saves the insight that I said earlier thereby accrued.

The result to be noted from this chapter is this: We have steadily worked away from an Idealist account of content with ever richer notions of recognition transcendence of truth but have not, without the argument about bivalence, found an argument for realism as opposed to an argument against Idealism.

So far as Dummett is concerned, he may well have confused two separate issues, what I have called the objectivity of content and the objectivity of truth. The former is to do with questions of *interpretation*, and any alternative to the account of content that employs a recognition-transcendent concept of truth would have to engage in novel *specifications* of content. Against such a non-realist

the kinds of argument that figure in the objectivity-of-content issue are well put. And certainly Dummett has often seemed as if he were engaged in an enterprise which would deliver novel content specifications. But he has also stressed the possibility of a non-reductionist anti-realism, and that would mean accepting the specifications of content delivered by the objectivity of content arguments.[20] But what is thereby gained by the anti-realist is the precision granted to a long-standing metaphysical conundrum by the identification of the metaphysical issue of realism about the objectivity of truth, with the question of the validity of classical logic. We are, it turns out, right to replace the old 'Does the world exist independently of our verification of it?' with 'Are classical laws of logic valid?' In the next chapter I begin the argument to show that we are right to think that there is a problem with the validity of classical inference and that our anti-realist is right to withhold bivalence from non-verifiable thoughts.

[20] See *Truth and Other Enigmas*, preface pp. xxxiiiff for Dummett's insistence on the possibility of a non-reductionist anti-realist. See my 'The real anti-realism and other bare truths', *Erkenntnis* 1985, for more on there being this possibility.

Meaning and Experience

1. The objectivity of truth

I have argued that there is an issue that can be isolated from questions about interpretation and content specification and which captures the core idea at the centre of the metaphysical image of realism. This issue is what I have called the objectivity-of-truth issue. It turns on whether we have reason to believe in the realist thesis of the objectivity of truth which was put thus:

> Thesis R: The contents we grasp are contents that have a determinate truth value independent of our knowledge of that value.

I shall now show how we should approach this issue. In the last chapter I argued that this question, essentially one about the validity of classical rules of inference, captured the core metaphysical idea of realism. What I now have to show is that there *is* a question about the validity of inference that throws doubts on classical rules of inference and, further, that this question is raised through considerations about meaning.

Now if the argument of the last chapter is correct, the realism question, in being focussed on the objectivity of truth, is essentially a question about the nature of our concept of objectivity. It is not a question about the kinds of content our utterances have, but a question about, as it were, *how hard our concept of objectivity is*. Is the objectivity that our concept of truth possesses enough to deliver Thesis R or is something else sufficient? Clearly any credible anti-realism must acknowledge *some* notion of objective truth. The issue is whether it makes sense to acknowledge so much that we get the realist objectivity-of-truth thesis. Now the argument I shall deploy is an argument to the effect that it makes no *sense* to endorse this thesis. So the argument is not that we should work with some *weaker* notion of objective truth, one which, unlike Thesis R, does not

deliver bivalence.[1] The point to the argument is that the only intelligible notion of objective truth is one that does not validate bivalence and the classical rules of inference. Therefore, it would be wrong to see the anti-realist as offering an attack on the objectivity of truth. What I am offering is an argument to the effect that the objectivity of truth does not amount to what is supplied in Thesis R.

In order to keep the structure of the dialectic clear it would be helpful if we put the matter thus. Our question is this:

In what does the objectivity of truth consist?

The realist answer is Thesis R, first identified in the introduction. We now have to find out what is wrong with Thesis R and what the alternative anti-realist answer to the above question is.

2. Three kinds of manifestationism

The connection between the issue about the validity of inference and our theorising about meaning is made through a constraint on the theory of content. This constraint is called the manifestability constraint. Before outlining my account of the constraint I distinguish three different schemas for constraints, all of which may be properly called versions of manifestationism. The point of this is to enable us to focus matters on the objectivity-of-truth issue.

Here are the three different schemas for constraints on the ascription of content that might be thought applicable:

Schema 1 If *P* does not satisfy constraint *C* the content fails in significance.

Schema 2 If *P* does not satisfy constraint *C* there is no sense to supposing that *P* is determinately true or false.

Schema 3 If *P* does not satisfy constraint *C P* is not distinguishable from some apparently different content *Q*

[1] Strictly speaking the above thesis does not deliver bivalence but only *determinateness* of truth value. By the above thesis contents might have determinate *trivalence* if one thought that there were three truth values. However, this does not affect the point of my argument. If the possibility of three, or more, truth values is thought viable, all references to bivalence in the text should be taken as 'bivalence or trivalence or . . .'.

Another way of putting schema 3 would be to say that failing the constraint reveals that the content has no *determinate* sense, no sense that individuates *it* from other contents.

Now, what sorts of issues are raised by these different schemas? Schema 1 is a schema for a constraint on content that supplies a criterion for meaningfulness. A constraint that satisfied this schema would be a constraint on whether some given content genuinely possessed a sense, whether there was a content there. We could get some such constraint if we took the point of verificationism to be one of providing content *specifications*; that is, if we took verificationism to be involved in the issue about the objectivity of content. Suppose constraint *C* were this:

For any content *P* the content must be specifiable in terms of the conditions under which it is verified, or would be verified in principle.

The difference between specifying content in terms of actual verification and in-principle verification need not detain us here. This distinction merely provides two instances for schema 1. No matter. All I wish to note is that it is only if the constraint is something like the above that is, if it deals with specifying content in terms of verifications that we get something that is an instance of schema 1. This, of course, is just the sort of way most commentators have taken Dummett's discussion of the manifestation of meaning and why he has been taken to be proposing novel content specifications in terms of assertibility conditions, criteria etc.[2]

Plainly schema 2 is the appropriate schema to look towards if we are to see the realism/anti-realism issue as concentrated on the objectivity of truth, but before outlining the constraint that gives us an instance on schema 2 let me comment on schema 3.

Peacocke has an account of manifestationism which is a constraint on content ascriptions that fits schema 3. His is not an account that seeks to specify or identify contents, but only to *individuate* them. His constraint is this:[3]

[2] See Crispin Wright's introduction to his *Realism, Meaning and Truth* (Oxford 1987) for a good account of this standard interpretation of Dummett's requirement of the manifestation of meaning.

[3] Peacocke's account of manifestationism first appeared in, *Thoughts: An Essay on Content* (Oxford 1986). It has been further elaborated in his inaugural lecture at the University of London, 'The Limits of Intelligibility: a post-verificationist proposal',

For any content *P* there is an adequately individuating account of what it is to judge that *P* rather than some other content *Q*.

Peacocke employs this constraint in order to rule out what he claims are various spurious hypotheses: for example, extreme inverted spectrum cases. The argument runs that a hypothesis of the extreme inverted spectrum cannot be individuated from other variant candidates of the hypothesis, and so the hypothesiser has failed to determine a content when he supposes that someone might possess a radically inverted spectrum.

Any such constraint as this, which is an instance of schema 3, operates by demanding standards of individuation of contents that suffice to determine a given content from among related contents. Such a constraint is clearly not involved in *specifications* of content as a schema 1 constraint is. The constraint is concerned only with *individuating* content, not *identifying* content. However, it should be noted that such a constraint is a stronger constraint than a schema 2 type constraint. Plainly, if *P* fails Peacocke's constraint, not only will it not be possible to individuate *P* from some apparently distinct content *Q*, but it could not make sense to claim that *P* is determinately either true or false. Failure on a schema 3 type constraint entails failure of a schema 2 type constraint. It is tempting also to think that failure on Peacocke's constraint also entails failure on a schema 1 type constraint. For if *P* cannot be individuated from *Q* it is unclear that we have a significant sense for *P* at all.

I think there is a problem for the schema 3 type notion of manifestationism here. The problem is this: It is unclear just what result is meant to be obtained when a proposed content fails such a constraint. This can be seen by way of the following dilemma:

Either candidate contents *P* and *Q* are distinct and the result provided by the constraint is that it makes no sense to say that *P* is determinately either true or false, or they are not genuinely distinct, but then the result of trying to individuate the hypothetically distinct contents, *P* and *Q*, is that there is no significance to the proposed content *P*.

forthcoming and the 1987 Henrietta Hertz lecture to the British Academy, 'Understanding logical constants: a realist's account', to be published in the proceedings of the Academy. The quotation is taken from the inaugural lecture.

On the first horn of the dilemma, the schema 3 type constraint collapses into a schema 2 type constraint, for what fails to be individuated is not the contents P and Q but the grounds for asserting the contents. That is, suppose Q entails not-P. Suppose also that, although the contents are different there is no way to individuate the evidential grounds for asserting P from the grounds for asserting Q, in which case there is no way to individuate the evidential grounds for asserting P from the grounds for asserting not-P. But in that case it can hardly make sense to say that P is determinately either true or false. It is just this sort of worry that surfaces in some of the examples Peacocke discusses, a worry about the individuation of the evidential grounds for asserting P and for asserting Q, rather than the grounds for distinguishing them as distinct contents.[4]

On the second horn, the schema 3 type constraint collapses into a schema 1 type constraint. For if P and Q are hypothesised to be distinct and yet no difference can be discerned, this may well be because the hypothesiser has failed to secure a significant thought at all.[5]

Peacocke aims to be providing something distinct to the schema 1 type constraint. And, in not having my distinction between the objectivity of content/objectivity of truth issues, he does not consider the possibility of there being a manifestation constraint of the kind of schema 2. Nevertheless in the examples he discusses he seems prey to this dilemma.

We can see the dilemma threatening in the following passage from Peacocke's inaugural lecture:[6]

> For each spurious hypothesis, there is an aternative hypothesis . . . legitimate by the standards of the spurious hypothesis . . . such that the spurious hypothesiser can give no account of what it is for a thinker to judge it rather than the original hypothesis.

[4] The confusion I am diagnosing here is apparent also in *Thoughts*; see below and footnote 8.

[5] Peacocke sometimes seems to make just this point. It appears to be the point he urges against the extreme inverted spectrum hypothesis.

[6] This is taken from p. 16, section 3, of the typescript for the lecture. Of course, Peacocke may revise the lecture further before it is published and so my point may no longer apply. However, my interest is not in criticising Peacocke, but in clarifying the geography of manifestation constraints, which is why I have taken the liberty of referring to work still forthcoming.

It is in the last clause that Peacocke's constraint appears to lapse into claiming that there are no distinguishing *evidential grounds for, asserting or grounds for judging* the alternative contents, rather than saying that they are not distinct. After all, he says there *is* an alternative hypothesis, although admittedly only by the standards of the spurious hypothesis. But Peacocke's problem here is this. If the hypothesiser has standards to distinguish the two hypotheses, he must attack those standards. But what he actually does is offer different standards to do with the evidence for asserting contents. It is this which, surely, only gives the weaker result that we have no grounds for taking either of the hypotheses as determinately true or false, rather than the strong claim that there is no difference in sense between the two. Just how threatening the problem is will vary with the examples considered. In the example of the extreme inverted spectrum it seems more reasonable to think that the result obtained is that there is *no* significant sense to the hypothesised content about the inversion. In another example he discusses, that of Chisholm's insistence that he knows what it would be to be one post-operative person rather than the other in fission problems of personal identity, it may seem more natural to take the weaker result. This would be to acknowledge that to think one is going to be 'Lefty' after the operation rather than 'Righty' is to think something different from thinking that it will turn out the other way round. But it is also to press the idea that, even so, one has not shown any reason to believe that the thought that one will be Lefty is determinately true or false.

I am sympathetic to the idea of there being instances of schema 3 type constraints on content, but it seems to me that most often the useful results one gets are more properly results about the determinacy of truth value of contents. These arise when the constraint is interpreted in a way that reduces it to a schema 2 type constraint. The issue turns on what is meant by 'individuating a content'. For sure, if P and Q are distinct contents there must be an individuating difference between them. But might this be no more than, for example, a difference in inferential connections that the contents bear to other contents $R, S \ldots$ etc.?[7] The individuating differences that Peacocke fixes on are not like this. They are rather

[7] I endorse such a principle of individuation of contents, what I call the *role* of a content, in Chapter 5, section 6.

differences in the way the contents bear upon the experience and actions of the subject, and although these are differences that serve to individuate contents they also serve to differentiate the *evidential grounds for asserting the different contents*. When we look to such individuating differences and find that for some putative contents P and Q they cannot be individuated by such means and, further, where Q entails not-P we get the result that it makes no sense to say that P is determinately true or false. We get this because the lack of such individuating dfferences between P and Q means that whenever we think we have reason for asserting P we have just as much reason for asserting not-P. That is plainly intolerable, so we conclude instead that it makes no sense to think that P is determinately either true or false.

The reason I think it useful to pursue this analysis of Peacocke's idea of manifestationism is this. Officially he is pressing the idea of a constraint which requires that contents be capable of clear individuation. Now if some putative content P fails some such test, then clearly, as already noted, it cannot be a content that is determinately either true or false. But as long as the test is thought of purely as one of individuation of *content*, rather than also as one of individuation of grounds for asserting content, the result about lack of determinacy of truth value is derivative. The main result must be that the putative content P really is putative, there is no genuine content there. And this, quite simply, is a very strong charge to make. In Peacocke's hands the matter is only alleviated because he focusses instead more on what I have called the derivative result. Quite how acceptable the main result will be will vary from case to case. I am sceptical that there will be many cases where the main result will be acceptable for, as the logical positivists found to their cost, it is no easy matter to rule out putative contents. What is interesting here is this thought: Although if there is no determinate sense (a content fails a schema 3 type constraint) there can be no determinate truth value (it also fails a schema 2 type constraint), the converse is, of course, not true. It is perfectly coherent to hold that, for some content P, there *is* a determinate sense but there is no determinate truth value. That is precisely the result we get if we work only with a schema 2 type constraint, if our account of the manifestation constraint is wholly of the schema

2 type. And it is just such a manifestation constraint that I shall now develop.[8]

3. The manifestation constraint

The constraint I pursue is an instance of schema 2 above. It is also a constraint that is not *directly* a constraint on contents. The *rationale* for the constraint draws upon fundamental features of the concept of knowledge and is important because certain contents, in order to be known, require that we transcend this constraint. The constraint works indirectly via the use of the concept of knowledge in our theorizing about content. In this respect my constraint is of a different kind to constraints of schema 1 and 3 types which operate directly on the notion of content. This should not be surprising. The resulting anti-realism has already been claimed to be non-reductionist and not to offer novel content specifications. It should be no surprise then that the manifestability constraint should not directly affect content but be a constraint on our knowledge of content. It is, in short, a constraint on the intelligibility of knowledge ascriptions which, when applied to certain contents, has the result of ruling them out as being determinately either true or false.

The general form of the constraint is this:

> *Constraint C*: For any content *P* if it makes sense to say that subject *S* knows that *P*, *P* must be an experienceable state of affairs and this entails that *S*'s knowing that *P* makes a detectable difference to experience.

Of course, the reference to 'experience' here is vague, the notion is left unanalysed. This does not yet matter and is, in fact, a virtue. I shall return to this point much later. I shall say that if some content *P* satisfies *C* then *S*'s knowledge of *P* is *manifestable*. If *P* does not satisfy *C*, knowledge of *P* is not manifestable or, as I shall

[8] The confusion I have just diagnosed in Peacocke between criteria that individuate contents and criteria that individuate grounds for asserting contents is also apparent in *Thoughts* and occurs with respect to his notion of the canonical commitments of a content *determining* its truth condition. In the book content is manifested in the subject's taking on canonical commitments for a content, e.g. Peacocke's account of universal quantification discussed in the last chapter. But it is not always clear whether he means the commitments to determine (individuate) the content that is, the truth *condition* or to determine the truth *value*.

say, it is *dislocated*. Let me draw out the underlying intuition that *C* is designed to capture before I put some detail into *C* and show how it works.

The underlying intuition behind *C* is this: It is a constraint that serves to ensure that all intelligible knowledge ascriptions be ascriptions of knowledge that 'touch' experience. The thought is that it only makes sense to speak of knowledge where the subject's knowledge is knowledge of something experienceable. And 'experienceable' means 'could be part of an experience of an objective state of affairs'.[9] We get at the idea of the state of affairs being experienceable by requiring that the subject's knowledge of the state make a difference to experience. The point behind constraint *C* is a limited but important logical point. Without further flesh on the notion of 'experienceable states of affairs' it might seem that constraint *C* is obviously acceptable, but only because all the interesting work is being left to an account of what is experienceable. But that thought is not quite right. My base line *is* a limited point, but from it follow devastating consequences for realism, for which I do not need to add further flesh on the notion of 'experienceable states of affairs'. My concern is with what kinds of logically complex states of affairs are experienceable. It is not a concern with what kinds of atomic states of affairs are experienceable. The concern with the latter question comes in chapters 8 and 9.

As it stands there are two components of constraint *C*. The central component is the requirement that the state of affairs that is the object of knowledge be experienceable. To begin with, I approach that idea through the second component which I claim is entailed by the first, namely that *S*'s knowing that *P* make a detectable difference to experience. On its own the second component amounts simply to a second-order verificationism about knowledge claims, but this is not the base line, it flows from the first component. The connection is this: If *S*'s knowing that *P* makes a detectable difference to experience because it renders *Q* true, and *Q* would not be true unless *S* knew that *P*, then that is to show how *P* itself is experienceable. For the principle underlying what makes a state of

[9] Note that I am not demanding that this experience be a shared *public* experience. That is, constraint *C* is not offered as part of a Wittgensteinian-style attack on private knowledge which holds that the right/seems-right distinction must be drawn publicly. My point is a logical one about what an experience of an objective state of affairs must be like. I do not start with a presumption in favour of the community over the individual. The point at issue here is elaborated in section 7 below.

affairs experienceable is that it *rules out* certain experiences. In the supposed case, *P*'s being true rules out the negation of *Q*. So the working of constraint *C* is not just a second-order verificationism. It is a thesis about what makes a state of affairs experienceable and the requirement that knowledge be restricted to experienceable states of affairs. For the moment I shall pursue the operation of this constraint informally with some examples concentrating on the second component of the constraint. I give the direct argument in defence of the constraint later in section 7 after we have seen the use to which the constraint may be put. For example, consider the following kind of case.

Suppose subject *S* claims to have been to the moon, even though we are quite sure that he has never set foot outside the country, let alone had the relevant training for such a flight. Nevertheless he insists that he knows that he has been there. For sure, in such a situation, we would demand a good deal of impressive evidence before accrediting him with this knowledge. On the matter of the quality and quantity of evidence required for us to agree that he knows what he claims I do not presume to decide. I am not concerned with criteria for its being *true* that he possess this knowledge, but with its making *sense* that he possess the knowledge. And this is the idea that if his knowledge is to be manifestable and his claim is not to be dislocated it must draw *some* constraint on experienceable states of affairs.

Now how may this claim affect our experienceable states of affairs? I think that there are two main lines of argument to show that the claim makes a detectable difference to experience. These are: (a) there is something about *S*'s behaviour which manifests the knowledge, something he does which is detectable and which can only be made sense of by crediting him with the knowledge in question; (b) there is some reason-giving inference which *S* can give, or which we can construct, which defends the knowledge claim, and this inference must defend the claim in a non-circular non-question-begging manner.[10]

[10] Of course line (b) is a version of line (a) concentrating on linguistic doings rather than doings in general. Nevertheless it is worth considering it as a separate concern, for it marks the line of critique to be developed against realism. The appropriateness of these lines of manifestationism has close affinities with David Wiggins' investigation of the 'marks' of truth, 'What would be a substantial theory of truth?', *Philosophical Subjects*, ed. Zak van Straaten (Oxford 1980), pp. 189–221. Wiggins' approach to the marks of truth via an interpretative theory which operates

In the example at hand it is difficult to see what could constitute
S's behaving in a way that could constitute grounds for granting
him the knowledge he claims. So suppose that there is no such
behaviour. Suppose further that he can give no reason in support
of his claim and we cannot construct one. That is, neither S nor we
can point to a difference his purported knowledge can make to his
or anyone else's experience. In such a situation we would be right
to respond with a sense of bewilderment. S says that he has been
to the moon but he does not know how, with whom, when, exactly
where, or even why; he just knows that he has been there, or so he
says. We repeatedly question him to find some defence for his
purported knowledge, but to each and every one of our enquiries
he responds only with a resolute, 'I just know that I have been to
the moon.' Someone whose assertion 'I just know that P' makes a
knowledge claim that is not responsible to experienceable states of
affairs is a person who cannot manifest his knowledge; the claim to
know has become dislocated. It is not clear what it is that such a
person claims to know and we may well wonder whether he is using
the words 'moon', 'go' and, most importantly, 'know' correctly. The
general problem with such dislocated knowledge claims is this: They
arc too *easy* to make in the sense that if *that* is allowed as an
intelligible knowledge claim then anything might be allowed.

A slightly richer use of the same example is useful here. Suppose
S comes up with some justification for his purported knowledge. He
shows us a piece of rock which hc says is moon rock. Testing
whether it *is* moon rock clearly opens up various avenues of enquiry.
However, such avenues of enquiry would be blocked and thereby
threaten the intelligibility of his claim if it turned out that his only
justification for these further claims went something like this: 'This
is moon rock because I remember collecting it when I visited the
moon last year'! If such further avenues of enquiry are blocked off
in this way it is not just the truth of his claim to have visited the
moon that is in question but also the very *sense* of his claim to *know*
of his visit. The supposition is that, even if we do a mineral analysis
on the rock and find it totally dissimilar to all previous samples of

with an anthropological theory to give the most satisfactorily explanatory account
of the life and beliefs of speakers of some language employs implicit constraints on
meaning and truth not dissimilar to those enforced in constraint C. There are, e.g.,
connections between what I call the A-R thesis, see below, and Wiggins' second and
third marks; cf. pp. 206–11.

bona fide moon rock, he is unmoved and says that *he* knows that it is moon rock because he collected it last year. That is, the reason-giving inference he supplies in defence of his knowledge claim is circular and question-begging. In such a situation *S* is offending an intuitively acceptable constraint on the correct use of the verb 'to know'. This is not a reflection of ordinary language, but a matter of logic. It is a conceptual point to do with the *sense* of knowledge ascriptions. It is a point that is captured by my constraint *C*.

I shall elaborate constraint *C* further by employing it to sketch the anti-realist answer to our question of section 1 about what the objectivity of truth consists in. The realist answer is supplied in Thesis R. The anti-realist answer must draw upon constraint *C*. That constraint serves to limit the range of intelligible knowledge ascriptions. Anti-realism is characterised by restraining truth to knowable truth. Accordingly, the anti-realist answer to our question must go something like this. I call it the A-R Thesis:

> A-R Thesis: An area of discourse is objective if and only if the propositions of the area of discourse are subject to standards of correctness and incorrectness of assertion encoded in a system of evaluation in such a way that through attendance to the system of evaluation the area of discourse is able to generate knowledge claims which satisfy constraint *C*.

This is quite a mouthful. But the intuitive idea is simple. It is this. Rather than look at the objectivity of truth in terms of a static conception of states of affairs 'out there anyway' as captured by Thesis R, the anti-realist offers a dynamic conception of what is required for a discourse to attain objectivity. What is required is that the discourse satisfy certain methodological requirements that fit in with what is taken as a necessary condition for the intelligibility of knowledge ascriptions: constraint *C*.

The reason the A-R thesis requires that there be some system of evaluation for the propositions of some discourse is that I am concerned with propositional knowledge, *knowledge that*, not *knowledge how*. The reason for this is closely connected with the *rationale* for constraint *C*. It is that when, for some *P*, someone claims to know that *P* the system of evaluation, which could in principle be employed to assess whether or not *P*, individuates just *what* it is that the subject claims to know. The identity of the proposition *P*

is fixed by its position within the surrounding system of evaluation. Simply: We know *what* it is the subject claims to know when we know what could be said for or against it. This was the case with the example of *S* who claimed to know that he had been to the moon. We know what it is he claims to know in knowing what *would* count for or against the claim. The dislocation of *S*'s claim consists in his refusal to submit his claim to the demands of experience appropriate.[11]

For the moment I shall not argue that the A-R thesis is a sufficient condition for objectivity, but I take it as a necessary condition. I elaborate the thesis further in section 7 where I derive what I call the 'Independence of Truth'. From then on, the sufficiency of the A-R thesis is the topic of the rest of this book.

Bearing in mind the two lines of manifestation (ways of showing how a knowledge claim makes a detectable difference to experience), it is relatively simple to see how the A-R thesis works to rule on the objectivity of some discourse. A discourse will fail of objectivity if the knowledge claims that it generates fail to make detectable differences to experience along either of the two lines indicated above; that is, if there is no behavioural difference possession of the knowledge makes to the subjects, or there is no non-circular non-question-begging reasoned defence available for the knowledge claims. These are the two ways of failing constraint *C*. When a whole area of discourse is such that the knowledge claims it generates fail *C* in these ways, then the discourse is not one of which it makes sense to say that it possesses an objective truth predicate. The discourse does not satisfy the A-R thesis. The two tests provided by constraint *C* for whether or not a discourse is objective are then these:

Behavioural test: Does possession of the knowledge claimed to be generated by discourse *d* make a behavioural difference to the subject claiming the knowledge?

and

[11] Recall the thought from the last chapter: realism is a coherent concept if we know what *would* have to be the case for the world to exist determinate beyond our knowledge of it. This gives us at least the position of our phenomenalist *R*, but it does not yet give us *reason* to believe in realism.

Argument test: Is there a non-circular reason-giving argument available in defence of any knowledge claim generated by discourse *d*?

Despite the fact that we are concerned with propositional knowledge, I accept that the behavioural test is, in principle, often sufficient to show that some knowledge claim satisfies *C*. If such a claim is typical of some discourse of claims, that would then also be sufficient to show that the discourse is objective.[12] However, it is the argument test that is of most importance for us. In terms of this test we can define one further piece of machinery before we construct the argument against realism.

The argument test highlights an important insight, originally due to Kant, about *types* or *systems* of knowledge claims. If we have some discourse where the knowledge claims are such that the only arguments in defence of the claims are circular, or question-begging, then the failure of objectivity is due to what I shall call the *closure* of the discourse. In general this will occur with a discourse where the system of evaluation appropriate for the propositions of the discourse presupposes that one already has knowledge of propositions which are constitutive of the discourse. In such a case we get a vicious circularity. So,

A discourse d *is closed* if and only if it fails the argument test.

This captures well Kant's important insight that *knowledge* of God is not possible, for a claim to *know* that there is a God is a claim that fails to impinge on experience; it fails constraint *C*.[13] The familiar idea that religious beliefs are not susceptible to rational defence that does not beg the question about the existence of the deity is then expressed by saying that religious discourse is *closed*.[14] In contrast to this, objective experience and objective knowledge are always open and depend upon the acceptability of a system of

[12] I defend the reasonable of *C* and the above definitions in section 7 below after developing the argument against realism.

[13] Of course I am aware of the claims for mystical or religious experience but these are as problematic as the cognitive claims they are meant to support. I do not mean to discount the possibility of a cognitivist theology, but I do not know of a convincing instance of one.

[14] For Kant's observation on the impossibility of *knowing* that there is a God, cf. *Critique of Pure Reason* B857/A829. Of course this is all done in order to leave room for faith.

evaluation for knowledge claims which permits continued independent testing. In the case of theistic beliefs there is normally accepted to be a closed circle of explanation and justification in the sort of reasons believers give for their beliefs. Of course, this is *not* to say that this closure makes the meaning of such beliefs unintelligible, only that it makes knowledge of the application of the relevant concepts unintelligible.[15] I think I know what people *mean* when they talk about God, but I fail to understand how they can have *knowledge* of the concept's application.

With constraint *C* and the A-R thesis we are almost in a position to sketch the argument against realism. First, in the next section, I shall consider some examples of how *C* may be employed as evidence in its favour. In section 5 I give the argument against realism, defending it against objections in section 6. In section 7 I return to give fuller justification of constraint *C*, before recapping the case against realism in section 8.

4. Employing constraint C

Let me briefly run through some examples to suggest that constraint *C* is a legitimate constraint on knowledge ascriptions. Fuller argument will be given after the statement of the argument against realism. I consider a number of cases where philosophers have perceived an oddity in speaking of knowledge and suggest that the oddity results from not satisfying constraint *C*. The examples I wish to consider at this stage are all cases of logically atomic sentences. In the argument against realism we will be concerned only with logically complex sentences.

First case. The example here is this:

(1) Lockean substance exists.

Plainly there is a problem with (1) considered as an object of knowledge. Further, the problem does not seem to be a contingent one, but rather a consequence of the very *sense* of the concept of Lockean substance. The postulation of Lockean substance is, one might say, an empty hypothesis. It plays no role within the

[15] Recall the point in Chapter 1, section 5 where I said that the important question was not about showing that a concept had content, but whether it made sense to think that it could be shown to have application.

machinery of our cognitive endeavours.[16] And clearly the supposition that a subject knows that (1) fails both the behavioural test and the argument test in straightforward and obvious ways.

Note that knowledge of (1) fails constraint *C* does not entail that (1) has no sense. On the contrary, it is precisely because of the sense it possesses that it fails *C*. In this respect (1) would seem to be of a kind with the example already alluded to in section 3, namely

(2) God exists.

and also

(3) The transfinite cardinals exist.

Example (3) is an interesting one. Clearly the behavioural test is of no use if a subject claims to know that (3), but what of the argument test? The fundamental insight that motivates the intuitionist reaction against classical mathematics is this: The very logic employed by classical mathematicians imports metaphysical assumptions into classical proofs the entitlement to which needs to be made good. That is, classical mathematics, in proving that some number *a* possesses the property *F*-ness, does not always prove such things *mathematically*. Often enough it is the logic which does all the work. The intuitionist demand is that mathematical proofs proceed mathematically unaided by logical principles which are question-begging about the nature of mathematical reality. Now the intuitionist can construct the transfinite cardinals up to a certain limit.[17] But an argument to defend the claim to know that (3), that is, that the *totality* of the transfinite postulated by Cantorian set theory exists, will require classical rules of inference. But then, if these rules of inference carry the metaphysical load that the intuitionist charges and I argued for in the last chapter, the claim to know that

[16] As Wittgenstein remarks, 'a wheel that can be turned though nothing else moves with it, is not part of the mechanism'. *Philosophical Investigations* (Oxford 1953) section 271.

[17] The issue here is delicate and complicated, but it is not contentious that the intuitionist might accept the transfinite up to aleph-zero, accommodating the cardinality of the domain of the natural numbers and the domain of the continuum. However, beyond that, it is problematic that more can be achieved with intuitionistic logic. I am grateful to Dan Isaacson for guidance on these matters.

(3) will fail the argument test. This failure is due to the fact that there is no argument to support the claim which does not beg the question about the determinacy of mathematical reality with respect to the existence of the transfinite.

Again, this is not to say that (3) has no sense. That would be the result obtained by a schema 1 type constraint. Nor is it to say that (3) has no determinate sense. That would be the sort of result obtained by a schema 3 type constraint. I am happy to allow that (3) possesses a determinate sense, and to allow that the individuation of that sense obtain in terms of the inferential connections taken to obtain between (3) and other related contents. That is, we have a content here and we know what content it is in virtue of knowing how it is supposed to fit in with various others as so many cogs within the complex machine of the mathematics of the transfinite. However, as with (1), we have no reason for thinking that this machinery issues with intelligible cognitive claims. The machine docs not turn for us. We have no experiential leverage to ground the claim to know that (3). As Brouwer might have said, the transfinite do not come within the compass of our mathematical intuitions.

Second case. The example here is this. Consider the situation of the resulting two people after a split-brain double-transplant operation and call them 'Lefty' and 'Righty'; the person from whom they issued call 'Centre'. The problematic content is then

(4) I am Centre

claimed as an item of knowledge by either Lefty or Righty. Again, when either claim to know that (4), their claims fail both the behavioural and argument tests. They fail the former since if Lefty claims to know that (4) there is no behavioural difference that claim makes to his actions that cannot be duplicated by Righty. And the same point holds of Righty. Of course, generally, there is no problem in two distinct subjects claiming to know some proposition P. The peculiarity here is that the proposition in question is such that if one of Lefty or Righty knows it the other cannot, given the plausible assumption that only one can be identical with the original Centre.[18]

[18] Given also the assumption that there is such a thing as the identity relation holding over persons. This, of course, has been contested: *locus classicus*, D. Parfit 'Personal identity' *Philosophical Review* 1971.

Their claims fail the argument test for obvious reasons. Given the way the situation is constructed there is no argument that could differentiate between their rival claims to know that (4).

Once again, this does not suffice to show that there is no *sense* to what Lefty, or Righty, says when they utter (4). It is not that they have failed to think a thought. Unlike Peacocke, I am happy to accept that the thoughts they have can be individuated as distinct thoughts simply in virtue of the fact that, post-operatively, they have different referents for the first personal pronoun.[19] This suffices to give them distinct individuations of contents in virtue of the differential connections between Lefty's thinking that (4) and Righty's thinking that (4) and other contents such as

(5) I am the person in the hospital bed nearest the door.

Only Lefty thinks (5); Righty is near the window. Where the difficulty lies with (4) is that there is no difference in what I earlier called the evidential grounds for their asserting the content (4).

These two examples suffice to give some idea of how constraint *C* may be employed in accounting for certain familiar peculiarities. The second case is, unlike the first, a case where the peculiarity is contingent upon special features of the circumstances of the knowledge claim in question. The first case was of a kind where the difficulties were due to the kind of sense involved. The argument against realism is of a kind with the first case, except that we will now be concerned with knowledge of the truth of logically complex sentences. For the problem for the realist is due to the very kind of sense he requires for the logical constants. Because we are now considering complex sentences it is the argument test that will be of paramount importance.

5. The argument against realism

Let us consider knowledge of sense, knowledge of the conditions under which it is correct/incorrect to employ linguistic units. In

[19] It matters that I am now discussing the post-operative situation. The pre-operative question is, perhaps, different. Then there might be less case for thinking that the thought that one was going to be Lefty rather than Righty was different from the thought that one was going to be Righty rather than Lefty.

particular, let us consider knowledge of the sense of the logical constants. A realist believes in thesis R; that is, all instances of

(6) $P \lor \neg P$

are true. The realist can give an account of the truth-conditions of such thoughts, namely that an instance of (6) will be true just in case either the proposition or its negation is true. There is no problem with there being a content in which the realist believes, for I am not questioning what I called the objectivity-of-content thesis. The issue is whether realism is tenable; that is, whether it is so much as possible to know that what the realist believes is so. *That* is the point that I wish to press in the argument against the realist. That there is a point to press here is because, although I concede that there is a content to (6) which the realist believes to be true, because of the very nature of the content involved one cannot *know* that the content is true. And the 'cannot' here is due to the claim to know violating constraint *C*. In short, for realism to be tenable we would have to exceed the bounds of objective knowledge as characterised in the A-R thesis.

So, the realist has a thought with a genuine content when he thinks that (6) is true for any *P*. Realism is not incoherent. Whether it is tenable turns on whether we can know that (6) is true, and that is to say that it turns on whether we are *justified* in accepting (6) as true. This, in turn, depends on whether we are justified in accepting those rules of inference, like the classical negation elimination rule sometimes called 'double negation elimination' (DNE) which require bivalence. So how could one manifest one's knowledge of (6)? And that is to ask, Are we justified in accepting (6)? Considering the general principle of bivalence, one clearly cannot manifest knowledge of (6) behaviourally. So a claimed knowledge of (6) would fail the behavioural test. This is not surprising. (6) covers undecidable sentences as well as decidable ones and so there can not be a detectable behavioural difference in a subject's knowledge of an instance of (6) with '*P*' as undecidable. What then of the argument test? Clearly any argument with (6) as conclusion where '*P*' is undecidable *must* employ rules of inference like DNE the validity of which presupposes (6). The simplest such argument is, of course, this:

(7) (i) $\neg(P \lor \neg P)$ *hypothesis*

 (ii) P *hypothesis*

 (iii) $P \lor \neg P$ v *introduction* ii

 (iv) $(P \lor \neg P) \ \& \ \neg(P \lor \neg P)$ & *introduction* i,iii

 (v) $\neg P$ \neg*introduction* ii,iv

 (vi) $P \lor \neg P$ v *introduction* vi

 (vii) $(P \lor \neg P) \ \& \ \neg(P \lor \neg P)$ & *introduction* i,vi

 (viii) $\neg\neg(P \lor \neg P)$ \neg*introduction* i,vii

 (ix) $P \lor \neg P$ \neg*elimination* viii

But that means that a claim to know that (6) must fail the argument test, for there is no non-circular reason-giving defence of such a knowledge claim. Any defence must beg the question by employing rules of inference the validity of which presupposes the knowledge that is supposed to be manifested through the argument test. Without begging the question, we can only get as far as step (viii) in our little argument, which is, of course, exactly just as far as an intuitionist would allow.

Now what exactly is at issue here? Does it really matter if there is no non-circular defence of classical rules of inference? I think it does for two reasons. First, as I argued in the last chapter, the question about the validity of classical logic is no idle matter. It is not an arcane matter, the special province of logical theory, with no ramifications elsewhere. The validity of classical logic is the question at the heart of what I called the objectivity-of-truth issue and *that* is what lies at the core of the metaphysical question about realism. That being so, we cannot respond to the above argument by claiming that the validity of classical logic is a mere technical matter of no concern if there is no non-circular justification for it. It is not, as it were, 'just logic'. The patterns of deductive reasoning characteristic of classical logic embody far-reaching metaphysical assumptions. That is the point of capturing the objectivity-of-truth issue with bivalence.

Secondly; the problem with justifying classical logic is not a contingent one, one that might, as it were, go away, if some contingencies were otherwise. *It is a problem that is a function of the very sense the realist claims for the logical constants.* The problem here is like the first case discussed in the last section. The difficulty with claims to know of the existence of Lockean substance, God or the transfinite was due to the sense those concepts have. Just so with the problem

about justifying classical logic. In short, for realism to be tenable it would have to be legitimate to endorse knowledge claims that infringe constraint *C* in just the way that we normally accept that claims to know of the existence of Lockean substance or God infringe intuitively respectable constraints on knowledge. Such constraints are captured in constraint *C*. But that means that it matters if the knowledge required for realism to be tenable infringes that constraint. And that means that a discourse for which the system of evaluation is classical logic is not an objective discourse. In short, the realist concept of truth, captured in his thesis about the objectivity of truth, thesis R, is not an objective concept of truth!

Contrast what we could say in defence of a claim to know an instance of (6) with decidable '*P*'. For the moment, assume that decidability is due only to sentences about the immediate sense experience of the subject. '*P*' might then be something like

My current visual experience is coloured red all over.

To assume that '*P*' is effectively decidable is to assume that it is a matter of brute experiential fact that we can directly perceive that our visual experience is red all over, or is not red all over, and that these two possibilities are mutually exclusive. That being so an adequate manifestation of a subject *K*'s claim to know that (6) *in this case* would consist in his claim that he knows this to be true because either it is true that his current visual experience is red all over or it is not true. Of course, in supposing that he can manifest his knowledge of this instance of (6) so, we appeal to a use of those logical constants *K*'s knowledge of the contribution of which to the truth of the original sentence we were trying to justify. However, the justification is not rendered invalid by this. For in considering an instance of excluded middle, where the sentence in question is *antecedently acknowledged to be effectively decidable*, the recurrence of the disjunction and negation operators in an argument in justification of one's knowledge of the truth of the instance of excluded middle is perfectly licit. The point may be put thus: What makes *K*'s knowledge that (6) manifestable *in this case* is the fact that we thereby show how his knowledge is a function of *experienceable truth*. We see how knowledge of the disjunction is compounded out of knowledge of the experienceable truth that the visual field is coloured red all over, the experienceable truth that it is not coloured red all over,

plus the acknowledged fact of experience that these two experiences, or sets of experiences, which render these truths true are mutually exclusive. In allowing K to manifest his knowledge of (6) in this manner for this case we succeed in not begging any questions about the correct use of the constants, for we only grant K knowledge of an experienceable use of the constants. Indeed this is the virtue of such support for his knowing that (6); namely, that it shows how his knowledge is grounded in an experienceable use of the constants. For such instances of excluded middle, the knowledge of their truth (or falsity) only presupposes knowledge of an experienceable use of the logical constants; a use which constitutes what I shall call the *logic of experience*.[20]

In allowing K's knowledge of this particular instance of (6) to be manifested in this way we allow K to show how, as it were, his knowledge touches experience. The point about showing how knowledge of the truth of some particular disjunction or the validity of some rule of inference rests upon knowledge of an experienceable use of the logical constants depends on the following observation: Without such an account of the knowledge in question, in terms of its experienceable constituents, we are left with no non-circular non-question-begging account of K's knowledge.

The idea I want to press here is this: There is an experienceable use of the logical constants which is epistemologically foundational. Its foundational role in matters of validity is due to its characterising the logical complexity or logical contours of experience: the experience to which all our knowledge claims must be manifestable (constraint C). When I say that the logic of experience is foundational I do not mean to use this adjective in the way it is employed when we speak of foundationalist epistemologies. The foundations I have in mind are not to do with this or that class of statements, sense-data reports, protocol statements, etc. They are foundations in *the way we evaluate* the truth or falsity of statements. It is not to say that certain statements or regions of reality are foundational; that is the old verificationism of logical positivism. The thought is that certain *methods of evaluation* or *rules of inference* are foundational.

[20] Experienceable truth is the aim of Brouwer's reconstruction of mathematics; cf. L. E. J. Brouwer, 'Consciousness, philosophy and mathematics' in *Collected Papers 1*, ed. A. Heyting (Amsterdam 1975), pp. 489–94; p. 489: 'There are no non-experienced truths and ... logic is not an absolutely reliable guide to discover truths.'

The contrast between the last case and the case of *K*'s claimed knowledge of an undecidable instance of (6) allows us to formulate the following hypothesis about the logic of experience. At the present it is only an hypothesis. I have so far only mentioned the law of excluded middle, and that very briefly. The issue really centres on negation. It is the account of experienceable negation that delivers the results about excluded middle. I shall not get to discuss negation until Chapter 4. However, it is as well to formulate the hypothesis suggested by the failure of knowledge of an undecidable instance of (6) to pass the argument test. The hypothesis is this:

> *Logic hypothesis*: There is a logic *L* knowledge of the validity of which conforms to constraint *C*. That is to say, the sense of the constants in *L* is such that knowledge of the truth of complex sentences can be validated by reference to experience.

The logic of experience, *L*, will turn out to be proof-theoretically intuitionistic. And although knowledge of the truth of an *L* logically complex sentence, when put to the argument test, will only be supportable by an argument that employs *L* rules of inference, this does not matter. For, unlike the case of knowledge of a classical logically complex sentence, *L* logical complexity is the minimum notion of complexity required for a coherent account of experience to be developed. That is to say, in the central case of negation, I shall argue that we have to have at least an account of negation as rich as *L* negation, experienceable negation. But having developed *L* complexity and the notion of arguments being experienceable truth preserving, the *L* logic plays an even more important role. For the foundational nature of the logic of experience is due to the fact that, if a purported knowledge claim is not manifestable with regard to inferences licensed by the logic of experience, it is not knowledge. The logic *L* characterises the patterns of inference that must be employed when meeting the argument test. This is not too surprising, for the logic comprises an experienceable use of the constants and the whole point of the argument test was to show how a knowledge claim impinged upon experience in order to meet constraint *C*.

The positive claims above will be supported as my argument proceeds through the next three chapters as I substantiate the Logic Hypothesis. But we are now in a position to complete this initial

account of the core argument for anti-realism and against realism. I said that in grounding K's knowledge of an instance of (6) in an experienceable use of the logical constants we achieved a non-circular justification for the knowledge. This is because an experienceable use of the constants, one for which validity is defined in terms of preservation of experienceable truth, is the use which must be appealed to in our manifestations of knowledge simply because the manifestation of knowledge is a question of relating that knowledge to experience. But if we consider a claim of knowledge of the truth of a logically complex sentence where the knowledge fails constraint C because it fails both the behavioural test and the argument test, realism is faced in the following bind. Given the sense it requires for the logical constants, realism requires that we know that all instances of (6) are true.[21] But manifestation of this knowledge will fail the argument test if it resides only in our licence to engage in certain inferential practices, the classical ones. For it is exactly the justification of our use of patterns of inference that is supposedly supplied by our knowledge that the content we suppose for the constants obtains. When we come to consider the general character which our theorising about meaning should take, it is precisely this question of which patterns of inference are justifiable that is at issue. Therefore in theorising about meaning we should not employ a logical theory the sense of which requires that we possess knowledge that fails constraint C. We should not burden ourselves with contents which are such that it makes no sense to suppose that they obtain. Realism requires that we place at the centre of our theorising about meaning a conception of logic and truth which transcends constraint C, which, I have suggested, captures familiar and acceptable intuitions about the limits of the intelligibility of knowledge claims. For the only reasoning to the point in defence of knowledge of Thesis R would be reasoning employing classical rules of inference. But this is only valid if we have the knowledge such reasoning is meant to be used to manifest. We are chasing round in circles.

6. Three objections

(a) Could it be a mistake to ask for justification for forms of inference in the manner above? Is it not plausible to say that they stand in

[21] This is simply the realist answer about the objectivity of truth: Thesis R.

need of no justification? Their continued use *is* their only justifi-
cation, in that the propensity to reason in the classical manner just
is the manifestation of knowledge of the truth of, e.g., bivalence.
When someone has once understood the way the classical truth
tables serve to fix the value of complex sentences, he has grasped
the meaning of these sentences in a realist manner and manifests
his knowledge of their truth in his reasoning according to the
classical rules of inference.

This objection is hardly persuasive. Either it says that there is
no justification for classical rules of inference, or it says that the
justification is given by arguing in a classical manner. If the former,
all the objection amounts to is the claim that the laws of classical
logic are simply and unquestionably valid. If the latter, the objection
simply begs the whole issue. This sort of begging of the question is
evident in the following passage:[22]

> The classical mathematician need not be described as holding that the
> claim that there is . . . a number . . . with a certain property [of which]
> it is possible neither toconstruct a number which has that property, nor
> to prove that there could be no such number . . . must be either true or
> false even though we can neither prove nor disprove it; he believes that
> we *can* prove it, indirectly, by *reductio ad absurdum* of the assumption that
> there is such a number.

But such a proof can only count as a proof if we think that such
forms of argument are valid for arithmetic, and that is the point at
issue. The idea that we can prove the existence of such a number,
albeit 'indirectly', is of no point to the critic of realism, who does
not see what sense there is to attributing to ourselves the knowledge
which would be required in order to validate such reasoning.[23]

Clearly then the present objection would be better construed as
a claim that classical logic is simply and unquestionably valid and
not in need of any justification at all. But now this is plainly
implausible. For anyone who pursued such a claim it appears that
there is no difference between really knowing the validity of classical
logic and blindly going ahead with classical reasoning. We need
only find some case, or domain, in which such a person does not

[22] S. Haack, 'Dummett's justification of deduction', *Mind* 1982; cf. pp. 235–6.

[23] Haack's point would be well put to someone like Tennant who gives no semantic
grounding for intuitionistic logic in terms of experience as I do with constraint *C*.
See the works cited in footnote 17 to Chapter 1.

want to be a realist in order to see that the question about justification is a real one. The option of a global realism hardly seems viable. It would probably be enough to point to cases such as (4) above to bring home to the objector that there is an issue about the determinacy of truth values, and so about the validity of classical inferences. Cases like this are matters of some dispute and that fact alone is enough to rule out a blanket global and unjustifiable realism.

(b) A second objection is this: Instead of looking for the manifestation of knowledge in terms of the giving of reasons, we should turn to consideration of what it is to *act* on the truth of a sentence. It is here, so the thought would go, in our dispositions to act differentially with respect to the truth or falsity of sentences, that we will find manifestation of our knowledge of the determinacy of truth values.

I do not think that the suggestion is coherent. For example, suppose a community of Jacobites still exists in Scotland. The suggestion would then be that in their actions (their plotting to come down to London to install the present Pretender to the throne) they are manifesting their knowledge of the determinacy of truth value for some past-tensed sentence about the ancestors of their Pretender. But it is utterly unclear how present behaviour could possibly manifest knowledge of the determinacy of truth value of a past-tensed sentence. There is nothing that I can *do* which reveals that I know of an *undecidable* sentence that it has a determinate truth value, unless we are to return to objection (a) and count among my doings here the inferences I employ. At its best, this objection would make sense on the assumption that I was engaged in a project other than the one on offer; that is, the assumption that I am offering novel content *specifications* of undecidable sentences. Then the counter-offer to specify content in terms of some pragmatist theory of meaning in which the content of an utterance is specified in terms of what it is to act on it would have some point. But I am not engaged in such an enterprise, and so the counter-offer is beside the point.

(c) A third objection might be formulated in terms of the distance between my project and the usual construal of Dummett's work on realism. It might be noted that I have not appealed to anything to do with characterising knowledge of sense behaviouristically or concentrated on issues to do with the representationality of linguistic

understanding in sketching the core anti-realist argument in section 5. To some this may seem as a deflection from the way they have understood anti-realism as presented by Dummett and, further, that I have avoided addressing the most damaging features of anti-realism. This would all be because Dummett's arguments are taken to proceed in the following way.

For language to serve the function that it does, preeminently to serve as a vehicle of communication, the sense it possesses must be public and shareable. Our grasp of this sense must also be public. Dummett's argument, so the usual account would go, is to show that we could not manifest a grasp of the sense a realist account of linguistic understanding would have us possess. For if a theory of meaning ascribes implicit knowledge to a speaker (and only implicit knowledge will do, for explicit knowledge would only suffice for sentences introduced into the language by verbal explanations and is therefore linguistic-competence presupposing), then the theory must say something about how such knowledge is manifested. It must tell us in what having that knowledge consists. But as there is nothing that we *do* which could count as manifestation of knowledge of recognition-transcendent truth conditions, it is not clear that anything could count as manifestation of the required knowledge.

Such is how we might recap a familiar line of argument often found in Dummett. The argument seems to hinge on thoughts about the representationality of knowledge and embody a drive towards a behaviourist theory of mind. For if all knowledge resides in possession of representations, we would be faced with a closed circle were we to attempt to state our understanding of a language as explicit knowledge of sense.[24] For such understanding is understanding of a system as a system of representation and of how it is such a system. That being so, there can be no account in terms of *knowledge* of what it is for a language to be a system of representation. That would only be to ascribe to speakers some representation of what they knew when they understood a sign as being a representation of something extra-linguistic. Such knowledge would be linguistic-competence-presupposing and so could not figure in a general explanation of linguistic competence. Hence linguistic competence must be explained in terms of implicit knowledge, and

[24] For the drawing of this point from Dummett, see John Campbell's, 'Knowledge and understanding', *Philosophical Quarterly* 1982.

implicit knowledge is not a representational state but consists in one's possession of a battery of behavioural dispositions.

But what is all this about? For sure, the above captures much that is present in Dummett's writings on the theory of meaning but not, I think, much that has to do with anti-realism as I have argued it must be developed. After all the above argument is all about the objectivity of content. It is to do with *specifying* content behaviourally and non-representationally. But I argued in the last chapter that the anti-realist need have no truck with such concerns. What anti-realism is concerned with is the issue about the objectivity of truth. The point is that we cannot manifest the knowledge of the determinacy of truth value that is required for realism to be tenable without presupposing the very knowledge possession of which such manifestation is supposed to make intelligible. The anti-realist case does not rest upon the above issues about the representationality of knowledge. There is nothing wrong in *specifying* knowledge of the sense of some past-tensed sentence representationally as knowledge of condition *c* which is a recognition-transcendent condition. That is just to grant the objectivity-of-content thesis. What is at issue is the objectivity of truth. Can we manifest knowledge that *c* determinately obtains or not? But the simplest way of doing that is to embark on some justificatory procedure with *c* as conclusion, and such procedures depend for their acceptability on the very question of whether or not knowledge of the obtaining or not of *c* is possible. This is the *impasse* which confronts the realist.

For those sentences on which we agree that their sense is such as to render them effectively decidable and so to make acceptable the full gambit of justificatory moves allowed in classical logic, there can be no objection to a characterisation of a speaker's knowledge of such sense in a representational manner. And for those sentences which are not effectively decidable there can still be no problem in characterising their sense in a representational, non-behavioural, manner *so long as one is prepared to give up arguing with such sentences in the classical manner. That* is what has to be given up if the arguments so far are correct. The point about behaviour is not that meaning must be cashable in terms of raw behavioural dispositions. That, perhaps, would be a Quinean way of viewing the matter. The point for the anti-realist is that behaviour acts as one part of a constraint (constraint *C*) upon the intelligibility of knowledge ascriptions. It acts as a constraint on the richness of our cognitive claims, for it

makes no sense to claim knowledge of the sorts of things we need knowledge of for realism to be tenable.[25]

Of course, it might be objected that the circularity I charge realism with is not vicious. We need no deeper justification, it might be supposed, other than to see our knowledge of the determinacy of truth values in the context of other knowledge; knowledge of the truth of (6) in the context of knowledge of the truth of an instance of DNE, and so on. But the point in avoiding the circularity is not to achieve a particularly 'deep' justification. Rather, it is to make our knowledge claims intelligible instead of leaving them only supportable within a closed system of justification our entry into which would appear to be mysterious.

The analogy I used earlier about knowledge of God is still useful. The idea that there is no non-question-begging reasoning a believer can present to the agnostic with which to bring him into the faith is familiar. The transition from lack of belief to belief is mysterious.[26] If such mystery is in order in an account of knowledge of God, it is wholly out of place in the knowledge which plays such a central role in our linguistic practices: knowledge of the validity of inference.

A fourth objection might seem pressing at this point. Perhaps, after the developments that have now taken place, the identification of realism with the objectivity-of-truth issue and the validity of classical logic should be re-examined? Perhaps it could be claimed that a determinate world as conceived by realists just is sometimes available to experience? I shall pursue these matters in the next chapter. For the remainder of this chapter I reinforce the argument for constraint *C*.

7. In defence of constraint C

Constraint *C* operates by imposing two tests on the intelligibility of knowledge ascriptions: the behavioural test and the argument test.

[25] For an examination of the differences between Dummett and Quine on the role played by behaviour in accounts of meaning, see my 'Dummett and Quine: meaning and behaviour' *Reading Dummett*, ed. A. Grayling, forthcoming.

[26] Again, I am not invoking the strong claim, associated with writers like D. Z. Phillips (cf. *Faith and Philosophical Enquiry* (London 1970), esp. ch.2) that the very *meaning* of statements about God form a closed system of understanding. I understand what 'God' means, as I also understand talk of the transfinite; it is another matter whether I understand how we are meant to know that these concepts have application. The leap of faith that is important here is not to do with concept acquisition, but with gaining knowledge about concept application.

What I shall do in this section is show how, despite the use of *C*
against realism, it is a very reasonable demand. I do this by showing
how much gets through these tests with a variety of examples. I
then give fuller argument to support the constraint which highlights
the principles about truth that underpin it.

A knowledge claim gets through the two tests when it is mani-
fested behaviourally or via an argument. Behavioural manifestations
are very common. In cases of what Ryle called 'knowing how' a
behavioural manifestation is the norm. Often the simplest manifes-
tation of one's knowing how to produce a genuine Chicago pizza,
or a portrait after the style of Modigliani, is to produce the desired
object. More than that, often enough the subject who has this
knowledge cannot verbalize any justification for ascribing such
knowledge to him. Or, if the subject can verbalize the knowledge
in terms of 'knowing that', this fails to convey mastery of the knowl-
edge to a pupil. The chef who laboriously analyses and articulates
his actions still finds that his understudy's pizzas are but pale
imitations of his own saporific creations. In such cases a demand
for an argumentative manifestation is out of place.

This is not so with an important kind of 'knowing how', knowing
how to speak a language. It is because this 'knowing how' requires
the backing of 'knowing that' that we laugh at the incident in the
Wodehouse novel when a character, when asked if she can speak
Spanish, replies, 'I don't know. I've never tried'.[27] If speaking a
language were *simply* a matter of 'knowing how' – for example, if
this character had 'tried' and had produced a Spanish sentence –
we would have to take such chance production of the relevant noises
as speaking the language. But we would not count this as speaking
a language. Therefore understanding is more than simply a case of
'knowing how'. The problem is to give content to the notion of
'tries' in such a situation. We know what it would be like to try to
make a Spanish-sounding noise, but surely not the further idea of
trying to speak Spanish without the subject having any 'knowing
that'. This is why it seems appropriate to say that the production
of a Spanish sentence in such a context would be chance. We
distinguish between knowing how to produce the relevant kind of

[27] P. G. Wodehouse, *Ring for Jeeves* (London repr. 1971), p. 86. I learnt of this
example from Michael Dummett who has often referred to it in lectures and also in
his address, 'What do I know when I know a language?' Lecture given at the
centenary celebrations of Stockholm University, 24 May 1978.

sounds which is a skill in the Rylean sense of 'knowing how' (someone may have a physical difficulty in producing certain Spanish consonants akin to the novice's difficulty in spinning the pizza dough) and knowing how to produce these sounds *as a meaningful utterance*. The propositional 'knowing that' seems required to mark this distinction. Only then can we mark the distinction between the sort of thing a parrot does when it produces that string of sounds with which a competent speaker of the language achieves the distinct act of saying that it is raining. This kind of 'knowing how' then seems appropriately constrained by the argument test as well as the behavioural test. Put another way, some of the behaviour that manifests grasp of sense had better be linguistic behaviour. This should not be so surprising for, as noted above in section 3, the individuation of a content requires the placing of that content in the context of other logically and conceptually related contents. That, anyway, is one way of individuating contents. I suspect no stronger way is plausible.[28]

But now, in order to show how reasonable and generous constraint *C* is, I want to consider examples of propositional knowledge, 'knowing that', which pass the constraint. This also serves to reveal something of the interplay between the behavioural and argument tests. Here is the first example.

Consider the case of someone to whom we play fragments of organ music. On hearing these fragments the subject confidently responds with either 'Bach' or 'not-Bach'. Further, suppose that he regularly gets the attribution of the music right. However, when we probe him to find out *why* he attributes a piece to Bach he can give no answer. He does not even understand the musical terminology we employ in describing the structure of the pieces. He simply knows, or so he says, that some pieces are by Bach and some are not. Now in such a situation I will take it that the knowledge claims *pass* constraint *C* because they pass the behavioural test. Naturally we would find this skill very peculiar and there would be a strong inclination to say that there must be *something* about the music

[28] The last thought commits me to an account of the individuation of contents that is strongly Fregean; that is, it will resist reduction in physicalist or behaviourist ways. I cannot see that this matters, although I know it upsets many theorists of content who reject any account, like Frege's, that individuates content through epistemic modalities. For example, cf. R. Stalnaker, *Inquiry* (Cambridge, Mass. 1984). pp. 24–5. Although this is not central to the present enquiry, something of this point will recur in Chapter 6.

which the subject notices. But constraint C does not rule on this. Indeed it leaves it open that we may be wrong in thinking so. The constraint is satisfied by the subject's doings, his successful attributions of organ works to Bach.

Consider a slightly different example where the inclination to think that the subject must be noticing some reason-giving feature of the situation that could figure in a defence to pass the argument test lapses. Suppose a subject at the races repeatedly picks out the winning horses by looking around the parade enclosure *before* each race. He does not have to inspect each horse, for as soon as his sight alights on the creature in question he announces it to be the future winner. Therefore he cannot be making a subconscious comparison between the size and musculature of the horses. He is not making an hypothesis on the basis of *present* evidence at all. This is a case of precognition. Once again, I do not think that the idea of this subject knowing the next winner can be ruled out as unintelligible on *a priori* grounds. And so, again, I will say that it satisfies constraint C by passing the behavioural test. All this although we would clearly find these cases very odd.

However, even if this much could get past the behavioural test it is no consolation for the realist. This for two reasons. First, the realism question is concerned with our knowledge of the truth of logically complex sentences and the dispute arises over those that are not effectively decidable. But *ex hypothesi* there can be no behavioural difference in a subject with regard to knowledge of the truth or falsity of a non-effectively decidable sentence. Secondly, although in the two examples so far considered I have allowed knowledge of recognition-transcendent states of affairs through constraint C, it is important that the behaviour in question was *successful* behaviour. This matters, for our notion of what constitutes success turns on the argument test and the way the two tests are connected.

So, rather than pursue recherché examples ad nauseam, let us consider the argument test. There are two ways in which a subject's claim to know may pass this test. We might call them 'agent manifestation' and 'community manifestation'. In the former the subject provides the reason-giving defence in support of his knowledge claim that shows it passes the test. In the latter, although the subject may know of no such defence, *we* can construct one. Clearly, in considering the argument test, the question of whether the subject

or the community provide the defence for the knowledge claim has no bearing against the core anti-realist argument as presented above (section 5). As long as an argument is involved, the question of its validity is there to be raised. So the issue that must concern us here is rather the following. Is it legitimate to demand that knowledge claims meet constraint *C*? And, in particular, how important is the argument test?

Consider this example. Suppose we ask an off-duty station master the time of the next train from Oxford to London. Without hesitation he replies, 'Eight-fifteen.' However, he can find no reason in support of his claim. When probed, he just scratches his head and says, 'I just know.' This does not matter. His claim passes the community-manifestation version of the argument test. Although he cannot provide any reason in support of his claim, we can clearly produce reasons which would account for it: 'He saw the timetable before leaving work', 'The train cited is a regular one', etc. But now change the example. What if someone for whom we could not suppose any such reasons in support of his knowledge made the very same claim? Suppose an illiterate inhabitant of some far corner of the globe claimed to know the time of the next train to London? Would there not be something odd about this? It is not simply that we would suspicious about *how* he could have acquired the knowledge (we cannot see any causal links between the requisite evidence for this belief and his experience), but rather, if no experience of his could be relevant, does not the claim to know appear senseless? Well, perhaps he could know. Perhaps he could get a queer sort of feeling that leads him, now and again, to know that the next train from Oxford to London leaves at such-and-such time. Perhaps an aborigine in the Australian outback at various times of the day is overcome by this strange sort of feeling. He goes into a trance (we might imagine this as part of a religious ritual) and pronounces, 'The next train from Oxford to London departs at . . . GMT'. Could we make sense of this?

We have to distinguish two distinct questions here: the causal question of how he could acquire such knowledge, and the logical question of whether it makes sense to say that he has knowledge here. Our finding his acquisition of the knowledge inexplicable is beside the point. Just suppose this happens, and now ask, 'Can we make sense of it?' To give substance to the case we need to allow that he successfully recites the train timetable and that he under-

stands the words involved in his claim. Otherwise his utterings would become mere incantations with no reason to think that they were to do with Oxford, London or even knowledge. But if we grant him success, he passes the behavioural test and the case is like that of the perfect predictor at the races. And although it might seem perverse to grant such claims the honorific title of 'knowledge', I do not see that we rule this out *a priori*. A lot is getting through our constraint *C*, but so far nothing to aid realism, for it is getting through via the behavioural test. What we need to do is consider a case that excludes success on the behavioural test, to see whether the argument test on its own can serve as a legitimate constraint.

Consider again the identifier of Bach organ works. Assume that this subject *K* is played a piece of music which we list as a non-Bach piece. Suppose it is by K. P. E. Bach, third son of J. S. Bach who is the Bach for whom *K* has his cognitive faculty. On hearing the K. P. E. Bach piece *K* confidently proclaims 'Bach'. Suppose, further, that this is the only time *K* has slipped up in the exercise of his capacity. What is more, when we point out his error he responds, indignantly, 'But it is you who err. That piece is by J. S. Bach!' We are now in a qualitatively different situation to when we first considered this subject. It was one thing to allow his claims through constraint *C* via the behavioural test when he was being successful, but what counts as success must defer to the argument test. That is, *K* cannot claim knowledge of things for which we could not in principle find an instance of the argument test. The thought is this: So long as the knower is not claiming to know something which could not in principle be checked on and for which reasons could not be given, perhaps he does have some peculiar and hitherto unknown source of knowledge. This possibility cannot be ruled out a priori. But now, if he extends this faculty beyond cases for which we can find reasons, or in a manner contrary to the results we get after checking all sources, the content of his claim becomes suspicious. Suppose we check our sources. We have the best possible evidence for attributing the piece to the younger Bach and still *K* insists that it is by the elder. As before, all he can say is, 'I just know', but now his claim is totally unresponsive to the ways we go about validating claims. Of course *K*'s insistence might cause us to recheck our sources, given his previous success. No matter. The point I am concerned to press is that if, after such checking, we are convinced that we are right, then *K*'s queer faculty

must succumb to our claim that the piece is by K. P. E. Bach which passes the argument test. It does not make sense for K to claim to know that P if it is in principle impossible for us to fit the supposition that P into the web of our shared experience.

Change the example slightly. Suppose K claims a general faculty for intuiting historical truth. The idea seems absurd, but if he were consistently right independently of having acquired the knowledge by normal means (in practice such independence would probably be impossible to prove), perhaps we should not rule out such a faculty. But in saying 'if he were *right*' I am supposing that his purported faculty agrees with standards of right and wrong supplied by the argument test. This then is only to allow such claims where the purported faculty offers knowledge in cases which we judge independently to be so. The behavioural test defers to the argument test. For suppose K says he knows whose dagger pierced Caesar's left ventricle on the Ides of March? Suppose he says it was Cassius' dagger. What are we to make of such a claim where there is no support in terms of the argument test of what counts as the truth? If we have no evidence one way or the other, this claim is no better off than any other that might be made about Brutus' dagger, Casca's dagger, etc. The trouble with K's claim is that it is too easy to make. It opens the door to the claims about Brutus' dagger and so on. Assuming that only one dagger could have pierced Caesar's left ventricle, allowing the claim about Cassius' dagger, and thereby allowing a claim about the other daggers, would lead us to the intelligibility of the assertibility of a contradiction. K's claim makes no constraint whatsoever on experience. It allows too much in. To allow the intelligibility of the knowledge claim here would be to allow that whatever seems right to this person is right.

It is important to be clear what principle is involved here about the drawing of the right/seems-right distinction. I am not simply appealing to a distinction between private and public criteria of correctness.[29] The principle involved is concerned with my

[29] For one thing, to do so would be to become embroiled in the debate over the interpretation of Wittgenstein's private-langauge argument, two recent opposing and important contributions to which are, S. Blackburn, 'The individual strikes back', *Synthese* 1984 and C. Wright, 'Does *Philosophical Investigations* 1. 258-60 suggest a cogent argument against private language?' in *Subject, Thought and Context*, eds. J. McDowell & P. Pettit (Oxford 1986). The idea that the community can provide standards of correctness in a way that the individual cannot receives its clearest articulation in S. Kripke, *Wittgenstein on Rules and Private Language* (Oxford 1982).

constraint *C* and the requirement of the argument test of manifest-
ability. This requires that for any knowledge claim to be manifest-
able there be a non-circular defence of the claim available. There
is, as yet, no requirement that this defence be given by the
community rather than the individual. The principle behind all this
goes as follows.

We are looking for the principle which supports the requirements
of the argument test which I have so far employed and defended
in an intuitive way. The principle concerns what it is to make an
assertion. Suppose I claim some piece of objective knowledge. I
claim to know that *P*. If I claim to know that *P*, I must be prepared
to assert that *P*. Now I take it as a necessary condition of the
making of an assertion that in asserting that *P* I *rule out* certain
states of affairs. If I say that such-and-such is the case, my saying
must be incompatible with some states of affairs or else my utterance
cannot be an assertion.[30] Another way of putting this is to say that
in asserting that *P* there must be some criteria of mistake; my
assertion must be sensitive to states of affairs that would render it
false. For suppose this requirement were not met. Then my assertion
that *P* would not rule out my asserting something that was incom-
patible with *P*. It would not even rule out my asserting not-*P*. But
that is ridiculous. It simply cannot be the case that I have asserted
something if what I have said is compatible with its negation. In
such a case I have said nothing.

So, if I claim to know that *P*, my claim, like an assertion, must
be sensitive to states of affairs that would render it false. This then
is the principle which underpins the argument test. For without
some in-principle available argument in defence of a knowledge
claim, there is no criterion of mistake in the original claim. The
idea that a knowledge claim must be sensitive to states of affairs
that would render it false is a metaphysical, or constitutive, point
about knowledge; it is not an epistemological point. That is to say,
I am not arguing that a subject could not have a self-verifying
faculty for intuiting some truth, only that *what* he thereby intuits
must be separate from his intuiting of it. It is this metaphysical

But my point is not a public versus private one, it is a logical point about what we
mean when we speak of objective truth. I suspect that the point I elaborate in the
text underlies Wittgenstein's remarks about private language, but I shall not tackle
the exegetical question here.

[30] I pursue the argument for this point about assertion in Chapter 4, section 5.

point that gives a critique of one notion of private knowledge. It is here that there is something that has priority over the individual. The priority is not however a priority that says that the community standards of correctness and incorrectness must take precedence over those of the individual; it is the priority of what is true over what the enquirer says is true. It is a priority that says that truth must be independent of the knower, whether that subject be an individual *or* a community. It does not matter whether we take our subject in the first person singular or plural; either way, if it is a truth that the subject knows; *what* the subject knows must be independent of the subject's knowing it. The notion of independence may seem out of place in a work on anti-realism. We need to distinguish two notions of the independence of truth.

In the first place we might speak of truth being independent of the enquirer after truth in the sense that the truth is 'there anyway', whether or not the enquirer notices it. *That* is realism. It is acceptance of Thesis R and, as such, it is clearly not a concept of the independence of truth that I accept. However, there is a much more fundamental concept of the independence of truth which I do accept and which underpins the constraint on knowledge that fuels the anti-realist argument. It is this: the idea that, on being confronted with a truth, an enquirer is confronted with something the existence of which is causally not dependent on the enquirer's thought about it. A truth is something separate from the enquirer's enquiry after it. That is, for some *P*, if *P* is true, its being true is not dependent on the enquirer's taking it to be true. But from this it does not follow that the state of affairs that *P* is 'there anyway' in the first sense of the independence of truth. Let me make this distinction sharper.

The first sense of the independence of truth is simply realism, acceptance of Thesis R. This is the claim that for any proposition '*P*' it has a determinate truth value irrespective of our ability to determine what that value is. The second sense is this:

The Independence of Truth: If '*P*' possesses a truth value, it possesses that value irrespective of any subject's claim that it possesses that value.

From now on when I speak of the independence of truth I mean the above thesis. Another way of putting the core point to anti-

realism as I develop it is to say that the anti-realist challenges the right to discharge unrestrictedly the antecedent to the above thesis. It is because of the independence of truth that a knowledge claim must be sensitive to states of affairs that would render it false. For without such sensitivity we have no guarantee that a subject is claiming that a *truth* obtains, something that is independent.

So, if I claim that P, my claim must rule out certain states of affairs; it exhibits the required sensitivity to states of affairs that would render the claim false. Doing that is constitutive of claiming a *truth*, something which possesses the independence of truth. But if in claiming that P I thereby rule out, say, that Q, I have automatically provided a simple instance of the argument test. For I could defend my original claim by observing that 'not-Q'. Of course, none of this shows that what I claim *is* a truth, only that it is a *candidate for truth*. We may never discharge the assumption that truth is attainable and show that we possess truth. But in meeting the argument test and satisfying constraint C, we at least show that we are in the business of making claims that are legitimate candidates for truth.

Without constraint C we are faced with knowledge claims that fail to rule anything out. That is why I said the problem with such claims was that they were to *easy* to make. A claim that fails constraint C is not a knowledge claim as we ordinarily use that concept, and this is not a reflection of ordinary language, but a matter of logic. This point about knowledge is not a new one. It is the point enshrined in the criticism of Descartes' project when we ask, 'How is Descartes to know when he really has a clear and distinct idea as opposed to one he *thinks* is clear and distinct?'[31] As such, it is not a point contrasting private with public knowledge, but one contrasting intuitive knowledge and reasoned knowledge. And it is not a point that says that the former cannot exist, only that knowledge arrived at by the operation of some faculty of intuition must be defendable by the argument test.

It is now clear why it was legitimate to allow the earlier examples of precognition and intuition of historical truths past the behavioural test. The examples were ones where, although the subject appeared to have his own private criterion of right, his answers were ones which could also be called 'right' by application of the

[31] Cf. Gassendi's first objection to Meditation 3 in *Descartes Philosophical Works*, vol. 2, translated by Haldane and Ross (Cambridge 1911), pp. 151f.

objective standards of the argument test. It is precisely when we drop this relation between the independence of truth and what the subject calls 'right' that the requirement of the argument test becomes compelling.

I conclude then that we are right to insist that knowledge claims meet constraint *C* through one of the above tests.

8. Reprise

I have outlined and defended a constraint on the intelligibility of knowledge ascriptions, constraint *C*. This does not operate directly on contents in the manner of other types of constraint that I distinguished. However, although it operates on the concept of knowledge, the interesting cases ruled out by the constraint are those that arise because of the content possessed by the claim in question. Some cases are cases of atomic sentences, e.g. the claim to know that there is a God, and the claims of subject *K* in the previous section. The important case for present concerns is the case of knowledge of the truth of logically complex sentences.

Knowledge of the truth of undecidable instances of bivalence, (6), cannot be manifested. Because of the kind of content claimed for this case, the knowledge claim fails the argument test of constraint *C*. The behaviour test is inapplicable. It fails the argument test because the only manifestation available presupposes that we have the knowledge we are trying to manifest. This, I have hypothesised, is not the case with a weaker logic, logic *L*, the validity of which turns only on experienceable truth. Knowledge of the truth of *L*-complex claims is manifestable because *L*-complexity *has* to be acknowledged in order to give any coherent account of experience. Classical logical complexity is not required and cannot be shown tenable. These last claims form the substance of the remainder of this book. So far I have proposed *L* as an hypothesis. The requirement for it has yet to be proved, and the non-requirement for classical logic has yet to be shown.

Realism is no better off than those philosophies of religion which claim knowledge of God and then encircle this purported knowledge within a closed system of belief. Even if this were a satisfactory situation for religious beliefs, it cannot be the basis on which we are meant to accept classical rules of inference and the metaphysical image that goes with them – the myth of realism. Of course we may

have faith in realism, but faith does not show its tenability. By the end of this book I shall show that such faith is idle.

There is no basis for realism unless we stretch our concept of knowledge beyond the bounds of its manifestability. Keeping within the bounds of manifestable knowledge ascriptions, we have yet to see what account of experience can be given. It remains for us to see what account of the world can be developed from within the manifestable logic of experience, the logic which outlines the very contours of objective experience because it is the foundational structure upon which all manifestable knowledge claims must be built.

Modesty and Realism

In this chapter I consider variations on a response which might seem to threaten the argument so far. I show how the response fails due to non-observation of the distinction I made in Chapter 1 between the objectivity-of-content issue and the objectivity-of-truth issue.

1. A response

It might be thought that there really is no problem about the nature of the world as given to us in experience. The world we experience just is a world that is determinate beyond our capacities to know it. It is a world that impinges itself upon us. And it is a feature of our experience that we do, as a matter of fact, find the world as experienced as having this objective independence from us. The sorts of states of affairs which are available to us in experience are states of affairs which on other occasions obtain independently of our recognition of their obtaining. And all this is not a theoretical claim which stands in need of justification; it is a fact about the nature of experience that experience just is of such states of affairs. Such a response to the argument of the previous chapter is readily gleaned from the writings of John McDowell.[1]

This response has two components. First, it claims that the argument about the tenability of realism is misguided, for there is no deep metaphysical issue about the nature of the world as experienced. Secondly, because of the first component, the connection between realism and the justification of logic, in particular bivalence, is irrelevant. However, I shall show that this first component

[1] Cf. especially, J. McDowell, 'On "the reality of the past" ' in *Action and Interpretation*, eds. C. Hookway & P. Pettit (Cambridge 1978), pp. 127–44; 'Anti-realism and the epistemology of understanding' in *Meaning and Understanding*, eds. H. Parret & J. Bouveresse (Berlin & New York 1981), pp. 225–48; 'In defence of modesty' in *Michael Dummett*, ed. B. Taylor (Dortrecht 1987).

only has bite if it is seen as making a point about the objectivity of content and that the second component is therefore wrong for, as already argued, realism is concerned with the objectivity of truth and bivalence *is* a way of characterising that issue. All this is evidenced by the fact that the cases McDowell discusses in the first component are to do with the sense of *atomic* sentences, not logically complex ones. This reveals that his arguments are about content specification (objectivity of content), and this is an area which I have argued is not in contention with anti-realism. It should be remembered that I am not offering a recipe for novel content specifications. The argument for anti-realism is an argument to the effect that, given the sense realists assume that the logical constants possess, knowledge of the truth of some logically complex sentences (those characteristic of classical logic) fails constraint *C*. This is not to say that such sentences cannot be given such sense. It is only to say that, given that sense, knowledge of their truth *must* fail constraint *C*. And the hypothesis is then that if we work with an account of the sense of the logical constants that sustains what I have called an experienceable logic we will get a notion of logical complexity such that knowledge of the truth of complex sentences will satisfy constraint *C*. But first, let us see what is right in McDowell's response.

2. A translation manual for the cosmic exile

One point that McDowell makes against Dummett on which I think he is right is his defence of modesty. Dummett has characterised a modest theory of meaning as one that gives no account of the concepts expressed by primitive terms of the language.[2] He has seemingly endorsed the idea that a theory of meaning should be full-bloodedly immodest; hence the idea that it should be capable of conferring the concepts of a language on someone just by that person's learning the facts that the theory states, even if that person is the 'cosmic exile'.[3] Simply, the idea seems to be that a theory of meaning should give an account of content such that the theory

[2] For Dummett's pronouncements on modesty see his, 'What is a theory of meaning?' in *Mind and Language*, ed. S. Guttenplan (Oxford 1975), pp. 97–138, especially around pp. 101–4.

[3] The cosmic exile appears in McDowell's 'Anti-realism and the epistemology of understanding'; see his 'In defence of modesty' for a detailed discussion of Dummett's requirement of immodesty most of which I endorse.

makes that content available to those 'outside' the language. It is a demand that turns a systematic theory of meaning into a theory of interpretation, but one that makes interpretation of our language available to those outwith our conceptual scheme.

Now Dummett's requirement of immodesty is clearly a constraint on theories of content that is concerned with the sorts of specifications of content we supply. It is easy to see how someone enamoured of this sort of constraint might think that behaviour has a role to play in our theorising about meaning which would go like this: Behaviour supplies the *currency* in the exchange of meaning between speaker and hearer whether or not the speaker and hearer share a language, conceptual scheme or whatever. If 'behaviour' is here taken to include linguistic behaviour, this may seem truistic. But Dummett's immodesty constraint requires more of behaviour. It requires a reductionism about content such that the very content of an utterance could be specified in terms of raw behavioural data. It is not surprising then that McDowell should draw comparisons between Dummett and Quine.[4] For Dummett's immodesty requirement appears to be an instance of a constraint on the theory of content that satisfies the schema 1 type of constraint (see Chapter 2). And if that is so, we may happily agree with McDowell that Dummett is wrong here without affecting the course of our argument. Indeed I have already endorsed a strong form of modesty in accepting that a content can only be individuated by locating it within the context of other contents of the language (Chapter 2 section 7). But that does not affect the issue about the objectivity of truth of such contents. It amounts only to the idea that a theory of meaning should be a structure-discerning theory.[5]

[4] See the closing paragraphs of 'Anti-realism and the epistemology of understanding'.

[5] The idea that a theory of meaning should discern structure in our language has come in for a lot of misguided criticism. However arguments may rage over particular claims of structure found in language, at least this much must be accommodated: If I say, 'John gave Mary a book' I have said something which entails, 'Someone gave Mary a book', as also, 'Someone gave someone a book', and 'Someone gave someone something'. But in order to reveal the validity of these entailments we have to acknowledge at least that amount of structure in terms of which a Tarskian recursive truth theory explains these inferences. Of course, the question of how finely one should construe the atoms of the recursion is often a delicate question; on this turns the dispute about Davidson's argument for an event ontology. But that we should discern some structure is, I think, incontestable. Nevertheless, for criticism of the very idea of a systematic structure discerning theory see G. Baker & P. Hacker, *Language, Sense and Nonsense* (Oxford 1984). For recent defence of the requirement of

3. The world independent of us

What of the idea that our experience just is an experience of a world independent of us that impinges itself upon us? Of course realism is often defended by appeal to vague metaphorical gestures about the idea of a world 'out there'. Indeed it is noteworthy how people are reduced to arm-waving and repetition of such metaphors when talking about realism. Not surprisingly. We need to mark a distinction here between two different things that might be intended by this talk.

If we were only left with such vague metaphors as are employed in the claim that realism is the thesis that the world exists 'out there', we would have no leverage with which to sustain any argument about the position's tenability. The whole point of the present book is to argue that we get such leverage through the objectivity of truth issue and that this shows the position untenable. After all, with only the bare metaphorical 'out there', with what use do we note that University College is 'out there', as also are the trees and grass which are presumably external objects? These facts are not in question. Neither is it of any argumentative worth to note that the world we experience is a world that impinges itself on us. The reason I discount these metaphors is this. To say that the world is a world 'out there' *at best* captures what I have called the Independence-of-truth and the objectivity-of-content thesis. The former (see section 7 of Chapter 2) does not give us realism. So what is captured with the objectivity-of-content thesis? This thesis captures the idea that the representational content of our experience is a content that can only be fully characterised by reference to more that the actual occurrent qualities of the experience. It must at least be characterised in terms of possible experiences and, as I accepted in Chapter 1, their characterisation acknowledges a grasp of a spatial and temporal framework extending beyond the specious here and now. But none of this grants us the right to think that realism, as characterised in Thesis R, is vindicated.

Put it another way. It is correct to say that our experience is an experience of a world not of our own making (the independence of truth). It is a world that, if you like, comes to us in experience. It

structure see M. Davies, 'Tacit knowledge and the structure of thought and language' & J. Campbell, 'Conceptual structure', both in *Meaning and Interpretation*, ed. C. Travis (Oxford 1986).

is not created by our experience. Further, the sorts of contents we possess can only properly be characterised by reference to the objective framework of space and time in which we take this world to come to us. This was the point of the thought about the cubic block (Chapter 1, section 3). But all this is to do with the objectivity-of-content thesis. It does not deliver the objectivity-of-truth thesis required for realism, Thesis R. Of course, there is a danger that the whole debate may slide into a squabble about the correct use of the word 'realism'. However, there clearly *is* an issue addressed by what I have called the objectivity-of-truth issue and it is clearly closely connected, if not identical, with what many have had in mind in discussing the metaphysics of realism. And that issue is not addressed by the above thoughts. For want of a better label, I record that fact by saying that realism is not so addressed. I have argued for a more precise treatment of the metaphysical issue about realism which locates it firmly in questions about the validity of inference. The idea that our experience just is an experience about a world 'out there' which impinges itself on us is a claim about the *kind of content* our experiences have and the need to characterise these contents by reference to more than the subjective character of the experience (the objectivity of content thesis). Our concern is with the objectivity of truth, with the question of what system of evaluation for claims about the experienced world can be shown to be valid for empirical discourse. Let me now pursue these general claims in some detail through an example that McDowell has employed in defence against the anti-realist. This serves to reinforce the identification of the objectivity of truth issue with what really matters for the metaphysics of realism.

4. A detailed proposal

Take the case of our knowledge of others' mental states. This case has been employed by McDowell and, further, is one on which I have considerable sympathy with his account of the epistemology of other minds.[6] McDowell has done much to realise the thought that others' mental states are states of affairs which are sometimes available to experience. The general line of thought is that it is at

[6] Cf. his 'Anti-realism and the epistemology of understanding' and also his, 'Criteria, defeasibility and knowledge', Henrietta Hertz lecture to the British Academy, *Proceedings of the British Academy* 1982.

least partly constitutive of what it is to be a normal socialised human being that one should have an unreflective ability to perceive in the action of another that the other is, e.g., in pain. Let us grant McDowell the idea of a perceptual capacity for the unreflective detection of another person's being in pain. Even so, we do not grant enough to validate Thesis R.

Suppose Smith is in pain. Suppose Smith has trapped his finger in the hinge of the lecture-room door. He is tugging at his trapped hand. He is calling for help. His eyes are watering and his hand is bleeding. In short, he is in great pain. Now if the thought that my knowledge that he is in pain is acquired through the operation of a perceptual capacity which equips me with a means of knowing directly, in some useful sense of that word, that Smith is in pain, then this is something which takes us beyond the traditional problem of knowledge of other minds. The thought is that the person's being in pain is *itself* available to me in experience rather than via behavioural proxies for pain. The situation is not that of my making a hypothesis upon the behavioural evidence; it is meant to be a case of a non-reducible capacity to recognise pain in another. I shall say that the claim for the existence of such a capacity is a claim about the *range* of experience; that is, the range of states of affairs available to experience. The principle governing this idea of the range of experience is this:

Range of experience: The state of affairs that P falls within the range of experience if and only if P is effectively decidable.

The question whether or not some P falls within the range of experience is then the question whether we have an effective decision procedure for ascertaining its assertibility. McDowell's claim can then be construed as saying that for many statements traditionally thought to be non-effectively decidable, we have such decision procedures simply in virtue of our ability to open our eyes and look. That is the proposal I am currently accepting. Note, the governing principle here applies to statements individually; it is not expressed in terms of statements of a certain *kind*. This will come to be important.

So, suppose we have such capacities for effectively determining the assertibility of, e.g., 'Smith is in pain'. What follows from this? It gives us determinacy of truth value for this statement, but that

is obvious, for this statement has, in virtue of the perceptual capacity, been rendered effectively decidable. The important question is this: Does this innovation in the epistemology of other minds give us any reason for thinking that some *other* statement about another's pain has a determinate truth value if we are not in a position to determine it? I think not. For consider this. Anyone who does not like this broadening of the range of experience for other minds would probably complain that the suggestion embodies a problematic leap from the behavioural proxies of pain to the hypothesis of pain itself. I do not agree with this charge, but there is a similar leap to be made from the case of the determinability of detectable pain to that of undetectable pain. That is to say, even if on the envisaged occasion of Smith's trapped finger, where that he is in pain is something which is available to us in our experience, how is *this* to help with the thought that on some other occasion the stoical Brown, whose finger is similarly trapped, determinately is or is not in pain? Is it not that this is just of a kind with the sort of irresponsible generalisation from one case to another which, in a slightly different context, bothered Wittgenstein?[7]

It is important that the point of my criticism be seen aright. One criticism would be this: McDowell cannot have presented us with *realism* about others' mental states just because he has rendered them as states that are sometimes available to experience. This is just to press the idea that if it is available to experience it cannot be pain, because experience does not, as it were, reach that far. But such a criticism ignores McDowell's insistence that his position be separated from the heady metaphysical Cartesianism of inner and outer states of affairs in which others' mental states are essentially unavailable for public inspection because hidden away beneath several layers of protective behavioural proxies. McDowell's thought is that this common and persuasive picture of our knowledge of other minds is fundamentally mistaken. He is suggesting that, Cartesian models and metaphors aside, another's being in pain is something which is sometimes available to us in experience.[8] My criticism takes this thought seriously.

[7] *Philosophical Investigations* (Oxford 1953), section 293.

[8] For further elaboration of a thoroughly non-Cartesian philosophy of mind see McDowell's 'Singular thought and the extent of inner space', in *Subject, Thought and Context*, eds. P. Pettit & J. McDowell (Oxford 1986). See also Chapter 8 below where I develop the anti-realist version of expanding the range of experience to cover other minds.

The state of play here is this: We have a proposal to extend the range of experience to cover, on occasion, the state of affairs of another's being in pain.[9] Clearly, if McDowell did not break with Cartesian metaphysics, the proposal would fall flat; you cannot have a perceptual capacity to effectively detect pain conceived of in a Cartesian manner. That being so, McDowell's proposal comes to the thought that, whatever the ontological status of mental states like pains, they are items which we can experience obtaining in others. But in leaving the ontological status of such affairs open, the proposal cannot deliver the idea that we thereby experience states of affairs of a kind such that, when not detected by us, they nevertheless determinately obtain or not. *The proposal offers no metaphysical insight into the nature of the state of affairs it delivers to experience.* The proposal is an epistemological claim only, a claim about the range of experience. And it is because of the lack of metaphysical input about the nature of the states delivered to experience that the range of experience principle has to be construed as applying to individual statements, *not* to statements of a *kind*. The only classification on offer is this: *statements of a kind to fall within the range of experience.* And that, of course, crosses traditional boundaries, given that we accept the sometime availability of others' mental states. As previously noted, the 'sometime' here is crucial for the plausibility of the claim. However, given also the silence on the metaphysical status of the claim (just what kind of state is it the detection of which brings it within the range of experience?), it is invalid to generalise from the determinacy of detectable pains to the determinacy of undetectable ones.

From the Cartesian perspective we know what sort of thing being in pain is supposed to be for another person and then, *because of this*, we are left with the epistemological problem of how we could ever acquire knowledge of such states of affairs. McDowell is *starting* with the thought that we can and do sometimes experience the state of affairs of another's being in pain, but then it behoves him to go on and tell us what kind of state this is. I raise this question not because I want to know whether he thinks it is something to do with the perturbation of a non-extended substance, or whether it is

[9] The 'on occasion' is crucial. It would be plainly false to think that *all* occasions of another's being in pain were available to experience, the possibility of stoicism has to be acknowledged, as also the less dramatic borderline cases where the pain is not so great as to render its presence effectively decidable by observation.

something to do with the subject in question possessing a particular kind of behavioural disposition. I raise the question because I want to know whether such knowledge is meant to be knowledge which makes it legitimate to take it that an otherwise identical state of affairs could be determinately true or false of some person of whom we do not experience the relevant state of affairs. Until McDowell tells us more about the metaphysics of the states of affairs he claims are sometimes available to us in experience, we have nothing to take us from knowing of some person in whom we see pain to knowing of some other person of whom this is not true that it is determinately either true or false that they are in pain. Only metaphysics will do here, for the epistemological claim from which McDowell starts is of the form 'Whatever the ontological status in terms of the heady metaphysics of Cartesianism and its rival behaviourism, another's being in pain is a sort of thing that is sometimes available to experience'. This is fine, but if it is to credit us with knowledge of states of affairs of a kind with those that determinately obtain or not independently of our recognition of their obtaining, then an account must be given of what kind of states of affairs this is, other than just they are of a kind to sometimes fall within the range of experience. McDowell does not supply any further metaphysical illumination here and, I am sure, does not even wish to attempt such a task nor think it desirable.[10]

[10] On McDowell's attempt to break with what he calls the traditional 'see-saw' of Cartesianism versus behaviourism, see his 'Anti-realism and the epistemology of understanding', 'Singular thoughts and the extent of inner space', op. cit., and also 'De re senses', *Philosophical Quarterly* 1984, reprinted in *Frege: Tradition and Influence*, ed. Crispin Wright (Oxford 1984), pp. 98–109. I applaud this break with the traditional problem framework. I simply do not believe that realism survives the break. The core of my criticism here, that there is an unwarranted transition from cases of detectable pain to undetectable pain, is also picked up by Crispin Wright in his 'Realism, truth-value links, other minds and the past', *Ratio* 1980, now reprinted in his *Realism, Meaning and Truth* (Oxford 1987), pp. 85–106. However, Wright makes the point within an argument about the objectivity of *content* not of *truth*. He worries whether an account of the *understanding* of utterances about detectable affairs can grant *understanding* of utterances about the undetectable. I, of course, do not take this line and, indeed, think it hopeless. My concern is only with an unwarranted assimilation of determinacy of truth value, not of meaning. As ever, this marks an important and considerable difference between Wright and myself on the development of anti-realism. On the idea that there is no problem about our understanding of utterances about undetectable pain, see section 6 below.

5. An analogous proposal

The point of the above argument may be better appreciated if I
briefly consider an analogy with the way McDowell has employed
similar thoughts about the range of experience in the case of moral
epistemology.[11] McDowell has claimed, along with others,[12] that it
is part of the way we experience the world that we experience it as
a world of value. Once again, let us not dispute the phenomeno-
logical thesis here, nor the accompanying epistemological claim that
we can know of this value merely by opening our moral sensibility
to the world. The question is: What follows from accepting these
ideas? As many have felt with regard to McDowell's moral epistem-
ology, it is problematic that he discusses these issues wholly in terms
of *cognitivism* and *non-cognitivism*. That is, McDowell's discussion of
values is a wholly epistemological one that offers no guidance on
the nature of values. He may have an interesting claim about our
knowledge of value but he tells us nothing about what it is of which
we are thereby supposed to have gained knowledge. He is silent
on the metaphysics of value. The problem is this: What can an
epistemological thesis about the detection of value tell us about the
objectivity of value? It would appear that the answer to this is, 'Not
a lot!' and that the sort of epistemology McDowell has espoused
takes us no further than a relativism about values. The world I
experience may be a world of such-and-such values, but as experi-
enced by someone from another culture (class? epoch?) it may
contain incompatible values. If McDowell's moral epistemology
allows such a thought, then although it may have something of the
traditional air of cognitivism about it, it has left out that feature
most distinctive of cognitivism; namely, the idea that values are
objective.[13]

[11] Good examples would be his 'Virtue and reason', *Monist* 1979, and 'Values and
secondary qualities' in *Morality and Objectivity: A Tribute to J. L. Mackie*, ed. T.
Honderich (London 1985).

[12] The most influential being David Wiggins; see his 'Truth, invention and the
meaning of life', *Proceedings of the British Academy* 1976 and now reprinted in his *Needs,
Values, Truth: essays in the philosophy of values* (Oxford 1987) which contains many
further treatments of this and related issues, and T. Nagel; see his Tanner lectures,
'The limits of objectivity' in *The Tanner Lectures on Human Values, vol. 1* (Oxford 1980)
and, more recently, his *The View from Nowhere* (Oxford 1986), especially chapters
8–10.

[13] For an example of this kind of criticism of McDowell's account of values see
J. Lear, 'Ethics, mathematics and relativism', *Mind* 1983. I believe this problem
infects Wiggins' treatment of these issues in *Needs, Values, Truth: essays in the philosophy*

I do not wish to follow up the argument about values here. All I am presently concerned with is the idea that McDowell's position in ethics suffers from just the same kind of problem as posed above in the case of knowledge of other minds. Any dissimilarity is due only to the fact that, in the case of mental states, we seem to have a inbuilt Cartesian tendency to treat the claimed item of knowledge as something determinately there or not regardless of or ability to know of its existence. This is not so tempting in the ethical case where an argument about the 'queerness' of values already threatens their objectivity with the epistemological thesis not supported in a way to ward off the threat of relativism. My point is this: such support is just as much in need in the case of our knowledge of other minds.

The general moral is this: An epistemological thesis about the sometime availability in experience of such-and-such states of affairs is insufficient to warrant the claim that such states of affairs are in general determinate beyond our ability to know of their determinacy. It is one thing to claim to know that another is in pain in the manner described. It is another to think that such knowledge transcends the constraint of manifestability, constraint *C*, and is thereby knowledge of something objective in the realist sense, Thesis R.

6. Accommodating the stoic

I argued above that the principle governing claims about the range of experience had to be construed as applying to individual statements and not to statements of a kind. This was because, although it might be plausible to claim that *on occasion* one can know directly via some sort of perceptual capacity that another is in pain, this cannot always be the case. We have to acknowledge that pain often goes on undetected, whether because the subject is a stoic or because the pain is not so severe as to make its detection unproblematic. Now McDowell argues that accommodating the stoic reveals the realism inherent in his epistemological proposal about the range of experience. I think he is wrong on this.

of value, op. cit., especially on his insistence that, despite their objectivity, value statements are essentially contestable; see essays 4 and 5, and section 3 of the postscript.

McDowell argues[14] that the acknowledgement of the possibility of undetected pain is constitutive of grasp of the concept of pain. If you do not realise that *that* might occur, you have missed out something quite central to the concept. But this point, the accommodation of the stoic, cuts no ice. Let us assume that we do not fully understand 'pain' if we do not understand that a person may be in pain on an occasion when the being in pain is not available to experience. We must understand what this means. But the claim is simply an instance of the objectivity of content thesis. It is the claim that an understanding of 'pain' requires a grasp of possible states of affairs beyond those actually present to experience. However, it is not the fact of our *understanding* the possibility of undetected pain that is in question, but the determinacy of truth value of statements about undetected pains. After all, to borrow Dummett's example,[15] we know what 'Jones was brave' *means*, and we may well understand the thought that someone who is not now manifesting the appropriate behaviour is, nevertheless, brave. What is in question is whether we have any right to hold the relevant statement determinately true or false and so validly employ it in inferences typical of classical logic. Similarly of Brown whose finger is trapped in the door but who, unlike Smith, is not screaming. I understand the thought that he is in pain – he is in that state which I am sometimes able to perceive to obtain in others – but with what right do I assume that it is determinately either true or false that he is in such a state now, when I am not exercising this perceptual capacity?

I think it is now plain that in these discussions McDowell is really addressing what I have distinguished as the objectivity-of-content issue and not the objectivity-of-truth issue, which I have separated and argued for as the point of the realist/anti-realist debate. This is further evidenced when we reflect that McDowell's examples are all concerned with the sense of atomic sentences; he does not consider complex sentences, let alone the justification for ascribing determinate truth values to them. This is not really surprising for, as I said in Chapter 1, it is to McDowell that we owe the new orthodoxy that identifies the realism issue with the objectivity-of-content issue, the question about whether sense should be characterised in terms of recognition-transcendent truth

14 'Anti-realism and the epistemology of understanding', op. cit.
15 Cf. his 'Truth', *Proceedings of the Aristotelian Society* 1959 repr. in *Truth and Other Enigmas* (London 1978), pp. 15ff.

conditions. I accepted that sense should be so characterised and argued that realism should be identified with the objectivity-of-truth issue, the choice between Theses R and A-R. It is not therefore surprising that my analysis of the proposal in section 4 should have gone the way it did. I shall now generalise that analysis by considering in a little detail McDowell's original argument that set up the new orthodoxy. The effect of this is to confirm that in order to be a realist we must affirm bivalence.[16]

7. The end of the new orthodoxy: general polemics

McDowell set up the new orthodoxy when he argued that bivalence was not a necessary condition for being a realist.[17] And although this earlier general argument might seem to constitute a different line of response to that already encountered in the detailed proposal of section 4, it turns out not to be so.

McDowell's thought was that in framing a theory of meaning for a language we require a theory which would issue theorems of the form

's' is f if and only if p

where 'p' is a translation of the sentence 's' such that the latter can be used to assert that p. If the production of theorems of this form sufficed for a theory of meaning we have to ask what predicate would do in place of f. McDowell notes that 'true' will serve just nicely and does the job required. Of course this is not to say that something else may not serve just as well, nor to justify picking on truth for the job. More importantly, saying this much tells us nothing about the character of the concept of truth, what sorts of inferences we take to be licensed by the concept. What McDowell

[16] The sufficiency of bivalence for realism will not be confirmed until the next chapter, where I give the account of experienceable negation. Dorothy Edginton has argued that one can be an anti-realist and still accept bivalence, see her 'Meaning, bivalence and realism', *Proceedings of the Aristotelian Society* 1980/81, pp. 153–73. But Edginton's argument suffers from the same fault as McDowell's; she identifies realism with the thesis of the objectivity of content; she falls under the influence of the new orthodoxy.

[17] See his 'Truth conditions, bivalence and verificationism' in *Truth and Meaning*, eds. G. Evans & J. McDowell (Oxford 1976).

does offer is the following proposal. I sketch McDowell's argument first without commentary, and then offer criticism.

He suggests that a fundamentally Tarskian truth theory could be given in the context of a proof theory which is intuitionistic and that[18]

> such a theory might seem apt to serve as a truth-conditional theory of sense . . . for a language for which, because of . . . verificationist scruples . . . we are disinclined to insist on the principle of bivalence.

He argues for this thesis in the following manner. He first attributes to Dummett the idea that the linguistic act of assertion requires the principle of bivalence because the truth value of an assertion is determined in such a way that there are only two possibilities, truth and falsehood. (The attribution is inaccurate and McDowell concedes this but thinks it heuristically valid.) In the light of the observation, which he shares with Dummett, that a theory specifying truth conditions for sentences can only provide a specification of their sense in the context of an overall theory giving an account of their use in speech acts of various types including, centrally, assertion, he suggests that this shows how the principle of bivalence might be thought a prerequisite for a truth-conditions theory of sense. However, this connection can be severed by reflecting on the possibility, mentioned above, of utilising a Tarskian truth-theory with an intuitionistic proof theory in the theory of sense. If the observation about the connection between assertion and bivalence were right, such a suggestion would be incoherent. But the suggestion is not incoherent. Intuitionists regard themselves as making assertions, and so it must be wrong to take the supposed connection to hold. He then concludes this argument with the thought:[19]

> There need be no incoherence . . . in the suggestion that a Tarskian truth theory with an intuitionistic proof-theory might serve, for a suitable language, as a truth-conditions theory of sense, *certified as such by interacting, in the standard way, with a theory of force mentioning assertion.*

Again, earlier, in explanation of the thought that there might be an inconsistency in the suggestion of a Tarskian truth-theory with an intuitionistic proof-theory serving as a theory of sense he says:[20]

[18] Op. cit., p. 50.
[19] Op. cit., p. 54, my italics.
[20] Op. cit., p. 51.

The suggestion involves appeal to interaction with a theory of force mentioning assertion *in order to justify the idea that a theory of the sort envisaged is a truth-conditions theory of sense*; but that mention of assertion ought, according to the argument, to import the principle of bivalence which a theory of the sort is designed, precisely, not to require.

Now what is the point of this argument? It is designed as a diagnosis of why Dummett thought the bivalence issue was connected with the issue of the viability of a truth-conditional theory of sense: further, a diagnosis that shows Dummett mistaken on this. But it is plain that the issue McDowell is here addressing is the issue about the objectivity of content. It is an issue about the appropriateness of specifying sense truth-conditionally. It is this, the employment of recognition-transcendent truth *conditions* in specifying sense, that is supposedly certified fit by the theory of sense interacting with the theory of force and the concept of assertion. The concept of what can be asserted by an utterance of '*s*' is what introduces the requirement for recognition-transcendent truth conditions. Now I think McDowell is right on this. As he claims elsewhere, he is right to think that a truistic connection between our notion of the content of an assertion and a familiar notion of truth guarantees[21]

> that a correct specification of what can be asserted, by the assertoric utterances of a sentence, cannot but be a specification of a condition under which the sentence is true.

And further, I believe that if we attend seriously to what constitutes a correct specification of even very simple utterances the notion of truth here has to be a recognition-transcendent one. This was the point of the account of the content of 'That block is cubic' of Chapter 1 section 3. But that the concept of truth is a recognition-transcendent one is a point about truth *conditions*, not truth *values*. It is the point that a correct specification of the content of the utterance requires one to have a conception of states of affairs beyond those currently verified. It is *not* a point about the determinacy of such states of affairs.

So, we might agree that you can have a truth theory that interacts with a theory of force mentioning assertion when the proof theory is intuitionistic. But agreeing to this, at most, commits us to the

[21] 'Anti-realism and the epistemology of understanding', *op. cit.*, p. 229.

objectivity-of-content thesis, not to realism. It is because McDowell is identifying realism with the question about the appropriateness of specifying content with recognition-transcendent truth *conditions* that he thinks this general argument shows that bivalence is not necessary for realism. But he is wrong. Worse than that, he gives the anti-realist all that is required. For a truth theory that interacts with a theory of force mentioning assertion and possesses an intuitionistic proof theory is precisely what is on offer in this book! For all that is compatible with the A-R thesis, the denial of the general determinacy of truth *value* for undecidable sentences.

Of course it is fair to say that McDowell was mislead by Dummett on these questions. There is no doubt that Dummett often runs together the issues I have separated under the headings 'objectivity of content' and 'objectivity of truth'. Very often Dummett puts the realism matter in terms of an interpretative question about the appropriateness of interpreting an utterance in terms of a theory of sense employing a recognition-transcendent concept of truth. My purpose is only to try to clear some of the air on this issue. However, it should be noted that the confusion of these separate concerns runs deep in McDowell's thought. The attribution which he makes to Dummett, that the linguistic act of assertion requires the principle of bivalence, is a case in point.

What he means by this attribution is this. Assertion requires bivalence because the truth value of an assertion is determined in such a way that there are only two possibilities, truth and falsehood. But aside from the acknowledged fact that Dummett does not hold this and it is only intended as a diagnostic tool, it would be absurd to think that anyone should hold it, for the point given in explanation of the idea has nothing to do with bivalence. The fact that there are only two possibilities for an assertion, truth and falsity, does not require bivalence. It requires, at most, *tertium non datur*. Bivalence is the *extra* idea that not only is there no more than the two values truth and falsehood, but determinately one of these obtain. That being so, the attribution is doubly odd to someone like Dummett who has been at pains to distinguish these separate semantic principles.[22] I suspect McDowell's confusion here is simply a function of Dummett's running together bivalence and the recognition-transcendent truth-conditions issues. The concept of assertion

[22] On the distinction between bivalence and *tertium non datur*, see Chapter 4 below.

might give one access to the latter notion, and if we are working within the shadow of the claim that these are the same thing it could easily seem plausible to think that assertion required bivalence. Hence McDowell's heuristic value of attributing a connection between assertion and bivalence before revealing that the connection cannot exist on pain of disallowing intuitionists the concept of assertion. And this strategy presumably blinded McDowell to the fact that the connection he noted was, at best, a connection between assertion and *tertium non datur*, not bivalence. Of course, in effect, I am claiming that McDowell anticipated my distinction between the objectivity of content and the objectivity of truth in breaking the connection between bivalence and the adequacy of a truth-conditional account of sense. But he would not see things like that, precisely because he mislocates the realism question on the latter rather than the former.

I conclude then that McDowell has not shown that one can have *realism* with rejection of bivalence in the proof theory of one's theory of truth, because he has failed to substantiate the fact that what he has *is* realism. My general argument to this effect was given in Chapter 1. In this chapter I have merely reapplied the distinctions drawn there to show how the point resurfaces in the particular case of our knowledge of other minds and the more general argument from McDowell's 'Truth conditions, bivalence and verificationism' paper. The point is that, without substantiating the claim that the introduction of the epistemology of non-reducible perceptual capacities provides knowledge of states of affairs that licenses the thought that such states of affairs determinately obtain or not on those occasions when we have no access to them, the discussion of which predicate we use to replace 'f' in the theorem schema above has no bearing on the realism question. McDowell's defence offers no leverage on the question of whether 'f' should be replaced with a non-experienceable concept of truth, because it simply does not address this issue. It is the central challenge of anti-realism that it should not be so replaced, for there can be no justification for doing so that does not break constraint C. McDowell does not address the right issue because the distinctions I have been drawing were not available in the work of Dummett to which he was responding. My point has been to articulate *the* central issue on which the tenability of realism turns. There has yet to be a response to the real anti realist challenge. The end of the new orthodoxy was to

focus the defence of realism upon an issue that was not to the point. Having now further defended the identification of the realism issue first given in Chapter 1, it is time for the end of the new orthodoxy.

8. The real challenge

The only response left to someone of McDowell's persuasion would be to mount a defence that plays upon a kind of holism in our account of truth. It would run like this. The account of the kind of states of affairs that enter experience is not to be tackled piecemeal as I have been tackling it. Rather the contact between language and the world obtains holistically. The same applies for our justification of logical practices. The confrontation with the world, and also the justification, of any particular claim must be seen in the context of smoothness of fit in the whole theory. Further, our total theory, as revealed in the practices we do in fact employ, simply is realist. There is no question of justification for our knowledge claims about others' mental states, or of justification about what kind of predicate we replace '*f*' with above, other than what we actually take as justification from within the linguistic practices we employ. We have a practice of using language which conforms to classical rules of inference.

Once again we must be careful to be clear which issue is being addressed in the holistic appeal to 'our practices'. On the question of specifying content I have already accepted the desirability of some such homely approach. This is the idea that we can only explicate content to those within our conceptual scheme; our *specifications* of content are modest. This is to accept a hostility to the idea that we might, in specifying content, seek to step outside our language and account for content in a manner intelligible to the cosmic exile. On this I agree with McDowell. On the attempted holistic appeal to 'our practices' with regard to the justification of patterns of inference (the objectivity-of-truth issue) I cannot agree. What matters here is the cogency of an appeal to 'our practice' on questions of the validity of inference.

Put the issue like this: What if I were to come across a community of McDowells all speaking and claiming to be justified in their logical practices in the realist way? What could I say to these people as someone proposing a revision in their logic that might give them some reason to amend their ways? Of course the role of revisionist

is always a difficult one until after the revision, when it all appears so thoroughly sensible and reasonable.[23] Looked at like this, it would appear that there is little to which I could appeal, for any experience to which I refer will, from within the perspective of their practice, be reinterpreted in a way that conforms to their practice. I would be like an atheist walking into a religious community and trying to restrict what I would take as an extravagance on the part of the community in what they take as experienceable parts of the world. However, the case is not really like this at all. For it is not that I *might* comes across such a community of McDowells: I am in the midst of such a community! McDowell's point in making the holistic appeal to 'our practices' is that our practice is the way he describes it. This is important, for it is the downfall of this final defence of realism.

What it amounts to is a denial that there is any normative enquiry about which rules of inference we should accept, or about what kinds of states of affairs we should admit as experienceable. And although it might be correct to rule out normative enquiries conducted from the standpoint of the cosmic exile, it cannot be right to rule out such enquiries conducted from the inside. It amounts, in the end, to saying that, in questions of logical validity, anything goes, and that is plainly wrong. My enquiry is an enquiry about the justification of logic from the inside.

The point of taking the anti-realist case to depend on the connection between the concepts of objectivity and knowledge as outlined in constraint C of the last chapter is to say that the anti-realist is offering, in his account of the logic of experience, the bare *core* structure of *any* critique of knowledge claims. An anti-realist account of the logic of experience offers the groundlines from which any critique must be measured and does so from within the practices we currently employ without the need to 'step outside' those practices. Structural components of our practices, like logic, cannot be protected from critique from within. *That* is all that is required to get the anti-realist critique off the ground. But let me now give one last analogy to aid the thought that our logical practices are up for critique in the way anti-realism takes them to be.

One way of construing Hume's critique of induction is to take it

[23] By the end of this book I hope we will be somewhere near to this position. The reasonableness of anti-realism, especially once the argument of the last three chapters is complete, should induce wonder that it was not adopted a long time ago.

as noting the following: *that the past is a rule for the future* cannot be established deductively, while any inductive justification of this would itself depend on the rule being reliable, and hence be circular. In response to this it seems reasonable to note that perhaps not all cases of having a reason for believing that P need be cases of knowing something from which we can infer that P. Thus, we might say, 'Why all the fuss about the circularity of an inductive justification of induction? What other kind of justification could possibly be relevant? Why think that deductive canons of reasoning should apply to matters of fact?' One way of showing that this familiar type of response to Hume misses the point would be to say this.

It matters that an inductive justification of induction is circular in a way that it does not matter that a deductive justification of deduction is circular, for the following reason. If someone does not see that from A, and if A then B, B follows, all we can do is to appeal to another instance of *modus ponens* and say, 'But if A and if A then B then B, and A and if A then B, *then* B'. But this does not matter in the sense that deduction does not aim to tell us anything that was not already implicitly contained in the premisses. Its validity is a matter of *form* alone. And, in not taking us from the truth of premisses to the truth of anything not already contained in the premisses, this justifies us in saying of someone who does not see the validity of *modus ponens* that they do not understand what we mean by the 'If . . . then_____' construction. We might put this by saying that, as it were, deduction wears its validity in the open for all to see in virtue of a valid deductive argument having a certain structural form.

Induction is not like this. *Its* validity is not due only to the form of an argument; it also depends on a certain amount of real world input. It depends on the world being such a place that the past *is* a reliable guide to the future. This is why the circularity of an inductive justification of induction matters. Inductive reasoning is ampliative. It tells us something new that was not contained in the premisses, and any inductive justification of the practice would have to assume that in general induction was fit to deliver this new information, but that is the point at issue in the problem of induction. We express this by saying that induction is a metaphysically loaded form of inference in contrast to the apparent innocence of deductive patterns of inference.

The relevance of this to realism is as follows. The anti-realist notes that deduction is not after all so innocent with regard to whether its validity is a matter devoid of relevance to the way we take the world to be. The key anti-realist insight is that classical rules of inference embody the realist metaphysical image of a world determinate beyond our powers to recognise its determinacy. In short, classical logic is not *logic*, it is logic *plus* metaphysics. The experienceable logic of anti-realism is *pure* logic, containing no more than the essential metaphysical commitments required for any coherent account of experience. That is why constraint *C* matters and why it is legitimate to put our logical practices through the critique of constraint *C*, a critique that is undertaken internal to our practice. Certainly the logic of experience on offer from anti-realism can only be justified in a circular manner, but the metaphysical and experiential presuppositions of such a logic constitute the *minimal characterisation of experience and the one in virtue of which all knowledge claims are to be manifested.*

The realist must admit that his use of classical rules of inference embodies a richer metaphysics, for I have argued that without bivalence we have no non-metaphorical grasp of what it is the realist wants. But if he admits this *and* falls back to saying that classical rules of inference and the kind of characterisation of experience he wants are simply features embedded in our practice, then this appeal to practice cannot meet the following objection. As with the practice of induction, the rules of inference, acceptance of which make realism tenable, are susceptible only of a circular justification, and hence cannot be shown to be valid. The realist would then have no response to the objection that practices *are* subject to critique from within owing to the circularity of justification for those parts of the practice which embody far-reaching metaphysical presuppositions about the nature of reality and the concept of objectivity. This is not to say that the anti-realist revisionist logic carries no such presuppositions, only to say that it embodies the core presuppositions essential for any concept of objectivity and objective experience. Further, not only is it unclear *how* one could justify a logic which transcended the logic I shall offer below. As I go on to show, because of the range of experience that the anti-realist can accommodate, there is no reasons *why* one should wish to attempt such a task.

The Logical Constants: Negation

Realism turns out to be identifiable with the thesis of the validity of classical logic. Anti-realism is a claim that the only logic which can be shown to be valid is what I have called an experienceable logic, a logic which is experienceable-truth-preserving. This is a logic that does not deliver those theorems, or embody those rules of inference, distinctive of classical logic. In the first category the prime example is the law of excluded middle. In the second, the best is the classical rule of negation elimination, the rule:

$$\frac{\Gamma: \neg\neg A}{\Gamma: A,}$$

otherwise known as double negation elimination, DNE. In this chapter I shall begin the task of outlining an experienceable use of the logical constants.

1. A condition of adequacy and opening polemics

Intuitionists allow that a statement is only determinately either true or false if we have an effective method for arriving at a decision procedure for the statement. This is more generous than demanding that we actually possess such a decision procedure (call this the 'actualist position'); the procedure needs only to be *in-principle* available. This is important, and something like this should be retained as a condition of adequacy on the logic of experience. For consider the following.

I argued in Chapter 2 that we have no right to assent unrestrictedly to the principle of bivalence and thereby neither to assent to the classical rules of inference governing negation. I have yet to conclude that argument by showing what rules we are entitled to and why. This concluding argument comes shortly. However, if we

are generalising from the intuitionistic account of the constants, we should have to say something like this for negation: a proof of not-*P* will be a proof that a proof of *P* leads to contradiction. But then, in stating the required contradiction we have to make use of negation. The option of replacing the contradiction with an obvious absurdity like '1 + 0' as in intuitionistic mathematics, is not viable when giving a semantics for the constants to be applied to empirical discourse. One way of avoiding the apparent problem of circularity here would be this. We say a proof of not-*P* is a proof that a proof of *P* leads to a contradiction '*Q* and not-*Q*' where '*Q*' is an effectively decidable statement whose truth or falsity is directly recognisable. This is to adopt a dual account of negation, leaving it undefined and primitive for those statements whose truth and falsity are directly experienceable and, for all other statements, defining it in terms of this primitive notion. But to be able to do this we require an antecedent characterisation of those states of affairs which are experienceable. It is this that would be impossible if we had only the actualist position on the determinacy of truth value; we must have the notion of in principle determinacy of truth value. We get this from having an account of effective decidability for empirical discourse, otherwise put as an account of those states of affairs which are experienceable. It is this which I take as a condition of adequacy on the logic of experience; it must deliver such a notion. However, there is a question whether I am entitled to this condition.

The issue between the actualist and in-principle accounts of determinacy of truth value is the focus of the debate in the philosophy of mathematics between intuitionists and strict finitists. Crispin Wright has put the case for strict finitism. The points at issue are instructively general and affect my entitlement to the above condition. Wright argues that there is a problem for the intuitionist notion of *in-principle* decidability. For the simplest suggestion of how to cash out the concept would be:[1]

P: an undecided statement, *S*, may be regarded as decidable in principle just in case an appropriately large but finite extension of our capacities would confer on us the ability to verify or falsify it in practice.

[1] C. Wright, 'Strict finitism', *Synthese* 1982, pp. 203–82, p. 210.

But then this explanation makes use of a notion of finitude and, as Wright puts it,[2]

> our best efforts to explain the intended notion of finitude involve more
> or less explicit appeal to possibility in principle; but the general notion
> of possibility in principle can hardly be clear if the special case of
> decidability in principle is not.

Notice here how Wright is concerned with a question about the *coherence* of concepts, something falling within the province of the objectivity-of-content issue and not the objectivity of truth. Nevertheless, it might be thought that the problem here could be overcome if in principle decidability were to be defined differently as, for example:

P*: an undecided statement, *S*, may be regarded as decidable in principle just in case the hypothesis of its assertibility draws constraints on the assertibility of the class of statements which are effectively decidable through the operation of the capacities we currently have.

This, of course, is in line with the account of intuitionist negation generalised to empirical discourse noted above. P* still employs the concept of decidability in requiring a base class of experienceable statements, but perhaps this could be delivered. From Wright's point of view there is a much more serious flaw in P*. P* ignores a distinction Wright takes to be crucial, the distinction between possession of a verification properly so regarded and possession of supportive evidence. This points to a difference in the way in which Wright and I understand the nature of anti-realism which runs very deep. It is a matter that cannot be resolved until we reach the business of the next chapter, but something may be said on it now.

In considering statements that might be thought susceptible to anti-realist challenge, Wright says of hypotheses of theoretical science and certain sorts of statements about others' mental states:[3]

> It seems intuitively correct that no finite extension of any of our capacities
> would put us in a position directly to verify or falsity such statements,

[2] Ibid., p. 235.
[3] Ibid., p. 210.

and:[4]

> For very many types of scientific hypotheses . . . we *can* guarantee actually
> to be able to amass a body of either supporting or conflicting evidence;
> the same is possible for many types of statements about others' mental
> states. But that is no guarantee, or so we ordinarily suppose, that we
> can actually verify or falsify such statements.

Now the thought that the evidence we can amass does not amount
to a verification or falsification is clearly right from the standpoint
of the realist. From such a standpoint the determinacy of the truth
value of these statements is something which 'goes beyond' an
experienceable determinacy. These are statements whose determi-
nacy resides in a reality determinate beyond our powers of investi-
gation. But why should the anti-realist accommodate this notion of
determinate states of affairs that go beyond experienceable determi-
nacy? The sort of cataloguing of evidence that Wright describes
cannot verify or falsify a statement the determinacy of truth value
of which is supposed to transcend an experienceably determinate
truth value. But if we accept the anti-realist argument for an exper-
ienceable notion of truth why should we subscribe to the realist
picture of evidence gathering here? The anti-realist should make a
far more radical break with accepted philosophical thinking.

Wright's insufficiently serious appraisal of the consequences of
anti-realism is further evidenced when he considers statements
about others' mental states. To McDowell's suggestion that another
person's being in pain is something which is available to experience
in its own right and not merely through behavioural proxies, Wright
responds,[5]

> that no inference, via 'proxies' or whatever, should be involved is quite
> consistent with what is actually perceived being not that someone is in
> pain, *tout court*, but that criteria in what I take to be the *Philosophical
> Investigations* sense that he is in pain are satisfied.

But it is far from clear that Wright can claim that criteria are not
'proxies', having said that we do not actually perceive that someone
is in pain. One wonders what he meant by the '*tout court*'. Wright

[4] Ibid., p. 211.
[5] C. Wright, 'Realism, truth value links, other minds and the past', *Ratio* 1980,
p. 123.

seems to take criteria as sorts of super-inductive warrants for the
ascription of what is, nevertheless, a private inner state, rather than
take seriously McDowell's thought that they be a means for putting
an end to the whole inner/outer imagery. That is to say, Wright is
still thinking of pain ascriptions in an essentially realist way, as
states of affairs the determinacy of which transcends experience.
This is an odd position for an anti-realist. I shall return to these
matters in Chapters 5 and 8 to show how the anti-realist has no
truck with criterial semantics.[6] But enough can be said here to allow
me to continue with a richer notion of decidability than that of the
actualist position and one that is sufficient to generate an adequate
account of experienceable negation.

The essential difference between Wright and myself is this.
Wright takes 'effectively decidable' or 'experienceable' in a positiv-
istic way as 'observable'. He contrasts this with statements the
determinacy of whose truth value is not observable. The criterialist
semantics is then offered as a 'bridge' between the observable and
non-observable.[7] But if he takes himself to be questioning the realist
concept of recognition-transcendent truth this is a peculiar stance.
More importantly, it is a stance that errs in the original characteris-
ation of effective decidability with observability. This is an identifi-
cation typical of a position which concentrates its critique of realism
on atomic sentences rather than logically complex ones. Wright's
analogue of 'experienceable' is defined over atomic sentences, and
this is why, if he thinks there is some problem with non-experience-
able sentences, he will have to offer some novel content *specification*
of the latter in terms of the former. The criterial relation was
supposed to do just this. As ever, this is all to do with the confusion
of thinking that anti-realism offers an argument within the objecti-
vity-of-content issue. I have argued against that, and have pressed
the idea of taking the notion of experienceability in terms of a class
of logically complex sentences. The concern is with experienceable
logical complexity, *not* experienceable atomic states of affairs. And
this is why I think it is legitimate to employ a notion of decidability
in principle rather than the actualist position. For the only notion

[6] As noted earlier, Wright is no longer so sympathetic to criterialist semantics,
cf. his 'Second thoughts about criteria', *Synthese* 1984.

[7] Another such offer of a 'bridge' is the probabilistic semantics for the constants
produced by Edginton; see her 'Meaning and bivalence and realism' *Proceedings of
the Aristotelian Society* 1981. I discuss this further in Chapter 5.

of decidability required is one to do with the idea of a class of *experienceably valid logical inferences*, or the experienceable truth of certain complex sentences. It is, once again, only if we are deflected into an argument about the objectivity-of-content issue that we get pushed into the actualist position. So I shall continue to employ the notion of decidability thus construed, although the consequences of my remarks above about Wright's principle *P* will turn out to be far-reaching. We will arrive at such consequences in the next chapter.

2. The proof-theoretic justification of logic

We are concerned with the justification of logic. The sort of justification I am demanding is a *semantic* one not a *proof-theoretic* one. One way of approaching the question of the justification of logic would be to look for a proof-theoretic procedure which took certain laws as self-justifying and then attempted to justify others on the basis of the former. This approach has attracted a number of sympathisers of late.[8] I think the approach is misguided and shall sketch the reasons for this before developing the approach I favour.

The proof-theoretic approach attempts to take seriously a remark of Gentzen's that the introduction rules for the constants fix their meaning, and the elimination rules serve to draw out the consequences. This suggests a proof-theoretic approach to justifying logic which goes as follows. If the meaning of a logically complex sentence is fixed by the introduction rules, the licence for the assertibility of such a sentence depends upon the possibility of arriving at that sentence by an application of the appropriate introduction rule. In its simplest, if the meaning of

[8] Michael Dummett has recently pursued this line of work with great vigour and much success in lectures delivered in Oxford and London. His earlier starts on this line are to be found in his 'The philosophical basis of intuitionistic logic' and 'The justification of deduction', both in his *Truth and Other Enigmas*, op. cit. Other workers in this field are, most notably, Prawitz and more recently Tennant. See D. Prawitz 'On the idea of a general proof theory', *Synthese* 1974, 'Proofs and the meanings and completeness of the logical constants', in *Essays on Mathematical and Philosophical Logic*, ed. K. J. J. Hintikka *et al.*, (Dordrecht 1978); N. Tennant, *Anti-realism and Logic* (Oxford 1987). Christopher Peacocke has recently begun to develop a similar approach with the aim of characterising the constants classically; see his, 'Understanding logical constants: a realist account', Henrietta Hertz lecture to the British Academy 1987, to be published in the Academy's proceedings.

A & B

is fixed by the introduction rule for '&', and of course the sense of
the constituent sentences, then the licence for the complex sentence
turns on the possibility of there being some deduction δ with '*A* &
B' as conclusion, the conclusion having been reached by an appli-
cation of the introduction rule. The same idea applies to any
complex sentences which may be embedded within '*A*' or '*B*'.

For example, if the conjuncts are atomic, '*P*' and '*Q*', the licence
for asserting '*P* & *Q*' depends on their being a deduction δ which
just is an instance of the introduction rule for '&'. The introduction
rule is

$$\frac{\Gamma : A \quad \Delta : B}{\Gamma, \Delta : A \ \& \ B.}$$

But as we are dealing with atomic sentences '*P*' and '*Q*' the deduc-
tion δ will have to be of the form,

$$\frac{P \quad Q}{P \ \& \ Q.}$$

That is, there are no subsidiary deductions α,β with *P* and *Q* as
their respective conclusions. If that were the case, and the conjuncts
were themselves complex, then we would require that these
subsidiary deductions α,β were also deductions where the last step
was an instance of the appropriate introduction rule. The intuitive
idea here is to arrive at a notion of a *canonical* deduction δ for
conclusion *C* where a canonical deduction is one using *only* introduc-
tion rules and atomic premises. The idea to be captured is that
whenever we are in a position to assert a complex sentence we could
have got into that position via a canonical argument with atomic
premises. The logic is then justified relative to the introduction
rules which are taken as self-justifying.

Now clearly for this programme to work a good many conditions
will have to be met. The most obvious is this: Where a deduction
δ employs an elimination rule to arrive at some conclusion *C*
(whether or not *C* is the main or a subsidiary conclusion), it must
be possible to rearrange the order of the deduction so that the

elimination rule follows immediately upon that of its corresponding introduction rule. If that is so, we can apply a reduction procedure so that the deduction can be turned into a canonical one with the elimination rule no longer required. For example, suppose subsidiary deduction α gives us the sentence '*A*' and by the introduction rule for 'v' we get '*A* v *B*'. Suppose then that by the elimination rule for 'v' we derive the conclusion '*C*', and call the subsidiary deduction from the disjunct '*A*' to '*C*' that occurs within the application of this rule, deduction β. Now, if the whole deduction δ can be so arranged so that the elimination rule follows immediately upon the introduction rule without affecting the validity of the whole, clearly the deduction could be reduced to that of deduction α followed immediately by deduction β; that is the reduction procedure. Application of this procedure throughout δ would then give us our canonical deduction for '*C*'.[9]

I do not wish to follow up in any further detail this kind of proof-theoretic justification of logic. I think I have said enough to reveal the general outlines. The programme is still in its infancy, and as yet it is unclear what a full and detailed account of such a programme would have to contain. But what I do wish to argue is that such a programme faces three chief difficulties that point the way to the need for a semantic justification of logic along the lines already hinted at with the notion of an *experienceable logic*. The difficulties with the proof-theoretic approach are these: (a) With what *rationale* do we take the introduction rules as self-justifying and, further, *which* introduction rules fall into this category? (b) Does the proof-theoretic account offer only a justification of inferences, or does it also offer, or presuppose, a particular theory of the specification of meaning? (c) Can the proof-theoretic justification be applicable to inferences about the empirical world? These are all serious problems. I shall discuss each in turn.

[9] See Tennant op. cit. especially chapters 9, 10 and 13 for some of the details of working out this kind of proposal. Dummett has recently formulated such a proposal in considerable detail although it is, as yet, unfortunately not published. He has also investigated the possibility of, as it were, working back-to-front with this proposal and taking the elimination rules as self-justifying and fixing the meaning of the constants with the introduction rules as derivative. This way is a deal more complicated but appears in principle to be workable. These ideas of Dummett's have so far only been presented in lectures, most recently in Oxford in Trinity 1987.

3. The need for a semantic justification

The first problem can be put quite simply as follows: What logic is shown to be justified is a function of what you take as the self-justifying base, so what guides our choice of base rules (call these the B-rules)? This is the problem I identified in Tennant's work before.[10] In response to his claim that DNE is not justifiable, for one is not allowed to employ fundamental classical laws in justifying inferences employing this rule without encountering a vicious circularity, we might reply:[11]

> Such a procedure is only viciously circular from the absurd perspective of one trying to justify fundamental principles from independent ones.

Now Weir is mistaken here, for I think there is a schema of justification that is appropriate, although not the proof-theoretic one adopted by Tennant. Weir's characterisation of the Tennant scheme is accurate. The point of the proof-theoretic notion of justification under consideration just is that we should justify an inference by showing that adoption of it does not produce a non-conservative extension of the logic provided by the B-rules.[12] But that only pushes the question of how we are to characterise the B-rules further to the foreground. In the hands of Tennant, Prawitz and Dummett, the above sort of proof-theoretic approach to justification results in an intuitionistic logic, but to the classical logician who finds the classical rules governing negation self-justifying this only reveals that an important question about the criteria for membership of the class B-rules has been dodged.

I do not think that Tennant has an answer to this problem other than something like this:

> A rule of inference r is a member of the B-rules if and only if

[10] See Chapter 1, footnote 17.

[11] As Alan Weir does, 'Truth conditions and truth values', *Analysis* 1983, p. 178. See also the other works in the debate between Tennant and Weir referred to above in footnote 17 to Chapter 1.

[12] See Tennant, op. cit., chapter 10 for a discussion of the notion of conservative extension as it figures in Dummett's writings.

the sense of the principal constant c satisfies a manifestability constraint on meaning.[13]

I say '*a* manifestability constraint' for this then turns on problem (b) identified above. Now Tennant employs something like the above criterion for membership of the B-rules, although it is not explicit, but it draws upon an account of manifestationism that I have rejected. So I shall defer further discussion until I come to problem (b).

For his part, Dummett has developed the proof-theoretic approach in greater detail than anyone else, but as it is as yet unpublished it is hardly fair to comment on it further except to note two points. First, like Tennant he seems still to endorse a notion of manifestationism that I reject and, although not explicitly invoking this as a criterion for membership of the B-class, acknowledges that it is closely connected with the overall plausibility of the proof-theoretic approach. Secondly, that he does not employ a manifestability constraint as criterion for membership of the B-class is shown by the remark noted earlier (in the Introduction) that negation is not a logical constant because its meaning cannot be explained by laws which are self-justifying. That is, whereas Tennant seems to assume that restricted (intuitionistic) rules governing negation pass the manifestability constraint and enter the B-class, Dummett seems prepared to take a more rigorously proof-theoretic approach, less closely connected with semantic questions about manifestation, which shows that negation does not even make it as a logical constant at all! In this respect, I suspect that Dummett's approach, when available, will turn out to be the most consistent proof-theoretic approach, but also the most limited if it cannot find justification for rules governing negation.

Problem (b) is the worry that the proof-theoretic approach to justification ultimately depends on an account of the manifestability constraint on content that is untenable, for it requires a notion of manifestability that has the verificationist *specifying* content in a

[13] The question of which is the principal constant in a rule is not a straightforward question if the investigation is to be conducted with full generality. Which is the principal constant in, e.g., De Morgan's laws? Clearly we need further constraints to identify the introduction rules. Dummett, for one, has investigated these questions at great length but still so far in unpublished lectures.

manner rejected in Chapter 1. Certainly, Dummett thinks that the
above sort of proof-theoretic justification is most plausible on a
verificationist approach to meaning where by this he means an
approach that *specifies* content in terms of verification. But that
is to saddle the anti-realist with just the sort of suspicious novel
specifications of content that I have argued against. It requires that
the anti-realist employ the manifestability constraint in something
like a version of the schema 1 type constraint identified above.[14]
And that is untenable. It requires that the anti-realist argue that
there is no sense to the realist reading of the constants, rather than,
as I have been pressing the issue, the sense the realist requires
entails that the knowledge necessary to show the tenability for
realism must lie forever beyond the boundaries of constraint C. The
issue here is quite hazy, or, at least, hazily expressed by those who
favour the proof-theoretic approach.

Officially, this approach seems fit for an argument about whether
or not a particular rule of inference can be shown to be valid. For
example, can we justify DNE?[15] And of course this point is closely
allied to my use of constraint C, especially what I called 'the argu-
ment test'. It is an argument strictly about the *justification* of a rule
of inference; that is, can we *know* that the inference is valid, or can
we know an instance of the appropriate theorem to be true? And
for such questions to apply we must be able to understand the
constants in the proposed manner. Otherwise we lose focus on the
strict question of justification and turn to the issue of whether the
proposed *sense* is tenable. *That* issue will, of course, affect the one
about justification, but the result obtained by denying the classical
sense for the constants is only derivatively one of no justification for
classical inferences. I am tackling this justificatory matter directly
without legislating on whether or not the classical constants make
sense, always a difficult task anyway. The justificatory question has
nothing to do with whether or not the sense the realist wants
for the constants is coherent. For the question about justification
demands that there be a coherent sense for the classical, realist,
concept of negation. How else can we ask if DNE is valid? This
suggests that we should keep separate the question about validity
of a rule of inference and the question about the sense that can be

[14] Chapter 2, section 2.
[15] See Tennant, op. cit., chapter 14, esp. pp. 148–50 for an argument that seems
to concentrate on just this point.

intelligibly attributed to the constants. This separation is just a further instance of the distinction I pressed in Chapter 1 between the objectivity of content and the objectivity of truth. I accept that there is a sense that the realist attributes to the constants. However, I hold that it entails that knowledge of the truth of certain complex sentences and of the validity of typically classical rules of inferences is then forever unmanifestable by constraint *C*. And that is a different matter from saying that its sense is unmanifestable, that it has no coherent sense. But, in Tennant's hands, the two issues quickly run together. For when Tennant half spots the difficulty posed by problem (a) and asks whether or not the intuitionist has hoisted himself by his own petard he replies:[16]

> Not quite. For the intuitionist takes the introduction rules as constituting the very sense of the logical operators concerned.

But this then is to embark on what is really a separate issue, one to do with whether or not the constants can coherently be given the sense the realist demands. It is to demarcate the B-class by invoking a manifestability constraint that rules out the classical sense for the constants as unmanifestable. *That* is ludicrously strong. It is easy to manifest the classical *sense* for the constants: you merely show how to construct the classical truth tables. What is required is the separate job of showing that inferences employing constants *with such senses* cannot be shown to be valid. So, although I think it plain that Tennant answers problem (a) in the manner hypothesised, invoking the manifestation challenge, it is also plain that he invokes this challenge in the form I argued against.[17]

Further, if the way to demarcate the B-class is via the manifestability constraint construed the way Tennant takes it, ultimately he must meet the transcendental arguments discussed in Chapter 1 which seek to show the necessity of our having a *conception* of a world that transcends experience. Ultimately he must be engaged in an argument with writers like Peacocke who have been concerned

[16] Op. cit., p. 150.

[17] It is clear that Tennant understands the manifestation constraint as a device for offering *specifications* of content. See, e.g., p. 1 where principle IV is clearly a content specifying constraint; also chapter 11 entitled 'The Dummettian Reductio'. It seems to me that Tennant has uncritically taken the full range of ideas that Michael Dummett has employed in his discussions of realism and utilised the lot without regard to their cotenability, let alone their individual plausibility.

to argue that there is a coherent sense for the realist understanding of the constants.[18] Because I have the distinction between the objectivity of content and the objectivity of truth, I have been able to accept these arguments and to trim the question about the validity of inference away from spurious worries about content specifications.

Let us be clear about what is going on here. There is a question about the justification of logic. Tennant and I agree on that. This question raises a further question: From what base does this justification take place? The proof-theoretic answer is to appeal to the introduction rules, but why should this be an appropriate base? Dummett has seemed more aware of this problem and has seemed willing to stick faithfully to a strictly proof-theoretic approach even if this entails the result that negation is not a logical constant. Tennant appends a semantic justification of the choice of B-class, but employs a semantic justification of dubious worth, a manifestation constraint which, unlike my constraint C, involves the anti-realist in novel reductionist content *specifications*. It would involve the anti-realist in just the sort of debates about the objectivity of content issue that I have repeatedly urged as dead-ends for anti-realism.

In my account the question of justification of inference is grounded on a base class of rules of inference, what I shall call the ϵ-class, the class of experienceably valid rules of inference. On this account the proof-theoretic and semantic approaches to justification of inference merge. At bottom the approach is semantic in justifying the ϵ-class and this is fuelled by constraint C, the fundamental constraint on the intelligibility of knowledge claims. From the ϵ-class justification proceeds in a proof-theoretic manner, for this then is simply the argument test of constraint C from Chapter 2. But the whole is fuelled by a fundamental and general appeal to experience as captured by constraint C. It is this very general base for anti-realism which has consequences for logic. I do not then need to

[18] C. Peacocke, *Thoughts: An essay on Content* (Oxford 1986), and especially the 1987 British Academy lecture, 'Understanding logical constants: a realist account'. Peacocke is involved in an enterprise to show how to make coherent the realist sense for the constants (an objectivity of content issue), and this is the right sort of issue to put to Tennant and, sometimes, Dummett. It is the wrong issue to put to my sort of anti-realist. Tennant tries to locate anti-realism on the right issue, the objectivity of truth (although he lacks my distinction here), but then confuses the matter by involving this with a mistaken use of the manifestability challenge.

claim that there is no sense for the classical constants, but simply that there is no justification for classical rules of inference and no sense to the claim to know, for any P, $P \vee \neg P$.

Problem (c) is perhaps the most acute. If diagnosis were required why Tennant has muddled the question of justification with a question about the possibility of sense for the classical constants, it could plausibly go like this. Tennant handles the debate almost exclusively within the mathematical domain. Within that domain there is no use for the general notion of experience and experienceable truth. The relevant concepts here are those of a *construction* or *proof* of a number possessing a particular property and the *provability* of an arithmetical sentence. But then, working in this restricted domain, it can seem quite plausible to think that there must be a base class of self-justifying rules of inference, for the only appropriate notion of *evidence* is that of possessing a proof. Some proofs must be basic. There is, then, no temptation to look beyond the formal system of proof for a further semantic or experienceable ground for a rule of inference. That being so, the only way to gain leverage over those who are not already committed to one's restricted logical practices is to argue that their practices do not *make sense*. For to say that they are unjustifiable can only come to saying that they are unjustifiable given one's restricted practices, and that, of course, is both obvious and unimpressive.

However, if there is any general interest to Dummettian-inspired critiques of realism (and I think there is) the debate had better be generalisable from the mathematical domain. This book is an attempt to do just that. But then two things follow. First, there had better be a more general notion of provability for our central semantic concept, for the concept of *proof* is not appropriate as the notion of *evidence* for empirical discourse. Our notion of evidence must be general. It is this that I am trying to get at with the notion of *experienceable truth*. This general notion will have to be fit to give an account of all the constants, for the intuitionist account of, e.g., implication does not generalise to empirical discourse.[19] Secondly, it is in terms of this general notion that we must give our account of the constants and our test of the validity of logic.

Put another way, if the proof-theoretic approach provided the

[19] I explain why this is so in the next chapter. This is a particularly pressing problem, one which is enough on its own to query the plausibility of Tennant's approach as capturing the general insight behind anti-realism.

final analysis of the point behind anti-realism, it is doubtful that the position would have any general morals for metaphysics, for it could not then apply to empirical discourse. If there are such general issues involved and lessons to be learnt, the proof-theoretic approach cannot be the end of the matter. It cannot have got hold of what essentially drives the anti-realist challenge. The point must be expressible in some more general notion such as the notion of experienceable truth. Of course, I think that the proof-theoretic approach has failed to capture the central challenge, for that, I have been arguing, lies on the objectivity-of-truth issue and is unconnected with questions about specification of content or denials that the classical constants have a coherent content. This trimmed-down issue is the issue about experienceable truth, the issue about showing how our knowledge claims must defer to constraint C and thereby be claims to knowledge of experienceable states of affairs.

We must now turn to this more general way of putting the issue about the validation of logic.

4. The experienceable justification of logic

The fundamental task is to demarcate the ϵ-class and show which rules of inference are experienceably valid. Negation is the central concern in all this, for it is negation that marks the difference between intuitionist and classical logic. And although we have no *a priori* reason to expect that an experienceable logic will be intuitionistic, intuitionism is still our guiding example of the sort of dispute we are now generalising to empirical discourse.

With conjunction there is no problem about whether the rules governing inferences employing this constant are rules that are experienceably valid. Take the introduction rule

$$\frac{\epsilon : A \;\; \epsilon : B}{\epsilon : A \;\&\; B.} \;\& +$$

I write 'ϵ' for 'Experience' to mark the fact that our justification is not proof-theoretic depending on some set of sentences Γ, Δ etc. An unadorned 'ϵ' means simply 'experience', I shall subscript it, ϵ_i, ϵ_j . . . etc. to refer to particular experiences. If experience gives us licence to assert A and it also gives us licence to assert B then it

cannot but give us licence to assert A & B. It is inconceivable that there could be an experience which licensed the first assertions but not the conjunctive assertion. Similar thoughts apply to conjunction elimination:

$$\frac{\epsilon : A \ \& \ B}{\epsilon : A} \ \& - \qquad \frac{\epsilon : A \ \& \ B}{\epsilon : B.} \ \& -$$

We could, alternatively, justify conjunction elimination proof-theoretically if we could show it valid given the introduction rule and the reduction procedure sketched in section 2. This is easy to do. For if within some deduction δ we reach a point where we have deduced A & B and then employ the elimination rule to get, say, A, patently the deduction could be reduced. For we must have got the conjunction from some source that had, among other components, a deduction α yielding A as a component, the simplest instance being a deduction involving the introduction rule for '&' on α and deduction β yielding B. But then, rather than apply the elimination rule, we could instead have employed simply α. Similarly where we eliminate for B. However, as the programme with which I am concerned is not committed to a wholly proof-theoretic justification, I prefer to stick to the experienceable justification for conjunction elimination. In that way, no precedence is given to the introduction or to the elimination rules. It is given only to what is experienceably valid.

Disjunction introduction is similarly easy:

$$\frac{\epsilon : A}{\epsilon : A \lor B} \lor + \qquad \frac{\epsilon : B}{\epsilon : A \lor B.} \lor +$$

If experience warrants the assertion of A, it cannot but warrant the disjunction 'Either A or B'. However, with disjunction elimination matters are not so clear cut. We require

$$\frac{\epsilon_i : A \lor B \ \epsilon_j, A : C \ \epsilon_k, B : C}{\epsilon_i, \epsilon_j, \epsilon_k : C.} \lor -$$

This reads: If from experience ϵ_i $A \lor B$ is warranted and, if experi-

ence ϵ_j warrants C given A, and if experience ϵ_k warrants C given B, then C is warranted given the logical sum of experiences ϵ_i, ϵ_j and ϵ_k. The problem here is to capture the conditionality in the sub-deduction of C from ϵ_j and A, and from ϵ_k and B. It is not at all clear what notion of conditional utterance can be made good for our experienceable logic. We cannot simply take the notion of proof, as it is employed in intuitionistic logic, and apply it in empirical discourse. This problem is sharper with the rules governing the conditional.

The introduction rule will be

$$\frac{\epsilon, A : B}{\epsilon : A \to B.} \to +$$

Read as: if B is warranted given experience warranting A, then experience shows that B is warranted given A. The elimination rule

$$\frac{\epsilon_i : A \quad \epsilon_j : A \to B}{\epsilon_i, \epsilon_j : B.} \to -$$

Read as: if experience ϵ_i warrants A and experience ϵ_j warrants B given a warrant for A, then the sum of these experiences warrants B. The problem is simply this: What is it to experience such conditionality? There seems no ready answer. This is a difficult problem which I defer to the next chapter. There I show how to handle conditional utterances within an experienceable account of the constants. For now the issue is how to handle negation.

In intuitionistic logic negation can either be handled by a pair of introduction and elimination rules:

$$\frac{\Gamma, A : B \quad \Delta, A : \neg B}{\Gamma, \Delta : \neg A} \neg + \qquad \frac{\Gamma : A \,\&\, \neg A}{\Gamma : B} \neg -$$

or by the single rule *ex falso quodlibet* (EFQ), perhaps better thought of as 'absurdity elimination':

$$\frac{\Gamma : \perp}{: B} \perp -$$

where '⊥' stands for a single absurd proposition (in intuitionistic mathematics, $1 = 0$). What is it about this handling of negation which makes it an experienceable use of the operator? Or, if this is not an experienceable use, what is? To put it another way, is there a suitable reading of these rules with 'Γ' and 'Δ' replaced with experience 'ε'? That is the question we must now answer?

5. Negation, the core component

It is exceedingly difficult to say, in a non-circular way, what we mean by 'not' and the laws employing it. So obvious and familiar is the thought that a sentence is false just in case its negation is true, that it is hard to see how we are to say any more on the matter. But we must have something more to say on this on pain of allowing that classical logic stands in need of no justification. I criticised the classical defence of bivalence in Chapter 2 for failing the argument test of constraint *C*. That is, there is no non-circular defence of the claim to know, for some undecidable *P*, either *P* or not-*P*. For this argument to work there must be some demarcation of what is an allowable ground in defence of arguments employing negation. This is just the analogue of my critique of Tennant. For the proof-theoretic attack on classical negation to work there must be some account of the base class. That is what we now require. More specifically, we require an account of negation that is legitimately defended in a circular manner, for it carries the minimal requirements in order that we make sense of experience. This will then be the experiential use of negation, the use suited for our logic L, with its rules of ε-validity.

We do well to consider the following four logical laws the distinctions between which Dummett has been at pains to point out.[20] We have:

(i) $A \lor \neg A$
(ii) $\neg\neg(A \lor \neg A)$
(iii) $\neg(A \,\&\, \neg A)$
(iv) $\neg\neg A \rightarrow A$.

Following Dummett, I shall refer to these as the law of excluded

[20] For example, see *Truth and Other Enigmas*, p. xix.

middle, the law of excluded third, the law of non-contradiction, and the law of double negation, respectively. Correspondingly, we have the following four semantic principles:

(1) the principle of bivalence
(2) *tertium non datur*
(3) the principle of exclusion
(4) the principle of stability.

The intuitionist rejects the claims of (i) and (iv) and of (1) and (4), although preserving the other laws and principles. To the classical logician, such picking and choosing among fundamental logical laws may seem incomprehensibly capricious. I want to clarify this by justifying it terms of the way in which working with an experience-able notion of truth requires a revision in our account of negation to deliver an experienceable account of that constant. It is not enough to stop with the claim that the negation of a sentence is true just in case the sentence is false and false if and only if the sentence is true. For it is only by giving a more substantial account of truth and falsity than is delivered by the equivalence theses that we overcome charges of circularity in our validation of logical principles and rules of inference. It is only by giving a more substan-tial *experienceable* account of truth that we *guarantee* that we meet constraint *C*.

It is a familiar fact that ordinary language does not provide uniform procedures for forming the negation of a sentence. The negation of 'Some politicians are wise' is not 'Some politicians are not wise'; it is only the contrary, not contradictory. In the same way, although in ordinary use we often take the negation of '*a* is *F*' to be '*a* is not *F*', a difference emerges when '*a*' is empty and we need to distinguish between the latter and 'It is not the case that *a* is *F*'. Again, the point is to ensure that in negating the sentence we obtain the contradictory, not the contrary of the original. And this is important for our current concern, for it highlights the centrality of the notion of contradiction to our understanding of negation.

The standard and primary use of 'not' is to contradict or correct: to cancel an assertion of one's own or another's. Now I have already observed that unless we can say more about our concepts of truth and falsity than what is given in the equivalence theses we cannot achieve a non-circular justification of our use of negation in a

manner to justify the logical laws (i) and (iv). However, we do not need to achieve such an account to justify our acceptance of the laws (ii) and (iii) which the intuitionist has in common with classical logic. For perhaps these laws represent an experienceable use of the constant.

Whatever else we may want to say about the meaning we give to negation, it seems obvious that, regardless of whether we bestow upon it a meaning so as to validate (i) and (iv), we cannot give it a sense so as to question the claim of (ii) to be a law, and also (iii). However richer the concept of negation may be, its core is given in our acceptance of the principle of exclusion and *tertium non datur*. It is from this core that we must start in explicating the concept fit for a generalisation of intuitionist logic to empirical discourse. The common acceptance between classical and intuitionistic logic of the law of non-contradiction means that we need not worry about the impossibility of achieving a non-circular account of negation *as it is used to justify this law*. But a stronger point can be made, for, as I shall now argue, this law is experienceably justifiable. Indeed it is a minimal requirement for experience that the law should hold.

Now a realist will typically want to say that the law of non-contradiction holds because reality cannot be such that both P and not-P hold. But if he thereby means to invoke a notion of a determinate reality fixed beyond our investigation of it, he has said more than is necessary to justify non-contradiction. It is enough that we appeal to the idea that our experience could not be such that both P and not-P hold. That is the experienceable claim about negation. What argument is there for it? There are two arguments in defence of non-contradiction, both of which are arguments about what is experienceable.

The first argument is the more obvious and simply amounts to the claim that we could not make sense of the idea that both P and not-P held of experience.[21] If anyone claimed to be having an experience as of P and not-P we would surely respond that whatever they mean by 'and' and 'not' it is not what we mean. This seems a cast-iron result, but a more interesting way of arguing for the necessity of exclusion is the following.

The second argument for exclusion connects up with *tertium non*

[21] Cf. H. Putnam, 'Analyticity and apriority: beyond Wittgenstein and Quine', in *Midwest Studies in Philosophy*, vol. 4, ed. P. A. French *et. al.* (Minnesota 1979) for just such an argument.

datur. It goes like this. It is in the nature of what it is to make an assertion that, in asserting that *P*, we rule out certain states of affairs as obtaining and do so without provision for the possibility of a gap between those states of affairs which would render the assertion correct and those which would render it incorrect. That is, the very concept of an assertion requires exclusion and *tertium non datur*. This is a limited point about assertions, but an important one.[22] The point is this. In making an assertion we must, at least, confer a sense upon the utterance that divides all the possible experiences in two: those that are excluded by the assertion and those that are not. But in doing so, we ensure that it cannot be the case that neither of these two classes of states of affairs obtains and that both classes cannot obtain simultaneously. But this is not yet to ensure that either one or the other of some state of affairs from either class obtains. For, in guaranteeing that it cannot be the case that neither obtains, we only guarantee that such states that are ruled out by the utterance's being correct and such that are ruled out by its being incorrect are all and only all the relevant states of affairs. The argument for this point about what it is to make an assertion goes like this.

Suppose I claim to make an assertion with an utterance of

ngu urgblm thatchler splerg.

Consider now an attempt to interpret this utterance. In this attempt you hypothesise that I meant that *P*. Further, it transpires that *P* is false. In which case if I do not retract my utterance you must, other things being equal, take your hypothesis as mistaken. But what if my utterance fails to be sensitive to all attempts at interpretation that is, for any interpretation *P* offered I do not withdraw my utterance when *P* turns out false? In such a situation it is not just that you fail in the interpretative enterprise; it is then questionable whether there is any reason for taking my vocalisation as a *saying that something* at all. It is no longer plausibly an assertion, for it is no longer seen to be amenable to assessment as being correct or incorrect. At a minimum, if some utterance is an assertion it must

[22] It is noted by Dummett in *Frege: Philosophy of Language* (London 2nd ed. 1981), p. 344. This is also the point alluded to in Chapter 3 section 7 in my criticism of McDowell's general argument in favour of logical revisionism without abandoning realism.

make some divide upon possible experiences that give us criteria for evaluating it as correct or incorrect. This is not just an interpretative point about how we would go about radical interpretation, although it is most easily seen as valid when thinking of such situations. The requirement for these criteria of evaluation is a constitutive point; *that* is what making assertions is all about. And the point germane to the current enquiry is that, for there to be standards of correctness and incorrectness of assertion, *tertium non datur* and exclusion must hold. Without those, we cannot make the effective divide upon possible experiences which provides the standards of semantic evaluation. This point about the nature of assertion is important for later argument and so, to be clear just what is invoked, I shall note the present point as a principle, to which I shall later refer. The principle governing what it is to make an assertion goes then like this:

> *The Assertion Principle*: For any proposition *P*, in asserting that *P* we rule out certain states of affairs as obtaining and do so without provision for the possibility of a gap between those states of affairs which would render the assertion correct and those which would render it incorrect.

The thought provoked by the above argument then is this: exclusion and *tertium non datur* are required to hold good in order that we make sense of experience, for they are required in order that we be able to make assertions about the world as we find it in experience. An experience which did not conform to these two principles would not be an experience which could coherently support *talk*.[23] These two principles therefore constitute the core component of negation.

If these two principles constitute the core of the concept of negation, how do they provide us with leverage on an account of experienceable negation? The answer here goes as follows. An assertion effectively divides our experience into two: those states of affairs that rule out the assertion's being correct and those that rule out its being incorrect. Now an experienceable use of negation will

[23] I would also support the stronger claim that experience which did not conform to these principles could not support *thought*, but the weaker version is sufficient for present purposes. The argument is the same though, for thoughts are things to be assessed semantically as correct or incorrect.

be a use such that an assertion of 'not-*P*' must similarly divide our experience in two. If '*P*' is antecedently acknowledged to be effectively decidable, there is no problem, for that is just to say that its truth and falsity are directly experienceable, and we may take 'not-*P*' as equivalent with the falsity of '*P*'. Where '*P*' is not effectively decidable matters are not so simple. Suppose '*P*' is some atomic sentence which we take to be non-effectively decidable. Its truth or falsity is not experienceable. In this case an experienceable use of negation in 'not-*P*' would be: 'not-*P*' is warranted just in case we have a proof that a proof of *P* leads to a contradiction '*Q* & ¬*Q*' where '*Q*' and '¬*Q*' are effectively decidable statements about experienceable states of affairs. This then is to take negation defined as:

$$P = {}_{df} P \to (Q \& \neg Q), \text{ or } P \to \bot$$

just as suggested in section 1. This is to define negation in terms of directly recognisable contradictions. Such a contradiction '*Q* & ¬*Q*' is one where the assertion that *Q* so divides our experiential input that we can directly verify that those states of affairs which are ruled out by the making of the assertion and the remainder cannot simultaneously form part of our present experiential input. This idea of a state of affairs, '¬*Q*' ruled out as a possible experience by an assertion of '*Q*' founds the notion of directly recognisable contradiction. That we have such a notion is implicit in our concept of what it is to make an assertion. The notion is required in order that we be able to give any general account of experienceable negation for non-mathematical discourse.

Although the negation of a non-experienceable claim '*P*' will consist in a proof that a proof of *P* leads to a contradiction '*Q* & ¬*Q*' where the latter is experienceable and so requires a notion of negation as primitive, this primitive notion is restricted to just those states of affairs which are directly recognisable in that they or their negation can be directly recognised as obtaining or not. It is such states of affairs that are captured in the foundational logic of experience, and they are constitutive of the experiential use of negation. For in order to meet constraint *C* that is, in order to manifest knowledge of the truth of a negated sentence that does not already presuppose that the operator requires the sentence has a determi-

nate truth value the experienceable use is the level to which appeal must be made in manifesting such knowledge.

Taking negation defined generally, such that not-P means that a proof that P leads to absurdity, is to ensure that our use of negation remains an experienceable use. It is a use that conforms to exclusion and *tertium non datur*, but does not provide bivalence and stability. For it is to take negation defined by the rule EFQ. It is then acceptable to take this rule as the one that governs experienceable negation, and we write:

$$\frac{\epsilon : \bot}{: B.} \bot -$$

That is, if experience warrants an absurdity, any proposition is warranted. This is implicit in our taking exclusion and *tertium non datur* as principles of experienceable negation.

6. An objection

It might seem that, in so founding the concept of negation in the notion of the impossibility of experience being of such-and-such a kind, I am open to the following charge: Throughout the history of philosophy claims about what is possible for experience have invariably turned out wrong; therefore so might this. This charge misses. I am not saying that we cannot conceive of experience being such as to include two *different* atomic sentences which we at present may think inconsistent, but only that there is a basic concept of contradiction founded on the very act of assertion. That is to say, an example of a directly recognisable contradiction would *not* be 'This is red and this is green', where 'this' refers to some one region of a visual experience. All I require is the thought that in, e.g., asserting 'This is red' restrictions are placed upon the range of experiences that are compatible with the assertion's correctness. And although this might seem a limited point, the resulting experienceable account of negation turns out to be much stronger than many have thought an anti-realist notion of negation might be. In this we are able to see the error in recent criticisms of the anti-realist enterprise and also the failure of examples designed to show the insufficiency of bivalence as a criterion for realism.

7. Experienceable negation in action

The strength of the proposed account of negation may be seen by considering sentences with bearer-less names. Take some sentence '*a* is *F*' and assume that it represents an experienceable state of affairs. I shall signal this by saying that the sentence is an ε-sentence. For this to be the case '*a*' cannot be empty. But now consider non-ε-sentences, those with bearer-less singular terms. Working with experienceable negation, the negation of such a sentence must be explained in terms of how a proof of it leads to a proof of an ε-sentence and its direct denial. Well, suppose that 'The present King of France is bald' is just such a sentence. This is a non-ε-sentence, for even if we thought (*contra* Russell) that Kings of France were experienceable like Russell's momentarily enduring referents of 'this' and 'that', as there is no present King of France it automatically enters the non-ε-sentence category. But that then explains why it can seem plausible to think that the sentence lacks a truth value. Put more intuitively, it is not clear what division is made in our possible experiential inputs by an assertion of the above sentence. This is why it is not an ε-sentence. And if we can see no reason to think that a proof of this would lead to a proof of an ε-sentence and its direct denial, it will fail to have a truth value. It is only by assuming that the concept of negation is of such a kind to validate bivalence as well as exclusion and *tertium non datur* that we could insist that an assertion of the above is such that either it must be true or false and, as it is not true, it is false.

This is not yet to agree with Strawson that an utterance of this sentence is neither true not false, nor even with the weaker Fregean claim that it lacks a truth value. The concept of experienceable negation would support, at most, the latter idea. However, it is intuitively plausible to agree with Russell that the sentence *is* false, although for different reasons. That is, it is plausible to think that a proof of its assertibility would, in an intuitive way, come to rest on the assertibility of some sentence like 'He is the present King of France', which is, plausibly, an ε-sentence readily contradicted. The concept of experienceable negation then captures many of our intuitions about the dispute about sentences with bearer-less names. Here is another example of the concept at work.

I stipulate 'Bartholomew' as the name of the last person to die of the Black Death in London. Now consider the sentence 'Bartho-

lomew was illiterate'. This is a non-ϵ-sentence, although the singular term is not empty. The sentence has a sense, and also a referent, but *experience* provides no referent; we have no way of discovering the referent. For what would be the relevant experience for 'It is not the case that Bartholomew was illiterate', and what would be the relevant experience for 'Bartholomew was illiterate' being true? We have no evidence for the truth of either of these sentences. Nor do we have any evidence that such evidence would lead to the assertibility of a contradiction in the ϵ-sentences. In short, the supposition of the truth of the sentence or its negation does not cash out into experience. That being so, we have no reason to take it as determinately either true or false without first *assuming* a richer non-experienceable concept of negation.

The general moral from these two examples is this. It seems natural to think that, however else the anti-realist concept of truth may go, it cannot be an account of truth *simpliciter*, but a matter of truth in a model. This is right, but instead of the formal notion of a model, I shall speak of a sentence being true in an experience ϵ. Of some sentence 'a is F' we say then that it is only true if true in ϵ where ϵ provides a bearer, or a means of providing a bearer, for 'a'. The negation of this is not then to say that the sentence *fails* to be true in ϵ. *That* would be to employ a non-experienceable notion of negation. Rather, if the sentence is an ϵ-sentence and so 'a' has a bearer, the negation is the experienceable 'a is not-F' where this is something that is experienceably detectable. If the sentence is a non-ϵ-sentence, its negation amounts to the claim that a proof of it would lead to a proof of some sentence 'not-Q' where this is an ϵ-sentence and where 'Q' is true in ϵ. That then gives us the negation of the sentence being a proof that a proof of it leads to a directly recognisable contradiction 'Q & $\neg Q$'.

8. Further polemics

In his critical notice of *Truth and Other Enigmas* Wright argues that Dummett has parted company with the intuitionist account of negation and that his 'Jones was brave' example does not work. The sentence turns out false.[24] Wright is wrong here, and in a manner that both exemplifies the point about negation that I have

[24] C. Wright, 'Critical notice of *Truth and Other Enigmas*', *Philosophical Quarterly* 1981. See Dummett's 'Truth' in that collection, pp. 15ff, for the example.

been pursuing and the issue of the correct method of generalising the intuitionist account of negation. Wright says:[25]

> Intuitionistically, the negation of P is counted as proved just in case we have a construction of which we can recognize that it would enable us, were we to obtain a proof of P, to construct a proof of a contradiction.

But he then continues:

> The account is tantamount to the stipulation that a proof of the negation of P is any construction which we can recognise to rule out the possibility of P

It is this last claim that leads Wright astray in his generalisation of intuitionist negation for empirical discourse, for there is an issue about what he means by the notion of ruling out the *possibility* of P. Wright's generalised account of negation is this:[26]

> (N): A total state of information (hereafter a TSI) justifies the assertion of the negation of P just in case it justifies the assertion that a TSI justifying the assertion of P cannot be obtained, no matter how thoroughgoing an investigation is conducted.

The problem is how to read the modality. When some TSI rules out the possibility of a proof of P, is this because a proof is logically ruled out, or is the modality only a physical one? On Wright's account the latter seems enough, for on that account a sentence turns out false and its negation true if, due to some contingency, there is no experience ϵ such that it is true in ϵ. But that means that Wright is employing a non-experienceable notion of negation, and if *that* is so his argument against Dummett's 'Jones was brave' example will be worthless. I believe that this interpretation of Wright is correct.

Wright's reasoning goes as follows. Because of the way the example is constructed, our current TSI is such as to justify the assertion that no subsequent TSI could justify the assertion that Jones was brave. But then, by (N), we must be able to justify the assertion that it is not the case that Jones was brave. But this follows only because it takes negation of P effectively as 'P' is not

true, in the sense of *fails* to be true. This is acceptable if we employ a non-experienceable concept of truth such that every sentence must be either true or false, where the latter is 'fails to be true'. But such an account not only prejudges the issue of whether or not bivalence and stability are valid, but further, if we replace truth with provability as Wright does, we get not-*P* as meaning that a proof of *P* cannot be obtained. The counter-intuitiveness of this notion of negation is apparent from the fact that we want to be able to say something like this: From the fact that we can prove that we cannot prove that *P* it does not follow that we can prove not-*P*. Not only is this an intuitively plausible claim, *it is enshrined in intuitionistic logic.*

Let me put the matter another way. We are distinguishing provably not-*P* (experienceable negation) from provably not provable that *P*, non-experienceable negation. We contrast

(5) A proof of ¬*P* is a proof that *P* is unprovable

with

(6) A proof of ¬*P* is a construction which can be applied to any proof of *P* to yield a canonical derivation of a contradiction in the class of ε-sentences.

I have said little so far in explaining the notion of a canonical derivation. Clearly this employs only an experienceable use of the constants, one that conforms to the rules of ε deductions. The difficulty, as already noted, is to explain the notion of *proof* or derivation for empirical discourse. No matter. I shall discharge that difficulty in the next chapter. The intuitive idea is this. The relevant construction in (6) will have to be one which showed how the assertibility of the sentence made effectively decidable constraints on experience. The thought that lies behind the idea that bivalence fails for 'Jones was brave' is that the sentence makes no effective constraints on experience. *There is no way we could take it as being true or false which did not already assume that it had a determinate truth value.*

The point of distinguishing (5) and (6) is connected with the earlier discussion of Wright's argument for strict finitism. It is because Wright thinks that any concept of proof cashed out in terms of recognitional capacities has to be elucidated with a notion of finitude which gives no independent leverage on the notions of

possibility and decidability in principle that he sees no difference between (5) and (6). But there plainly is a difference.

Clearly the anti-realist cannot merely assert that he has a concept of negation stronger that our proved *in*ability to prove a sentence *P* by appealing to a notion of proving not-*P* unless he can give some account of this latter notion. But I have produced in the concept of experienceable negation just such an account building upon the negation of ε-sentences, those for which we can directly recognise their obtaining or not-obtaining. I think that the view that proving not-*P* is stronger than provably not being able to prove that *P* is part of our everyday linguistic practice. As such it is something the anti-realist would do well to retain. This is possible, because the former concept may be captured purely by considering our acceptance of exclusion and *tertium non datur* and the core content that this gives to negation.

Perhaps it may now be objected that, whatever the merits of experienceable negation, I have parted company with intuitionistic negation. This would be wrong, and can be seen to be so if we return to the question of the status of the modality in (N). This is where Wright errs in generalising intuitionistic negation, in saying a proof of not-*P* is tantamount to a proof which rules out the possibility of a proof of *P*. This is acceptable for the mathematical case only because the notion of ruling out the possibility of a proof of *P* is that of *logically* ruling it out. Like my general experienceable account, the mathematical case relies on an implicit circularity by defining negation in terms of proofs which lead to contradiction. In mathematics the 'contradiction' is cashed out in terms of an obvious absurdity like '$1 = 0$'. And this is to see a proof of not-*P* as logically, or canonically, ruling out a proof of *P* on pain of contravening the third Peano axiom. We would not be able to construct the natural numbers if such a proof were available. More intuitively, in the mathematical case the negation of a sentence is a matter of showing that no proof of it could obtain because there could not logically be an experience that would be one of '$\neg P$' without destroying the possibility of constructing the natural numbers at all. Put like that, this is plainly an idea that is missing in (N). (N) has the consequence of rendering false any sentence for which evidence cannot be obtained! We need to amend (N) in order to accommodate the intuitions about negation which, I have argued, form the central

core to the concept, as well as being the experienceable notion of negation.

To strengthen (N) we need to say something like 'A TSI justifies the assertion of not-P just in case it justifies the denial of P'. Replacing 'TSI' with experience ϵ, in the light of the preceding argument we get:

(N*): An experience ϵ_i justifies the assertion of not-P just in case, for whatever supplementation of ϵ_i to form ϵ_j to justify the assertion of P, ϵ_i and ϵ_j together enable us to justify a directly recognisable contradiction.

For example, take

S: It was raining in Los Angeles on 22 July 1987.

By (N) not-S will be proved by our current experience just in case it justifies an assertion that an experience justifying S cannot be achieved. Simplifying greatly, suppose that the only evidence for S is

E: 3 inches of rainfall are recorded in the Los Angeles weather centre's record book for 22 July 1987.

So S is justified if our current experience contains E or an effective means for finding out that E. Not-S is justified by (N) if experience justifies the assertion that no experience containing E or an effective means for finding out that E can be obtained. But this only requires that not-S is assertible if S is not-assertible, and this clashes with common-sense as well as intuitionistic logic. For suppose that the Los Angeles tourist board locks away the offending record book in a cabinet which incinerates its contents if opened. (The board is out to quash any facts which might impair the city's desirability to tourists.) This would not lead us to suppose that not-S is true, and the intuition about what makes not-S true here is not an essentially realist one. The realist would not take not-S true here because he takes the truth or falsity to be wholly independent of evidence. But the anti-realist may also baulk at the suggestion that not-S would be true here.

In the mathematical case an analogous example would be to

suppose that a systematic and continuous annihilation of mathematicians would render a mathematical statement P false, on the assumption that P were sufficiently complicated to be provable by only a mathematician. The realist would not allow this. The point is that the anti-realist may also reject the move from 'We cannot prove P' to 'not-P' by giving a strong account of negation extracted from our core common acceptance of exclusion and *tertium non datur*. For the realist these matters are all part of the same overall conception which he claims to have of the concepts of truth and falsity. It is the point of this chapter to show how such apparently connected intuitions about negation may be held apart.

So, in the example about S we get the following. S is justified if our experience ϵ includes E or some means of finding out that E. By (N*), not-S is justified if ϵ justifies the assertion that E justifies \perp; that is, E leads to a directly recognisable contradiction. In which case, where E is not assertible and neither is not-E, the case of the tourist board's interference, we have no right to insist that S is either true or false. We understand what it is for c to be true or false, but we are not guaranteed that it is one or the other. Similarly with 'Jones was brave' and 'Bartholomew was illiterate'. In contrast to the case of a sentence with a bearer-less singular term where, despite initial uncertainty over what is being excluded by an assertion of 'The present King of France is bald', we nevertheless expect that a proof of this will issue in the proof of a contradiction. With the other examples this is not so. The conditions for warranting such sentences do not cash out into experienceable states of affairs.

9. Bivalence is sufficient for realism

Wright's account of negation is important, for if he were correct it would follow that one could accept bivalence without being a realist. He is not correct. I shall draw the general moral of this by considering a final example, similar to Wright's, which is due to Dummett. The example fails because, like Wright's, it requires a non-experienceable account of negation.

Dummett considers the case of a neutralist about the future[27]

who calls a statement 'true' if true in every definite future course

[27] *The Interpretation of Frege's Philosophy* (London 1981), p. 437.

of events, and false if it is not (and thus not only if it is false in every future definite course of events).

But now:[28]

> Since for him every statement is objectively determined as true or false in this sense, he may claim to subscribe to the principle of bivalence: but he is obviously not a realist.

Clearly the neutralist is not a realist, for what determines the falsity of a statement is, in part, a decision by him to accept certain things as false, not, as it were, a determination by reality that the statement is false. The position also owes little to anti-realism. I think we can analyse what is going on with this example in the following way.

The point about identifying acceptance of bivalence with realism was always, surely, meant in the sense that every sentence was either true or false *simpliciter*. It is characteristic of classical semantics for the constants that either truth or falsity could be taken as the designated value, the one being defined in terms of the other. This, of course, is why double negation elimination is such an important rule of inference in classical logic. However, with Dummett's neutralist, although some form of excluded middle will hold for the sentence '*a* will be *F*', it is not guaranteed that this is either true or false *simpliciter*, but only with the mutated truth and falsity offered in setting up the example. And this is why he is not a realist about the future. Bivalence, understood classically, such that every sentence is either true or false where either of these values can be taken as the designated value, the other defined in terms of it, still stands as the criterion for realism. In other words, there is reason to think that the neutralist's subscription to classical logic is too nominal to be relevant to the realist/anti-realist question. It is too nominal, for it is not classical logic under the classical semantics. Indeed it is important to note that double negation elimination fails for the neutralist.[29] The fact that the neutralist employs a non-

[28] Ibid.

[29] If not-*P* is defined as *P* is not true in all future histories, false in all of them being the limiting case, then that is to say that there is at least one future history where *P* is not true. That is, there will be an ϵ which does not justify *P*. But then, not-not-*P* will be: there will be an ϵ which does not justify that there will be an ϵ which does not justify that *P*, and from *that* it does not follow that for all future ϵ *P* is true.

experienceable negation operator does not, alone, render him a realist, it only renders him non-anti-realist. It is the classical account of bivalent semantics with a non-experienceable negation operator and the truth values such that either may be taken as designated that is characteristic of realism. But it is also characteristic of classical logic classically interpreted.

The point of all this is that, although we can validate a logic that provides all and only all the classical theorems, this is not to validate classical logic as classically interpreted. With the examples Wright and Dummett have produced we do not get the classical account of bivalence. Their examples show, at best, that classical logic can be proof-theoretically validated, not semantically validated after the fashion of classical semantics. But of course, to validate classical logic semantically is to infringe constraint C, for once we accept the challenge to validate logic semantically we have to pay service to experience. Experience validates only our logic L, with its rules of ϵ-validity; a logic of an experienceable use of the constants: the logic of anti-realism. I conclude then that the identification of realism with bivalence survives both McDowell's critique discussed in the last chapter and the critique from Wright. Anti-realism entails logical revisionism. Giving up the classical semantic account of classical logic entails giving up realism.

If the account for experienceable negation is correct, there is a pressing need for an account of how we are to delimit the states of affairs which are effectively decidable, the experienceable states of affairs. The account of negation hangs on this, as does much else besides. I shall come to this. But the task would appear insuperable if I did not now turn to one of more immediate concern. This is the question of how to handle the concept of proof when dealing with a generalised semantics of the constants fit for empirical discourse.

The Logical Constants and the Objects of Experience

Consider the following: Traditional epistemology has taken the world as populated with objects whose existence and properties determinately obtain independently of our knowledge of their obtaining. The epistemological enterprise has then been to forge some connection between the knower and objects thus construed. Now the anti-realist argues that we have no right to a concept of truth which underpins this image of a world determinate beyond our capacities to know of its character. If that is so, there can be no right to conceive of the world and its objects as presented to us in experience as objects whose existence and character transcend our knowledge of them. A critique of the realist concept of truth must infect our concept of an object. It is the purpose of this chapter to show how this is so and how it is connected with a problem about specifying an experienceable sense for all of the logical constants. The problem is a general one about what the central semantic concept should be for an anti-realism generalised to empirical discourse. In this chapter I solve this general problem. The account of the constants is handled in Appendix 1.

1. The nature of the problem

Intuitionism in mathematics is the only developed account of an experienceable logic and metaphysics. The justification for calling intuitionistic logic 'experienceable' goes deeper than the fact that my account of experienceable negation in the last chapter turned out to deliver just the same account of negation as intuitionistic logic; that is,

$$P =_{\text{df}} P \rightarrow \perp$$

This fact is by no means insignificant, for it is negation which differentiates intuitionistic and classical logic. However, the main reason for treating intuitionistic logic as an experienceable logic is that, as remarked in the last chapter, the notion of a construction or proof as employed in intuitionism just is the analogue of the notion of experience. Because intuitionism is a theory about a formal mathematical system, the notion of *evidence* or experience comes to that of *proof within a formal system of rules*, but at root the idea is still that of evidence. A constructive proof in mathematics that number *n* is *F* is one which enables us to experience that *n* is *F*. Brouwer, I am sure, would not have thought that last remark at all odd, for of course he took the idea of an *intuition* in a straightforward Kantian way; constructive proofs were those that enabled one to intuit the natural numbers. It is only the peculiarities of dealing with a formal system that leads the concept of a construction or proof to take on a life apparently unconnected with the concept of experience.[1] However, just because intuitionism is a theory about a formal system, its treatment of the logical constants cannot be generalised to empirical discourse. This is the problem remarked upon in the last chapter about how to handle the conditional.[2] The account of negation offered depends on a resolution of this problem. It is the problem that will now occupy us.

If we tried simply to borrow the intuitionist accounts of the constants we would meet with limited success with '&', 'v' and ' \exists '. For with these we could replace the concept of proof with that of a verifying observation. For example, '*A* & *B*' is proved just in case we have a verifying observation of *A* and a verifying observation of *B*; that is, our experience ϵ verifies both sentences. Similar accounts could be given of disjunction and existential quantification. But with implication, negation and universal quantification the matter is complicated, for the intuitionistic meaning of these constants is a function of operations, or constructions, upon proofs. '$A \to B$' is

[1] I am grateful to Dan Isaacson for pressing upon me this point about the notion of a construction in intuitionist mathematics.

[2] This problem underpins my argument against Tennant about relying on a proof-theoretic justification of intuitionistic logic against classical logic. The heart of intuitionism is not an idea about the legitimacy of *proofs* understood as moves within a formal system; it is an idea about the legitimacy of such moves depending on what is experienceable. To get at that idea we have to invoke, at bottom, a semantic justification for our logic.

understood intuitionistically as saying that any proof of the antecedent can be turned into a proof of the consequent. The assertion is warranted when we have a proof that such a construction upon a proof of the antecedent to turn it into a proof of the consequent can be obtained. Our problem is that, for empirical discourse, the notion of proof does not seem relevant. And although this is because the idea of proof we take from intuitionism is, as noted, restricted to that of evidence within a formal system, this only offers another way of putting the present problem: What is the experienceable notion of a conditional? Put like that, the problem may seem insuperable, for how could one possibly *experience* the conditionality of 'If A then B'?

I do not think that we could make any headway with this problem if we were to stick with the latter formulation. It offers no leverage, no idea of what might be required in answer to the question. Although the notion of proof is distorted by the idea of moves within a formal system, we make a better start with our problem by seeing the difficulties of employing the notion of proof within empirical discourse.

For example, suppose we assert

(1) If it is raining, the ground is wet.

Generalising the intuitionist account to the conditional, this would be assertible just in case we had a construction which we could effectively recognise as converting a proof of 'It is raining' into a proof of 'The ground is wet'. Even if we thought that the concept of proof for the atomic sentence was satisfactory, it is plain that it is not for the complex sentence. What could it be to have such a construction? It is not just that it appears to impose very strong conditions on the assertibility of the conditional; it is not clear just *what* the conditions are.

Suppose we tried the bold manoeuvre of handling 'proof' in terms of verifying observations. Then a proof of our conditional might consist in the observation that no observation of 'It is raining' and 'It is not the case that the ground is wet' is to be had. But this begs the question at issue. It merely asserts that we can observe the assertibility of complex sentences like conditionals without telling us what or how this might be. We simply do not seem to have

proofs or observations of the sorts of items required. Knowledge of empirical reality does not proceed by such means.[3] Clearly the notion of deductive proof is out of the question here, but so too is the notion of inductive proof or, more generally, a probabilistic semantics for the constants. We may have strong inductive grounds for asserting a conditional like the above, but our present question is: *What* are we asserting when we assert such a conditional. Inductive proof might, at best, give us a basis for believing in the assertibility of the conditional, but our present problem concerns what the nature of the conditional assertion is. Our understanding of what we are doing in making such an assertion must consist in more than our basis for believing in such an assertion, for a specification of the former is needed to say *what* it is we believe when the latter condition obtains. Our problem is

What does it *mean* to assert (1)?

not

When are we licensed to assert (1)?

for we want to know what it is we are asserting with (1). Let me generalise this point.

2. A dilemma for the notion of non-conclusive proof

We have some conditional assertion:

If *A* then *B*

Suppose we think that *some* notion of proof can be rendered suitable as analogue for the intuitionist account of this; that is,

(2) We have a proof that any proof of *A* can be converted into a proof of *B*.

[3] It is only the observationality of *complex* sentences that I am questioning here. With atomic sentences I shall argue for a much deeper range of experience than is common as, indeed, I did in 'Verification, perception and theoretical entities', *Philosophical Quarterly* 1982. For the notion of the *range* of experience, cf. Chapter 3 above and Chapters 8 and 9 below.

Clearly, if we are dealing with empirical discourse, conclusive deductive proof is out of the question, so the candidate notion of proof must be non-conclusive. As the notion of proof must be sufficient to handle conditionals, it cannot be simply a notion of observation. But then the notion must be of this general form:

(3) Ω *p-warrants A*,

where *A* is some logically complex sentence, Ω is some observation sentence or set of such sentences, and '*p-warrants*' is some probability relation, such that in some sense *A* is rendered probable to an appropriate degree by Ω. The important point about (3) is that the relevant notion of non-conclusive proof, the *p-warrant*, must be a relation between sentences. What is more, it must be a relation that holds just as much between Ω and atomic sentences as between Ω and complex sentences. Although the notion is introduced in order to give an account of the sense of the logical constants, in particular the conditional, the general form of the account of the conditional (2) requires that we be able to speak of the proof relation for atomic sentences. For the account of the conditional speaks of a proof that a proof of *A* can be turned into a proof of *B*, and the use of 'proof' in 'proof of *A*' is a use of the proof relation with regard to an atomic sentence.

But now we have the following dilemma: Either the proof relation of *p-warrant* serves to *specify* the content of atomic sentences or it does not. If the former, the whole notion is incoherent; if the latter we have no guidance on the project of an experienceable account of the conditional and the constants in general.

Suppose the *p-warrant* relation specifies the content of atomic sentences. So

(4) Ω *p-warrants A*

gives the meaning of '*A*'. This is incoherent. The general intuitive idea behind the notion of a non-conclusive proof like the *p-warrant*, is this:

(5) *A* is *likely* to degree *n* given Ω.

The thought is that Ω makes the sentence probable, but if this is

to say something like (5), the *p-warrant* relation cannot give the meaning of A, for A is a constituent of (5) and so its content must be given *before* describing the *p-warrant* that obtains between it and Ω. This problem originates in the idea that the *p-warrant* relation is a non-conclusive relation of support. To say that it is non-conclusive is just to say that the sense of A transcends that of Ω; and that is why the latter provides only defeasible evidence for the former. But then it is incoherent to hold this *and* claim that the *p-warrant* relation between Ω and A gives the meaning of A. If it gives the meaning A cannot be a stronger claim than Ω and the *p-warrant* relation cannot be *non*-conclusive. But if the *p-warrant* relation is non-conclusive, it cannot be a content-specifying notion.[4]

So suppose that the *p-warrant* relation does not give the content of A. In many ways, despite what various supporters of some notion of non-conclusive proof may say, this is a better way of viewing the relation. In Chapter 3 I remarked on how Wright seemed to view the criterial relation as what I called a 'bridge', a sort of super-inductive warrant for the assertibility of some state of affairs realistically conceived. So we suppose that the sense of A is not given by (4). We understand A to say more than what is said by Ω which *p-warrants* it. The *p-warrant* relation must then serve the following purpose: It gives the grounds for asserting A. The relation does not give the sense of A; it merely tells us under what conditions we are warranted in asserting that A. But once more, because the *p-warrant* relation is non-conclusive, this is incoherent. For suppose now that A is logically complex. If Ω obtains we are warranted in asserting A. But we wanted the *p-warrant* relation to tell us what we are asserting when asserting complex sentences, but it cannot discharge this function. For if the *p-warrant* relation gives us the grounds of the logically complex sentence A, then asserting that A would amount to no more than

(6) A is likely to degree n.

[4] It is this problem that Wright now acknowledges with the criterial relation as he has often promoted it; cf. his 'Second thoughts on criteria', op. cit. For an instance of this problem cf. D. Edginton, 'Meaning, bivalence and realism, op. cit., where she is lead to remark (p. 162) that, on an assertibility-conditions theory of meaning where the assertibility relation is non-conclusive, 'we say what a sentence means without using a synonymous sentence' ! If saying what a sentence means is not specifying its content, she does not say what else it might be.

But saying that (6) is not the same as asserting that *A*. For (6) is compatible with

(7) *A* is false.

But generally, any assertion of a sentence *A* must, at least, so divide all possible experiences into those that render the assertion correct and those that render it incorrect, there being no third possibility (*tertium non datur* holds) and, most importantly, there being no possibility that experiences from both classes obtain together (the principle of exclusion). But Ω, which *p-warrants A*, because it only gives non-conclusive proof of *A*, is compatible with whatever supplementation of Ω which renders *A* false. But then Ω cannot render *A* correct, for it is possible that Ω obtains *and* whatever shows *A* false obtains. That infringes the above condition on what it is to make an assertion.

Note that it would be no reply to this argument to say that Ω is not meant to render *A correct*, only to render it *warranted*. That does not matter. The point is this. The conception cannot give content to the idea of *asserting that A*; at best it only gives content to *saying that A is likely or warranted*. But then, as before, asserting that *A* is a constituent of asserting that *A* is warranted, or likely, and so the latter construction sheds no light on the former. And where we take *A* as logically complex, the *p-warrant* relation cannot help in giving an account of the constants, for it presupposes that we already know *what* we are asserting when we assert a logically complex sentence. It is the defeasibility of any *p-warrant* relation which causes the problems on the second horn of the dilemma on which the idea is that the relation does not specify the content, but merely tells us when a sentence is warranted.

In summary, the dilemma for the notion of non-conclusive proof applied to empirical discourse is this. On either option, of employing the *p-warrant* relation for content specification or as giving the grounds for asserting, the relation is a *bridging* notion. On the former it is a *content bridge*, on the latter a *truth bridge*. What this means is that, on the former option the *p-warrant* relation is used to specify the content of an assertion that *A* in terms of Ω which is acknowledged to be a weaker assertion. That is incoherent. On the latter option, the relation is used to say when we are warranted to assert that *A*, but, where *A* is complex, we want to know what it *is* to assert

that A. The *p-warrant relation* can only deliver this by assimilating the assertion that A with the assertion that A is likely, but *that* is incoherent for it provides no genuine account of asserting that A. For that requires that to assert that A is to say something that is incompatible with A being false. Because the *p-warrant* relation is defeasible, it cannot meet this condition.

3. The root of the problem

Our problem is to find some analogue for the notion of proof when applied to empirical discourse. I have argued that a notion of non-conclusive proof cannot work. It is time to unwrap the root of our problem and the root of the dilemma for the theorist of non-conclusive proof. The root is contained in the idea of a *bridging notion*.

The root of our problem is this. In looking for a concept of empirical proof we inevitably look for some relation that serves as a bridge between some base class of sentences and the sentences in question. I mentioned two such notions of bridges in the previous section. One is when the *p-warrant* relation is used as a *content-bridge*. That is when the base class Ω is used to specify the content of the sentence(s) in question. Such a notion can only have point within the context of a meaning theory that offers novel content specifications; a theory engaged on the objectivity of content issue. As such, it is of no interest to the present enquiry. The second bridge notion is that of the *truth-bridge* whereby the Ω base is employed to provide a warrant for the assertibility of the disputed sentence(s). Most discussions of a non-conclusive proof relation fall unhappily between these two notions, sometimes employing one and sometimes the other. The first need not concern us. The second reveals the root of our problems.[5]

So long as we view the facts expressed by empirical statements as facts determinate independent of our knowledge of them, we do so at the expense of creating a problem of how we are to account for our knowledge of them. So long as the truth of A is conceived

<hr />

[5] Crispin Wright's advocacy of criterial semantics has mixed these two bridge notions. But see also Edginton, op. cit., where she starts off with a notion of assertibility conditions that are offered as specifications of content and then goes on, on this basis, to provide assertibility-conditions rules for the logical constants where the conception is that of a truth-bridge relation. Both these writers fall foul of the dilemma in section 2.

as something determinate beyond our investigation of it there must be a problem about how to *prove* A with only the Ω base to go on. At best that can only give a warrant for asserting that A; it cannot prove it. But then, by the argument of the previous section, that does not give us the means to explain what we are doing in complex assertions, like conditionals, involving A. But this is no more than to emulate the traditional problems of epistemology. *The* traditional central epistemological problem is to find a suitable truth-bridge for statements about the empirical world, to take us from the starting point, defined by some account of the Ω base, to the truth of statements beyond the base. Normally the Ω base is defined as statements about those states of affairs that fall within the range of experience. The debates instigated by earlier forms of verificationism were concerned with outlining the Ω base; asking *which* truths are accessible or fall within the range of experience. And, normally, all other statements have been construed as having their meaning defined as some function over the Ω base. However, these questions were always questions about which *truths* were accessible. It is because the traditional concerns have been in terms of *truths* realistically conceived as the objects of knowledge that the problem of finding the truth-bridge appears. For, on the realist conception, a truth is something determinate beyond our capacities to know of it. But this is not something which the anti-realist should accept.

If the anti-realist argument against the intelligibility of the classical, realist, concept of truth figuring in knowledge claims is right, we must reject the idea that the objects of knowledge are *truths* thus conceived. The anti-realist challenge is to question whether truths, realistically conceived, are the proper objects of knowledge, for they fail constraint C. But in that case we are mistaken in thinking that the problem of section 1 about how to characterise a satisfactory notion of proof, more generally a truth-bridge, is a problem for the anti-realist. Nor is the dilemma outlined for the notion of non-constructive proof our dilemma, for that too presupposed the very notion of the objects of knowledge that is not available to the anti-realist. The anti-realist cannot think of our knowledge of empirical reality as knowledge of those sorts of things that leave us wondering how an adequate truth-bridge can be constructed to give us access to the facts. The move for the anti-realist is not to say that, as neither deductive nor inductive proof will work, we need to invent a new logical relation. Rather, the

correct move for the anti-realist will be to question the very notion of the facts which are, supposedly, such problematic objects of knowledge, conceived of as somewhere beyond a problematic truth-bridge. In short, in reversal of the criterialist approach, we must refashion the concepts of knowledge and objects of experience to meet the logical constraints of anti-realism rather than invent a new logical relation to give a truth-bridge to facts and objects realistically conceived.

This still gives us no ready answers. For we cannot simply say that the objects of knowledge are *proofs* instead of *truths*. For, as we have seen, we have no grip on what the relevant concept of empirical proof might be. The concept of *proof* inevitably requires the idea of *proof from* some base and we have, as yet, no reason for picking on any one base over another. Even if the anti-realist restricted the range of experience to some such base Ω as, say, sense-data reports, this would still not be to say that the objects of knowledge were *truths* about sense-data. For we have yet to see quite what the relevant anti-realist construal of the central semantic notion must be when dealing with empirical discourse. The inherently realist nature of such a position is seen if the advocate of such a move were to deny that there was any problem in giving an account of the conditional:

If such-and-such sense-data are experienced then so are such-and-such other ones.

If there is a problem here, our initial question about the conditional has not been touched, and we are now further burdened with what is, I believe, an independently dubious epistemology which restricts the range of experience. However, if such an advocate feels no problem here, this can only be because he understands the conditional in the classical manner, and such a move is not therefore part of the general anti-realist position.[6] What is required is a framework in which we may break away from the realist picture of the settings of empirical knowledge which suggests the need for the truth-bridge. Only then can we get right the issue about the central semantic concept for anti-realism.

[6] Cf. my 'The real anti-realism and other bare truths', *Erkenntnis* 1985, for more on the connections between traditional verificationist theses and realism.

4. Reversing an image: a metaphysical diversion

One effect of the intuitionist's idea of replacing truth with proof in his semantics is to break away from the idea of numbers as determinate objects about which we make discoveries when engaged in arithmetical enquiry. Intuitionistically, coming to know that an arithmetical statement is true is not the same as the platonistic conception of gaining knowledge about some number. For the intuitionist, his concept of the object about which we know something is not of something the existence and character of which is fixed antecedent to our knowing how to handle certain proofs and decision procedures. In general we do not, on such an account, have any knowledge of numbers prior to our ability to use proofs in certain ways.[7] To be sure, in the arithmetical case we are not wholly in ignorance of the nature of arithmetical objects. We know that whatever numbers there are they conform to the Peano axioms. The world of numbers is not wholly unconstrained. This is not so in the empirical case. But this then suggests that we should retreat from asking questions about the objects of knowledge and experience prior to our ability to handle the methods we employ for ascertaining the assertibility of empirical utterances. That is to say, we should refrain from thinking of knowledge as a truth-bridging relation linking the knower to a realm of objects and facts. Rather, any concept of objects and facts must be consequent upon our grasp of the conditions in which we are justified in making an assertion. In making this shift we change the fundamental image in terms of which we think about the problems of epistemology.

For example, we no longer think of my knowledge that there are kangaroos in Australia as a truth-bridging relation relating me and the determinate recognition-transcendent existence of these creatures in some far away land. Rather, my knowledge must consist in my ability to handle assertions like 'There are kangaroos in Australia' in ways held appropriate by the rest of the linguistic and cognitive community. The concept of an object of which my knowledge is about cannot extend beyond that which is required given the correctness of the assertions concerned. This is not to deny that my grasp of the meaning of this assertion is a grasp of

[7] Herein lies part of the reason for Wittgenstein's remarks in *The Remarks on the Foundations of Mathematics* (Oxford, 3rd ed. 1978) about mathematics creating concepts.

the conditions under which it is true. It is only to deny that my grasp of these conditions is a grasp of conditions the character of which extends beyond my grasp of what would show the utterance correct or incorrect. For the realist, grasp of the truth conditions is meant as knowledge of conditions determinate beyond our investigation of them. The danger for the anti-realist is to emulate this conception and look around for some notion of empirical proof that will serve as a truth-bridge to such conditions. This is mistaken. For the anti-realist, the conception of the truth conditions cannot be a conception of states of affairs the existence and character of which is determinate beyond our investigation of them. We do not *start* with a conception of objects and properties antecedently understood as determinately there or not and then try to prove that they are there. Rather, the anti-realist conception of the objects of knowledge must reverse this, so that the conception of the objects of knowledge follows in a decomposition from our understanding of the connections between utterances like the above and, for example, 'Bruce has seen a kangaroo', 'Bruce lives in Australia' . . . etc.

For the realist, as for earlier forms of verificationist, there is a conception of objects such that knowledge is always a relation between the self and objects in a world determinate beyond our capacities to know of it. The debates between realists and earlier verificationists were fought over the question of which class of objects is suitable, because knowable, for grounding our knowledge of external reality. This ground would form the Ω base for a truth-bridge. But this whole conception of a world determinate beyond our capacities to know of it portrays the objects of knowledge in a way to infringe constraint C. The distinguishing feature of anti-realist epistemology and account of experience is not that it picks on this or that class of objects as the ground of our experience. Rather, it calls for a fundamental change in our concepts of object and knowledge. Objects are constrained to those items required, given the experienceable truth of assertions. Knowledge is being possessed of experienceable truths. And the only candidate now for the notion of experienceable truth must be that of an assertion's *survival*: the idea of an assertion that has stood the test of experience. This must be the case, for if we forgo the notion of a world determinate beyond our capacities to know of it as the object of our cognitive enquiries, we must, in general, view the sense of an assertion in terms of a claim to rule out what would *defeat* it. We can have no

conception of the pre-existent state of affairs about which the assertion makes some claim. We work the other way about, fixing on the idea of an assertion as *ruling out* certain possibilities. The assertion *survives* when experience does not provide those ruling out possibilities.

There is some irony to all this. Descartes planted epistemology at the heart of philosophy because, in part, he wished to show that empirical knowledge was possible in the way that he thought mathematical knowledge was. The last four centuries have seen a continuing assault upon this sceptical challenge. But now, what I am saying the anti-realist has to offer is that, taking our cue from intuitionist mathematics, we realise that *knowledge* is not like *that*. It is not, after all, a question of relating selves to objects of various classes such that we are left wondering why we cannot strike up the same sort of relation with empirical objects that Descartes thought we had with mathematical ones. This whole picture of the enterprise is mistaken. If we accept the arguments against the realist concept of truth and classical logic, we must give up the image in which we picture the epistemological enterprise and its ensuing conception of a world populated with objects the existence and nature of which is determinate beyond our capacities to know of them. These consequences for the concepts of knowledge and object are further instances of the effects of accepting constraint *C* upon knowledge ascriptions. In so far as that constraint, as it were, *tames* our concept of truth and valid inference, so too it tames our concept of the objects of the world and our idea of what it is to have knowledge of empirical objects.

The point is this. In attempting to find some general procedure for handling the logical constants we find that the suggestion that we employ some concept of empirical proof (e.g. criteria) embodies a deep-seated realist prejudice about the very nature of knowledge, a prejudice we should give up if the preceding arguments are correct. This is all part-and-parcel of the general constraints on the concept of objectivity which, as I claimed in Chapter 2, is the centre of the debate between realist and anti-realist. It is a constraining of our concepts of object and knowledge to fit in with the constraints already imposed on our concepts of truth and valid inference.

The central issue is what kind of logic is suitable as the system of evaluation in the definition of objectivity provided by the A-R thesis. This ran:

A-R thesis: An area of discourse is objective if and only if the propositions of the area of discourse are subject to standards of correctness and incorrectness of assertion encoded in a system of evaluation in such a way that through attendance to the system of evaluation the area of discourse is able to generate knowledge claims which satisfy constraint *C*.

The question is whether classical logic can fit here, or whether we must use a logic which employs only an experienceable use of the constants. If the argument so far is right, the latter choice is correct. The former is but an extravagance due to the closure it involves which dislocates the knowledge claims required for realism to be tenable. The argument for an experienceable use of the constants is an argument about how the concept of truth is to be constrained. But now, if this is right, the sorts of problems involved in knowledge of empirical reality which make it difficult to see how to frame a concept of empirical proof for our semantics are *not our problems*. They are suggested only by assuming that the states of affairs of which we seek knowledge are independent of us with just the sort of unintelligible extravagance that characterises the realist concept of truth.

For too long the central problem of epistemology has been to show how objective states of affairs are knowable, where 'objective' meant something captured by the realist thesis, thesis R:

Thesis R: The contents we grasp are contents that have a determinate truth value independent of our knowledge of that value.

But if the only non-metaphorical way of characterising this conception is through the question of the validity of classical logic, this whole project has been one ghastly conceptual confusion, for *such a concept of objectivity is untenable*.[8] The only concept of objectivity which squares with intelligible knowledge ascriptions is the A-R thesis with an experienceable logic. *That is our concept of objectivity*. From the vantage point of tradition in philosophy this is to constrain the

[8] For a lucid account of some of the problems attendant upon this notion, cf. B. Williams, *Descartes* (London 1978). This conception of objectivity and its concomitant concept of knowledge are the objects of attack in R. Rorty's enigmatic *Philosophy and the Mirror of Nature* (Oxford 1980). I do not share Rorty's project. He works too closely within the framework of the myths the exposure of which is constitutive of anti-realism.

concept of objectivity. But, if the argument is right, it is nothing of the sort. It is merely to put us back on course from the delusions of extravagant grandeur that have characterised so much philosophy. Anti-realism is not an *alternative* to realism; it is where we should all have been for some time now.

In so far as Thesis R is deeply embedded in our practices the proposal here may seem radical. It does seem to change things. However, the change is only one of metaphor. Traditionally objectivity and knowledge have seemed to be concepts to do with *static* relations between us and various states of affairs. But our grasp of these relations, essentially the truth-bridge relation, has always been metaphorical.[9] But it is an enchanting metaphor and one that has convinced not only philosophers but practitioners in many disciplines who have been led to a growing nihilism as their enquiries continued to fail to meet up to exacting and impossible standards.[10] Once we see that the standards are illusory, the nihilism is out of place. And the change I am advocating is but a concentration on those aspects of our cognitive enquiries for which we have a non-metaphorical grasp of what is involved in saying of some discipline that it is objective. For those who like to deal in metaphors such a constraint signals a shift from viewing the objectivity of a discipline in terms of the static relations it bears to reality to viewing objectivity dynamically. Objectivity is a matter of continuing submission to the logic of experience: the continuing critique of closure in systems of evaluation for areas of discourse which results in dislocated knowledge claims. As long as our experience exhibits such a dynamic it is objective. This is a process concept without the need for any end-state to which the process inclines, be such a conception a Hegelian or Peircean one. It is the dynamics of the continuing application of an experienceable use of argumentation that matters. I do not think that such metaphorical ways of describing the position should be necessary. But for those who are deeply wedded to the 'mirror' conception of knowledge and objectivity it may help. The real point is this. When once we limit ourselves to experienceable forms of argumentation we have done all we can do, because

[9] Hence the 'mirror' in Rorty, op. cit.
[10] I have in mind the influence felt from the work of writers such as Kuhn and Feyerabend. For some account of how these problems may be overcome in the case of the social sciences, see my 'Understanding anthropologists', *Inquiry* 1982, and 'Social science or dialogues of the deaf?', *Inquiry* 1985.

there is nothing more to do, and thereby we have said all that can be said about what makes for objectivity and knowledge.

5. The logical constants revisited

The general answer to our opening problem (section 1) is then this. We no longer need see ourselves as wondering what could constitute a proof that converts a proof of 'It is raining' into a proof of 'The ground is wet', for our problem is not the traditional one of how we can have proofs of empirical matters like that. We do not claim a conception of these states of affairs independently of our ability to assess the truth of statements like these. It is not that we claim an antecedent conception of such empirical facts which then leaves us wondering, 'How are we to prove that this is so?' Rather, our conception of these states of affairs, and of the objects in virtue of which we take them to be true, is a consequence of our grasp of the standards of correct and incorrect assertion appropriate for the utterance. But as we cannot, on the conception outlined, have any prior grasp of the facts and objects of experience prior to our grasp of the correctness and incorrectness of assertion for the utterance, these standards of correctness must be formulated in the following way.

We cannot take the making of an assertion as an attempt to state that some definite, antecedently conceived, determinate fact obtains. Rather, we must view assertion as a claim to *rule out the class of defeating evidence*. This was deemed a necessary condition on the making of an assertion in the Assertion Principle, Chapter 4, section 5. I am now claiming that it is sufficient. The class of defeating evidence may be open-ended. This is only a problem as long as we persist in viewing empirical assertions as attempts to state that reality determinately is one way or another, irrespective of our ability to determine which. Rather, making an assertion, like making a move in chess, is a sophisticated skill in which we make a move in the linguistic game and wait to see if our utterance survives. Understanding the meaning of an assertion then consists in our ability to support the utterance once launched upon an often hostile public. In the skilful interplay of these abilities which characterises our normal discourse we find an enormous shared grasp of the patterns of assessment without which communication would be impossible. This leads us to suppose that this shared

knowledge consists in knowledge of a reality conceived of as existing independently of that existence licensed by the assessments so far secured. And this then leads us to the idea of assertion as an attempt to say that such an independent fact obtains. For the anti-realist this conception must always be reversed. It is the conception of the facts and objects of knowledge and experience which is consequent upon our grasp of the ways of supporting our assertions once launched, not *vice versa*. Indeed our conception of the facts and objects of knowledge and experience just *is* given in our grasp of the ways of supporting our assertions.

In terms of our original problem we can put the matter thus. Knowing the meaning of the conditional assertion (1) does not consist in having an understanding of the facts this statement is about *and* possessing a proof that they are as the assertion claims. The assertion is rather a claim to rule out a certain set of experiences. In the case of conditional assertions, the set of experiences involved is still a special sort of set. I give a falsificationist account of the sense of the constants in Appendix 1, where the details of the conditional can be found. (The set of experiences ruled out for the conditional 'If *A* then *B*' turns out to be the experience that the defeaters for *B* are not a subset of the defeaters of *A*.) But these details need not detain us now. What is important is the general point about the need for anti-realism to embody a falsificationist account of sense. And although this is required because of the problems with generalising the concept of proof to empirical discourse, once accepted the details of the account of the constants can be left to an appendix. It is more important now that I amplify the proposal properly without the trappings of the current metaphysical diversions.

6. The answer to all our problems

So far I have been concerned exclusively with questions about the truth of logically complex sentences. But this has now led us to consider atomic sentences, because of the general claim about what it is to make an assertion.

An assertion is a claim to rule out a class of defeating evidence. This is a general claim. Although it derives from problems encountered in handling complex assertions it must also apply to atomic assertions. It is important to see how, in working out this idea, we

do not succumb to the temptation to indulge in a reductionist account of sense. Let us be clear about this.

We need to distinguish between two closely related ideas that I shall call *sense* and *role*. The former is the familiar Fregean notion of content individuated by the familiar Fregean criterion of difference of sense: S_1 and S_2 have different senses just in case it is possible to believe one and not believe the other. The concept of *role*, although connected with a notion which appears in what is called 'conceptual role semantics', is employed to capture what truth remains in the ideas of those who, employing a criterialist semantics, attempt to give a reductionist account of sense. My notion of *role* is not used to give an account of sense. The notion, and its connection with sense, goes like this.

First, I accept that the only proper way of providing the content of many concepts is to proceed homophonically with the sort of clause supplied in a standard homophonic recursive truth theory. This does not apply to all concepts but only to what we might call 'experiential concepts'. These are concepts concerned with properties that are intrinsic to experience for creatures of a particular kind. So, for example, colour properties are intrinsic properties of experience for humans; colour concepts are experiential concepts. That is, they are concepts such that it seems plausible to say that one cannot grasp that concept without the ability to enjoy the appropriate experience. This is in contrast to, say, the concept of justice. So, for example, we would have clauses like

(8) x satisfies '. . . is in pain' iff x is in pain

delivering theorems in the usual way like

(9) 'John is in pain' is true iff John is in pain.

To accept this is to turn against any attempt at a reductive analysis of what 'pain' means. It is to turn against the idea that a theory could be supplied that would provide non-homophonic versions of (8) and (9) where the concept mentioned on the left-hand side did not get used on the right-hand side.[11]

Although for some sentence S its sense is best specified by a

[11] I am only presently concerned with specifying the content, sense, of concept words, not singular terms. Singular terms are discussed in the next chapter.

theorem like (9), this is not all that a theory of meaning should address. For as well as knowing the sense of S we need to know its *role*, where this is its inferential position within the language. That is, one who understands S knows not only its sense but what inferential connections S bears to other sentences of the language, and it bears these connections *because* of its sense. In general, one who grasps the sense of some concept F thereby grasps that sentences employing that concept bear inferential relations to other sentences, for example '. . . is incompatible with . . .', '. . . entails . . .' and so on. So, in asserting a sentence employing concept F, one is committed to denying certain other claims, accepting further claims, being disposed to accept the probability of yet others, and so on. Outlining these connections is what I call outlining the *role* of the concept.

Now the notion of role is clearly an individuating notion, it serves to individuate sense, not identify it. But it is an individuating notion unlike others on offer recently.[12] For my notion of role is solely concerned with the inferential connections a sentence bears to others. This is unlike the notion of individuation of sense employed by Peacocke in his concept of manifestationism which requires not just that a concept be individuated within a corpus of other concepts, but that individuation occur by reference to behavioural criteria. That is why his notion sometimes seems to have the consequence, for contents the applicability of which is problematic, that there is *no* content, no sense. And although I would accept that if we can supply no role for S it is likely that no content has been specified for S, this is a weaker condition than Peacocke's. For his condition appears to rule out a content if there are no behavioural criteria but still a role defined by the sentence's inferential connections within a corpus of other claims.[13] It is the role of a concept that provides the grounds for asserting a sentence employing that concept. In general, for some concept F and utterance P employing F, the role of the concept will define a set of sentences g_P which bear the various inferential connections to P required by the role of F. Let us call the set g_P, the *constraining criteria* for P. This is simply the sentential version of the notion of role. This notion is

[12] For example, Chris Peacocke's notion of manifestationism offered in *Thoughts: an essay on content* (Oxford 1986) discussed in chapter 2 above.

[13] This is why I was more generous in discussion of the Lefty versus Righty case of Chapter 2, section 4, where I allowed a content for Lefty's 'I am Centre' distinct to the content that Righty makes with 'I am Centre' even though there are no differential grounds for asserting either.

close to the idea of criterialist semantics, but different in an important way. The point is that the constraining criteria for P do not give the *sense* of P, but they provide the means for grounding the assertibility of P. This is not because we hold, e.g.,

(10) 'P' is true iff g_p.

On the contrary, I hold

(11) 'P' is true iff P.

However, by constraint C, if it is to make sense to say that I *know* that P—that is, if it to make sense to say that 'P' is true—my knowledge that P must make a detectable difference to experience. And *that* is provided by g_p. Knowing the sense of P entails knowing its *role*, what would be said for or against the assertibility of P. The truth of P is only an experienceable truth, the claim to know that P only meets constraint C if the propositions in g_p enable us to connect the claim to know with experience via either of the behavioural or argument tests as outlined in Chapter 2.

Criterialist semantics takes the set g_p to provide a non-deductive support for P; this is the notion of a truth-bridge. It also, somewhat confusingly, takes the g_p set to give the meaning of P. I take neither of these options. The g_p set gives only the *role* not the *sense* of P.[14] But further, because of the general argument above about the nature of assertion as a claim to rule out defeating experiences, I shall now only be concerned with a subset of the set g_p, namely those members of the role, or constraining criteria for P, that would defeat it. Call this set, f_p. To work the other way about with a truth-bridging notion is to presuppose the determinate existence of the state of affairs that P that one is trying to prove obtains.

The general notion of *role* as just outlined could be employed in various ways. It supplies the idea of a set of sentences semantically connected with an utterance. Take the utterance that P, and the role set g_p. Now the criterialist must give an account of the logical relation that obtains between g_p and P if he is to make good the idea

14 With regard to the logical constants, their sense *is* their role, for the role of some utterance is defined by the inferential connections it bears to other utterances and that is precisely what the sense of the logical constants is. Put it another way, the logical constants have no sense, only role.

that the former give non-deductive though certain and defeasible evidence for *P*. I do not see how to set up an account of such semantic connections, especially if we are to do justice to a non-reductionist specification of *sense* for *P*. However, such problems do not affect the anti-realist. For I am limiting my concern to a subset of the general notion of the role g_p, the set of falsifiers f_p. These are the set of atomic sentences ruled out by an assertion that *P*. And to be able to make use of such a set I do not need to invent some novel logical relation connecting *P* with f_p. All I need to invoke is the general point about what it is to make an assertion first noted in the last chapter in the Assertion Principle. Making an assertion is to *rule out* certain experiences. The set f_p is just the set describing those experiences ruled out by an assertion that *P*. That is to say, although my concept of *role* captures a point about meaning which I think many others have tried to capture in ways that end up with reductionist specifications of sense, my use of this concept is much more limited. I use it in a way that is licensed by a fundamental point about what it is to make an assertion. I do not need to convince you that there exists some special notion of semantic entailment between g_p and *P*. All I need is acknowledgement that in asserting that *P* some things must have been ruled out. That they are ruled out is entailed by the very sense of the claim that *P*. The set of propositions describing those states of affairs ruled out is then the set f_p. Let us see how this works for atomic sentences.

Take an atomic assertion *G*:

G: George is bald.

Clearly the sense of *G* is that George is bald but what exactly are we committed to in taking *G* true, in asserting *G*? We are committed to ruling out its set of defeaters. This class will contain such sentences as 'George washes his hair every Friday', etc., but the class is presumably open-ended. But if this defeater class contains, say, $\{Q, R, S \, . \, . \,\}$ this is not to say that the class $\{\neg Q, \neg R, \neg S \ldots\}$ *justifies* it in the sense of confirmation used by the logical empiricists. To do this would be to assume that there is an antecedently determinate state of affairs which we are trying to prove, and this is what the present suggestion denies. So although in general for some sentence '*P*' knowing its sense requires that we know the constraints on this sense in terms of the set of its defeaters f_p, and knowing the

sense of '$\neg P$' is knowing its set of defeaters $f_{\neg p}$, we cannot know generally that these two sets are such that one or the other must always obtain.

But now, if we invert the usual order of things so that making an assertion is a claim to rule out certain states of affairs, what is to stop anyone, on such an approach, from asserting sentences willy-nilly? We do not want assertions to become like spontaneous vocalisations. But this is easily avoided.

We may remember an earlier example:

J: Jones was brave

said of a person long-since dead who never manifested any disposition towards brave or cowardly actions. Just as this chapter started off with a problem about the concept of empirical proof, so too it might now seem that we have a problem about the concept of undefeat. What would constitute a canonical undefeat? For if assertion is *simply* the act of claiming that a sentence is undefeated, why then is *J* not assertible, contrary to previous argument?

It is at this point that I have to pull together several loose strands in the whole argument. Suppose someone claims to know that *J*. Their knowledge must be manifestable; it must, by the argument of Chapter 1, satisfy constraint *C*. Now, to recap the argument of Chapter 1, the process of manifesting our knowledge claims is one of relating our knowledge to experience. For the moment it does not matter that we have no account of atomic experiences; a positivistic one will do for now. The manifestation shows how the purported knowledge can be defended through shared experience. But then constraint *C* already offers enough to show that *J* is not assertible simply because undefeated. For suppose Harry says that Jones was brave. He claims to know that *J*, but how is he to manifest this knowledge? To what elements of experience çan he appeal? What difference does this supposed item of knowledge make to his or anyone else's experience? Clearly Harry's claim places no constraints on experience, given the set-up of the example and this is why *J* is not assertible. The problem is this. If Harry claims that *J* is assertible simply because undefeated we might as well claim also that not-*J* is assertible because undefeated. The point here is the same as that made in Chapter 2 about the person who claimed to know whose dagger pierced Caesar's left ventricle. We do not

need a notion of canonical undefeat to stop *J* being assertible; all we need is the observation that if it were assertible simply because undefeated this would also allow that not-*J* is assertible. The anti-realist may not have much faith in bivalence, but his respect for exclusion is uncontested.

What we need then is that a sentence is assertible just in case its sense succeeds in providing a *role* that rules out certain experiences in such a manner that the consequent undefeat of this sentence does not also allow for the undefeat of the negation of the sentence. But as we are adopting a falsificationist stance in all this, it would be happier if I now dropped the word 'assertible' and replaced it with the notion of an utterance's *survival*. The idea is of those utterances that place a test, a constraint, on experience such that knowledge of what they claim satisfies constraint *C*, and the utterance survive the test. The concept of *survival* is then the analogue required for the central semantic notion of proof when generalising from intuitionist mathematics to empirical discourse. We have

S survives — df The sense of *S* rules out a class of experiences such that the consequent undefeat of *S* is not compatible with the undefeat of not-*S*.

We can now see how it is that certain problems that I have been storing up during this book begin to be resolved. From the last chapter we seemed to require a notion of canonical proof for empirical statements; from earlier in this chapter it seemed we might need a notion of canonical undefeat; and I also had an obligation to say something on the alleged difference between Wright and myself on our accounts of anti-realism. These issues now resolve themselves in the one single conception of an assertion as a claim to rule out certain experiences; ruling out the defeaters provided by the role of the utterance, in turn entailed by its sense. It is by this reversal of the usual perspectives of epistemology that we are released from the issue of whether 'provably not-provable' equals false, and hence *J* is false. When once we accept that without a prior conception of a determinate reality onto which we could latch some notion of empirical proof (this is where I part company with Wright), the anti-realist must make a more radical break with the usual epistemological issues; then we see how it is that a sentence such as *J* and its negation can both fail to *survive*. With the anti-

realist claim not to have a conception of reality determinate beyond our means for knowing of its determinacy, there is no way in which a positive notion of proof could be constructed. We turn then to characterising our central semantic notion in terms of defeaters. To be sure, I still have a large cheque drawn on the matter of providing an account of effective decidability for empirical discourse. For the moment I am content to accept that the position so far developed only provides us with, say, a world of macro-sized observables. There may be some doubt as to even this.

7. A doubt forestalled

A possible doubt here is this. It might be plausible to suggest that, for a large class of objects, our concept of an object is dependent on that of the survivability of our utterances and not *vice versa*, but it cannot hold for all objects, for we need some notion of object with which to start the whole process of measuring survivability. This doubt is illusory. In suggesting that we do not have a notion of determinate objects prior to the survivability of empirical utterances I do not need to make the further claim that our grasp of the latter is prior to that of the former. It is just that our grasp of what it is for a name to have a referent consists in a grasp of the conditions under which utterances employing the name survive. When once we have grasped that, there is nothing more to be said.

I pursue this point about objects in the next chapter and quell the doubt just voiced. The present point is this. Our conception of empirical objects is something we come to as we come to grasp the conditions under which various utterances survive. We do not *start* with the notion of a world populated with objects and properties and then set out to construct true utterances about such things. Rather, we start with utterances that survive and then grasp the consequences for ontology of taking such-and-such utterances as survived. The 'start' here is a logical 'start'. Whether or not it might be a temporal one is a confused question. The fact that the present enterprise is a *constructivist* one is not due to the fact that, in some sense, *we construct* reality. There is no metaphysical construction involved. That it is a constructivist project is due only to the following point. *Our conception of reality is limited to a conception of reality that is experienceable,* or, as the mathematical intuitionist would say, *constructible.* As noted earlier, the mathematical notion of a construc-

tion just is what I mean by something that is experienceable. In the mathematical case the concept carries a more literal sense due to the idea of mathematical experience as the construction of objects within a formal system of proof.

However, the root of the idea of constructivism is that of constraining reality to experienceable reality, not because this is the only reality we can construct in the sense of *build*, but because it is the *only notion of reality which permits an intelligible use of the concepts of truth and knowledge*, a use which satisfies constraint *C*. To look for a further, more literal, sense of our construction of reality is to confuse the manner in which anti-realism liberates us from traditional metaphysical wrangles about which pieces of reality are constructed out of others.[15]

Anti-realism offers a restriction on our concept of objectivity which turns out to be nothing other than a weeding out of an extravagance which is metaphysical in the pejorative sense of that adjective. The conception of the objects of experience which anti-realism has to offer is based upon a falsificationist sense for the logical constants. An account of the sense of the constants is offered in Appendix 1, in which the concept of experienceable truth is captured in terms of an utterances *survival*. The logic of experience is proof-theoretically intuitionistic. This may seem surprising given the falsificationism, but should not be so given the account of negation in the last chapter. Because of this central falsificationism, the objects of knowledge and experience are such that they cannot be characterised prior to our grasp of the defeating conditions for an utterance, experience or knowledge claim. Only dealers in metaphors should be disturbed by this.

[15] For more on this theme, cf. my 'The real anti-realism and other bare truths', op. cit.

Objects

In this chapter I rebut a potential problem concerning the concept of an object. My rebuttal draws upon a general argument for the Fregean notion of sense. I believe the general argument correct, irrespective of its bearing upon the development of the main concerns of the present essay.[1]

1. A problem

I have argued that our conception of an empirical object is something we come to as we begin to grasp the conditions under which utterances survive. But given this falsificationist account of the central semantic concept for our semantics of empirical discourse, how are we to understand the usual account of, for example, the quantifiers? An existentially quantified sentence $\exists x \; F(x)$ is normally understood in such a way that it is true just in case, for some object n, F is true of n. And yet it is precisely this concept of an object n that stands apart from the possibility of a predicate's being true of it that would appear to be threatened by the proclamation that a generalised anti-realism forswears any concept of an object prior to a grasp of the survivability of utterances. It is our right to some concept of an object, a thing *named*, that is in question here. This is the problem I touched on in the last chapter.

Now of course, although I am committed to the claim that we have no conception of empirical objects prior to our grasp of the survival of utterances, I do not need to make the further claim that our grasp of the latter is prior to our conception of the former. The thought is simply this: Our grasp of what it is for a name to have reference consists in a grasp of the conditions under which sentences

[1] At this point I touch upon matters properly requiring separate treatment. The following argument is pursued in much more detail in a project currently to hand and provisionally entitled *Thinking of Objects*, which develops a full and general account of the Fregean theory of reference.

employing that name survive. When once we have grasped that, there is nothing more to be grasped. To think that something extra may be in order here is to succumb to the illusion that 'the sense of a name . . . can in principle be given by a confrontation with the object to which the name is attached'.[2] Now, as Dummett notes, such an illusion is undoubtedly part of Frege's target in expounding his context principle, but dispelling it is also central to a correct account of the argument for Frege's celebrated sense/reference distinction. We can put the issue sharply, if perhaps abstractly, by asking the following question: Which notion has priority in our semantics, the semantic value of a sentence or the semantic value of a sub-sentential unit?[3] I shall call any theory which takes the semantic value of sentences as prior a *molecular* theory, and any theory which takes the semantic values of sub-sentential units as prior an *atomic* theory. I shall argue that the argument for the sense/reference distinction requires that we adopt a molecular theory. This then gives us just the concept of an object that is required by the general anti-realism currently being developed.

2. The need for the concept of sense

Let me clarify the difference between atomic and molecular theories of meaning and show how a particular sort of atomic theory reveals the fundamental need for the concept of sense. My concern is only with the sense of singular terms, not of predicate expressions. Now if our question is whether or not the semantic value of a singular term should be given priority over the semantic value of sentences, it may seem that the obvious answer is that it should. For this answer encapsulates a familiar sort of theorising about meaning: a sort of theorising found in Russell.

For Russell the meaning of a linguistic unit was the object for which it stood, and we understood the term when we were acquainted with the appropriate object. There are two components in Russell's theory. First, there is the claim that the meaning of a term is the object for which it stands. I label this the object theory

[2] M. Dummett, *Frege: Philosophy of Language*, p. 498.

[3] I follow Dummett in taking 'semantic value' as a neutral term for what Frege would have called the *bedeutung* of an expression. The semantic value of an expression is then that which it contributes to the determination of truth value of sentences in which it occurs. For singular terms, this is their *bedeutungen*; for sentences, it is their truth value.

of meaning. Secondly, there is the claim that in order to understand a term we must be acquainted with the object for which it stands. Call this the principle of acquaintance.[4] It was because of the first thesis, the object theory of meaning, that Russell had to argue that definite descriptions were not *bona fide* singular terms. For, if they were genuine singular terms, given that they are meaningful there would have to exist the objects for which they stood. Hence, prior to his discovery of the theory of descriptions, he accepted the bloated ontology of round squares, golden mountains and the rest. It was because of the principle of acquaintance that, given Russell's extreme Cartesian epistemology, it turned out that the only genuine singular terms were the demonstratives.

In a theory such as Russell's the semantic value of a sentence is arrived at by composition from the semantic values of the sub-sentential units. But the theory is radically flawed in a way that infects both the components distinguished above. The flaw is this. When Russell speaks of the meaning of an expression he does not mean what Frege calls 'sense': rather what Frege called the *bedeutung*, or reference. But then, without the apparatus to draw the sense/reference distinction, Russell cannot give an account of the contents of thoughts which meets what Evans calls the intuitive criterion of difference for thoughts, namely:[5]

T_1 and T_2 are distinct thoughts just in case it is rationally possible to assent to one and withhold assent to the other.

Now of course this might seem to be begging the question in favour of Frege's sense/reference distinction, for it is this criterion of difference for thoughts which Frege repeatedly appeals to in elucidating the concept of sense. But the point is this. On Russell's account of thoughts the identity conditions for thoughts appear to agree with

[4] For these two aspects of Russell's views see *The Principles of Mathematics* (London 1903), p. 47: 'Words all have meaning, in the simple sense that they are symbols, which stand for something other than themselves'; and *Problems of Philosophy* (London 1912), p. 32: 'Every proposition which we can understand must be composed wholly out of constituents with which we are acquainted.' See M. Sainsbury, *Russell* (London 1979), esp. chs 3 and 4 for a good account of Russell's views.

[5] See G. Evans, *The Varieties of Reference* (Oxford 1982), p. 18. The clearest exposition by Frege of the requirement of the sense/reference distinction occurs in a passage Evans quotes at length, cf. pp. 14–5, from a letter Frege wrote to Philip Jourdain, to be found in Frege's *Philosophical and Mathematical Correspondence*, ed. B. McGuinness & trans H. Kaal (Oxford 1980), p. 80.

the identity conditions for facts.[6] If that is so, the position is hope-less, for the fundamental reason for drawing the sense/reference distinction is to capture the fact that the identity conditions for thoughts are more finely individuated than the identity conditions for facts.

This is not a familiar way of putting the point behind Frege's theory, so let me amplify the idea.[7]

Consider a universe with three objects *a*, *b*, *c*, and three properties *F*, *G*, and *H*. There are then nine possible atomic facts in this universe. Suppose all these facts obtain. There are nine atomic facts. From this we have no idea of the number of different atomic thoughts someone contemplating this universe may entertain. For suppose an observer travelling through this universe visits each object in turn collecting facts as he goes. He visits *a* and discovers that *a* is *F*. Not being a particularly systematic enquirer, he then rushes on to the next object, *b*, to see if that is *f*. He records the fact that it is. It is only when he later comes across *a* *again* that he notices that it is *G*. But now he may not recognise *a* as the object

[6] See the particularly telling passage in 'Knowledge by acquaintance and knowl-edge by description' in *Mysticism and Knowledge* (London 1918, reissued by Penguin, London 1953). On p. 205 Russell discusses making a judgement about Bismark. He says: 'we should like, if we could, to make the judgement which Bismark alone can make, namely, the judgement of which he himself is a constituent.' It is Russell's Cartesian epistemology which operates here to stop us making that judgement, for we cannot, he thinks, be *acquainted* with Bismark. Accordingly 'Bismark' is not a genuine singular term, only a truncated description. Nevertheless, he continues, 'we know that there is an object B called Bismark, and that B was an astute diplomatist. We can thus *describe* the proposition we should like to affirm, namely, 'B was an astute diplomatist', where B is the object which was Bismark', op. cit. Note that here the object concerned is a constituent of the proposition which we aim for in making our judgement, stopped only by our lack of acquaintance with Bismark. But then that means that the proposition we would like to judge is one the identity conditions of which equal the identity conditions of the *fact that* Bismark was an astute diplomatist. Only with genuine proper names though do we get propositions which are like this; in all other cases the best we can do is describe the proposition we would like to judge.

[7] Too often the reason for the distinction is put as a result of a puzzle about identity statements. For sure, this is how Frege *introduces* the distinction, but it is not the main argument. See M. Dummett, 'Frege's distinction between sense and reference' in *Truth and Other Enigmas* for the idea that there is more than one argument for the distinction, and the puzzle about identity statements is not the main one. Dummett's account of the main argument is closely connected with mine. See N. Salmon, *Frege's Puzzle* (New York 1987) for an account which sees the identity puzzle as central. This leads Salmon to miss the main point about the distinction and, indeed, to go on and offer an account of information content that fails to meet the argument I suggest. Salmon offers a version of the object theory of meaning.

previously visited, and it is because of this possibility that the identity conditions for his *thoughts* that *a* is *F*, that *a* is *G* etc., must be more finely discriminated than the identity conditions for the facts that *a* is *F*, that *a* is *G* etc. For if he gets lost in his travels around this little universe, on returning to *a* a third time he might record its being *G* as a judgement which he takes to be distinct to the one recorded when he first discovered that this object was *G*. All this reveals is the need to take account not only of the object, the semantic value of a term, but also of *the way in which the object is presented in thought*: the 'mode of presentation' as Frege called it, or what Evans calls the 'way of thinking of an object'.[8]

This point, which lies at the foundation of the sense/reference distinction, may be summarised like this:

(1) For any given universe or domain, the number of possible thought contents is greater than the number of facts.

Any theory of meaning which is to capture the contents of our thoughts must be sensitive to (1). If it is to capture the *intentionality* of our relations to objects when we think of them, it must offer a way of individuating thoughts which is more discriminative than the way of individuating facts. Whatever we may want to call the extra to which the individuation of thoughts must be sensitive, it is what Frege called 'sense' or 'mode of presentation'. Of course, to lay such a constraint on a theory of meaning that it must offer an individuation of thought contents which is sensitive to (1) may seem to rule out the possibility of a naturalistic, or physicalistic, account of thought. I do not think that this result follows quite so quickly, but I do not much care. It seems to me that (1) is a datum for any adequate theory of thoughts and is not to be avoided because of a prior metaphysical commitment to some particular ontology.[9]

[8] For Frege's introduction of this phrase, cf. 'On sense and reference' in *The Philosophical Writings of Gottlob Frege*, ed. P. Geach & M. Black (Oxford 1953).

[9] The idea that any adequate theory of thought and representation must provide a physicalistic account of the representational properties of representational states is very common and may be found in, among others: J. Fodor, 'Semantics Wisconsin style', *Synthese* 1984, p. 232; H. Field, 'Mental Representation', *Erkenntnis*, 1977 reprinted in *Readings in the Philosophy of Psychology*, ed. N. Block (Oxford 1985), p. 78; S. Schiffer, 'Intention-based semantics', *Notre Dame Journal of Formal Logic* 1982, p. 119.

Indeed something stronger than (1) is, I believe, true, namely:

(2) Given a procedure *m* for individuating the number of facts in a domain *d*, there is no further procedure *m**, which will supplement *m* to provide a procedure for individuating the number of possible thought contents about *d*.

This claim is implicit in my example of the universe with three objects above. There is no limit to the number of times our subject may revisit object *a* and not realise that it is the same object on each occasion. Therefore there is no limit to the number of possible thoughts he may have about *a*, even though there are only three properties to predicate of this object. For if, on his nth return to *a*, he fails to notice that the object is *F*, it is still coherent for him to believe that the object he visited on his n-1th return is *F*, so long as he does not realise that it is one and the same object. Even (2) does not rule out the possibility of a naturalistic account of the representational properties of thought. I shall note how it manages to be so generous below after I have developed the account of sense I think follows from taking these constraints seriously.

I shall say that a theory of content that is sensitive to (1) and (2) captures the intentionality of our relations to objects in thought. Any theory of thought contents that individuates contents with respect to the *bedeutungen* of expressions will fall foul of these considerations in favour of a Fregean sense/reference distinction. It will fail to capture the intentionality of our thought about objects. Our trawl catches a lot of theories. All theories which offer what Evans calls a 'Photograph Model of Mental Representation' will be affected.[10] But this basic reason for the sense/reference distinction not only threatens all instances of the object theory of meaning; it also threatens any theory which follows Russell on the second component of his position, the principle of acquaintance.

Recent work on reference, as well as seeming too hospitable to the object theory of meaning, has taken Russell's theory of acquaintance to heart. For Russell, genuine singular terms were such that one could be acquainted with their objects. But now, if we drop Russell's restrictive Cartesian epistemology and allow acquaintance

[10] Evans, op. cit., p. 78.

with a far wider range of objects we can apply a Russellian notion of genuine reference to a wider category of singular terms, even allowing definite descriptions to fall within this category.[11] But just as an object theory of meaning seems doomed to fail to capture the intentionality of our relations to objects in thought, so much talk of acquaintance appears similarly amiss.

If our acquaintance with objects is to be the acquaintance of *thinkers*, those that entertain representations of objects, then this acquaintance relation must be characterised in a way richer than a simple causal connection with the object. For to return to our traveller in the three-object universe, the fact that he is causally connected with *a* because it is visually present to him is not sufficient to pick out an acquaintance with *a* that is the relation of a thinker. For the object *a* can causally stimulate our subject on any number of occasions without that causal relation producing identical thoughts on each case. Sometimes he approaches *a* from the rear, sometimes from the side, etc. And if, on these different approaches to the object, he fails to realise that it is the same object as previously approached from a different angle, the fact of his standing in this causal relation fails to determine his *thinking of a*. And even if he approaches *a* from exactly the same angle as on a previous occasion, this is no guarantee that his thought will be the same. Although the object looks the same, he may have lost track of his position in the environment and so think that it is a different object. As before, the causal notion of acquaintance fails to capture the intentionality of our thought.[12]

Now although Russell's kind of atomic theory is flawed for failing to capture those features of our thought about objects, (1) and (2), which reveal the deep need for the Fregean notion of sense, it does

[11] This, of course, was what Donnellan did in his seminal, 'Reference and definite descriptions', *Philosophical Review* 1966.

[12] In the context of present concerns I cannot pursue this issue about acquaintance further. I hope to do so at greater length in the work currently at hand, *Thinking of Objects*. For examples of a Russellian notion of acquaintance in recent work on reference see, e.g.: Evans, op. cit., p. 65, where he speaks of the idea of being *en rapport* with an object. This idea is also found in Kaplan's 'Quantifying in', *Synthese* 1968. Under the title 'direct cognitive contact' the idea is found in J. Kim, 'Perception and reference without causality', *Journal of Philosophy* 1977. The idea is also part-and-parcel of the idea that, in one sense of the phrase, *de re* thoughts are thoughts where the object concerned is *part* of the content of the thought; cf. Woodfield's introduction to *Thought and Object*, ed. A. Woodfield (Oxford 1982) and the papers therein.

not follow that all atomic theories will be so flawed. An atomic theory which utilised the sense/reference distinction would be satisfactory. So now, having drawn out the reason why we need the concept of sense, I shall go on to show how the only plausible way of characterising that concept commits us to a molecular theory of meaning: that is, a theory in which the semantic value of sentences is taken as primitive with the semantic value of sub-sentential units as derivative.

3. A constraint on the account of sense

The concept of sense is explicitly designed to capture the intentionality of our relations to objects in thinking about them. It is designed to capture the idea that there is more to specifying the identity conditions for thoughts than specifying the identity conditions for the states of affairs thought about. What this extra is, is what Frege called the 'mode of presentation' of the object. Another way of putting this is to say that when we think of an object, when we have a mode of presentation of it, we have some *representation* of it. This is what distinguishes thinkings from reactings. Someone who suffers from hayfever does not thereby *think* about the pollen in the atmosphere, although he causally *reacts* to the pollen. He is acquainted with the pollen in the sense that he stands in some causal relation to it, but that does not make him a thinker about the pollen. For that to be the case he must be possessed of some representation of the pollen. Appealing to the concept of representation here allows us to draw out a basic constraint on any adequate theory of sense.

Take the sense of a singular term to be a representation. Now I take it as constitutive of something being a representation that it be something that can *mis*represent: it can get things wrong. For of a representation we can always ask, 'Is it true or false?', 'Is it a likeness or not?'. Representations are things that are open for semantic evaluation, as true or false; therefore there cannot be a representation which is such that it cannot be false.[13] This gives us the following constraint on a theory of sense:

[13] This, of course, does not hold for analytic representations, those thoughts which are analytically true, e.g. mathematics. For example, the representation, 'the square root of four' cannot but fail to represent the number two. Space does not permit me to discuss the special case of analytic representations here.

(3) Any adequate theory of sense must show how the sense of a singular term admits of the possibility of misrepresentation.

This is a difficult constraint to meet, but I am not the first to think that the question of how to handle misrepresentation is an important one, if not *the* important one.[14]

Clearly the constraint would not be so difficult if we adopted the following view: Take the possession of a representation to consist in possession of an *Idea* in the Cartesian sense of that word. That is, an Idea is an intentional object the character of which is discovered by mental inspection. On this Cartesian theory of representation, the possibility of misrepresentation is accommodated by postulating a range of entities, Ideas, which stand as intermediaries between the mind and objects. Misrepresentation occurs when the mind entertains an Idea which stands for nothing. On such a theory, misrepresentation is possible because the theory is a *representative* theory of representation. Like any broadly representative theory, the postulation of such an extra layer of entities is otiose and to be avoided at all costs. I shall take it then as a further constraint on any credible theory of sense that it give us a notion of representation that not only meets (3), but give us a concept of representation that does not require *bearers of representation* like the extra representative entities postulated on the Cartesian theory.

Having ruled out the Cartesian theory of representation as a candidate theory that satisfies the constraint at (3), it is not so easy to see how to proceed. What I shall now do is present a way of accommodating the idea of misrepresentation. I believe it is the only credible way of doing justice to the intentionality of our thought when we think about objects. Having presented the proposal, I shall turn to provide an argument to show that it is necessary.

4. Proposal for a molecular theory of sense

One proposal for partially accommodating the constraint at (3) would be this. Postulate atoms of representation with which misrepresentation cannot occur and then treat misrepresentation as the

[14] Cf. Fodor, op. cit., which is devoted to discussing what a causal theory of representation can say to this matter. I find Fodor's answer to this, that a causal theory cannot allow misrepresentation *and* that is okay, untenable, but I cannot pursue discussion of Fodor here.

result of error in combinatory processes upon the atoms. This is only a partial accommodation of (3), because it accepts that misrepresentation cannot occur with the atoms. This is, in effect, to accept existence-dependent senses for the atoms and is a position now common with certain writers. It is not my purpose now to engage in a general enquiry into the theory of sense. However, because the idea of existence-dependent senses does not allow for misrepresentation, I do not think it is workable. After all, given (3) and given the idea that it is possession of representations that reveals the intentionality of our thought about objects, we ought not to accept existence-dependent thoughts. For suppose the thought '*Fa*' is a thought where the sense of '*a*' is existence-dependent. In such a case the representation provided by the sense of the singular term as part of the overall thought is not a representation that can misrepresent. The thought might misrepresent at the sentential level; the overall thought is wrong: *a* is not *F*. But the representational component provided by the sense of '*a*' cannot misrepresent. But if it cannot do that its credibility as a representation is questionable. And if that is questionable, it is questionable that we have here an account of the relation between subject and object that is an account that provides for the sort of intentional relation characteristic of thinkers. Nevertheless, let us carry through this partial proposal before developing the proposal that works.[15]

The idea is that misrepresentation is possible through combinatory errors upon atoms. Now what kind of combinatory methods would be applicable here? One thing that seems central to this ability of misrepresentation is the idea that the ability of a thinker to think that, e.g., *a* is *F* is *structured*. It is an ability that conforms to what Evans calls the Generality Constraint.[16] This is the idea

[15] The idea of existence-dependent sense first arose in McDowell's 'On the sense and reference of a proper name', *Mind* 1977, where he proposed an 'austere' conception of sense on which knowing the sense of '*a*' is knowing that '*a*' stands for *a*, and of course one cannot know that if *a* does not exist. The idea receives much further elaboration in Evans, op. cit. The notion of singular thoughts they get·from this is mistaken and runs together two separate concerns. These are: (a) admitting that there are object-directed thoughts which cannot be captured with the apparatus of Russell's theory of descriptions, and (b) claiming that there are thoughts which are such that they cannot be had if the object does not exist. (a) follows from dropping the descriptive theory of sense in favour of a theory that allows non-descriptive sense. But from that it does not follow that non-descriptive sense has to be existence-dependent. If the general argument about representations is correct, not only need we not accept existence-dependence, but we should not.

[16] Evans, op. cit., pp. 100–5.

that the ability to think that *a* is *F* is an ability at the intersection
of two sets of abilities; the ability to think other things about *a*, and
the ability to think of other things that they are *F*. That is, a
subject's representational state that *Fa* cannot be a single unstruc-
tured state. One cannot credit a subject with the thought that *Fa*
if the subject does not have the ability to think those other thoughts
required by the Generality Constraint. So, even if a subject has a
single state which represents *a*'s being *F*, that state must be struc-
tured. Appeal to the Generality Constraint here reveals that the
structure must be that of predication.

The argument to support this requirement of structure is another
instance of the argument about what is constitutive of a represen-
tation. It is this. A thought has to have structure because it is
something to be assessed for truth and falsity. A subject who uttered
'*Fa*' on being confronted with *Fa* and yet who lacked the ability to
see that there was something in common between *a* and *b* (on the
assumption that *b* is *F*) could not credited with the *thought* that *Fa*
but only with a peculiar kind of *reaction* to the state of affairs of *a*
being *F*. It is the compositionality of a thought which gives it its
semantic assessability. For without this compositionality we have
no reason for thinking that when this subject says that *Fa* he is
saying of *a* that it is the way *b* is. But without *that*, we have no
reason to think that he has said anything at all. Recall the Assertion
Principle from Chapter 4. If a subject has asserted that *Fa*, he must
have ruled out some experiences. But precisely which experiences
he has ruled out will depend upon the inferential connections he
admits to obtain between his utterance and others. However, the
only grasp we have of the way some utterance is connected inferenti-
ally with others is via the idea of the *structure* of an utterance.
Our grasp of inferential connections proceeds via our discerning
structure.

There might be subjects who have reactive attitudes to *Fa*, but
they are only *thinkers* of '*Fa*' if the state which we suppose to be
their belief state is compositionally related to distinct abilities with
regard to *F*-ness and a grasp of '*a*'. The point here is not an
epistemological one. I am not making a point about radical trans-
lation to the effect that one could have no *evidence* for thinking that
a subject was thinking that *Fa* if one could not see this thought as
structurally related to such distinct abilities. My point is a meta-
physical one. It is constitutive of thinking that *Fa* that the appro-

priate state of the subject be so structurally related. For to think that *Fa* is to grasp the utterance's *role*, those states of affairs that would be ruled out by an utterance of *Fa*. But that is to grasp the inferential connections in which this thought stands with regard to other thoughts. And the only way of characterising those inferential connections requires structure to the thought.

So now we have a partial proposal for accommodating the constraint at (3). It will not do. Evans' account of sense is of a kind with this partial proposal, one that accepts existence-dependence at the atomic level and accommodates misrepresentation at the molecular level, false beliefs, via errors in combining the atoms. Now even if the idea of atomic representations that could not misrepresent were acceptable, and I have suggested that it is not, this partial proposal is still unsatisfactory, for it requires a bifurcated account of sense. Representation at the molecular level meets constraint (3), but at the atomic level it does not. Evans only gets round this unevenness in his account by invoking an unarticulated notion of 'the way of thinking of an object'. This is his expression for the idea of a *mode of presentation*. The problem now is this. If I am right in taking the intentionality of our relation to objects in thought to be manifested in our possession of representations, and if I am right in taking the concept of representation to require constraint (3), it will not do to support our use of the Fregean notion of sense by simply invoking the idea of the 'way of thinking of an object'. For if *that* does not meet (3), it does not capture properly just what it is to stand in the peculiarly intentional relation in which we stand to an object when we represent it in thought, when we think about it. We require some account that not only meets (3) but gives us some leverage on the central idea of a 'mode of presentation' or the 'way of thinking of an object'. My proposal for a molecular account of sense does just this. It builds upon the partial proposal just discussed.

The proposal I wish to make is really very simple but, for all that, it has the advantage of providing a unified account of sense that accommodates thoughts employing both descriptive and non-descriptive senses. The proposal goes like this. We have seen that misrepresentation can be handled at the molecular level if we allow for thoughts that are *structured* and where the structure is that of predication which conforms to the Generality Constraint. What I now want to suggest is that we handle misrepresentation at the

atomic level by making use of this feature of the molecularity of
thoughts that allows for misrepresentation. We do this by invoking
a limited holism in our account of sense for the atoms. What this
does is to take the grasp of molecular representations as primitive
and define atomic representations in terms of them.

The story goes like this. Grasping the sense of some name '*a*'
consists in possessing molecular representations such as '*Fa*', '*Ga*',
etc. I shall not specify how many such molecular representations
have to be involved in grasping the sense of '*a*'. For the moment
the thought may be put that grasping the sense of '*a*' consists in
grasping some proprietary bundle of such molecular representations
the identity conditions for which have yet to be given.[17] I call the
idea behind this proposal the Complexity thesis, so named because
grasp of the sense of a singular term is not a matter of a simple
acquaintance with an object that can occur without grasping what
would be the semantic values of molecular units, sentences. The
complexity thesis makes a much stronger demand than the Gener-
ality constraint. That only demands that in grasping the sense of
'*Fa*' we grasp the possibility of '*Ga*', '*Ha*'. . . and '*Fb*', '*Fc*' . . . and
so on. The thought I am pressing is that in grasping the sense of
the singular term '*a*' we possess representations such as '*Fa*', '*Ga*'
etc.

It may look as if the Complexity thesis has matters the wrong
way round. How can grasp of the sense of an atom be explained in
terms of grasp of the sense of molecules in which it appears? Surely
that is viciously circular? Clearly it would be circular if the idea
was that grasp of the sense of a molecule was temporally prior to
grasp of the sense of an atom, but that is not the claim. The claim
is only that the former is conceptually prior to the latter. To say
what it is to grasp the sense of an atom requires that one appeal to
what it is to grasp the sense of a molecule. That is all. It is because
we can be so easily tempted into a building block image of the
construction of molecular senses—thoughts—that the idea can arise
that the account of atomic senses must precede that of molecular
senses. But that image has no good motivation, and I am not

[17] I do not pursue this issue of how to give the identity conditions for a thought
in this book. It is not an easy matter, when once one gives up a descriptive theory
of sense on which the identity conditions for a thought can be given in terms of the
universalist sentence, in Russellian notation, that provides the canonical translation
of the thought.

committed in avoiding it to saying that the sense of an atom is *decomposed* from the sense of the molecules in that the latter precedes grasp of the former. I am not denying or pursuing either of these relations of precedence. I am only suggesting that in our understanding of grasp of sense, grasp of the sense of molecular units plays the primitive role.[18]

The Complexity thesis offers an account of what a mode of presentation is. The account is this: The way in which I am presented with an object in thought is as the semantic value required for the semantic value of a number of sentences. More perspicuously, the way in which I am presented with an object in thought is as the intersection of a number of truths. We explain reference as the intersection of truths, not truth as the combination of references. That is the point of the Complexity thesis. Before I produce an argument to show that the Complexity thesis is necessary for our conception of an object, let me note two further points about the thesis.

First, the Complexity thesis gives no *explanatory* handle on how we are related to objects in thought. The account takes the notion of possessing a representation as primitive. The point is only to press the idea that by taking the idea of an atomic representation as defined in terms of molecular representations we get a concept of representation that meets the constraint at (3). But it is because the proposal takes the idea of possessing a representation as primitive that it begs no question about the possibility of a naturalistic account of representation. For it could be feasible for someone to produce a general theory that explained intentionality in nonintentional terms and have that theory apply to those intentional items, thoughts, which I am suggesting should be allocated the role of primitives in the present conceptual investigation. I do not know if this would be possible. All that is ruled out by my proposal is an attempt to reduce intentionality *via* reference. What is not ruled out is the possibility of a more general reduction of intentional phenomena.

Secondly, it is common to speak of 'singular thoughts' or 'Russellian thoughts' where these are taken to be thoughts in which the

[18] For a critique of the building block imagery with which I have much sympathy and which is also closely connected with some of the claims I make here, see D. Davidson, 'Reality without reference', *Dialectica* 1977 and reprinted in his *Inquiries into Truth and Interpretation* (Oxford 1984).

object concerned enters into the identity conditions for the thought; hence we get existence-dependent thoughts. However, I think we do well to distinguish two sense of 'singular thoughts'. The first is:

(4) T is a singular thought iff T is not expressible with the apparatus of Russell's theory of descriptions.

The second sense is:

(5) T is a singular thought iff T satisfies (4) and for. the main singular term 'a', a is required to state the identity conditions for T.

(4) gives us a concept of a thought the content of which is not descriptive; such would be indexical and demonstrative thoughts. (5) gives us a concept of a thought which is not only non-descriptive but also existence-dependent. It has always been assumed that if a thought were non-descriptive it would be like (5), but that assumption is misguided. For the point of the Complexity thesis can be put like this: If a thought meets the Complexity thesis it will have a Fregean style sense and this issue is independent of whether or not the thought can be captured with the apparatus of Russell's theory of descriptions. For where the singular term 'a' is an indexical, grasp of the sense of 'a' will consist in grasp of the sense of, e.g., 'Fa', 'Ga' . . . and so on. There is nothing to stop these contents being contents whose only linguistic expression is itself indexical. As long as the Complexity thesis is met, we have sense. As long as indexically expressed thoughts can be shown to meet the Complexity thesis, we have no need of a notion of singular thought other than (4). For not only is (5) not required, but in allowing existence-dependence it provides all the problems about misrepresentation the constraint at (3) is intended to overcome. This reveals the way in which the Complexity thesis provides a wholly general account of sense.

5. The argument for the Complexity thesis

The argument for the Complexity thesis is a transcendental argument. It is an argument that makes a metaphysical point about the nature of an object. It argues that the concept of an object is

derivative of that of a fact just the point I said we needed at the beginning of this chapter.[19] The argument goes like this.

What distinguishes an object from a subjective feature of an experience is that the former is something that can come and go. An experience of an object is an experience of something such that it can always make sense, on a later occasion, to say, 'Here it is again.' This is in contrast to an experience of, for instance, a quality. An experience which is an *F*-ish experience may be followed by another experience of the same kind, it too is *F*-ish. But if all we have is that these experiences possessed this *qualitative* character we have nothing which could constitute the idea of experiencing a *thing* which is *F*. For experience of an object which is *F* requires that it be an experience of something that can come and go, something that persists for some period of time. But now, in order to handle this idea of a persistent entity in time, it must at least be possible in principle to describe the object's track through space. It is the in-principle possibility of doing just this which separates the thoughts,

Here's the *F*-ish thing again

and

Here's another of those *F*-ish things.

An object just is something of which some truths must obtain, truths that we appeal to in offering criteria of identification and reidentification in our references to objects. Without such truths to supply these criteria it would make no sense to suppose that one had referred to an object at some purported referring.

For example, suppose I point to a figure over the street and say

(6) There's Margaret Thatcher.

However, when challenged I offer no defence of my identification. Further, suppose I cannot offer any defence. I merely repeat (6). If

[19] I take this to be the point Dummett was getting at in his 'Frege's distinction between sense and reference', op. cit., where he argues that the main point of the distinction is the claim that predicative knowledge must always depend on propositional knowledge: there is no predicative knowledge unmediated by propositional knowledge. An earlier version of the argument below was sketched in my 'The sense of a name', *Philosophical Quarterly* 1984, section V.

my purported identification of the object really is totally unsupportable, and I reject all proffered defences and challenges of the assertion, then the worry is not simply that I may have got my identification wrong. It is worse than that. The worry surely is that it makes no sense to suppose that I have had an object-directed thought at all. Without the support of some defending criteria of identification there is nothing to *focus* my utterance *on a thing*. If completely unsupported, there is no difference between my utterance of (6) and

(7) This is a Margaret-Thatchery experience,

where I speak of a subjective quality of my experience. But if I cannot differentiate between (6) and (7), my utterance of (6) lacks the credentials to be an utterance about an object. To have an object-directed utterance or thought requires that I be possessed of further truths, molecular representations, that serve to identify the object of my thought or utterance. This point is perfectly general, it holds for demonstrative and indexical identifications as well.

For example. Suppose at a meeting I say

(8) That heckler should be ejected.

Now in such a case, where I have a demonstrative thought about the object, the complexity thesis still holds. Of course I may have no conceptual criteria of identification for the man concerned. My thinking of him is wholly demonstrative. Nevertheless in order that I succeed in essaying an object-directed thought with (8) it is legitimate to require that I possess some further molecular representations that can, if challenged, be used to defend (8). Such representations may be no more than, e.g.:

(9) The man just behind *her*

said as I point at another member of the crowd; or

(10) That man *there*,

as I point at the man concerned. Both (9) and (10) are illuminating. For although both thoughts are thoughts with non-conceptual

content they are both in turn thoughts the entertaining of which require a good deal of 'surround' of other thoughts concerning the spatial framework in which I find myself. My use of 'there' in (10) requires that I have a notion of 'here' from which 'there' is suitably distanced at a certain angle. And although the distance and angle may, again, not be conceptualised, the object is just *'that* far away', how far that is must once more still be connected with my grasp of how I would move were I to try to reach the object.

The main claim in favour of the Complexity thesis is then this. There is no such thing as a thinking of an object, or a referring to an object, if there are no further molecular representations that the subject possesses and which identify the object concerned. Without possession of these further molecular representations there is no sense in believing that a thought of an *object*, or a reference to an *object*, has taken place. In contrast to the Cartesian theory of representation sketched above, we might put the central claim here as this: In thinking of an object the object must always be brought under representations. The Cartesian would say that the object must be brought under Ideas. A Kantian would say that the object must be brought under Concepts. That would also be a way of putting the point of a descriptive theory of sense on which all thinking can be characterised universally, in terms of concepts. My claim is that in thinking of an object, the object must be brought under representations. But the notion of a representation is built upon the notion of molecular representations, Thoughts, for only these meet the constraint at (3). Therefore thinking of an object requires a thinking of truths.

6. The sense of a name

The above argument does no more than press the case for making the sense/reference distinction and suggesting a way of thinking of the sense of a singular term. The argument does not address the issue on which Frege is most commonly attacked, namely that not only do names have sense, but each name has a unique sense. This latter thesis I leave untouched. I think it can be sustained, but it is of no relevance to the present enterprise.[20]

[20] Despite the almost universal belief that Kripke's 'Naming and necessity' in *Semantics of Natural Language*, eds. G. Harman & D. Davidson (Dordrecht & Boston 1972) reprinted in book form (Oxford 1980), sounded the death knell for the Fregean

The argument of section 5 is of a kind with arguments that have appeared throughout this book. It might be thought that I could have put the argument as follows: If I assert (6), by the Assertion Principle of Chapter 4 I must have ruled out certain experiences. However, if my utterance of (6) is unsupportable in any way, it must therefore violate that principle. Therefore I failed to make an assertion with (6). However, this is not quite the right conclusion; it is not specific to the question of singular terms. What this turns on is a difference in the nature of *sense* and *role* when applied to singular terms rather than molecular units or, for that matter, predicates.

Writers who accept Frege's sense/reference distinction tend to assume that the notion of sense is uniform across different types of linguistic expression. Of course Fregean theory has become a good deal more sophisticated of late with the abandonment of a descriptive theory of sense and the accommodation of demonstrative senses, indexical senses and so on.[21] But there is a presumption of uniformity that still holds despite these sophistications, and it is a presumption that I think is mistaken.

Earlier, I distinguished sense from role where the latter is the inferential position a thought has within a fragment of the language. I made this distinction in the context of a discussion of the sense of whole sentences (thoughts) and the sense of predicate expressions for experiential concepts. This was done in order to preserve a homophonic and thereby non-reductionist account of sense. But the above argument about the need for the concept of sense for singular terms might seem to be more to do with role than sense. For why could it not be said that the *sense* of a name '*a*' just is its standing for the object *a*? That is, we have a homophonic theory of sense for names, the sense given by theorems of the form

notion of sense, where it hit home, if anywhere, was on this second thesis about the uniqueness of sense. This, after all, is what the famous Godel/Schmidt example attacks. For some indication of how the uniqueness claim may be defended, see my 'The sense of a name', op. cit., section VI.

[21] Evans op. cit., is the best route into this more sophisticated style of Fregean theorising. But see also John Searle's *Intentionality* (Cambridge 1983), esp. chapters 8 and 9. Although Searle still writes as if he employs a descriptive notion of sense, it is not always clear whether his notion of 'intentional content' allows what Evans calls non-conceptual content, his arguments for the notion of sense are not unlike those given above.

'*a*' stands for *a*.

The point I pressed above, about the need for the subject who essays an object-directed thought to possess further molecular representations, could then be accommodated by saying that the subject must grasp the *role* of the name. If this were the case, we would not get a molecular semantic theory at all, but an atomic one. I think the suggestion does not work, and the reason is that the concept of sense is not so uniform across different types of expressions as people commonly think. The matter here is complicated (there is no reason why it should not be), but I shall briefly address it in order to support further the defence of a molecular semantic theory.

As I introduced the distinction between sense and role, the latter clearly is a different notion, for, for any given thought *T*, its sense is such as to meet the intuitive criterion of difference for thoughts given above. And this is different from its role, for it is possible for two subjects to grasp the thought without thereby grasping the same role. Role is not sensitive to the intuitive criterion of difference. But then we cannot meet the above arguments by saying that the information contained in the further molecular representations necessary to make sense of an identification is the role of the name not the sense. For the information concerned *is* sensitive to the criterion of difference for thoughts. That is why, in my earlier example of the three-object universe, the subject ends up having different thoughts when he returns to an object and does not realise that it is the same as the one he visited previously. Therefore, it is not an option to capture the above point in terms of my notion of role rather than sense. The further molecular representations required in order to make intelligible thinking of objects is a notion of information content that meets the standard criterion for demarcating sense. This is so, although it might seem more natural, given the distinction I used earlier with the sense of predicates and sentences, to think of it as information of a kind with the role of an expression.

The explanation for this difference between the way the concept of sense functions for singular terms and for predicates and sentences is none other than the very thesis that I have been arguing for in this chapter: the priority of the semantic value of sentences over the semantic value of sub-sentential units. Ours is a molecular theory.

In the domain of sense this means that the sense of a singular term is defined in terms of the sense of larger units, sentences. The sense of predicate expressions is different again. Although these are sub-sentential units, for many of them we still have a sense/role distinction that entails that a homophonic theory is adequate and therefore reductionism is out of place.[22]

Another way of putting the central claim of this chapter would be this: On the descriptive theory of sense, reference, incredibly, amounts to a cluster of predications! No wonder that the theory is open to all sorts of counter-examples and does not seem to capture the very singularity that makes us mark a distinction between singular terms and predicates in the first place. On the Complexity thesis account of the sense of singular terms, reference amounts to a cluster of *truths*, not predications. This is the difference.

In this chapter I have done no more than inch open a doorway onto all sorts of complications and conundrums in the theory of sense. I can do no more than that here, and no more is needed.[23] For what was required was the defence of what I have called a molecular theory of sense and reference for singular terms. This I have done. Thereby, I have defused the objection that in taking the semantic value of sentential units prior to the semantic value of singular terms I have gone without a credible concept of an object. Far from it. The notion of some particular *a* is nothing more than what is characterised by knowing what *sentences* containing the name survive; that is, knowing the sense of the name on the Complexity thesis account of sense. Not only is the notion of an object nothing more than this; it *is* this.

[22] I urged this distinction above with the concept of 'pain'. It is with such *experiential* concepts, the detection of the obtaining of which is specific to the availability of certain kinds of experience, that the homophonic theory is correct and the sense/role distinction appropriate.

[23] I hope to proceed to kick the door down on a later occasion.

Perceptual Experience: Content and Objects

1. The argument so far

I have now argued that the development of anti-realism for empirical discourse involves a reappraisal of our conception of the objects of experience and of the way in which we stand to such objects when we have knowledge. I have argued that the *claim to know* is logically prior to the conception of the objects of knowledge—certain states of affairs—and the objects of experience—states of affairs and their constituent objects. It is for this reason that the enterprise of this work is correctly called 'constructivist', although I have also argued that this constructivism is not a form of idealism which gives content to the thought that the world is *our* construction. Although the claim to know is logically prior to the conception of what we know—that is, having a certain experience is to have an experience with a certain structure and content and then, if the ascription of this content to the world survives, we take that structure and content to embody knowledge of a state of affairs isomorphic with it—there is no interesting temporal priority here that might suggest that the state of affairs which is the object of knowledge has been literally brought into being by our thinking of the relevant structure and content. Despite the intrinsic unpalatibility of such a position, it is not clear that it would make sense. An obvious question would be: *What* made you ascribe such structure and content in the first place? That is to say, would it not be the case that there would have to be some *input* which triggered the need to make the initial ascription. To the out-and-out idealist this must seem a question worth asking. It is not without answers. Berkeley's answer was that the input which occasioned (erroneous) thought about a mind-independent reality was the reception of ideas emanating from God. However, I am only claiming that there is a

logical priority to the claim to know over our conception of the objects of knowledge and experience. Temporal priority is out of the question here, and so too is what we might call, thinking of Berkeley, metaphysical priority. It is not the case that there is no state of affairs prior to our claim of knowledge ascribing content and structure to a state of affairs; neither is it the case that we can give content to the thought that there is such a state of affairs prior to the possibility of our understanding it. In speaking of the logical priority of the ascriptive claim to know I mean only to make this point: We have no understanding of the objects of knowledge prior to our ability to make ascriptive claims about them. Further, our understanding of such objects consists in our ability to make such claims. There is no further conception of the objects of knowledge and experience other than the conception manifested in our ability to make such claims. And of course, given the nature of such a constraint, there is no bar on the anti-realist speaking of experiential input in the manner which prompts an embarrassing question for the Berkeleyan idealist.

In this chapter I shall pursue these issues in developing a sketch of an anti-realist account of perceptual experience. I do this for two reasons. In the first place, given the above description of how the general enterprise of this work requires a reappraisal of the concept of knowledge in which the claim to know is logically prior, it is of some intrinsic interest to see what bearing this has on some traditional problems in the philosophy of perception with regard to the objects of perception. More importantly, I need to provide some account of the content of perceptual experience and, in particular, to defend the view that the content of experience is exhausted by its propositional content. This I shall do, although with some modification to the point as just put. This latter question is important for, as I have argued, the debate between realists and anti-realists is essentially a debate about the content of our concept of objectivity which is conducted, on the anti-realist side, in a way so as not to involve a reductionist metaphysics. My account of anti-realism leaves our ontological commitments much as they ever were only serving, at most, to take away something of the presumed richness of our notion of the objects we take to exist. The point of this is that anti-realism does not require an isolatable class of propositions to form the evidential base in our understanding of our utterances. Anti-realism embodies an evidential theory of content

only in so far as it imposes constraints on content to the extent that content must be amenable to characterisation within an experienceable logical structure. It is not evidential in the sense of utilising any particular conception of a relevant base class of sentences to be construed as the evidence conditions for sentences as a whole. That being the case, once the representational characterisation of perceptual content is defended in this chapter, I shall be able, in the next, to define effective decidability for empirical discourse in terms of our possession of perceptual skills for recognising that such-and-such state of affairs obtains without restricting such skills to anything like the restricted range of experienceable reality encompassed in traditional empiricism.

However, if it were to be argued that an account of the content of experience could only be fully characterised utilising a notion of non-propositional content, it might be thought that such a notion of content might serve as evidential base in experience and one to which an anti-realist ought to appeal. Although it is not obvious that if such a non-propositional level of content were substantiated it could be utilised as an evidentially basic level of content—it is only possible that it could be so used—nevertheless it is not an approach I favour for anti-realism nor find intelligible. Anti-realism is wholly non-reductive, the argument with realists being concerned solely with the intelligibility of certain knowledge ascriptions: the ascriptions a realist needs to be able to make.

2. Two questions about experience

These two reasons for investigating the nature of the content of perceptual experience correspond to two different questions that seem central to the philosophy of perception:

(1) What are the objects of my perceptual experience?
(2) How am I to characterise the content of my perceptual experience?

The former is the more traditional problem with perception and is not, I believe, so important. The anti-realist answer to that is quickly defended. The second question raises many more interesting questions and most of the rest of this chapter will be devoted to some of these.

Traditionally there have been two favourite answers to the first question about perception: namely, the direct realist response that the objects of perception are material objects and the representative theorist's response that the objects (or immediate objects) of perception are sense-data which are percepts.[1] On the face of it there are two responses possible to the second question also: either the content of perceptual experience is exhausted by its propositional content or it includes non-propositional content also. If we label these four responses 1a, 1b, 2a, 2b respectively, it *may* seem that the following relationships hold between these answers: 1a entails 2a (e.g. denying that there are sense-data involves providing a belief analysis of perception);[2] 1b entails 2b (sense-data are required precisely because a belief analysis does not do justice to the content of perceptual experience); 2a entails 1a (although I suppose one *could* characterise experience propositionally but take the propositions to be about sense-data or Berkeleyan ideas); but not that 2b entails 1b. This last fact should be apparent, holding that there is a non-propositional content to experience hardly requires that the experience have that content as its object.[3] As it stands I think that the possible combinations of these answers is not so obvious as suggested by thinking that they stand in the above relations of entailment. However, I shall argue that anti-realism provides us with a combination of something like 1a and 2a.[4] That is, the objects of perceptual experience are material objects and the content of perceptual experience is propositional, although this second part requires a good deal of elaboration, for I shall not be supporting a belief analysis of perception. Making the above claim and disclaimer

[1] Cf. D. Locke *Perception and Our Knowledge of the External World* (London 1966) who distinguishes four main theories, the other two being Idealism and what he calls the sensibilia theory which holds that sense-data are physical; I simply assume that these two options do not warrant serious consideration.

[2] For example, cf. G. Pitcher *A Theory of Perception* (Princeton 1971). Although I take it that most people would think that direct realism entails answer 2a, I think that it is far from obvious not because I intend to provide a combination of answers 1a and 2a which is not a belief analysis, but because one might be a direct realist while acknowledging that the content of perceptual experience is not exhausted by its propositional content. This becomes apparent below.

[3] Cf. C. Peacocke, *Sense and Content* (Oxford 1983) who opts for 2b but not 1b.

[4] One has to excuse the blossoming confusions of terminology; I am defending a direct *realism*! Direct anti-realism, if you like, but the point is about the appropriateness of our ontic commitments in perception, not the *reality* of the objects to which we are committed. See Chapter 8 below, or my 'The real anti-realism . . .', for the distinctions required in the use of the term 'realism'.

compatible is not too difficult, but first I treat of the easier claim that the objects of experience are material objects.

3. The objects of perception

The singularly most important point that makes people suspicious of direct realism is the general defeasibility of perceptual claims. Any perceptual claim I make can, so it seems, be defeated. Whenever I claim to see a tomato I may turn out to be wrong. This is thought to be important because if it does turn out wrong then it remains true that I was at least right about the way the situation *seemed* and here there is a supposed commitment to *seemings* which constitute a primary level of experience, the level of which my experience is primarily an experience. It is important to see that such a worry with direct realism is more than the thought that such a theory cannot suffice to defeat scepticism. Although many people seem suspicious of the theory for this reason it is hardly relevant. After all, a representative theory leaves scepticism untouched and this is, as such theorists are fond of pointing out,[5] irrelevant to its adequacy as a theory of *perception*. In seeking to understand perception we must leave epistemological concerns to one side. But the same holds for direct realism. On both theories there is a similar conditionality which allows scope for the sceptic. The direct realist is only saying that *if* I am right, I am seeing a tomato, and the representative theorist that if I am right my sense-data are related in a certain non-deviant way to a tomato. Allowing room for scepticism is a feature of both theories. However, if direct realism's failure to silence scepticism is not the point behind the worry about the defeasibility of perceptual claims perhaps this is: What can the direct realist say about the case where I am mistaken when I say that I see a tomato? This then is the thought about seemings or, the way my visual experience seems to be. When my perceptual claim is defeated I am at least right about the way things seem to be, and what else can the seemings be other than sense-data? This point is put more persuasively by saying that there is a use of 'looks', call it the phenomenal use,[6] such that something's looking *F* can remain true even if it is not *F* and we know that it is not *F*. What then *is F*? Answer, a sense-datum.

[5] Cf. F. Jackson, *Perception* (Cambridge 1977), ch. 2.
[6] Jackson, op. cit.

The argument about the irreducibility of the phenomenal use of 'looks' to a belief analysis is the best argument I know for the representative theory of perception, but it begs a very important question and, at best, serves only as an argument for position 2b. The question that is begged by the point about the irreducibility of the phenomenal 'looks' is this: From the fact that my experience looks a certain way it does not follow that there is something which *is* that way, not even in the sense of a mental something, a sense-datum. Of course, sense-data theorists acknowledge that they are committed to accepting the inference that from its being the case that something looks F it follows that there is something which is F, for they know that it is precisely this inference which a belief analysis seeks to avoid. Now I am not disputing this inference because, for example, it can be that something looks spatially extended when *nothing* is. This would just be to insist that it does not follow from something looking F that there is a *material* object which is F. Sense-data theorists acknowledge this but want to suggest that it is a different kind of object that is F in such a situation. The point I want to make about this inference concedes that the something which they take to be F when something looks F is clearly intended to be a member of a very different class of entities from normal material objects. The point I want to make is that one would already need to have accepted the existence of sense-data before the inference could be seen as valid. This turns on a familiar ambiguity in the word 'sensation'. Take the noun phrase:

(3) My sensation of a tomato.

(3) is ambiguous and may be taken to refer to some thing that I receive when I normally experience tomatoes, or it may refer to the character of the state I am in when I typically experience tomatoes. The first sense of (3) is the sense which reifies sensations and is the sense of (3) which thereby commits one to sense-data. The second sense of (3) acknowledges that on experiencing a tomato there is *a way my experience is*, but this is only to say that my experience has a certain *representational content*; that is, there are certain concepts under which the object falls as I experience it, but it is the *object* I experience not the reification of that representational content. I take it that this ambiguity is familiar. It is the point which lies behind the debate about whether or not Locke held a representative theory

of perception which focuses on the same ambiguity which, in Locke's case, rests on the term 'idea'.[7] But now, in the case where a subject's experience is such that

(4) $\exists x$ (x looks F)

which is not reducible to the subject's believing that there is a material object that is F, this only gives us

(5) $\exists x$ (Fx)

where we now take the quantification to range over sense-data if we construe the fact that something looks F as already involving the idea of *a looking*, or *a seeming*, which is F; that is, a sensation of F in the first sense of that ambiguous word. In other words, there is no argument from (4) to (5), but an assumption that one should take a *looking F* as a *thing* rather than a *way of looking*. But an argument is required here to induce us away from the alternative which involves no extra entities and only entails that we treat sensation talk as adverbial modification of lookings, not as things. In short, one can concede that there is a use of 'looks' which is not reducible to a belief analysis of 'looks' without thereby committing oneself to the existence of sense-data. At most one is committed to the idea that there is a representational content to one's experience which goes beyond the representational content of the beliefs one receives on having that experience.[8] As such, this is to take the arguments about the irreducibility of phenomenal 'looks' as, at most, arguments for position 2b: arguments about how to characterise the content of perceptual experience not about the objects of that experience.[9]

[7] Cf. J. W. Yolton, 'Ideas and knowledge in seventeenth-century philosophy', *Journal of the History of Philosophy 13* 1975, and also his recent book *Perceptual Acquaintance* (Oxford 1984).

[8] I use 'representational content' here as I employed it in the previous chapter to refer to molecular representations. These are not restricted to universalist contents.

[9] It should now be evident why I do not consider the question of whether or not there is any argument for sense-data which makes use of the idea that perception is an information-processing system which involves a good deal of inference. I take both claims to be incontestable, but they tell us nothing pertinent to the present enquiry, which is about the nature of the 'bits' which are processed by the system. On the position that I am defending the relevant 'bits' are qualitative features of experience, features which are wholly representational and thereby quasi-propositional. This latter claim I turn to shortly.

I want to leave the question of what the objects of perception are at this point. I have discussed it only in so far as to show that the best argument for a representative theory serves only to raise the issue about how to characterise the content of perceptual experience because on the question of the objects of experience it begs the question. It is the matter of describing experiential content which is really important, but it is useful to see that there is nothing in the direct realist theory with which an anti-realist cannot agree. Indeed, in so far as there is probably a considerable residual pull to the thought that even if something's looking *F* is ambiguous with regard to what we take its consequences to be with respect to positions 1a and 1b, nevertheless there must be *some* range of objects of experience which grounds our perceptual claims; this is the pull of realism, and anti-realism can help a direct realist theory of perception ignore it. For even if someone were to admit that (4) did not automatically entail (5), how else, might we ask, are we to account for the adverbial modification of the looking—its being an *F*-looking—without some range of objects which are *F*? But the thought that there is a good point here is confused and I shall return to substantiate this later. However, the general structure of the anti-realist account so far developed makes such a response to the residual claim for objects which are *F* a good deal more palatable if it should need such dressing. After all, if anti-realism has the consequence that the notion of an object of experience and knowledge is not prior to that of an experiential or cognitive claim, then we have no need to succumb to the temptation just mentioned. Indeed, it is only because the representative theorist treats sense-data as a class of entities in a somewhat realist manner that he is inclined to see sense-data as a class of objects in virtue of which we see all other classes of objects. However, if the claim to perceive, like the claim to know, is logically prior, then we need no longer succumb to the idea that there must be a single unevocal class of entities which are *the* objects of perception.

For example, take two men A and B walking in the desert where A says that he sees a snake, B says that he sees a stick and there is only a snake before them. All we need say is that A has a true perception and B does not; he sees a snake but thinks that it is a stick. B does not have to see any thing which *is* stick-like, it is only that his experience has a stickish quality to it. What is more, it has this quality in virtue of B's seeing the snake. What he did was apply

a poorly learnt skill ineptly. We need not see his mistake as a mistaken inference either, at least not in the sense of a mistaken inference from the perception of lower level objects or descriptions of his experience. Rather, the point is that he did not see enough to see that the defeat of his assertion, 'It's a stick', was imminent. The pull of the idea that if a subject has some qualitative content to his experience and it is not a quality of a material object then it must be a quality of some other kind of object is nothing more than the pull of realism. As such, if the argument of the preceeding chapters is correct it is a pull we avoid. I do not think that it is necessary to invoke the central claims of anti-realism in order to defend a direct theory of perception, but the two go together well. The idea that anti-realism would go equally well with an account of experiential content that invokes a distinction between different kinds of qualitative content in such a way that one kind might be thought suitable for the specification of an evidential base is the idea I now wish to combat. Given the anti-reductivism of my development of anti-realism it is important that, in a sense yet to be clarified, we should be able to characterise perceptual content propositionally. I think such a position is correct and can be seen to be so independently of support for anti-realism. I shall now show in what sense it is correct.

4. Perceptual content: some distinctions

I left the argument about the irreducibility of the phenomenal use of 'looks' (which I took as the best available argument for sense-data) as providing only an argument to the effect that there is a content to one's experience which goes beyond the content of the beliefs one receives on having that experience. This seems to leave nothing to be said on the matter of question (2) above; for does this not mean that the content of a perceptual experience includes non-propositional content? One can only concur, but the really substantial question is being lost in a terminological confusion. It is clear, and cannot be doubted, that perceptual experience is belief-independent and, as such, any theory which attempts to characterise perceptual experience as the acquiring of true beliefs about the environment must be inadequate. But this only gives us the conclusion that the content of a perceptual experience is not exhaustively described in terms restricted to those which figure in a characterisation of the

subject's beliefs. Which is to say that the content of the experience is not exhausted by its *conceptual content*. It is important that we be careful with terminology here, and I use 'conceptual content' to specify the content of a subject's experience describable using concepts he *actually has*. Now although it seems to be frequently thought that propositional content and conceptual content are the same, I think that it is far from obvious that they are and, indeed, it can be seen that it is false to think so. This may seem odd. How can we be justified in describing a subject's experience with some proposition if the subject does not have the conceptual resources to comprehend the proposition in question. Even when it is put so boldly I do not think the question is persuasive, but it will help if we avail ourselves of slightly richer terminology.

Let me re-phrase question (2) as the question whether or not the content of a subject's perceptual experience is exhausted by its *representational content*. If we think the content is exhaustively described thus, this is to say that the experience is exhaustively described by saying how it represents the world. That is, representational content is content that represents the world as being a certain way.[10] Now it has been argued that in order fully to describe the content of an experience our theory must embody a distinction between representational and non-representational where the latter is taken to be sensational content.[11] It is this claim that I want to resist, and I do so by observing that the distinction between representational and non-representational content is not the same as that between conceptual and non-conceptual content. The relevance of this is as follows. The examples used by Peacocke to support the notion of non-representational (sensational) content are all of a kind with the point discussed above about the irreducibility of a phenomenal use of 'looks' to a belief 'looks'. That is to say, they are examples designed to show that there are features of experience which are independent of belief. But that is just to say that there are features of experience which are not describable in terms of the subject's concepts; that is, there is a non-conceptual content to experience. However, this does not show that this content is not a content which represents the world as being a certain way; that

[10] As will be seen, my notion of representational content is narrower than Peacocke's, op. cit., ch. 1.
[11] Peacocke, op. cit.

is, it does not show that it is a non-representational content. So, if the notion of representational but non-conceptual content makes sense, we could acknowledge the belief independence of perception without needing to introduce the notion of sensational content and would do so by characterising experience in a way that is still quasi-propositional: 'quasi' because a level of propositional content below that of conceptual content, that is, belief. Now I think the notion of representational non-conceptual content makes sense, is intuitively plausible and can be argued for directly. I shall give an example to show the plausibility of the notion as well as arguing for it in a more direct fashion. But first, let me render the present abstract discussion more concrete.

5. The distinctions applied

Take the well-known Müller-Lyer illusion. This is but the

simplest of a host of such illusions which can be used to make the point. I choose it because it is so simple and leaves little scope for ambiguous handling. The bottom line in this illusion looks longer even though one knows that the lines are of equal length. The 'looking longer' is belief-independent. It is a part of the content of one's experience that the bottom line looks longer even though one does not believe that it is. Now, given the definitions of represent-ational and conceptual content above, we might list the three options for accounting for the looking longer here as follows: The bottom line's looking longer is part of the:

(i) representational/conceptual content, or
(ii) representational/non-conceptual content, or
(iii) non-representational (sensational) content

of the subject's experience. Option (i) is out of the question for the notion of representational/conceptual content just is the notion of propositional content as usually spoken of in connection with the

subject's beliefs and as one can lack the relevant belief here this option is ruled out.[12] However, we have yet to find grounds for choosing between options (ii) and (iii). I take it that a general presumption in favour of (ii) is licit if its coherence can be substantiated. This is because, although (iii) does not introduce sensations in a reified way that may be found objectionable, it does introduce properties that share one of the most objectionable features of sensations and that is their intrinsic privacy to the subject of experience. That being so, (ii) would be favourable if it can be upheld, for not only does it leave all perceptions as perceptions *of the world* (that is just direct realism which is compatible with (iii)), it also leaves all properties of experience as properties that represent the world as being a particular way. There are no properties of experience except those that serve to represent the world. My experience is not some thing to be described over and above giving a description of the way the world is taken to be on experiencing a part of the world. Indeed, my experience is not a *thing* at all, but a way in which I represent the world.

So how are we to decide between (ii) and (iii)? We can only do so by showing that the notion of representational/non-conceptual content makes sense and is in fact required. But first we might note what grounds are employed in arguing for (iii). The only person explicitly to do this is Peacocke. However, it is clear that he offers no *grounds* for arguing that we should take option (iii) rather than (ii) simply because he cannot distinguish between (i) and (ii). This is because he assumes that the representational/non-representational distinction is the same as the conceptual/non-conceptual distinction (in my terms, the distinction between (i)/(ii) and (iii), and the distinction between (i) and (ii)/(iii)). That is, he thinks all representational content must be conceptual. I admit that this is a *prima facie* plausible assumption, but it is false. It is clear that this is an assumption for Peacocke, not only because he states the fact quite categorically several times, but also because all the examples he uses serve only to highlight the non-conceptual content of various experiences. However, although Peacocke is quite explicit that representational content is equivalent to conceptual content, in a couple of places where he seems to be elaborating the assumption

[12] Of course, Pitcher, op. cit., gamely tries to account for the Müller-Lyer example with the notion of 'suppressed beliefs'. I think that this is incoherent and agree with Jackson, op. cit., on this.

a little further in justification of it he ends up saying something much weaker and compatible with taking option (ii) above.

For example, he says,

> it is the nature of representational content that it cannot be built up from concepts unless the subject of the experience has the concepts

but then continues in what is surely meant as justification of this,

> the representational content is the way the experience presents the world as being, and it can hardly present the world as being that way if the subject is *incapable of appreciating* what that way is. (my italics)[13]

Again, later on he does the same when he starts by making one claim and concludes with another:

> no one can have an experience with a given representational content unless he possesses the concepts from which that content is built up: an experience cannot represent the world to the subject of experience as being a certain way if he is not *capable of grasping* what that way is. (my italics)[14]

In both these cases Peacocke starts with the assumption that representational content equals conceptual content; that is, the former is constrained by the conceptual resources that the subject *actually* has. But each time, he elaborates on this by invoking a much weaker constraint: namely, the constraint that limits representational content to utilising concepts which it is *possible* for the subject to have. *This* constraint is so weak that it lets in the notion of representational/non-conceptual content and thereby allows us to use option (ii) above. To see this, consider an example that Peacocke uses: When looking down an avenue lined with trees of uniform height, the nearer tree looks taller although we believe it is of the same uniform height. Now why could we not capture this looking taller by saying that the nearer tree subtends a larger angle at the retina? This option is ruled, says Peacocke, because most subjects do not have the concept of subtended angle in the visual field. But, of course, they could acquire that concept, and that is why meeting

[13] Op. cit., p. 7.
[14] Ibid., pp. 19–20.

the weaker constraint allows option (ii). So, if option (ii) can be shown coherent, it has a good deal to offer and actually satisfies one version of a constraint Peacocke wishes to place on representational content. I now want to produce an example in favour of represent-ational/non-conceptual content and then to consider some argu-ments directly in its favour. But first let me introduce the relevant content I would suggest for capturing the 'looks longer' in the case of the Müller-Lyer illusion. This gives us some data for later discussion and also raises, and allows me to settle, another objection to option (ii).

The suggestion is that the content of the bottom line's looking longer be specified something like:

(6) It visually appears to the subject that were two discs of equal diameter to be placed one on the end of each line, then it would take the lower disc more revolutions to traverse its line than the upper disc.

This may seem provocatively complex, although I think it quite reasonable and rather simple. The objection that is raised by giving such a conditional translation of the 'looks longer', where the conditional represents the world as being a certain way, is the following: How can one specify the *actual* features of a subject's experience in terms of counterfactual circumstances?[15] This seems a very obvious objection, but it does not amount to much for consider this. For any experience which has a representational/conceptual content that object a is longer than object b; that is, an experience in which one believes that a is longer than b, then what

[15] Those *au fait* with Peacocke's work will have observed that I do not mention the first objection he puts to such translations, but the translation he considered was offered as a translation of (the tree e.g.): 'The nearer tree takes up more of the visual field', but as I do not know what the visual field is I am starting with the bare 'The line looks longer', 'The nearer tree looks taller', etc. Although the point Peacocke makes about such a translation model is right—it cannot capture the meaning of statements about the visual field for the looking longer may be a result of a stigmatism—nevertheless the translation can capture the content of looking longer simply because I do not take statements about a line's looking longer as statements about a subject's visual field. It is a statement about the way an object looks, not about an experience reified into some entity called the visual field. It is only because Peacocke always takes the object's looking longer (taller, etc.) as a fact about the visual field that the translation model is ruled out. But this assimilation is the very point at issue.

is it to describe the content of such an experience with the concept 'longer than'? Now I do not want to argue over the exact details of what the content of that particular concept is, but it strikes me that if one does not specify it in a way that connects the notion, in some quasi-mechanical way, with relative motion through space, one will not have captured the content of that concept. Of course, this is just what I did in the suggestion above for handling this concept with respect to the Müller-Lyer illusion. It is in the nature of this concept that its content be specifiable with regard to counterfactual situations. Indeed, it is a general feature of concept possession that this is so if one takes concept possession to involve a grasp of how the satisfaction conditions of the concept affect the survival value of sentences in which it is employed. But then there is nothing suspicious or unusual about characterising the content of a concept counterfactually. Therefore, for any experience for which it is agreed by all parties that the use of some concept *F* is licit in a characteris-ation of the content of the experience, there can be no mistake if that actual experience has a content only fully specifiable counter-factually. That being so, *if* it is coherent to employ that *same concept* in a characterisation of an experience when the subject in question does not possess the concept (i.e. is representational/non-conceptual content viable?), it can be no more a mistake if the content of the experience makes reference to counterfactual circumstances. And that is to say that it can be no mistake at all. In other words, the objection which seems to arise naturally from my suggestion for handling the Müller-Lyer illusion can rest on nothing more than a refusal to allow the notion of representational/non-conceptual content. I shall now rebut this refusal; first with an example and then with direct argument.

6. The example case

Let me drop the cumbersome title for the notion of content I am putting forward and simply refer to it as representational content. Only if I am concerned with the sort of content which beliefs have will I add the qualification 'conceptual'; 'representational' on its own is to be understood as non-conceptual representational. Here is the example in favour of representational content. A typical subject of experience has a limited stock of colour concepts. That is to say, there are many colour concepts—for example, 'duck-egg

blue', 'vermillion', 'azure' etc.—which he may not know how to use. If presented with an object and asked if it is duck-egg blue he would be lost for a reply and, furthermore, he has no ready classification of the colour at hand with that name, some other, or a description. But now, when this subject S is presented with an object a that *is* duck-egg blue, what is there to stop us saying that although he does not know what colour it is, his experience represents a as being *that* colour—that is, duck-egg blue. Clearly, S can discriminate this object and its colour from the environment, it does look a certain way to him. Indeed, it looks a duck-egg blueish sort of way, so why not employ that concept, a representational one, in characterising his experience.[16] That is, S's experience represents part of the world as being duck-egg blue but S lacks the conceptual resources to arrive at any beliefs about this shade of colour other than indexical beliefs like 'This is a nice colour', or 'This shade looks darker than that one'. After all, the sensationalist theorist will have to employ the concept 'duck-egg blue' in describing the sensational content of S's experience saying something of the form 'S's experience (or some region of it) has the sensational property of being duck-egg blue''. The primed colour here is the homonym-formed sensational version of the representational concept 'duck-egg blue' with which some other subject who possesses this concept can have the conceptual representational content of an experience which makes it that the object is conceptually represented as being that colour. What distinguishes S from the sophisticated subject is that the latter has the concept 'duckegg blue', but it seems quite plausible to suggest that what they have in common is that when they are both presented with an object of that colour they *both* have experiences that represent the object as being that colour. The difference is that the latter subject knows what that colour is, S does not. Of course, lacking the concept does not restrict S from being able to do a good many other things with this colour. Suppose we present him with a continuum of patches of colour along a strip with the middle patch being duck-egg blue and the patches either side being variations in the minimally perceptible gradations of lighter and darker shades in either direction and the strip is arranged so that he cannot see either end.

[16] It might be denied that colour concepts *are* representational, but that seems question-begging. Even Peacocke allows that they are, although a colour concept is definable in terms of its homophonically arrived at sensational property.

Suppose this strip is presented only long enough for him to fix on the duck-egg blue patch. He can discriminate it from the other shades. Having fixed on the colour, we turn him away, only to return him to the strip after a couple of minutes and after we have moved the strip one way or another. Not possessing the relevant concept, it is perfectly conceivable (and most likely) that *S* will not be able to re-identify the duck-egg blue patch with any reasonable degree of success precisely because it is not a colour with which he is particularly well acquainted. He has no need of an ability to classify shades at this part of the spectrum with such a degree of accuracy. This does not stop him from being able to discriminate and fix on a shade, but only as being able to conceptualise this fix—it remains intrinsically indexical—which is why he cannot pick out the patch again on returning to look at the strip. This is all non-conceptual but still representational. His experience represents the world as being a particular colour, as being a particular way, *that* way—the way it looks when presented with an object which is *that* colour (duck-egg blue)—and its looking that way is because it represents the object as being that colour, however some more sophisticated subject might conceptualise it. And so my experience represents the world as being just whatever colour it is (providing conditions are favourable; otherwise it represents wrongly), but being a subject with a limited grasp of colour concepts I get very little out of the content that is available for me because already a representational part of my experience.

It is not essential that the above considerations be put using colour concepts. I might have talked about shape instead. In many ways shape is perhaps better for the idea of being able to discriminate and individuate shapes demonstrably but not conceptually is more accessible simply because people generally possess a much more limited stock of shape concepts than colour concepts.[17]

[17] Of course, discrimination and individuation here are demonstrative in character, and so too is the sort of shape recognition involved in experiments when subjects recognise an irregular shape out of a sample of similar shapes some time after initial presentation and fix. Cf. I. Rock, *The Logic of Perception* (Cambridge, Mass. 1983), p. 53ff. It should be noted that Rock uses the experiments discussed there to support the view that form perception is based on description. This is compatible with my calling the recognition demonstrative, for I call them so in the standard way of meaning that there is no *conceptual* content to the recognition; that is, the subject does not know how he recognised the shape, and this is presumed to be a non-Fregean content of his thought 'That shape again' precisely because he has no conceptual content to the 'that shape'. However, because I have the notion

However, even if consideration of such examples gives the notion of representational content a *prima facie* plausibility and, even if option (ii) above is intrinsically more palatable than option (iii), some direct argument in favour of (ii) would be helpful. I now turn to this.

7. The argument

Consider again the Müller-Lyer illusion. Take the case of the naive subject presented with this illusion and who is fooled by it. This subject believes that the bottom line is longer than the top. That is to say, he has an experience that (falsely) represents the world as being such that the bottom line is longer than the top. This is an experience with a conceptual representational content that the bottom line is longer. Now, as I argued above, in such a case when we are dealing with a subject who believes that one item in the external world is longer than some other item, it seems that it is at least partly constitutive of such a notion of objective relative length that it be specifiable in something like the quasi-mechanical way I proposed above for the different, because non-conceptual, representational content of relative length. This is required in order that we be able to capture the idea that in saying one line is longer than another we are making a claim about relative occupancy of objective space. The quasi-mechanical way of capturing relative space occupancy is a way of ensuring that we capture a feature of an objective shared environment. Again, I am not concerned to enter into an argument over the precise sense of measurements of relative length in objective space, but if it is not specifiable in something like the manner suggested in terms of simple mechanical ideas about motion *through* space, then it will not be measurement of a feature of objective space. So, for the naive subject who believes that the bottom line is longer, the 'longer than' *is* correctly captured in something like the way used above for the account of the content of the

of representational content which is non-conceptual I can agree with Rock that form recognition is description-based, but at a lower level than conceptualised description. As long as the representational content meets the complexity thesis this offers the chance of a straightforwardly Fregean account of demonstratives. I can also agree with Rock's view that perception is inferential, although by this I only mean that it processes units of a propositional nature. This is distinct from saying that it is inferential in the way epistemologists have usually thought of it. On this, cf. Chapter 8 below.

experience for a subject who is not fooled by the illusion. The difference between the two is that while of the latter it is only true that the bottom line *visually appears* that p where 'p' is the proposition describing the content of '. . . longer than . . .', of the former subject it is true that he believes that p. This is, of course, an extremely important difference, but the point I want to emphasise now is that the concept of '. . . longer than . . .' is *identical* for both the sophisticated and naive subject. And that, surely, is how it ought to be. When the naive observer comes to learn of the illusion it cannot be the case that when he reports that the bottom line still looks longer than the top he is using '. . . longer than . . .' differently. He must be using it with the same meaning, or else we would not have an illusion here at all but a transition from one kind of perceptual experience to an experience of a qualitatively different kind and that is simply not true. Both the naive subject and the sophisticated subject are in states with a common representational content: namely, that the bottom line looks longer. The difference is that for the former this representational state proceeds unimpaired to produce a belief with that content. In the case of the latter subject such content is overridden with regard to belief production but still remains as a feature of how the object visually appears. And it is *the object* that visually appears a certain way, not the experience that has a certain non-representational quality.

Unlike the traditional belief analysis of perception[18] I do not have to deny that the 'looking longer' in the case of the sophisticated subject is a constitutive part of the subject's experience. Pitcher would want to analyse away all such apparently phenomenal uses of 'looks'. But it seems quite apparent that any theory which denied a large shared content between the sophisticated and naive subject's experiences in this case would be hard pressed to capture the illusory nature of the sophisticated subject's experience. The distinction between conceptual representational content and non-conceptual representational content allows us to preserve a significant degree of shared content between the experiences of the two subjects such that there is no difficulty in accepting that, for *both of them*, the bottom line looks longer and that this is distinct from the question of whether or not they have a *belief* with such content. The looking longer just is their both being in a state with representational

[18] For example, Pitcher, op. cit.

content as outlined at (6) above. This state is *not* a belief state. It is a state held in common by the two subjects only one of which has a belief with this content.

We need a name for the sort of state a subject is in when he has representational content which is non-conceptual, and I propose to call such a state an *informational state*.[19] In the case of the Müller-Lyer illusion and the naive and sophisticated subjects we are concerned with visual informational states. The two subjects share the same kind of visual informational state, but only the latter has a belief state with the relevant content. This offers such an obviously plausible account of the genesis of such illusions (as well as the genesis of beliefs) that we are presented with almost an embarrassment of support for the concept of such informational states. The obvious suggestion is that belief states are intrinsically complex cognitive states of a subject which arise from certain kinds of integration of informational states and other cognitive functions. Such integration would presumably involve a certain degree of cross-modal comparison, and also evaluation of the results of such comparisons by decision making sub-routines of a processing nature. With an illusion like the Müller-Lyer the operations which block the visual informational state's rise to belief content would presumably have to be operations of a fairly high level of processing control; cross-modal comparisons would hardly suffice given that the illusion works through tactile perception as well. Indeed, there seems to be a good deal of cross-modal transfer with such illusions with regard to the decrement over time of the magnitude of the illusion.[20] Indeed, it seems likely that cross-modal comparisons and transfers of information are non-conceptual because they are independent of the subject's linguistic abilities having been observed in experiments with apes.[21] This is as one would expect given that the level of representational content in informational states is non-conceptual. One does not need to possess the concept *F* in order to

[19] Evans, op. cit., uses the terminology of informational states, and although I do not think that my use is incompatible with his, it would be tendentious to claim that it was the same. For one thing, he arrives at the notion for slightly different purposes, he is not centrally concerned with giving an analysis of perceptual experience and he does not consider the question whether the content of informational states if non-conceptual might still be representational.

[20] Cf. experiments by Rudd and Teuter cited in L. E. Marks *The Unity of the Senses* (London 1978), p. 24f.

[21] Marks, ibid.

be in an informational state which represents some part of the environment as being *F*.

8. Three objections

Now the above argument has been to the effect that the notion of informational states supplies the required invariant content between our naive and sophisticated subjects. There are three further objections to the level of content that I am proposing that I want to consider. The objections are: (i) Why could it not be the case that the invariant content be sensational? (ii) The suggestion of objection (i) then gives further ground for objecting to the counterfactual specification of content above in (6), for the sensational content is an actual character of an experience; so why use a counterfactually specifiable character? And, to return to unfinished business from p. 186 above, (iii) How are we to account for an experience representing an object as *F* if there is nothing which *is F*, not even an experience where '*F*' is a sensational property of the experience? All three objections serve to promote sensational properties of experience as the invariant content, and I think that all three see the need for this to reside in the following major question,

(7) How can one *represent* an object as being *F* without possessing the concept *F*?

Now I have already suggested an answer to this question when I first introduced the notion of informational states, but the point now is that *if* sensational properties could serve as the invariance between our two subjects of the Müller-Lyer illusion, this would support the undoubted hostility that will be felt to the idea that one can represent without concepts. Surely, it might be said, it is concepts that represent; without concepts no representation can take place at all; we have only uninterpreted blind input? That is, although I have suggested a kind of example that seems to call for the notion of content proposed and have argued for it directly, is it not the case that I have failed to say how a subject can represent the world as being a certain way if he lacks the concepts which characterise that way?

I think a fully satisfactory answer to the question at (7) would require a detour into subjects currently at the centre of disputes in

cognitive science and the philosophy of psychology and, as such, would take me too far from my current brief. However, I shall pursue the point a little further if only because it allows me to make some conceptual points which will be employed in the following chapter.

In the first place, question (7) is misguided in so far as it asks how can a *subject* represent an object being F without possessing the concept F, for to this I reply, 'No way at all'. A subject can only represent by using concepts, for it is the subject who has beliefs. The whole point of the kind of content which informational states have is that it need not produce beliefs and need not therefore be a content of which the subject is aware. The kind of content which I am proposing is a content possessed by sub-personal states of an organism, presumably neural states.[22] Indeed, the content of an informational state is just the sort of thing one might speak of a subject being aware$_2$ of, in Dennett's use of an awareness$_1$/aware-ness$_2$ distinction where the latter picks out a notion of awareness characterised by behavioural control and not introspective consciousness. But perhaps this only stalls the objection, for how can a sub-personal state represent if that is a state with no access to conceptualisation? Now the simple answer to this is that such a state just can represent. Without going into the debate between brain-writing and behaviourism over how to characterise what it is to have representational states, let me side with the behaviourist on this, although I shall shortly add an important qualification which makes that title inappropriate and any connection with, e.g. Dennett's work, tenuous. I think that we have to accept the notion of a state with representational content as a given whether we are concerned with perception or cognition in general. Without it, any form of brain-writing theory, or, for that matter, claims about sensational content, only stalls the question of how content ever gets into an intentional system. Of course, this is an important question to ask, but only, I think, if one is asking how belief contents get into the intentional system? That is, how does conceptualised content arise out of informational states? *That* question, or so it seems to me, raises a respectable problem area for cognitive scientists. Question (7) does not, because the asking of it supposes that we must start with a sensational input which then, at some later

[22] Echoes of Dennett's distinction between two kinds of awareness are intentional; cf. D. Dennett, *Content and Consciousness* (London 1969).

stage of processing is 'read' and thereby seen as imbued with representational content. The sensational content serves as a *bearer* for the representational content. It is this thought which is confused. For our starting point is a question about how we 'read' the world, and I can not see how it can be thought plausibly to constitute an answer to that to be told that we do so by 'reading' *something else*. This does not explain the nature of such 'reading' at all, even if the objects of such reading are not reified sensations (sense-data) but an experience with sensational properties.

In point of fact, it is not clear that proposing the sensational content as the invariant content between our sophisticated and naive subjects really does justice to an illusion, for it leaves the difference as a difference in the way in which the two subjects 'read' the sensational input; that is, the sophisticated subject has read it correctly. But this leaves out the fact that even the sophisticated subject will accept that the bottom line's looking longer is something like (6) above rather than just a sensational property of relative length in the visual field. The sophisticated subject can still say that it *does* look as if were he to take 2 discs of equal . . . etc.; it is *just* that he does not believe this.

But now, if I am taking the notion of an informational state as given have I not assumed so much as to beg all the really interesting questions in the philosophy of mind? After all, the question of how a physical state can have content seems to be the most perplexing question in the field.[23] However, it is hardly fair to say that I am *assuming* such a notion. More importantly, I think one can diagnose the perceived difficulty with this question in the following manner.

I take it that a familiar way of saying how an organism can represent without concepts is to say that in order to represent the world as being F it needs only a certain kind of physical state which plays a certain functionally characterised role in the control of behaviour of the organism with regard to objects which are F. The idea is, of course, from Dennett.[24] Let me call this thesis the behavioural thesis, thesis B for short. I suscribe to a version of thesis B but do so without succumbing to what seems an obvious difficulty. The difficulty is this: Because thesis B picks out the state with the content ⌜presented object is F⌝, behaviourally it is open to the common charge against functionalism known as the missing

[23] A question made much of by John Searle in his BBC Reith lectures 1984.
[24] Op. cit.

qualia objection.[25] Put most strongly this is as follows. It is perfectly conceivable that Martians who lack colour vision could discriminate red objects by a particular *feel* they receive from the object's fine surface structure and that this discriminative ability might allow them to classify objects in a way that is extensionally equivalent with our colour concept classification. Because we have an extensional equivalence between our classifications, by thesis B the Martian and ourselves share a state which represents red objects as being a certain way, and yet there is *no one way* which is the way in which we and the Martians experience red objects. They do not have our concept 'red', they have only what we might call 'redfeel'. But then if thesis B fails to distinguish 'red' from 'redfeel', it will fail to say what it is to represent an object as being red. As it stands, I take this objection as well founded, but it requires only the slightest adjustment to thesis B to meet it.[26] The adjustment concerns only how one further specifies the 'certain kind of physical state'. One does so as follows:

Thesis B: In order to represent an object as being F an organism needs only a physical state α of a kind suitable to generate structures with a conceptual content F (if the organism possesses the further abilities for conceptualisation) where α plays a certain functionally defined role in the determination of behaviour of the organism with regard to objects which are F

There are but two points left to be said in clarification of thesis B before it can be seen as substantive and, I think, probably correct.

First, thesis B does not offer a means for characterising the *content* of an experience behaviourally, for the concept reappears within the scope of the *analysandum*. This is important. The fact reflects that we are now only submitting to the weaker constraint on content

[25] This objection has spawned a large literature which began with N. Block and J. Fodor, 'What psychological states are not', *Philosophical Review* 1972. See S. Shoemaker, 'Functionalism and qualia', *Philosophical Studies* 1975, for one of the earlier responses. I do not find this, nor later responses, adequate but cannot pursue the matter now.

[26] Whether or not someone like Dennett would accept this adjustment I do not know. I suspect he would not. For one thing, I take Thesis B to be neutral with respect to the question whether or not one can say anything about the *kind* of physical state which controls behaviour oriented to F-ness other than that it controls such behaviour. That is, Thesis B is neutral between a type/type or token/token identification of neural states with content 'presented object is F'. I favour the latter.

structure mentioned above; that is, use concepts that the subject *could* acquire. In the present context this feature of thesis B enables it to capture the difference between the Martian experiential content when presented with a tomato and the typical human's experiential content with the same presentation. However, thesis B does entail that unless the organism has a certain kind of behavioural repertoire—that is, it has behavioural patterns with regard to red objects as opposed to green, blue, orange objects etc., which we differentiate with regard to the object's shape, size, mass, location and so on— it can make no sense to say that the organism is aware of the object in a way that is extensionally equivalent to representing it as red. We cannot yet say that it actually has a state which represents the object *as red* even if it does have the appropriate behavioural patterns. Thesis B only restrains the *intelligibility* of claims about content. That is to say, thesis B uses behaviour as a *constraining criterion* (in the sense in which I introduced that notion in chapter 5, secton 5) on content ascriptions. If the creature has no specific differential behaviour patterns with regard to *F*-ness, it can make no sense to say that it is capable of representing objects as being a way that is extensionally equivalent to '*F*', let alone represent them as *F*. This use of behaviour to *constrain* content ascriptions is, of course, of a kind with the sorts of arguments presented earlier as the core anti-realist critique of realism.[27] There the point of the argument that knowledge be manifestable was that manifestation constrains the content of one's knowledge claims—one could not intelligibly claim knowledge of some state of affairs if one's knowledge were not manifestable. Returning to thesis B, behavioural dispositions with regard to objects which are *F* only tell us that the organism represents these objects as being a certain way that is extensionally equivalent with their being *F*, it does not tell us anything about the nature of the content. If the organism has no capacity for conceptual thinking—it has no language—then any description *we* can give of its informational states will be tendentious if it is thought to give any clue about what the organism's experience is like from the inside. And if the organism has no capacity for conceptual thought the fact that it represents such objects as being *F* is due solely to its sub-personal states representing the objects so.

[27] For more on the relation between behaviour and content, cf. my 'Dummett and Quine: meaning and behaviour', op. cit.

I shall return to this notion of seeing behaviour constraining content rather than characterise content in the next chapter.

The second clarification required of thesis B is an explanation of the recurrence of '*F*' within the *analysandum*. Given that this is so, can thesis B tell us anything of interest? For example, what kind of physical state *is* suitable to generate structures with conceptual content *F*? Now the fact that '*F*' recurs within the scope of the explanation comes to the fact that there is no illuminating account to be had that relates 'being red' and 'looking red' one way or another. That is to say, neither of these predicates is prior. Peacocke,[28] for one, is not able to accept such a no-priority thesis, but I can find no reason for thinking either term should be prior unless one already had a conception of non-representational properties of experience which could lever one out of a circular relationship between the two. So far as I can see there is no *a priori* reason for thinking that this is not a virtuous circle. The property 'red', for example, is an ineliminable feature of the way we experience the world. It is, of course, a relative description of an object to say that it is red; that is, relative to the sort of sensory capacities *we* have. But those objects look red which are taken to be red by those states of our nervous system with the informational (non-conceptual representational) content that they are red. That is to say, thesis B (and any functional individuation of states with content) cannot tell us anything about the content of the states that it individuates except that they have a content extensionally equivalent with some other content. The question 'What is it like to experience objects as red?' has no answer except the answer we give to fellow normally sighted humans: 'Like this.' If bats are creatures with radically different sensory systems there is no answer to Nagel's question 'What is it like to be a bat?'[29], but *neither does there need to be an answer* for us to conceive of content and consciousness being ascribable to such organisms. The Martian who experiences tomatoes, etc., as redfeel, the bat who experiences them as redbounce[30] and normally sighted humans who experience them as red all enjoy kinds of experience which are ineliminable and irreducible features of the way the world is experienced by that creature. These are intrinsic features of the way such creatures experience the world. Further-

[28] Op. cit., ch. 2.
[29] T. Nagel, 'What is it like to be a bat?' in his *Mortal Questions* (Cambridge 1979).
[30] This is a sound reflective property.

more, the fact that the three description types: $(\imath x)$ redfeel x, $(\imath x)$ redbounce x and $(\imath x)$ red x, are all relative descriptions does not rule out the possibility that they should be constituents of descriptions which are *objectively true*. There are some things about tomatoes which we will never experience; similarly for the Martian and bat. This should have been apparent all along for if the property 'red' *is* a representational property; and if we do not reify sensations, then the only objects of concern when I took at a tomato are the tomato and myself. I am not red. It is the tomato that is red and this is an objective feature of the tomato. It is a feature of the fruit which only certain kinds of creature can experience.[31]

And now there seems to be only one answer for the question 'What kind of physical state α is suitable to generate structures with conceptual content, e.g., red?', and it is the obvious answer. Namely, it is that kind of physical state of the brain and central nervous system one gets through having human eyeballs, optic nerves and visual centres of the brain. Again, having such physiological states does not characterise the content of the predicate 'red'; it is simply that without such physiology one will never experience red. That seems just about right. It is because Martians lack all, or part, of this physiology that they cannot experience the world as red. It is because we lack a sonar system of the required sensitivity that we cannot experience objects as redbounce.

In conclusion then perceptual experience has the following characteristics:

(a) The objects of perception are material objects.
(b) The content of perceptual experience is representational.
(c) The representational content is (i) non-conceptual, being the content of informational states which are identifiable by the sensory organs that generate the information, and (ii) conceptual, being the content of belief states which are the result of cross-modal and higher processing functions of the organism.
(d) The sorts of informational states an organism's cognitive centres can be in typify the intrinsic properties of experience as they are experiences for that kind of creature.

[31] For those whose views on primary/secondary qualities are affronted by all this, see Appendix 2, where a summary of these points with respect to secondary qualities is given.

(e) Content ascriptions are constrained by behavioural criteria, thesis B.

(f) Content cannot be characterised by behaviour. That a certain state has content is an unanalysable given to our enquiry; what that content is is an ineliminable given for the creature.

Having thus defended a wholly representational account of perceptual experience I can side with the main current among cognitive psychologists who take perceptual input to be propositional. In talking about informational states I have merely proposed a conceptual framework that accommodates writers like Rock who speak of the 'the literal percept', 'proximal input', 'proximal mode of perception' which are not sensational. These are names for what I have simply called non-conceptual representational content. I have only distinguished between this and conceptual representational content. Conceptually a bipartite theory seems sufficient, although in practice the processing of the input information may run through a hierarchy of levels. (This becomes important in the next chapter.) As Rock suggests,

> there are hierarchically based levels of description that occur beginning with one that is correlated with the stimulus, the proximal mode of description. This suggests that the proximal stimulus information is available rather than being swallowed up, so to speak, by the processes that lead to constancy of world-mode levels of description and that it can be internally scanned or examined.[32]

In this chapter I have only been concerned to show that this proximal mode of description is a wholly representational content of the experience. Having done this, it is now possible to show how, because experience is exhaustively characterised by its representational content, the range of experience can reach just as far as whatever representational content is experienceable. It is to this question that I now turn.

[32] Rock, op. cit., p. 40.

The Range of Experience and Other Minds

If the content of experience is exhaustively described by its representational content, then the range of states of affairs and objects of experience is not limited by the fact that the present argument is built upon an evidential theory of content. As I have remarked on a number of occasions, the fact that anti-realism embodies an evidential theory of content is exemplified by the logical *structure* of experience, not by there being some evidentially basic range of objects/states of affairs that are experienceable. This is the central thesis to the development of anti-realism on offer in this essay. The theory of content is evidential because it restricts the content of all utterances to a content such that knowledge of that content is experienceable knowledge; that is, it is manifestable. The content of all utterances is restricted to a content that is typified by its possessing a logical structure capturable by the logic of experience. The theory of content is not evidential because it restricts the content of utterances to transformations, by translation or weaker relations, of the content of utterances of some restricted class.

The latter notion of an evidential theory of content is the one that typifies traditional forms of non-realist semantics. It is distinct from the sort of evidential theory of content on offer here. It is because of this character of an anti-realist theory of content that there is no base class of utterances about a basic level of experience and out of which all experience is constructible. This is why it is possible to extend the range of experience beyond regions traditionally thought outside the range of experience. We can thus treat as effectively decideable all and only all those propositions the determination of the truth of which is such that we possess non-inferential perceptual capacities for determining their truth. Because of the non-realist character of the enterprise, this turns out to be a very large class of propositions. In this chapter I shall provide

the anti-realist response to the question of our knowledge of other minds.

1. Informational states do not limit the range of experience

It might be thought that the above statement about the possible range of experience is disingenuous. After all, the claim that anti-realism need postulate no class of statements describing a base level of experience and evidence may seem to conflict with the analysis of perceptual content given in the previous chapter. The conflict may be thought to arise because of the way in which I argued for the notion of the content of informational states which, although representational, are non-conceptual and as such constitute a level of content not available to the subject of an experience. Might it not be the case that the content of such informational states be just the sort of content which could be seen as providing an evidential base class in terms of which other content is constructed? After all, if the generation of belief is, in the broadest sense, a matter of processing the content of informational states presumably through inferential and analogical functions, is it not the case that the content of the belief state is, in some way, based upon that of the content of the informational state? The answer to this last question is that the content of belief states surely *is* based upon that of the content of informational states, but not in a way that gives scope to the idea of taking the content of the latter as an evidentially basic level of experience.

The thought that belief content is based upon informational content is presumably true in at least the sense that without informational state content no belief about the world would be possible. It is also presumably true that the content of certain beliefs is *constructed* out of informational states. However, it is not clear that admitting this is to concede evidentially basic contents. It depends on what we mean by 'constructed'. The sorts of examples that I have in mind are quite simple. Take my present belief that, as I am typing this sentence, there is a blue and white beer can in front of me. If it is thought that the construction of belief contents out of informational state contents confounds the non-reductive character of the present enterprise it might be for the following reason:

(1) The concept of a beer can does not figure in the content of

any *one* informational state but is only the result of the bringing together of contents of different informational states.

The thought behind (1) is that my visual input does not tell me that there is a can before me, only that it looks like a can-ish sort of experience. The concept of a can requires that certain tactile inputs be possible, and it is only the amalgam of these two inputs, plus other processing, that gives one the concept of a can. Now I doubt whether (1), thus elucidated, is true. For one thing, even if my visual experience does not tell me that there is a can before me, if it tells me that things look a can-ish sort of way, it is still employing the concept 'can' albeit as qualifying a way my experience is. So (1) would have to be understood as saying that the concept 'can' does not figure in, e.g., visual informational states, for all that figures in the content of such states is information about colours, shapes, shades, etc. If that is so, the concept 'can' is the result of processing upon information about shapes, colours, feels and inferential processing, connecting this information with memory information and conceptual information of a mechanical kind pertaining to the sorts of mechanical operations licit with such input information. Essentially the point at issue here turns on how finely we discriminate informational states, but it is not a point that bears upon the present argument, for I shall show that even if we take (1) in the manner just described it does not introduce the sort of reductionism envisaged. However, let me first say something about the question of the discrimination of informational states.

The matter may be put thus: Do we characterise informational states at a level where their input, if we are concerned with vision, is characterised as

(2) ⌜Presented object looks can-ish⌝,

or

(3) ⌜Shape *s*, colour *c* are presented⌝?

I do not think that there is a choice to be made here. In Chapter 7 I argued that all content is representational, so (3) still represents the world as having certain shapes and colours. And it seems undeniable that a plausible account of an infant's informational input

would utilise contents of a kind with (3). Further, that when one has inputs with content of a kind with (2) one also has inputs of a kind with (3). In the last chapter I individuated informational states at a level with those of kind (2), and this is surely right for capturing those inputs which reveal the belief-independence of perceptual illusions like the Müller-Lyer. But my discrimination of such states at that level does not preclude the possibility of discriminating states with non-conceptual representational content at a lower level. The only question concerns the relation between the two.[1] Viewed as a question about the genesis of a concept like 'can' the question may be put: 'Is the transition from having experiences with content of a kind with (3) to those with content of a kind with (2) a quantitative or qualitative transition?' More crudely, 'Is content of a kind with (2) just a matter of having a sufficient number of contents of a kind with (3)?' Put in this last way I think that the answer is clearly 'No', because the concept of a can is open-ended with regard to the sorts of content in (3). I shall not argue this point here for, as remarked above, whichever way it is taken (1) does not threaten the extensive range of experience that I shall develop. Furthermore, when once one sees how to take the sting out of (1), the above claim about the qualitative difference between states suitable to produce the content (2) and those suitable to produce the content (3) comes to be quite innocuous.

The result of making the above claim about the relation between (2) and (3) is to concede a point to Gestalt accounts of experience. Although the general drift of the distinction between informational states and belief states seems to favour a bottom-top processing in perceptual experience, the point about (2) and (3) seems to favour a top-bottom processing. I think the point to this is to say that as a matter of the operation of the cognitive machinery in perceptual experience the processing is often of a bottom-top variety. That is to say, the firing of some structure β_1 with the informational content ⌜can here⌝ is often activated by the firing of structures α_1, α_2 . . . with contents like ⌜shape s here⌝, ⌜colour c here⌝ etc., although I do not see that it must always be so. However, the content of the concept of a can is a matter of the relation between the structure

[1] This is another reason why I hesitated to draw too many comparisons with Dennett's work in the last chapter. I suspect he would favour the lower-level discrimination and would not accept my account of the relation between the two. I may be wrong about this.

β_1, and other structures β_2, β_3 . . . etc. of the same kind. This is brought out in the fact that when the structure β_1, is activated with content ⌜can here⌝ the subject would not test this content by checking the shape of the supposed object but by seeing if it could contain a liquid. Of course, in doing this, the subject is *ipso facto* learning about the object's shape, but it is not the particular shape that matters, only that it is suitable for holding liquids. This account of the relation between (2) and (3) is but a further instance of the general breakdown in type-type correlations between functional discrimination of states with content and the content of those states allowed for in the previous chapter with the Martians and bats and the contents, ⌜red here⌝, ⌜redfeel here⌝, ⌜redbounce here⌝. It is conceivable that an organism might have behavioural repertoires which suggest that it has informational states α, α_2, . . . etc. with the relevant contents about shapes without ever having states with the content ⌜can here⌝.

It is not necessary to see the relation between (2) and (3) as sketched above in order to see that (1) offers no challenge to the anti-reductionist nature of the anti-realist account of experience. Suppose that one thinks that the concept of a can *is* constructed out of contents like (3) in a stronger sense than conceded above. Suppose, that is, that the content in (2) just is arrived at through the summation of contents like (3). This does not give an evidentially basic range of experience; at best it only gives an evidentially basic *character* of experience. This follows from the argument in the previous chapter in which I defended a representationalist account of content and a non-representative theory of perception. The point is that whatever kind of content we are considering, be it content like (2) or (3), it is a content that represents the world as being a certain way. The difference between (2) and (3) is not a difference in the *range of objects* experienced by the subject, it is a difference in the representational character of our experiences of objects. Because the account of perception that was proposed and defended in Chapter 7 does not reify sensations (reify the representational character of experience), whatever the representational character of an experience it is an experience which represents the objective world as instantiating certain properties. The difference between (2) and (3) is not a difference between contents one of which characterises a basic range of experience beyond which one can only infer those states of affairs which are represented by the other

kind of content. The difference resides only in the qualitatively different information that the contents give of the world through their representing the world in certain ways. Put another way, contents like (3) are not contents of some range of protocol statements about shapes and colours, etc., they are contents which could only be captured by statements about the world saying that such-and-such shape properties were true of it. On a traditional and familiar model of the relation between contents like (2) and (3) their different qualitative contents are due to their being contents representative of distinct ranges of experience: that is, about different ranges of objects. If one thinks of the different levels of content as a matter of the application of different conceptual grids one can model this idea as follows:

Fig. 1 Subject → concept grid 1 → concept grid 2
 range of experience → sense-data → material objects

The thought is that the application of grid 1 gives one experience of sense-data and it is only through application of this level of content that one can proceed to an application of grid 2 and acquire knowledge of material objects. The relation between grids 1 and 2 would be something of the order 'All grid references (concepts) on grid 2 are functions of grid reference (concepts) on grid 1'. The point of putting grids 1 and 2 at different points on a line away from the subject is to bring out the idea that the admittedly distinct qualitative contents of these grids is due to their applicability to different ranges of objects. However, if we have a non-representative theory of perception in which the only objects are material objects then the two grids would have to be superimposed on each other if we were to represent the system with a figure analogous to figure 1. Something like the following might be appropriate:

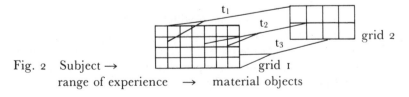

Fig. 2 Subject →
 range of experience → material objects

where the lines t_1, t_2, t_3 etc. are the lines of transformation for ˈ
constructing grid 2 concepts out of grid 1 concepts. But now, even
if one thought that contents like (2) were so literally constructed
out of contents like (3) this does nothing to delimit an evidentially
base class of content unless, implausibly, one held that the concepts
of grid 2 were reducible *in meaning* to functions of concepts on grid
1, and that is out of the question. After all, we are concerned to
provide an evidential theory of meaning, so any relation of import-
ance between these levels of content, if one level is to be evidentially
basic for a general theory of meaning, must be a relation of reduction
in meaning. Even if one thought that *such* a relation could be tenable
between levels of content like (2) and (3) there would be no reason
for thinking that one had thereby restricted the range of the objects
and states of affairs in experience. For one would only have a thesis
about how the general qualitative character of an experience could
be captured by some restricted qualitative character of an experi-
ence. However, such character would still be a character describing
the way the *world* is experienced. Even if you could capture (2) in
terms of contents like (3) the properties used in characterising
content (3) are still properties that represent the world as having a
certain region where certain shapes, colours and shades are jointly
instantiated. It is only through thinking that the properties utilised
in (3) are properties not of the objective world but of one's experi-
ence (the visual field) that one is left with any reason for thinking
that anything hinges on whether or not one can capture (2) with
contents of a kind with (3). Given that both contents are represen-
tations of the same region of the objective world, the mere fact that
there are *two* such contents makes it plain that the thought that one
might be exhaustively captured in the other is pointless and the
thought that they do not bear a relation of an evidential content
specifying nature innocuous.

I might add that I do not take the above discussion, especially
the metaphorical notion of concept grids, to make any claims as to
the psychological reality of our processes of object recognition. I
have only been concerned to pursue a conceptual point in justifi-
cation of my claim that the anti-realist theory of content is evidential
because of the logical structure of content, not because content is
capturable in some evidentially basic category of content specifi-
cation. Figures 1 and 2 only have a heuristic purpose. There are
doubtless many levels of content to be included in any accurate

account of object recognition that would do justice to the psychological reality of the operation of our perceptual capacities. The point that I have been concerned to show is that this does not introduce any idea about different ranges of objects correlative with such levels. The point of this is to capture the central thought to the non-reductive character of the present enterprise which might be expressed thus:

> Thesis NR: In moving from having an experience with one kind of general qualitative content to an experience with another kind (utilising a different conceptual grid) one's experience is still an experience which ranges over the same objects, viz. external objects. Changes in qualitative content give no reason for restricting (or enlarging) the range of objects experienced.

I take Thesis NR to hold in cases where different qualitative contents to an experience introduce new entities in explanation of phenomena: for example, the introduction of theoretical entities in science. Even in this case we are not dealing with an enlargement of the range of experience, but rather, a more specific characterisation of just the same region of the world. Someone who has an experience as of the presence of certain 'theoretical entities' differs from an ordinary experiencer only in terms of the different qualitative content of his experience, not in terms of experiencing anything that is essentially different. Of course, he does experience *more* objects, but not objects of a different range; that is, he has more *ways of characterising* the world, not more *world*. I shall devote the next chapter to handling this question about scientific realism so I shall say no more on the matter here.

2. A further constraint on ascribing content

Although there is no content specifying relation that obtains between experiences with different qualitative contents, there is an important relation that obtains which is a consequence of Thesis B from the previous chapter. Take the experiences in (2) and (3) above and call the respective kinds of experiences e_1 and e_2. Then the relation that obtains between e_1 and e_2 kinds of experiential content is this:

Thesis C: The ascription of an experience with content kind e_1 to an organism is constrained by the possibility of ascribing experiences with content kind e_2 to the organism.

The constraint here is the one mentioned at the end of the last chapter where I said that Thesis B served to show how behaviour constrained content ascriptions but did not characterise content. The same point holds between levels of content ascription. The constraint is a matter of the *intelligibility* of e_1-kind content ascriptions if e_2-kind content ascriptions are not possible. For example, could a subject have an experience as of a beer can without having an experience as of the object being a certain shape? Clearly, if the subject does not experience the object as being any particular shape at all then he cannot be experiencing the object as an *object*. Of course, it need not be the case that the subject's experience of the object as being a certain shape be a conceptual experience of that shape. The subject need not possess the concepts required for characterising the object's shape. But then his experience of whatever shape the object is need only be a matter of being in the informational state that the presented object has such-and-such shape. (The conceptual grid for e_2 characterises informational states, not beliefs.) So the claim to Thesis C need only be that if the subject is not aware (in the sense of behavioural control) of the object being any particular shape—the information of what shape it is plays no part in controlling the subject's movement in the environment and is therefore not part of his cognitive map of the environment—then there is no sense to saying that the subject experiences the object. Thesis C is but a general version of a constraint that has been employed throughout this work. Thesis C applies in those cases where the e_2 kind of contents figure in what I have called the *role* of e_1 kind contents. I shall not argue in favour of Thesis C in its general form here, partly because I take it that it is clearly true and partly because I now wish to argue for it in a particular case: our knowledge of other minds.

3. Other minds: the problem

The problem of our knowledge of other minds is easily stated but usually thought difficult to resolve. I believe the resolution of this

issue is a good dealer simpler than has seemed, and this is because the problem arises from a denial of Thesis NR and an oversight of Thesis C. We can state the problem by considering the relation between the following two statements:

(4) Smith is exhibiting pain-behaviour
(5) Smith is in pain.

The problem arises from a combination of (i) refusing to characterise the content of (5) in terms of the content of (4) (i.e. refusing behaviourism) and (ii) assuming that the content of (4) is a content of an evidentially basic range of experience (we can only experience another's pain behaviour, not his being in pain.) I take it that (i) is legitimate even though a presently popular method of handling this problem is but a variation of a denial of (i); I shall consider this shortly. If we accept (ii) and (i), it would appear that the only relation between (4) and (5) is that of (4) giving inductive support for (5). That is to say, the meaning of an utterance of (5) transcends what is given in the experience captured by the meaning of an utterance of (4) and yet because only (4) can characterise the content of an experience we can only ever inductively suppose that (5) is true (or false). The supposition that (5) is true is, at best, an hypothesis that accounts for experience characterised by (4). This is the problem of our knowledge of other minds. Either we see the relation between (4) and (5) as deductive, but that could only be to deny (i)—behaviourism—or we see the relation as inductive because we accept (i) and (ii) and then our knowledge of other minds is open to a straightforward inductive scepticism. The answer to this problem to be proposed here requires denying (ii), thereby admitting that one's experience can be characterised by contents of statements like (5) (adhering to Thesis NR); and yet constraining such experiential content by seeing the relation between (4) and (5) to be of a kind captured by Thesis C. The denial of (ii) is not easily accomplished, for simply invoking Thesis NR may not seem to the point or, if it does, leaves out too much about statements like (5) that seems to make them difficult as possible candidates for characterising experiential content. For example, if one claims that one can experience directly that another is in pain, exactly *what* is it that one is experiencing? This seems an apposite question that

requires answering. I shall do so below, but first I shall consider and reject a favoured solution to the problem.[2]

4. A common proposal rejected

It has become something of common currency to propose that there is an alternative way of denying (i) other than by adopting behaviourism. This is the way of saying that behavioural statements of a kind with (4) provide *criterial* support for statements like (5). Despite the popularity of the invocation of the notion of criteria with the claim that there is a third possible relation that might obtain between (4) and (5) other than deduction or induction, I fail to find the idea coherent.[3] Despite this, the criterial approach (whatever it is) is important, for it involves accepting (ii) above, since in so far as it claims not to be behaviouristic it accepts that the meaning of a statement like (5) transcends what is given in experiential content. The incoherence of the criterial approach comes out in its claiming both that experiential content is restricted to (4)-like contents *and* that this can constitute certain (non-inductive) evidence for (5)-type contents even though (5) is not reducible to (4); it does transcend the content of experience. It is precisely this acceptance of the thought that (5)-type contents transcend contents capable of specifying states of affairs available to experience that characterises the position I criticised Wright for taking in Chapter 4. It is this acceptance which characterises his readiness to give away too much to realism which I again criticised in Chapter 5 when I argued that a developed anti-realism had to make a more radical break with received wisdom than that occasioned by introducing a novel logical relation of criterial support. It is because

[2] John McDowell is the only person I know to have explicitly denied (ii), and his claim that we can have experiences with such content seems open to attack with the question just posed, precisely because he wants to deny that such a question has any point; recall the discussion of this in Chapter 2.

[3] The clearest and most comprehensive account of the proposed alternative is to be found in G. P. Baker's 'Criteria: a new foundation for semantics' *Ratio* 1974 in which he uses the idea to defeat scepticism of many forms, correctly noting that scepticism requires something like the combination of (i) and (ii) whatever the particular class of statements. Criterial talk recurs repeatedly throughout Crispin Wright's discussions of anti-realism; cf. his works already cited and also 'Anti-realist semantics: the role of *criteria*' in G. Vesey (ed.), *Idealism: Past and Present* (Cambridge 1982). A recent use of the same point as Baker's is to be found in A. C. Grayling, *The Refutation of Scepticism* (London 1985).

the criterial approach to the problem of the relation between (4) and (5) involves such acceptance of (ii) that I reject it. But even if one had reasons for accepting (ii) the criterial approach does not work. As already remarked, it seems incoherent to accept that the content of (5) transcends experienceable contents and yet contents of the latter kind, (4)-type contents, are partly constitutive of the content of (5)! This is surely impossible. Unfortunately, one has little scope for investigating the possibility of coherence here, for despite the popularity of the criterial approach no one has yet given a formal specification of the novel logical relation. A sympathetic assessment of the proposal is hampered by this lacuna. Even more worrying is the fact that despite claims to the effect that (4)-type contents are partly constitutive of (5)-type contents, I know of no attempt to specify just how this is so. I know of no attempt to specify the content of (5) either partly or wholly in terms of (4)-type contents that is not outright behaviourism. The problem behind the flaws in the criterial approach arises from an inability to see the relation between (4) and (5) as anything other than some method of content specification. Not liking an outright behavioural version of this, criterialists suppose they have a novel logical relation which does the content-specifying in a less objectionable way. But until we are given some examples of such content specification, or told just what the novel logical relation is, the proposal as a solution to our knowledge of other minds is a chimera. The correct way of seeing the relation between (4) and (5) is to see it as a relation of *content constraint*; that is, as an instance of Thesis C and I shall argue for this below. For the moment I only want to distance further the present work from the position of criterialists, like Wright, who although sympathetic to anti-realism feel that it must utilise some sort of criterial semantics because they take anti-realism to offer novel content specifications instead of content constraints. The criterialist move is a mistake and comes out in the acceptance of point (ii) above: namely, the thought that the content of (4) is of an evidentially basic range of experience or, alternatively, contents like (5) cannot characterise contents given in experience.

5. Experiencing that another is in pain

Clearly then, tackling the question of how one can admit that contents like (5) *can* characterise one's experiential input is going

to be essential for the development of an anti-realist solution to the problem of other minds. Given the argument of the first half of this chapter this should be straightforward. What argument is there for supposing that another's being in pain *cannot*, on occasion, be directly available to one's experience? What reason is there for denying the obvious fact that, on many occasions, a correct phenomenological description of our experience of others would have to include quite literal reports of the form 'I saw that he was in pain'? In situations where one has before one an individual who is badly injured, what could be more perverse than to deny that one knew that the man was in pain? Is it not that in such circumstances one simply recognises that the other is in pain? Indeed, is it not a part of a normal socialised human being's upbringing that it should provide him with just such a capacity for discriminating *pain* (not pain-behaviour) in others?[4] To all these questions the simple reply comes down to the following thought that,

(6) Pain is something over-and-above pain behaviour.

This is ambiguous. If the reason for denying the familiar phenomenology of our everyday recognition of pain in others is no more than the thought that (6) is true because the content of (5) is not capturable by (4)-type contents, it is not to the point. That would be to beg the question about whether (5)-type contents can enter into a characterisation of a subject's experience, and we are currently looking for a reason for denying our everyday phenomenology on this matter.[5] If the difference between (4)- and (5)-type contents lies not in the range of objects they bring to our experience but the richness of the qualitative characterisation of that experience, the irreducibility of (5) to (4) gives no reason for supposing that (5) cannot be an experiential input in its own right.

Perhaps (6) might be interpreted differently. Perhaps the thought is that, despite the immediacy (phenomenologically speaking) of our recognition of pain in others, there is still an 'unconscious' inference from (4)-type contents to (5)-type contents. We may not

[4] Cf. McDowell, op. cit. for eloquent defences of the idea briefly canvassed here. This is where I agree with McDowell, as earlier noted in Chapter 2. I agree with the epistemology, but not with the semantics and metaphysics.

[5] Of course, it might be part of our everyday phenomenology to admit that one cannot *have* others' pains or *feel* their pains, but that is a different matter from whether one can *know* that another is in pain.

recognise this, but it occurs, and because it occurs there is a sense in which (4)-type contents form a base level of experience.

The introduction of 'unconscious' inferential processes is highly suspect and is itself an ambiguous notion. In the present context it can be seen in one of two ways. In the first place the thought would be something like:

(7) Despite the immediacy of a subject's recognition that another is in pain what actually occurs is an inference of an ampliative nature (e.g. inductive reasoning or reasoning to the best explanation) from recognition of behaviour to the conclusion that the other is in pain.

But again, to make a claim like (7) is simply to beg the question at issue. It assumes that (4)-type contents are experientially basic with regard to (5)-type contents; it does not say why. And although something like (7) is doubtless popular, on its own it gives no reason for thinking that there is some error in taking at face value the common fact of experience that when I see a man scream as his finger traps in a closing door I see that he is in pain and have no reason for thinking that this is inductively, or ampliatively, based upon my seeing him behave in a certain way. In other words, if the concept of inference employed is simply that of ordinary inductive inference, or some other ampliative concept like 'inference to the best explanation', then (6) still begs the question against the idea that we typically possess perceptual capacities for non-inferentially perceiving that another is in pain. In short, it begs the question against the view that (5)-type contents can be directly available to consciousness, be an element of our experience and not a state of affairs inferred from experience. Perhaps then the second way of understanding the idea of unconscious inference provides a reason for doubting this.

Suppose the unconscious inference model were suggested because it was thought that it was required by considering the models of perceptual experience employed by cognitive psychologists. That is, the claim for such inferential processing comes to:

(8) Despite the immediacy of a subject's recognition that another is in pain what actually occurs within the subject's cognitive machinery is a complicated processing function with inputs about

behaviour culminating in the result that the other is seen to be in pain.

Doubtless, many will think that (7) and (8) are the same, but they are importantly different. As I remarked in the previous chapter, when agreeing with writers like Rock who see perceptual processing as inferential, I meant this only to concede that the processing was a processing of propositions. It is inferential in the sense that the atoms of the processing are states of affairs with propositional content (often non-conceptual representational content) because perceptual experience is exhaustively characterised by its representational content. This is what I take to be entailed by (8): namely, that there is some processing, which is a processing involving states with propositional content, which occurs when one recognises that another is in pain. This does not commit one to the sort of view in (7) where the processing is inferential in the sense of an inference taking the subject from what is experienceable to something that transcends the content of the experiential given. *The questions are distinct.* (4)- and (5)-type contents are contents employing concepts of different levels (grids); that is just to acknowledge that (5)-type contents cannot be characterised by (4)-type contents—behaviourism is false. Accepting (8) entails accepting that the firing of (5)-type concept grids may be activated by the firing of (4)-type concept grids. This remark is made in deference to models of the psychological reality of such experiences as handled by cognitive psychologists. (Think of concept grids like neural nets.) However, as argued in the first half of this chapter the fact that we are dealing with concepts of different levels (grids) with contents like (4) and (5) tells us nothing about whether or not the content of experience is restricted to characterisation in terms of only one of these grids. The argument of the first half of this chapter shows only that we are dealing with a change in representational content of experience when we proceed from the application of (4)-type contents to (5)-type contents. If one has the sort of cognitive machinery which manipulates the activation of (5)-type contents on the activation of (4)-type contents, one has a perceptual skill for applying (5)-type contents to one's experiences and what one experiences is that another is in pain. Of course, there is no reason for thinking that (5)-type contents must always be activated by the activation of (4)-type contents. At a general level the point of the preceding

discussion may be put in the following way: The question is about which concepts can be used to characterise experiential contents, but from what has been said about (4) and (5) it is plain that (4)-type contents might not figure in a characterisation of conscious experience at all; they might only figure in a characterisation of the informational states processing on which brings about the perceptual experience that another is in pain. The *subject's experience* is characterised by (5); the content of *sub-personal* states is characterised by (4). Of course, this is not always so either. Indeed in the case at hand most usually this will not be the case. But the general point holds. Note, this does not contravene Thesis B, which did not require that the subject be conscious of the contents of the state suitable for generation of states that conceptually represent the object as being in pain, or whatever. That is, (8) only entails that *experience* is a construction, not that experience of some states is a construction out of experience of others.

Because there is no question about different ranges of experience brought about by the introduction of different conceptual levels, there is no reason for denying the common experience that one simply can tell when another is in pain. One has a perceptual capacity for recognising such states of affairs. That another is in pain can be, and often is, the sort of content that characterises one's experience; it is as immediately available to consciousness as the recognition that another is behaving in a certain way. These are simply distinct representational contents of one's experience. It is also quite likely that, as a fact of the operation of our cognitive machinery, the having of experiences with the former content is often activated by having experiences with the latter. Nevertheless, in the former case we still have an experience with *that* content: namely, that another is in pain. But if that is so, there is no reason for denying the common-sensical thought that not only can one sometimes know that another is in pain on the model of perceptual knowledge, but this is often the simplest thing in the world to know. Such common-sense epistemology, as also its eloquent defence by McDowell,[6] is available to the anti-realist.

[6] Op. cit.

6. Private knowledge

The matter does not end here. Although I have argued that there is no important sense of 'inference' to support the idea that (5)-type contents cannot be contents of one's experience, the thought in (6) above may be interpreted in one last way so as to forestall the above result. Someone may claim that pain is something over and above behaviour in the sense that only the subject of pain can *know* that he is in pain; others can only surmise because it is definitive of such sensations that they are private in the sense of privacy of epistemic access. *This* thought is the object of attack in Wittgenstein's celebrated private language argument. I shall conclude this chapter by pursuing the point further, for it centres on the matter of seeing how (4) and (5) *are* related and seeing them related in the manner of Thesis C above: (4)-type contents *constrain* (5)-type contents.[7] I believe that this is the central point to Wittgenstein's argument, although I am not particularly concerned with the exegetical matter here.

Suppose that it is claimed that (5)-type contents cannot characterise experience because pain transcends behaviour in the sense of the sufferer's privacy of epistemic access to the pain. Such an idea conflicts with the only relation I take to hold between (4) and (5), a relation of content constraint as typified in Thesis C. This, in turn, is to deny that the sort of essentially private knowledge suggested in the envisaged objection *is* knowledge.

We can approach this matter by noting the following consequence of the preceding discussion. The notion of private knowledge is the only sense to the claim that pain transcends pain behaviour that I deny. In any other sense I admit the difference between pain and pain-behaviour. 'What greater difference could there be?'[8] As I have argued, the content of (5) is not capturable by (4)-type contents. There is no relation of content *specification* between (4) and (5). What then, it may be asked, *is* the content of (5)? What can be said about the concept of pain if its content cannot be specified by the sorts of predicates found in (4)? As in the last chapter with the concept of red, I do not think that there is anything that can be said about what pain is other than that it is painful. Pain is an

[7] The argument connects up with the concepts of role and *constraining criteria* as introduced earlier.

[8] Wittgenstein, *Philosophical Investigations*, section 304.

irreducible and ineliminable feature of the way creatures of our biological kind experience certain sorts of environments. If a creature lacks the physiology the activation of which is the state we call 'pain', it could never understand what it is like to experience pain. Of course, it may understand the function of pain as it is behaviourally discriminated. And if it had a certain sort of experience it called '*q*-pain' which had the same behavioural function as 'pain' but was due to a radically different physiology, there would be no reason to suppose that '*q*-pain' was any more like 'pain' than 'redfeel' is like 'red'.

Such thoughts about the irreducibility of 'pain' are but a consequence of accepting that one cannot specify the content of (5) with (4)-type contents. The concepts of pain and pain-behaviour, like crying, are concepts of different levels or grids, to use the earlier terminology. The logical space of 'pain' is delimited in terms of other phenomenological properties of experience like tickles, itches, tremors, etc. Given a general inability in articulating the logical contours between such properties of experience it is not surprising that behaviourism, in one form or another, has always seemed an attractive option. However, it is a mistaken option, for the only content specification available for 'pain' is to say that a painful experience is an experience that is painful. Only someone who is physiologically incapable of experiencing pain will find that puzzling. But taking this irreducibility of the concept of pain as a consequence of the argument that there is no relation of content specification between (4) and (5) might seem to lead to the sort of privacy of knowledge about pain suggested above. This would be for the following reason: If all that can be said about what a painful experience is like is that it is painful, does this not mean that the meaning of 'pain' is essentially a first-personal meaning graspable only by the subject who experiences pain? And this now means that we have to see why the sort of private knowledge envisaged is not possible.

7. Pain: role and constraining criteria

The irreducibility of 'pain' need not be seen as suggesting this possibility at all. After all, all that was said was that only a creature with the ability to experience pain would be able to know what it is like to have an experience which is painful, but this only makes an understanding of 'pain' relative to a *kind* of creature, not an

individual creature. Knowledge of what a pain is like is relative to creatures of a particular physiological kind; this carries no commitment to the idea that knowledge of a particular painful experience is relative to the *individual* who has the pain. Even so, I am concerned with a stronger rebuttal of the current objection, one that shows that the objection does not make sense. This stronger rebuttal is required both because the objection is so common and also because from what has been said so far about perceptual capacities for seeing that another is in pain it may be asked, 'What is one saying and what is one seeing when one says and knows that S is in pain?' This question cannot be adequately answered until the general rebuttal is secure.

The claim is that only the subject of pain can know that he is in pain, others can only surmise it. Wittgenstein's argument on this matter has received a mountain of commentary proportional to the many convolutions his argument takes. Although I take the following point to be central to Wittgenstein's argument I do not pursue it as a matter of interpretation, but because I think it is correct. In section 258 of the *Philosophical Investigations*, the notorious diary example, Wittgenstein considers the possibility of giving a wholly private sign for a sensation, private in the sense that only the subject knows what the sign stands for, and only he can know what it stands for. The crucial comment comes towards the end of the paragraph. Wittgenstein is concerned to find out how one might impress on oneself the connection between sign and sensation. He concludes:

> 'I impress it on myself' can only mean: this process brings it about that I remember the connexion *right* in the future. But in the present case I have no criterion of correctness. One would like to say: whatever is going to seem right to me is right. And that only means that here we can't talk about 'right'.

The importance of this section lies in the denial, in the last two sentences, that it makes no sense to talk of knowledge if there is no criterion of correctness. The usual construal is that Wittgenstein is claiming that the only criterion of correctness must be public. However, if that is the point it clearly amounts to a simple refusal to countenance the Cartesian idea of private knowledge and begs the question. Now I shall not pursue the exegetical question of what Wittgenstein meant here. Instead I shall offer an account which

flows from principles already defended earlier in this book. I believe it is reasonable to see this account as capturing Wittgenstein's çore insight, but I think that Wittgenstein, like his many followers, failed to make the point in a satisfactorily non-behaviouristic way that does not beg the issue against the Cartesian view.

First, let us agree that it makes no sense to talk of knowledge if there is no criterion of correctness. This flows from the Assertion Principle. My knowing that P, like my asserting that P, must be sensitive to states of affair that would render it false. The requirement of the criterion of correctness is simply an instance of the general constraint on knowledge, constraint C, that I have been employing throughout this essay. However, it does not follow from this that the criterion of correctness must be public. *That* is far too strong a result to claim and begs the case against the Cartesian view. We must proceed more cautiously.

Now the requirement of the criterion of correctness holds because of the thesis of the Independence of Truth. It is because a truth is independent in the manner given in that thesis that the knowing of a truth, like the assertion of a truth, must be sensitive to states of affairs that would render the knowledge claim, or the assertion, false. But then, by the Independence of Truth, the criterion of correctness, if not public, at least cannot be private in any sense that contravenes the Independence of Truth. Let us recall what this thesis is:

The Independence of Truth: If 'P' possesses a truth value, it possesses that value irrespective of any subject's claim that it possesses that value.

It is failure to provide for the Independence of Truth that underlies the worry about drawing the right/seems–right distinction.

Suppose that 'P' is the proposition 'I am in pain'. Suppose further that P is a candidate for truth. This assumption means that P must conform to the Independence of Truth. That is, my being in pain is a state of affairs *in the world*. If 'P' is true, it is an objective fact about the world that I am in pain. And, once again, all that is carried by the adjective 'objective' is that this is a truth which conforms to the Independence of Truth. But then, if 'P' is true it possesses that truth value irrespective of my claiming that it does. If it is *true* it is so irrespective of its seeming so to me. This then

secures that there is a right/seems right distinction, the question now is: Can the subject draw *this* distinction in private?

If I claim that *P* my claim must be sensitive to states of affairs that would render the claim false, but could it not be that *I* recognise the sensitivity of my claim to such states of affairs in private? That is the point at issue. Put another way: If I assert that *P* I must have ruled out certain states of affairs, states delimited by the *role* of '*P*' but why could not the role of '*P*' be delimited privately? Well suppose this could be so. That is, I claim to know that *P* and I conform to the Independence of Truth. My claim is sensitive to states that would render it false, because in claiming that *P* I take myself to be ruling out that *Q*, where '*Q*' is some state such that its truth value is also the subject of private knowledge by myself. That is, the Cartesian builds up the objectivity of his knowledge claims by building up a realm of facts, or area of discourse, the interplay between which provides for the Independence of any one truth within that realm. This, surely, is the idea behind the Cartesian privacy of the mental. But note that it only provides for the independence of truth for any one claim within that realm as measured against others, and this matters.

The problem here is this. For any particular claim within the privileged Cartesian realm, the Independence of Truth is met relatively to other truths within the realm, but the realm as a whole fails the independence of Truth. This might not look to be important. After all, for any knowledge claim whatsoever, we can only meet the Independence of Truth for it relatively to taking other things as true. That is so, but this obvious and general relativity of our measurements of truth value is not the point. The point is that the Cartesian posits a special class of truths which form a system *independent of all other truths*. He posits a class of truths that fail to engage with truths in general. In short, in the terminology of Chapter 2, he posits a discourse which is *closed*, the knowledge claims of which are *dislocated*. That is to say, the problem about the drawing of the right/seems–right distinction is not to do with a public/private demarcation; it is to do with the dislocation of knowledge claims made within areas of discourse that are essentially closed. The point is not an epistemological one about the possibility of an individual gaining private access to knowledge. It is a metaphysical point about what it is the individual must have gained access to if what he has is knowledge.

This way of looking at the problem captures much that is relevant to an interpretation of Descartes. After all what is so interesting about his philosophy is the conjunction of his recognition that objective knowledge must stand in need of support and justification with the idea that this requirement for foundations can be supplied in an intuitive and first-personal enquiry. It is the attempt to hold both these ideas in common that provides the continuing interest in the Cartesian philosophy. In effect, I am suggesting that, with regard to the first conjunct of the Cartesian position, Descartes might recognise my constraint C as an attempt to reveal the objectivity of our cognitive claims. The second conjunct of the Cartesian position is problematic precisely because it is incompatible with the first.

Perhaps the Cartesian might object to the assumption I made above that the proposition 'P' is a candidate for truth. This assumption means that P must conform to the Independence of Truth thesis and it renders the state of affairs that P a fact 'in the world' as I put it before. But this just reveals the whole problem with the Cartesian position. For if the Cartesian says that the fact that P is not a candidate for truth, it is not a fact 'in the world'; that leaves us in the dark about what kind of proposition it is. Descartes would not, I believe, have taken this option. His being in pain is a fact in the world, an objective state of affairs because, of course, although no other *human* subject can know this, God can. For Descartes, the objective is closely connected with what can be known by God; God is the measure of what there is. But this, of course, is of no help to present enquiries. It merely puts greater weight on Descartes' arguments for the existence of God and, as noted in Chapter 2, such arguments comprise one of our commonest examples of dislocated knowedge claims issuing from closed areas of discourse.[9]

The problem then with private knowledge is this: It fails to engage with other truths and thereby fails the Independence of Truth. At best it can only engage with other claims of truth which,

[9] The connections between Descartes' use of God and his concept of objectivity have not, I think, been satisfactorily traced. It remains open for the Cartesian to protest that there *is* something objective about the truth of claims made within the closed discourses of religious belief and first-personal talk of the mental. But then the onus is on the Cartesian to say what this is. If we start with intuitions about objectivity as formulated in Constraint C and the Independence of Truth, I have to say that I can see no room left for the Cartesian protestations. But here I simply wait to be told better.

like itself, form a protected and closed system of claims which, as a body, fails the Independence of Truth.

How then does a claim to know that *P* engage with truth, meet the Independence of Truth? A claim to know that *P* must be sensitive to states that would render it false; it must rule something out. What is ruled out depends on the *role* of the concept of pain; it depends on what the *constraining criteria* are for propositions like *P*. Here we get the connection with behaviour and Thesis C. For *our* concept of pain just is a concept such that if I say that I am in pain I rule out the possibility that my behaviour proceeds in certain ways. The role of the concept of pain, not its specification, includes behavioural concepts. The constraining criteria for an assertion of *P* include propositions about my behaviour. But then, with regard to our knowledge of other minds and Thesis C, this means that an experience as of another being in pain is constrained, as in Thesis C, by the possibility of experiences of the other behaving in such-and-such ways.

The relation between statements like (4) and (5) is one of content constraint: it makes no sense to suppose that the concept of pain is applicable to a subject if there is not, in principle, any way in which the subject can manifest the pain.[10] This leaves the content of 'pain' irreducible, but not so free as to be dislocated from the sorts of predicates employed in (4)-type statements. This does not threaten the earlier argument about our possession of perceptual capacities for detecting that another is in pain. One may well have a capacity non-inferentially (in the appropriate sense) to detect that another is in pain, but the possession and operation of such a capacity is constrained by one's ability to manifest one's detection by defending it with the appropriate means employing concepts of the constraining level—in the case at hand, behaviour. (There is no reason to rule out the possibility that non-behavioural, physiological, concepts might be employed in the constraining of the concept of pain.)

What Wittgenstein called 'criteria' I am taking as *constraining criteria*. We do not have here a novel logical relation of an evidential nature to be employed in content specification, but a restriction on concept application. If the concepts employed in (4)-type statements are not in principle applicable it makes no sense to think that the

[10] Cf. Wittgenstein's remarks about the stone in *Philosophical Investigations*, sections 283–4.

concept of pain is applicable. One result of this is to rule out a Cartesian conception of pain, for it is definitive of such a conception that pains have the sort of privacy of epistemic access against which I have been arguing. However, in terms of traditional metaphysical categories for pains, that is *all* that is ruled out. A form of token/ token identity theory is, I believe, the most complementary theory to the thesis of the irreducibility of the concept of pain argued for here, but I shall not attempt to traverse such areas of debate. For one thing, once the relation between (4) and (5) is seen as above, questions about the metaphysics, the bare truth, of pain-talk lose much, if not all, of their interest. One can summarise the foregoing point as follows. Does knowledge of the satisfaction clause for 'pain', i.e. knowing that

x satisfies '. . . is in pain' iff x is in pain

suffice to account for an understanding of 'pain'? In saying that 'pain' is irreducible I am ruling out the idea that there is a substantive debate about what sort of states of affairs the right-hand side of such a clause picks out. The thought that such debates have point is the thought that a Tarskian truth-theory needs supplementation by a theory of primitive denotation and primitive satisfaction. (The criterialist is party to such disputes in wanting to engage in content specification of the right-hand side.) *All* that I am criticising is the use in such clauses of the verb 'to know'; that is, as long as the knowledge of such a clause is constrained by its manifestation conditions, knowledge of such a clause *will* suffice.

A further result to be noted is this. My account of the relation between (4) and (5) allows that one might understand what is being said of some particular person on some particular occasion that he is in pain even though he is not manifesting it. The concept of an undetected pain, or undetected-at-that-time pain, is perfectly intelligible. What *is* ruled out is the concept of an in principle undetectable pain. We can understand the notion of pain, on occasion, transcending the behavioural (or physiological) manifestations of pain, but not that the concept could in principle be dislocated from its manifestations. However, this also means that although the concept of an undetected pain is intelligible, there is no ground for supposing that it makes sense that the applicability of such a concept is determinate. That is, although I may understand

(9) Smith is in pain

said of Smith who is not manifesting that pain, this gives me no ground for thinking that (9) is determinately either true or false. I have no reasons for thinking that the *applicability* of the concept can so transcend experience. This is important, for it has been argued[11] that it is essential for having a proper grasp of the concept that one understand what it means to say that another is in pain even when the subject is not manifesting it. The *possibility* of stoicism is an essential part of the concept of pain. This is right, but it is wrong to think that *this* grants us a concept of truth that transcends experienceable truth. What it gives us is an understanding of a concept that transcends an understanding of its manifestation concepts. But this is no more than another way of putting the point about the irreducibility of 'pain' to (4)-type concepts. It does not give us a grasp of how the application conditions for a concept can transcend its manifestation, they cannot. The whole point of seeing the relation between (4) and (5) as one of content constraint is to acknowledge that although the content of (5) is not reducible to (4), it makes no sense to think that (5) is applicable if in principle (4) is not. But then, on any particular occasion, if (4) is not applicable that leaves us no way of knowing whether (5) is or not; bivalence fails. For if (4) is not applicable any non-inferential capacity to recognise the applicability of (5) is dislocated. The point about stoicism only shows how irreducible the content of the concept of pain is: it does not concede a grasp of recognition-transcendent truth.

8. In conclusion

It remains for me only to return to a few questions posed earlier on. What is one doing, what is one seeing, when one sees that another is in pain? Can one really see their pain? What is one doing when one says that another is in pain? The answers to these questions come from earlier chapters in this essay and, after the preceeding argument, should not now be so surprising. Given the general account of experience in the previous chapter which excluded the reification of sensations, the question about whether

[11] McDowell, op. cit.

one can literally see another's pain is not so difficult. If a subject Smith steps on a pin, it is in his foot that the pain is to be found, and we can see injured feet, painful feet. There is nowhere else for the pain to be, especially no privately accessible Cartesian realm; any more than when Smith looks at a red apple there is anything other than the apple which is red and *we* can see red apples too. However, perhaps it will be said that we only see the foot, not its pain. But this is a confusion. A pain is not a *thing*, it is a way the subject's foot appears to him when he does things like treading on pins. We need only the thought that we can see *that it appears thus to him*, just as we can see that an apple appears red to him. In both cases we need to know that the subject is physiologically similar— he is not having q-pains or experiencing 'redfeel'—but otherwise it is that he has a painful foot that we take as something available, on occasion, to consciousness. If there is any residual hostility to this, it is answered by considering the question: What are we doing in saying of another that he is in pain?

Given the general falsificationist stance of this overall enterprise, the assertion of (9) is, like all assertions, basically ascriptive. It is to say that one's experience is such that one takes this to be a survivable account of it. If the account is arrived at through the operation of the sort of non-inferential perceptual skill discussed earlier in this chapter, and if it survives, then we did recognise that the other was in pain. To say that another is in pain is to make certain constraints on future experience on pain of having one's initial assertion/claim of recognition defeated. But if either survive, the man was in pain and one saw that he was. It is, therefore, sometimes the case that one knows, as well as one knows anything, that another is in pain. Our experience includes such states of affairs.

The Range of Experience: Theoretical Entities in Science

The proposal that we can characterise effective decidability for empirical discourse in terms of our possession of non-inferential perceptual capacities has application across the board. I have argued that it can be used in an account of our knowledge of other minds, and also take it applicable in giving a cognitivist account of moral values. However, this latter issue would take us too far beyond the confines of this book. Instead, in this concluding chapter, I shall concentrate on how the proposal fares in dealing with our knowledge of so-called 'theoretical entities' as discussed in the philosophy of science. I choose this area because it is often thought that, however else realism may come under attack in other areas, when we turn to the philosophy of science it is the only reasonable position to adopt. In considering the range of experience in terms of the philosophy of science argument I shall also attempt to rebut the calm assurance with which realism is taken to be essential for a workable account of science and indicate how anti-realism can give as good an account. In doing this I shall be arguing, in part, that scientific realists have yet to produce any arguments for realism. I shall show how the sort of direct realist theory of perception so far defended is straightforwardly extended to the case of theoretical entities in science.

1. Semantic squabbles

An immediate response to this suggestion might be to say: 'Might it not be the case that philosophers of language and philosophers of science are using the term "realism" in different ways?' This is, I think, undoubtedly the case.[1] So I shall restate my claim: Scientific

[1] Cf. P. Horwich, 'Three forms of realism', *Synthese* 1982, who complains of the diversity of meaning and proceeds to make a tripartite distinction between what he

realists have yet to produce any arguments for a position that
would entail all of the things they seem to want under the heading
'realism'. In particular, I want to claim that they have yet to
produce an argument to support the idea of science as a progressive
enterprise which converges upon the truth.[2] In fact, given that I
shall be arguing that anti-realism can accommodate the literal
construal of theoretical statements, I think this convergence should
be taken as definitive of scientific realism. It is, I believe, the only
thing that the anti-realist need deny and, what is more, it does
precious little work in giving a workable account of science. To
elucidate a little further, let me remark that the commonest ambi-
guity in the term 'realism' is of central importance to my argument.
Sometimes people use the term to speak of what I call *ontic commit-
ment* and sometimes to speak of what I acknowledge as realism. The
former is the view associated with such claims as, for example, that
there are electrons (or there *really* are electrons); *there are* pains; *there
are* libidinal forces; *there is* a material dialectic; etc.[3] Accepting ontic
commitments in such cases is another way of putting the point about
the irreducibility of various concepts that figured in the discussion of
'pain' in the last chapter. The latter reading of the term 'realism'
is the view that there are things, of whatever kind you like, which
exist independently of the possibility of our knowledge of them. For
example, if we believe that there are electrons then we are realists,
as well as having an ontic commitment to these things, if we believe
that they exist, and always have existed, in a manner that is inde-
pendent of whether or not *we* shall ever have knowledge of them.
The first part of my thesis will be concerned with sketching an
argument to show that these two questions—Do we have an ontic
commitment to things of kind F?, and Do we have a realist under-
standing of things of kind F?—are separable, because the anti-realist
can accept an affirmative answer to the former. More directly, I
shall show how the anti-realist can argue, *contra* instrumentalists

calls epistemological, semantic and metaphysical realism. However, his distinction
is ill-made because he assumes that adoption of a verificationist semantics precludes
the taking of theoretical statements as literally true (what he calls semantic realism)
and this is precisely the assumption that I shall be arguing against.

[2] Cf. R. Boyd, 'Realism, underdetermination and the causal theory of evidence',
Nous 1973 for the idea of convergence in science.

[3] I take the 'there are . . .' seriously, to be read in a manner *not* admitting of a
positivistic reply, 'Oh, there are electrons, etc., but what *this* means is to be couched
in terms of some set of statements about some other class of (observable) entities.'

and positivists, that we do possess knowledge of theoretical entities. I shall then show that this is a separate question from that of whether we are able to understand so-called 'theoretical' reality in a manner to warrant a realist philosophy of science. The second part will consist in rebutting objections to my position and drawing some general consequences of meaning-theoretic anti-realism.[4]

2. Two concepts of 'theoretical entity'

I begin by noting that there is a case for contrasting two distinct definitions of the phrase 'theoretical entity'. In the first case this is defined in terms of those entities which are contingently outside the range of our experience as considered with regard to its natural sensory limitations; secondly, in terms of those entities which it is not possible for us to experience. Entities in the first category are those sorts of things which positivists were so suspicious of, microparticles being the prime example. These are the sorts of things that might lead one to say, 'You cannot see *them*, only their effects on the apparatus.' They are the kinds of things positivists would have denied could enter into a characterisation of experience. The point of this first notion of theoretical entity is that it is defined with respect to our perceptual capacities in some 'normal' state. Normal human vision does not allow *direct* (in some meaningful sense of that word) observation of electrons, most bacteria, etc. The second notion is defined in terms of that of which it is impossible for us to experience. The point here is to cover objects which would remain unobservable even if our powers of observation were extended to cover perception of, for example, much smaller objects. The kinds of example I have in mind in this second sense might be: the ether, Lockean substance, or God.[5] My argument for the compatibility of anti-realism and the rejection of a positivistic account of the ontological import of theoretical science begins with a critique of the first notion of theoretical entity.

What do we mean by saying that some entity is observable? Why is the issue so important, and why has it dominated the philosophy

[4] I have argued for the first part of this argument elsewhere, but in a different fashion. The present argument, although related, concentrates on different issues. Cf. my 'Verification, perception and theoretical entities', *Philosophical Quarterly* 1982.

[5] I mention God in this respect only as He figures in much contemporary philosophy of religion, as a being the experience of which is a matter of faith and not of justifiable cognitive experience.

of science? The answers to these questions no doubt lie in a certain historical context; the context of empiricist thought since Locke. More interestingly, I think we can do justice to the importance of the concept if we take the observability of an object as a matter of whether or not we can have effectively decidable evidence for its existence. Or, we might say, it is a question of whether or not statements about an object are effectively decidable; statements which are to do centrally with the object's position and essential characteristics. I only speak of *an* object's effective decidability (or, the decidability of statements about *it*) and not of the effective decidability of a *class* of objects of some kind. This is important for in wanting to unearth some of the problems in our notion of observable and theoretical entities, it is important that we do not pre-judge the issue by thinking that we can antecedently delimit a particular class of objects as not effectively decidable because, for example, they are unobservable to the naked human eye. Characterising the observable as the effectively decidable is particularly perspicuous for the importance of whether or not an object is observable then comes to the question of whether or not we have effective evidence for its existence. Can we really say that it determinately either is, or is not, there? This is the issue that lies behind the observable classification. According to traditional empiricism, only of those objects for which we have direct sensitivity can we say that they determinately exist or not. Because this traditional mould has so constrained *all* philosophies of science, both realist and non-realist, the concept has come to be of paramount importance. But now, in making the point of some classification of entities into observables and unobservables that between those for which we possess effective evidence and those for which we do not, we face the question of whether or not the normal understanding of the phrase 'observation statement' includes all and only all the statements that are effectively decidable. It is in showing how this question should be answered negatively that I criticise the first definition of theoretical entity.

3. Perceptual skills and effective decidability

Developing the argument from the previous chapter the manner of the proposal is to allow that, in a great many cases, we simply recognise the assertibility of the statement concerned and do so in

a manner that is not inferential upon our assessment of the assert-
ibility of statements of some other non-trivially different class. On
the proposal that I have to offer we generalise this point and make
our knowledge of empirical reality dependent upon and defined in
terms of our possession of certain perceptual skills—skills which
allow us to directly ascertain the assertibility of a large number of
statements. When I say 'non-inferential' I mean this to be taken in
the way of the last chapter. That is, I acknowledge the operational
complexity of such perceptual skills but hold that the relevant
content of a statement about a theoretical entity is a content that
can characterise experience.

What would be an example of such a skill and in what sense is
it direct? To take the second point first, I mean that such skills are
direct in the sense that no inferential processes are required for the
operation of a perceptual skill although it may often be the case
that the activation of a recognition of an object is triggered by
an activation of a perception with content with a lower level of
informational content. The non-inferential thesis is simply thesis
NR of Chapter 8. I would further require that the claim that
someone possessed a skill to recognise n perceptually only makes
sense if that person possesses information to defend his recognition
if it is challenged (Thesis C). But this is not to say that the percep-
tual skill is reducible to such knowledge, nor that operation of such
a skill proceeds via some mysterious implicit inference involving
those inferential procedures which *would* be invoked *were* the percep-
tion challenged. To insist on possession of such back-up knowledge
which can be used to support a perception is the imposition on
the intelligibility of such a knowledge claim discussed in previous
chapters. If I say 'I know that p' or 'I see n', then, to ascribe such
knowledge intelligibly, in the first case there must be a body of
information to be called upon in defence of the knowledge (this is
the point of Chapter 2) and, in the second case of recognition of
particulars, the agent must be cognizant of this body of information
(this is the point of Chapter 6). The proposal is that the operation
of such a skill is, in itself, *ceteris paribus* a *bona fide* act of cognition.
Furthermore, although it is only intelligible to ascribe a skill for
recognising n to people if they possess the knowledge required to
support a particular perception if challenged, the knowledge
acquired through the operation of such a skill is direct in another
important way. When someone is mistaken in their claim to perceive

n this need not be construed as due to an erroneous inference. After all, the claim is that for the operation of such a skill no inference is required and therefore, in the mistaken application of such a skill, no fallacious inference is required either. This point serves to give such skills a defeasible character. For example, if a technician mistakenly claims to observe an influenza virus on his microscope slide, this need not be because he has made an erroneous inference from more basic and directly perceived facts which 'support the hypothesis' that the entity is as it is claimed to be. The error may simply be due to the fact that the technician is not altogether reliable in his craft: he is not a particularly skilful technician. Perhaps his lack of skill in differentiating viruses may be apparent in his rudimentary and faltering efforts to defend his observations when questioned, but this should give no reason for thinking that his error each time relies on a faulty inference. Of course, it may sometimes be so, particularly when we are in the process of training such a technician. But there comes a point when he can quite simply and non-inferentially effectively decide the assertibility of some statement like 'There is an influenza virus'. He does so immediately and non-inferentially. All I need to emphasise now is that such errors need not *always* be construed as perceptual inferences gone astray. This point about such perceptual skills is extremely important. It might be thought that a virtue of the positivist position resides in the fact that *mis*-perceiving that *x* is an influenza virus is consistent with genuinely perceiving that *p* where '*p*' is a statement of a more basic and less theoretical nature. The error of thinking that this is a virtue is part of the general error of thinking that all mistakes, at least in perception, must be inferential ones. For although I will be charged with being unable to account for mistaken perceptions without recourse to statements about how things *seem* to us, this charge is deflected through consideration of the above point. The perceptual skill for identifying influenza viruses is defeasible just because it is a skill, a craft that has to be learnt, like the more primitive perceptual skills we acquire in the cradle for identifying nearest and dearest. It is not that perceptual recognition need not employ any inferential thinking, but that it need not embody any thinking at all.[6] It involves the possession and exploitation of knowledge previously acquired. It is a matter

[6] G. Ryle, 'Sensations' in R. Swartz (ed.), *Perceiving, Sensing and Knowing* (New York 1965), p. 202.

of directly applying to the experiential world concepts of a particular level (grid). The mistaken laboratory technician may simply not be, very good at his craft, and even the good one may be caught out in difficult cases. The example of the laboratory technician is just one example of the kind of perceptual skill I have in mind. Others would include the trained physicist's ability to spot particles in cloud-chamber experiments; the naturalist's ability to discriminate the flora of the British Isles; the physician's ability to feel a hernia or an enlarged liver; a sonar operator's skill in observing the approach of hostile forces; the ornithologist's skill in perceiving the calls of different types of bird.

Now it might be thought that although the above considerations suffice to make the point that such perceptual skills are non-inferential in the sense that the perceiver employs no *conscious* inferences in the process of recognition, there is a more subtle sense in which they are inferential. It might be claimed that despite an undoubted non-inferential immediateness with which the trained physicist detects the presence of an α-particle, when we come to ask the question 'In what does his possession of such a skill consist?' we find that the skill has to be conceptually analysed into the detection of certain more superficial phenomena like the appearance of a greenish streak in the cloud chamber plus certain more theoretical knowledge. Now I am unclear what the motivation for this might be. One motivation which must be discounted is that the best explanatory work on perception by cognitive psychologists shows that perception *is* inferential in a relevant manner. Such a thought seems confused and has been criticised earlier in this essay. As already conceded, our perceptual skills as studied by psychologists are information-processing systems. There is *a* sense in which perceiving an object as of a certain kind can be a matter of processing information of, as we might say, a lower grade of content than the information that x is an object of kind k. For a computer simulation of this we might at a first approximation do something like the following: Divide the electrical signal carrying the input in a manner that is isomorphic with dividing a television picture produceable by the signal into a $n \times n$ grid. That is, make a series of n^2 divisions through the signal through time such that, where t is the time interval for transmission of n^2 signal values, the first value of interval t_1 is taken to be the value for the same portion of the visual field as the first value of interval t_2, and similarly for the

second, third . . . n^2th values of t_1 and t_2. We then programme the computer to count certain distributions of signal intensity across these n^2 divisions, where the distributions survive over a specified number of time intervals as constitutive of an observation of x. Such procedures are a very crude way for modelling perceptual processes however much thinking along the lines of such models infects traditional worries about the inferential nature of perception. They are hardly pertinent to the present enquiry. Aside from the fact that such step-wise attempts to model pattern recognition in computers are notoriously inadequate at even a crude approximation of human pattern recognition,[7] they still could not tell us anything of relevance to the present discussion. For the atoms of such modelling are the intensity values for each of the n^2 divisions of the signal in a particular time interval. What these provide analogues for in human visual perception is the individual values of stimulation at the individual rods and cones at the back of the retina. Or, if we took our atoms to be the functions of n^2 values across a whole time interval t, we would be producing an analogue for the stimulation across the whole of the retina at any one moment. But all this is simply irrelevant to the questions currently of interest. To think otherwise is to confuse the causal question of what happens when we perceive x with the logical, conceptual question of what it is to perceive x. The latter question is concerned with what one would have to say, for example, in justification or defence of a claim to perceive x and apart from the fact that we know nothing of the pattern of stimulation of rods and cones when we perceive x such facts could play no part in such justifications or defences. They are not the right sort of thing to which one should appeal. Even if it were thought that such discrete informational states as individuated at the level of rod-and-cone stimulations had informational content, there is still no pertinent way in such information is an inferential base for the recognition of the object x. A claim to have perceived the object is not reducible in content to such information, Thesis NR.

Without such confused appeal to the facts of psychological investigations it is not clear what ground there could be for saying that possession of a perceptual capacity for recognising xs *consists in* one's discrimination of certain features of experience F_1 . . . F_n where these are of some epistemically more basic kind and are, for example, the

[7] For a useful survey of models and the problems involved, cf. P. C. Dodwell, *Visual Pattern Recognition* (New York 1970), especially chs. 5, 6.

features appealed to when training someone to perceive *x*. Of course, I do want to claim that possession of such a capacity requires sensitivity to the appeal to certain features of the environment in defending a claim to perceive *x* if that claim is challenged (Thesis C), but this is not the same as saying that the initial perception requires that one should perceive *x* *by* perceiving such-and-such features. When the physicist claims that he has seen an α-particle cross the cloud chamber he does not simply defend his claim by saying that he has seen a vapour trail! The temptation to say that this alone, or for the main part, is constitutive of what he really sees, as opposed to the interpretation on what he sees, is a mistake. What we have here are different qualitative contents of experience, nothing more. Take the case of our perception of meaning in a language. The fact that a unilingual Frenchman cannot perceive the meaning of the present sentence, although an English speaker can, cannot mean that the competent English speaker, although perceiving the same things—the marks on the page, *also* places an interpretation upon these marks. This cannot be right, for it would make the fact that a given set of symbols can mean something had to be explained in terms of the language user's ability to perceive these symbols as encoding a meaning otherwise grasped in his prior ability to perceive meaning in some other language, perhaps that of his private thoughts. And that only removes the question of how one can perceive a set of symbols as having such-and-such meaning to the question of how one can perceive one's private language as having meaning, and that is not to answer the question at all. Now there are doubtless good grounds for thinking that perception of meaning in an utterance or inscription are rather special cases, or at least sufficiently dissimilar to that of perceiving *x* as of a certain kind of entity to be pertinent to the present discussion. However, one point bears comparison. We feel inclined to say that when, for example, one learns a foreign language a totally new range of experiences becomes available. Sure enough, they are the same old things such as listening to people asking the time, discussing the weather, ordering a meal, or killing a reputation, but they are also new in that they are experiences that one would have gone without prior to one's instruction in the new language. Similarly, the trained physicist is not simply colouring old images with new interpretations, he is having new experiences opened up to him. As remarked above, the sort of features he will refer to in defending his claims

are not of the kind one would expect under the view that I am criticising. He does not say 'But I saw a vapour trail'. He is more likely to appeal to such facts as, for example, that its angle of deflection was d, its velocity was v, etc. The relevant defeaters are every much a part of the new experience as the claimed object of experience. To be sure, he must pay attention to vapour trails and the like in acquiring his skill, but that is not disputed here.

In the context of the discussion of the last chapter we might expect a psychologist to point out that in order to model the new experiences of the trained physicist or, for example, those of the trained physician who had previously only felt grossly distorted tissue and now feels a hernia, we would have to increase our division of the input signal within the time interval t from n^2 to many times that number; that is to say we introduce conceptual apparatus of a new level or grid. It is not just the old elements of experience plus noticing new relations between them, it is a wholly new experience. It is an experience which employs a new conceptual grid. And although this may fill the world with new objects it also fills experience with new objects. I acknowledge that the temptation to think that there must be a basic given is strong, but I think it is no more than a temptation and one for which there are no adequate grounds.

Of course, given the falsificationist semantics of the present enterprise the temptation to think of perceptual skills as cashable, in principle, into perception of epistemologically favoured units of experience is further resisted, for when a perceptual claim is defeated we simply acknowledge that there need not have been any*thing* of the relevant kind which it was about.

From this stage, the step to the unproblematic and direct knowledge of supposedly 'theoretical' entities is but a small one. The problem of our knowledge of these entities has been nurtured in the hotbed of an erroneous theory of perception. When once we accept the notion of a perceptual skill; when once we accept the consequent division of labour among the community, and note the essential learnability of these skills, then we have no need to worry that our knowledge of things perceived via the operation of such skills is, in any interesting way, inferential in a manner to threaten the cogency of this knowledge. In any meaningful sense of the word, such knowledge is direct. The fact that we have to use inferential processes in defending such a perception if its veracity is doubted tells not one iota against the view that in operating such skills we are gaining

knowledge of objects to which theoretical vocabularly refers. The instrumentalist may object along the lines that the skills are, in another sense, indirect due to the intervening causal processes (ICPs) involved in such perceptions. For example, the physicist needs his cloud chamber, the technician needs his microscope, etc. I have considered this point elsewhere, and it does the instrumentalist no good. I shall not repeat the argument here.[8]

So there we have it, or so it would seem: a sketch of an argument for realism in that sense of the word which insists that there really are electrons, there really are pains, there really is a material dialectic, etc. However, it would be a mistake to think that this has any bearing on the issue of realism as has been the subject of this book. To think that the issues of ontic commitment and realism come together is to confuse two separate issues which I shall now pull apart.

4. Reference and realism

I observed that the instrumentalist may object that there is a sense to the direct/indirect distinction in perception that has to do with the question of ICPs in the perceptual process. There are two distinct issues raised by this. It is uncontentious that in order to perceive certain kinds of entities we must be in possession of various kinds of sophisticated technology. While rejecting the idea that this *in itself* threatens the adequacy of our knowledge of such entities, there is a further point concerning ICPs to do with the fact that this very dependence on them threatens our ability to ascertain determinately the assertibility of statements about these things. That is, on many occasions, the relevant technology is simply absent or, if at hand, we are not trained in its operation. For example, although there is nothing wrong with the claim that the trained physicist, in watching a cloud-chamber experiment, sees and knows that there is such-and-such kind of particule before him, what about the claim that such a particle is crossing my study now? For example, we have effective decidability for the statement,

There is an α-particle at x, y, z, t

where the spatio-temporal co-ordinates refer to a region of space-

[8] Cf. my 'Verification, perception and theoretical entities', section 4.

time falling within the confines of the relevant detection equipment. Such effective decidability resides in the trained operator's skill in seeing such an entity. However, such skills are dependent on the ICPs. When the technology is absent, have we any reason to suppose that some statement about an entity detectable with that technology is determinately either true or false? That is, do we so understand statements about 'theoretical' reality in a manner for us to be able to say that they are determinately true or false independent of the possibility of our coming to know of their truth or falsity? Anyone familiar with Dummett's work on realism will recognise the measure of this question. It is the central question Dummett has pressed upon us, save only for the intrusion of the phrase 'theoretical reality'. My point is that there is no particular importance in referring to regions of reality as 'theoretical'. Our knowledge of such regions of reality is as good as our knowledge of others. This is why I say that in the sense of the word 'realism' to do with ontic commitment, anti-realists should have no worry about embracing an ontic commitment to entities which instrumentalists and positivists shunned. Anti-realism has no truck with such reductionist theses. But now, the question that remains is this: Does our understanding of our language reveal a conception of truth that guarantees bivalence? If not, we forego the realist notion of reality as independent and wholly external from our attempts at knowledge. And then, for *all* statements, we cannot assume that they are determinately either true or false. We then lack a conception of reality which would justify us in saying that there are electrons, there is a material dialectic, etc., in the sense that we understand claims about these things as being about a possibly recognition-transcendent reality; that is, that statements of the form 'There is an n at x,y,z,t' are determinately either true or false independent of our ability effectively to determine them so. That is to say, the anti-realist need only put the following question to the scientific realist: Regardless of the type of entity with which we are dealing, can we be said to understand our ontic commitments so as to warrant generalising from those cases where the evidence is effective to those where it is not? This is simply another way of putting Dummett's general critique of the classical concept of truth, except that I am now focusing on the concept of reference. It will do no good to complain that the question and any consideration of it is vitiated by the practice of science, for two reasons. First, unlike the positivist, I am

not denying that terms like 'electron' refer. Rather I am questioning the determinacy of the reality to which we take them to refer; that is, I am questioning the intelligibility of assuming that they refer to a determinate independent reality. Secondly, unlike the positivist, I am not generating any problems about the *meaningfulness* of non-effective statements like, 'There is an α-particle crossing my study now'. Let me briefly amplify these points before turning to the consequences of the position outlined.

5. The meaningfulness of theoretical terms

The first point, that I accept the reference of theoretical terms, is, I hope, sufficiently well supported by my proposed account of our perception and knowledge of such things. I have proposed an account of our knowledge of these entities which is, in many ways, stronger than anything realists have attempted. That they have not taken such a bold line in defending knowledge of 'theoretical' entities has been due to an unwarranted acceptance of a particular empiricist setting of the problems of observation and perception, a setting which I have argued against. On the point of the meaningfulness of the statements under consideration, consider the following case. Take two sentences '*p*' and '*q*' about the position of a particular type of 'theoretical' entity: '*p*' is the statement that such an entity exists within the confines of the relevant detection equipment and which thereby renders it effectively decidable, '*q*' is the statement that such an entity exists within a region of the world not so fortunately endowed. I do *not* claim that these statements differ in meaning, save only for the fact that they refer to different regions of the world. Generally, I allow that the meaning of both statements be given in terms of some subjunctive conditional of the form,

(1) Were such-and-such detection equipment available at x,y,z,t then we would observe n.

I do not see that a realist would disagree with this. Where we disagree is in the licence with which we claim to understand the concept of truth. I may allow that '*q*' is meaningful; all I question is our right to assume that it is determinately either true or false. A positivist who holds a truth-conditional theory of meaning but has a very restricted account of the truth-conditions can countenance no

meaning to 'q' without reducing it to the meaning of sets of 'observation' statements which possess the satisfactory truth-conditions. The anti-realist need only question the determinateness of the truth of 'q', not its meaningfulness. The point is that the realist wants to say that the relevant subjunctive-conditional is determinately true or false and, in so doing, ground this claim in the metaphysical conception of a reality populated with entities that exist irrespective of our ability to know anything about them. The anti-realist only denies that we can assume *a priori* that such conditionals are either true or false if we have no means for deciding which. In the second sense of 'theoretical entity' which I considered in section 2, I now say that 'q' *is* a theoretical statement because it is impossible for us to have effective evidence of its assertibility. This question leaves the issue between realist and anti-realist firmly in the philosophy of language. The scientific realist cannot complain that anti-realism vitiates the practice or intelligibility of science, only that it vitiates a certain metaphysical picture of science as an enquiry after *truth*, the facts about the way the world is independent of the possibility of our knowing anything about it.

6. Anti-realism and scientific practice

I have heard it objected that, even if anti-realism does not affect the intelligibility of science, might it not adversely affect scientific methodology? More particularly, if scientists differentiate between empirically equivalent theories does this not reveal a commitment to realism? I find this suggestion odd. Of course, given the above argument, without positivistic constraints on observation it is far from clear that there are going to be any theories which are empirically equivalent in an interesting manner. But apart from this, the move from differential treatment of empirically equivalent theories to realism seems laboured. Surely, there might be all manner of explanations for this differential treatment—such as different predictive power, mathematical simplicity, ideological convenience, aesthetic charm, smoother assimilation to other already accepted theories, etc.—without taking the step of introducing realism as one's explanation. More generally, it is not at all clear that there would be any obvious constraints on scientific methodology given acceptance of anti-realism. Remember, Brouwer's point was that we should not allow logical propositions to obscure mathematical

reasoning; we must prove mathematical truths mathematically. The analogy would be to insist that we prove our scientific theories experienceably and is that not what we do anyway? Science is an empirical enquiry, and it is not at all clear that the use of non-experienceably valid forms of reasoning is as tempting as in the mathematical case, or so common. The matter requires study of particular cases, and whether or not any consequences will follow from this for methodology would seem most likely only where the mathematics of a theory relied essentially on theorems not capturable in intuitionist mathematics. Certainly, it does not seem obvious that scientific methodology will be unduly affected by anti-realism. I shall now briefly outline some of the points on which it might be thought that the anti-realist has problems.

7. Three objections

As I see it, there are three main criticisms that might spring to the mind of a committed realist. The first two cover, respectively, the notions of object and objectivity that I employ. The third is to do with the account the anti-realist has to offer of the *point* of science. The first two are related and are not specifically concerned with questions in the philosophy of science.

(i) It might be thought that my claim that anti-realism can countenance objects like electrons, α-particles and the like is open to doubt, for what else is it for something to be an object other than for it to possess an independent existence, independent of our knowledge of it? Does my argument only survive on a fraudulent use of the concept of an object? Indeed, how can I speak of allowing ontic commitments to these entities when I only allow them on certain occasions? Surely, if there are these things, they exist—period—not when and only when they are effectively detectable by us? These questions raise some important points, but they are not peculiar to the philosophy of science and are to do with the issues discussed at the beginning of Chapter 6. One immediate point that needs clarifying is the following. For those cases where we lack effective evidence for the assertibility of some statement about the kind of entity at issue, I am *not* saying that the entity does not exist. All I need say here is that we cannot assume *a priori* either that it does or it does not. I am not saying that there are things of type *n* only under certain conditions and otherwise there are none. The

point is that we only understand these statements in a manner that allows that there are such entities under certain conditions and, that under certain other conditions, there is no sense in saying that there determinately are or are not such things.

The more general point to this first criticism concerns a worry about my use of the term 'object'. Clearly, when I say that the anti-realist can say that there are such things as electrons this has to be understood in a different sense from the way the realist wants to understand the concept of an empirical object. This much is right. However, to admit this is not yet to raise any objections specific to the philosophy of science and the reality of 'theoretical' entities. Given the intimate relations between the concepts of truth, reference and object, if there is a sound anti-realist critique of the former this must have bearing for the latter. But this is a point of philosophical logic which holds good for *whatever* kind of objects we are talking about, be they theoretical, observable, mental or phenomenal or whatever. That being so, although the scientific realist may complain that he would like a concept of an object that is not quite so capricious as the one to which I seem committed then, just as he would like to have a concept of truth other than the one that the anti-realist has to offer, his likes must be satisfied by general arguments that combat the sort of considerations that have brought the anti-realist's wares into the philosophical market-place. Unless, of course, the realist can show that he has some overpowering contribution to make when accounting for the activity of science. So far, I have attempted to show that this is not so and will return to the matter below. Furthermore, given the discussion of Chapter 6, I hold that, at this point, the realist is engaging in empty metaphysical flag-waving. The onus is on him to say just what this richer concept of an object is and how we could ever know of its application. The point is that both the realist and anti-realist lay claim to sayings like 'There are electrons', but the realist thinks that this has to be understood as 'There are things of this kind which exist, always have existed and, presumably, always will exist irrespective of our ability to know anything of the matter'. The anti-realist merely scratches his head at this improvident dissipation of entities. What point, he wonders, can there be in assuming that there determinately is or is not an entity of such-and-such kind at a particular place and time when there is no way of discovering whether or not this is so? Such extravagance can only be countenanced on the basis

of what I have called unflatteringly metaphysical flag-waving about a recognition-transcendent reality to the truth of which our scientific enquiries are supposed to be converging. The onus lies with the realist to cash out these metaphors. For the anti-realist, his claims like, 'There are electrons' come to something like, 'The kind "electron" is a kind which may be appealed to in bringing the blooming buzzing confusion of our experience to order'. But this is how he takes less sophisticated 'There are . . .' claims about tables, chairs, others' pains, influenza viruses, etc.

We can consider the above points a little further by reflecting on the following examples which might be thought to constitute objections.[9] First consider this: Australia was discovered in 1683 and, that being so, do we have effective evidence for assertions about *this same place* in 1682? So, for example, according to my account of anti-realism, the statement,

(2) Australia was hot in 1682

would seem to be not effectively decidable, and therefore I can allow no sense to the idea of the existence of Australia before 1683. Similarly, take the following pair of statements as examples of, respectively, effectively and non-effectively decidable statements about micro-particles:

(3) There is an α-particle crossing my study at t_1

and

(4) There is an α-particle crossing my study at t_2

where t_1 is a time when the room is equipped with functioning detection equipment and t_2 when it is not. Here, as with the Australia example, am I not forced to deny the idea of an object as a recognition-transcendent continuity if, as I do, I deny that there is no sense to counting (4) determinately true or false? There are a number of points to be made to these examples. First, as I have already pointed out, I can allow the meaningfulness of (2) and (4) and I do not *deny* that Australia existed in 1682 or the α-particle at t_2, only that there is no sense to supposing that they either determin-

[9] These examples and objections were put to me by Rom Harré when an earlier version of this chapter was read to his seminar in Oxford.

ately did or did not exist at these times. Secondly, and more important, it is not (2) that I deny to be effectively decidable, but

(5) Australia is hot

as uttered in 1682. Developments in geology may have given us means for ascertaining the assertibility of (2) but not (5) uttered in 1682.[10] However, thirdly, this does leave us with a denial that Australia, like the α-particle, is a recognition-transcendent continuant and that in coming to know the truth of statements like (2) and (3) we come to know things about recognition-transcendent continuants. This is important. It is the recurrence of the point made earlier that, although the realist claims a grasp of the understanding of what an object is that gives objects a continuous existence independent of the possibility of our knowledge of them, this claim, like his appeal to the classical concept of truth and logic, must be argued for and not assumed as part of a metaphysical framework within which a philosophy of science is to be constructed. One of the main points of the anti-realist critique of the realist concept of truth is that it brings basic metaphysical beliefs into the field of dispute. If it is right, so too must such beliefs that objects are recognition-transcendent continuants be disputable. And of course, from my previous remarks on this, the anti-realist thinks the dispute is somewhat one-sided; he is waiting to be told just what it is that he has missed out in his account of objects. I have merely translated the debate about the concept of truth into the realm of reference and without, it would seem, adversely affecting our understanding of science. As previously argued, on an anti-realist semantics the notion of an object is not prior to a grasp of the assertibility of utterances employing the name for the object. The anti-realist starts with the assertibility of utterances and moves to construct experience populated with entities. For the anti-realist, when I come to know that (2) I do not thereby come to know something about some pre-existing thing, but rather, I come to have a conception of the thing and its existence only as I come to know the assertibility

[10] To think that such developments affect (5) is simply to suppose that the relevant truth-value links between (2) and (5) hold, and this is exactly the point at issue in discussing the reality of the past. Although I would not agree with everything the following writers say on the matter, both McDowell's 'On "the reality of the past"' and Wright's 'Realism, truth value links, other minds and the past' make the point about truth-value links quite clearly, although from different viewpoints.

of (2) and other utterances containing the term 'Australia'. Put simply, we can say that on coming to know (2), I know how to use this utterance and related ones, 'Australia was cold' in certain ways, for example, in making deductions. The issue is whether we see fit to ground this use in a belief that it is a use of language to describe a reality that is possibly recognition-transcendent, or whether we found our notion of reality upon, and only upon, the uses of language which turn out to be effectively decidable; those uses of language that conform to experienceable logic.

(ii) The second problem is whether an anti-realist account of science can accommodate the *objectivity* of science. If the question is whether it can accommodate the notion of science as the attempt to mirror the way a wholly independent world is, then it cannot. But I have already criticised this conception of objectivity in Chapter 5. What anti-realism has to offer is a conception of science as objective, indeed the paradigmatic domain of objective enquiry, because it is a form of enquiry that continually criticises and exposes the sort of closure in belief systems that dislocates knowledge claims. One way of characterising such closure is by finding the myths that shape our thinking and research. The rise of science during the European Enlightment was due, in large part, to the change from a medieval dependence on arguments from authority to arguments based on experience. The former propagated myths, the latter dissipated them. Descartes is important in this, although he left us with the greatest myth of all—realism—and the concomitant epistemological problem of proving the existence of the external world. (The medievals concentrated on proving the existence of God, and I suspect that the two tasks are not too dissimilar, the latter being a secular version of the former, hence the analogy in Chapter 2 between knowledge of God and knowledge of determinate truth-values.) Present day concerns with objectivity in science (e.g. the work of Kuhn) only constitute a problem if one thinks that objectivity has to be understood in the way I criticised in Chapter 5. Kuhn's work, or the sociology of knowledge in general, is parasitic upon a realist preconception of what the goal of objective enquiry should be. This is not to deny that such work is extremely important. If sociologists are right when they inform us of the degree of myth that still enshrouds scientific practice (the degree of closure in belief systems), then this is a matter of concern. But, as I argued in Chapter 5, objectivity is the dynamic process of myth removal and, as far as I

know, scientists have not given up doing that in their response to Kuhn and others. Indeed, such work is often the stimulus to a more objective enquiry. Far from taking away the objectivity of science, anti-realism makes its dependence on manifestable knowledge and experienceable logic, rather than myth, the supreme virtue, the very essence of objective enquiry.

(iii) It remains to be seen whether the anti-realist can really be on equal terms with the realist when accounting for scientific activity. Within the compass of this point there might seem to be two issues. First, why does the anti-realist think we go in for the scientific enterprise and the generation of theories about the fine structure of materials and events? Secondly, what is the relation between the macro- and micro-levels? Between the common-sense and scientific conceptions of reality? These two questions are not altogether distinct. In the first place the anti-realist must obviously oppose the conception of science as an enterprise after *truth*; an enterprise that seeks to provide ever more accurate accounts of the way reality is independently of the way we know it to be. Similarly, the anti-realist must also oppose that conception of the relation between the scientific and common-sense accounts of experience which holds that the former give the true, *real*, account of the matter as opposed to the latter's only apparent one. He must do this for the simple reason that otherwise he could offer no explanation for why he finds many of the scientifically inspired descriptions indeterminate and yet the everyday statements they are meant somehow to underlie as quite possibly determinate. This would seem to constitute a problem for the anti-realist. I believe that it can be met and shall briefly sketch how, although some of the points are not specifically due to an anti-realist account of the central semantic concepts of truth, reference and object.

In *The Principle of Mechanics* Hertz made the following observation,

> If we try to understand the motions of bodies around us, and to refer them to simple and clear rules, paying attention only to what can be directly observed, our attempt will in general fail.[11]

He went on:

[11] H. Hertz, *The Principles of Mechanics*, translated by Jones and Welley, (New York 1965, p. 25.

We become convinced that the manifold of the actual universe must be greater than the manifold of the universe which is directly revealed to us by our sense. If we wish to obtain an image of the universe which shall be *well-rounded, complete and conformable to law*, we have to presuppose behind the things which we see, other, invisible things—to imagine confederates concealed beyond the limits of our sense.

As Hertz clearly articulates, the pursuit of science and the construction of theories about 'unobservables' is required if we are to obtain an account of experience which is complete and conformable to law; that is, if we are to give an account which is *effective*. The pursuit of science, as Hertz saw the enterprise, is the pursuit for an effective description of reality as experienced. Our simple common-sense conceptions of the world do not yield everywhere effectively decidable procedures for ascertaining the assertibility of our utterances. The pursuit of science is, following Hertz, the pursuit for effective decidability. In this we have something with which the anti-realist may agree; all he need question is the need to see this effective decidability as underwritten by an ontological unification in a conception of reality that extends beyond the knowable. Why we seek such effective decidability is another matter, one which is answerable in terms of the evolutionary advantage to be gained by those who possess such knowledge. However, this still leaves us with the question of the relation between the pre-scientific and scientific account of experience.

The idea that there is a problem here for the anti-realist in accounting for the relation between the common-sense and scientific accounts of experience is only due to a particular view of the status of these two, apparently separate, accounts. The anti-realist will only oppose those realists who think that, in some sense, the scientific discussion of invisible structures gives the *real* description of reality as opposed to an apparent one given in common-sense. It is not clear how many realists want to commit themselves to this, but those whose accounts of reduction support an *eliminative* materialism in the case of the mind/body problem would be a case in point.[12] However, many realists see the reduction relation in terms of identity, but then they cannot say that, for example, there are *no* mental states, for these are identified *with* physical states, not identified *as* physical states. The anti-realist could agree with such

[12] A classic statement of such a position would be R. Rorty 'Mind-body identity, privacy and categories', *Review of Metaphysics* 1965.

realists. He will only wish to argue with those realists who find the progress of science an eliminatively enlightening one. He will not want to deny that a table is made up of a structure of lattices of molecules and that its brown colour is due to the fine details of its immediate surface structure, but he will deny that this somehow entails that the scientific account is the *only true* one and that the everyday account is thereby false. It would be argued that to give a complete account of the objects in a room the concept of a table would be required and could not be left out. Such an argument is not the especial preserve of the anti-realist, it is akin to Strawson's argument about the 'relativity of our "reallys"',[13] but it is an argument that falls most naturally from the anti-realist position. The anti-realist cannot accept the reductive account of the relation between common-sense and scientific accounts of reality, where the reduction shows that, in some sense, there are not really any things of the common-sense type. To do this would be to commit him to the view that in doing science we were discovering truths about an independent world, facts which must have always been true (in the realist sense) just because the everyday conception is only an apparent one dependent upon them. As long as he rejects such a conception, the anti-realist may acknowledge the relation between these two accounts of reality (if it makes sense to speak of *different* accounts, it is contentious that they are everywhere as opposed as is often imagined) as that of different ways of describing our experience. He can also accept that an identity between talk of tables and talk of masses of particles will, presumably, give him a means for determining the truth or falsity of statements like 'There is a such-and-such kind of mass of such-and-such kind of particles in the room' without thereby giving him grounds for taking statements about the position of any particular particle as determinately either true or false. And if to say that the two, if they are different, accounts of this reality are just different ways of describing experience sounds reductionist, it is not. It may be thought that to say this is to say that the scientific account is *just* another way of describing our everyday experience in the sense that the latter description has some priority. This is not so. Both descriptions are ways of describing our experience which includes objects of all different kinds. Our experience includes tables and such objects which are usually, but

[13] P. F. Strawson, 'Perception and its objects', in *Perception and Identity*, ed. G. F. MacDonald (London 1979), p. 57.

not necessarily effectively detectable; and it includes entities like molecules, electrons, pains, etc., which are often, but not necessarily effectively detectable. *All* that the anti-realist will deny is that it makes sense to suppose that these objects or, more correctly, statements about them, are *a priori* bivalent. Such a conception would allow intelligibility to the realist claim to conceive of science as an enterprise after the possibly recognition-transcendent truth about reality, a concept of truth which would allow the realist ideal of the convergence of science towards this truth. In denying such a conception of truth, the anti-realist takes away such an explanation of the pursuit of science.

However, with his right to speak of ontic commitments to the sorts of entities earlier verificationists thought meaningless, the anti-realist can speak of the pursuit of science in the way in which Hertz saw the enterprise. Again, I think the realist would acknowledge such a characterisation of the interest of science; that it is an enquiry to find effective accounts of experience and the way we expect it to develop. All that stands between realist and anti-realist here is the further conception that such effective decidability somehow resides in a metaphysical conception of a possibly recognition-transcendent reality. All that further stands between them is a dispute about the correct account to be given of our concepts of truth, reference and object; a dispute which belongs within the philosophy of language because the anti-realist account of these concepts, as I have tried to outline in this book, does not in any obvious way restrict either the intelligibility or scope of the scientific enterprise. If this is right, the argument for realism in the philosophy of science has barely begun and the range of experience that the anti-realist can accommodate is thereby broadened. If this is right, we may well wonder what service realism has to offer philosophy, for it employs a concept of truth the application of which, much as Kant showed with respect to the application of the concept of God, has no role in the sciences of reason. It is, as I suggested in Chapter 2, something which may be the subject of faith, but if the argument of this chapter is correct, it is not something for which there is any point in having faith, for the onus lies with the realist to tell us not only *how*, but *why* we should transcend the logic of experience.

Coda

All the things realists take to exist in the world, the anti-realist also admits. Indeed, given the account of the range of experience in these last two chapters, the anti-realist has a more secure claim to accept the various entities of science and common-sense. All this is available within the constraints of the logic of experience, an experienceable use of the logical constants. The cost of this is the rejection of certain myths and metaphors that have for too long now plagued our faltering grasp of the concepts of objectivity, truth, reference and knowledge. It is not much to give up.

The Logic of Experience

In this appendix I outline how one can understand the logical constants in a falsificationist manner. This provides a non-classical logic which has the central characteristics of intuitionistic logic, although I offer no formal proof of the equivalence between intuitionistic logic and that offered below.

In saying that we know the sense of an utterance A when we know what would defeat it, knowing the set f_A, and similarly for ¬A, knowing the set $f\neg_A$; we do not have enough to know that either f_A or $f\neg_A$ will obtain. For as it is a prerequisite for A to be assertible that it make some claim upon experience, if A is to be assertible then either it must be effectively decidable or f_A must include sentences that are effectively decidable. If the former, then f_A comes to simply ¬A and $f\neg_A$ comes to A. If we assume that effective decidability is due only to sentences about our immediate sense experience like 'This is red' or 'This is not red', then if A and ¬A are not of this class we cannot antecedently demand that it must be the case that either f_A or $f\neg_A$ hold. So we cannot demand this generally for any non-effective sentence, whatever it may be about.

There may be some doubt as to the correctness of the above point, for surely a falsificationist logic *must* differ from intuitionistic logic the most striking feature of which is that there are non-equivalent sentences whose negations *are* equivalent: for example, A and ¬¬A, or A→B and ¬(A∧¬B). As the negations of these intuitionistically non-equivalent sentences are equivalent, surely a falsificationist logic must take these respective pairs as equivalent. Intuitively, we might say that for the intuitionist what distinguishes A and ¬¬A is that, although they are falsified in the same instance, the former requires stronger *justification*. In arguing that the generalised anti-realist must proceed upon a wholly falsificationist basis in proposing a logic for empirical discourse, the ensuing logic will perhaps have to be non-intuitionist as well as non-classical? Dummett has briefly sketched just such an approach for a thorough-

going falsificationism, although I think the proposal incorrect.[1] Indeed, as I shall outline, there is good cause for thinking that the logic is intuitionistic, and the reason for this is, not surprisingly, the account of negation given in Chapter 3. I say 'not surprisingly', for in a natural deduction system for intuitionist logic which takes '⊥' as a constant absurd proposition and which, in place of introduction and elimination rules for '⊥' uses only the rule, (*ex falso quodlibet*)

$$\text{EFQ} \; \frac{\Gamma : \bot}{\Gamma : B}$$

then to obtain classical logic we need only replace EFQ by the rule

$$\frac{\Gamma, \neg A : \bot}{\Gamma : A}$$

for this rule is tantamount, by first invoking the introduction rule for '→', to double-negation elimination. It is because negation was taken in Chapter 4 as defined as in the rule EFQ—that is as $\neg A = A \rightarrow \bot$—and that only this gave us an experienceable use of '¬' subject to the constraints of Chapter 2, that we forego being able to claim that either f_A or $f_{\neg A}$ must hold.

For example, taking the sentence J—'Jones was brave', then where 'S' describes a situation offering chance of brave or cowardly action and 'F' and 'G' are actions of kinds such as 'running away' and 'storming the machine gun nest single-handed' which would, respectively, falsify J and ¬J, then

f_J will include 'If S Jones F-ed'

and

$f_{\neg J}$ will include 'If S Jones G-ed'.

However, in restricting negation to experienceable negation we forego the opportunity of designating a set \overline{f} where this includes sentences describing states of affairs which preclude the occurrence

[1] M. A. E. Dummett, 'What is a theory of meaning? II' in *Truth and Meaning*, eds. G. Evans and J. McDowell (Oxford 1976), p. 126.

of those states of affairs described by the sentences in f, such that we could then define $f\neg_J$ as \overline{f}_J.[2] For the following sentence,

Jones was never in situation described by 'S',

precludes *both* the occurrence of states of affairs referred to in f_J and $f\neg_J$. So, although we have a falsificationist logic, we have, due to the account of negation in Chapter 4, no obligation to construe the constants in the manner Dummett thought a falsificationist account likely to go. We do not then have a general guarantee that either f_A or $f\neg_A$ will hold and so will not have $\vdash A \lor \neg A$.

Clearly we will have

$$(1) \quad f_{A \land B} = f_A \bigcup f_B$$

and

$$(2) \quad f_{A \lor B} = f_A \bigcap f_B,$$

but what is not so clear is how we account for $f\neg_A$ and $f_{A \to B}$. Now, from our account of negation, it appeared that we needed to take $\neg A$ as provable just in case a proof of it leads to a proof of a directly recognisable contradiction, and so

$$f\neg_A = f_{A \to \bot}$$

but then how are we to treat $f_{A \to B}$? It might seem that the obvious response would be to take '$A \land \neg B$' as the falsifier of the conditional, and so

$$f_{A \to B} = f\neg_{(A \land \neg B)},$$

but this is plainly circular, for given the above remarks on negation it comes to

$$f_{A \to B} = f_{(A \land \neg B) \to \bot}$$

If we could employ the notion of proofs upon proofs as used in the

intuitionist account of the conditional, we could circumvent this problem, but it has been the purpose of this work to show that we must forego the concept of proof for empirical discourse and turn to that of the defeat of an utterance.[3] However, we can capture the spirit of the intuitionist conditional in a manner that preserves our account of negation. Clearly the assertion of A→B commits us to ¬(A∧¬B), but the point to be asked is why? What is it we are doing in making a conditional assertion over and above saying that it is not the case that the conjunction of the antecedent and the negation of the consequent hold? What more, that is, are we ruling out than just A∧¬B? An intuitionist distinguishes these, and we need to do so as well *if we are to be able to give content to the strong account of experienceable negation.* For the point of the experienceable account of negation as presented in Chapter 4 was that negation is more than a blanket operator covering all possible situations in which an assertion fails to be warranted. Instead, in conforming to the general constraints of experienceable truth, negation is seen as a specific operator to the effect that the assertibility of the sentence in question would lead to the assertibility of a directly recognisable contradiction. And hence we get the above supposition that $f\neg_A = f_{A\to\perp}$. Following intuitionistic logic, we need then to distinguish A→B from ¬(A∧¬B) because, as with the intuitionist, our concept of negation is the strong concept of experienceable negation whose content would be rendered vacuous if we failed to make the above distinction. Our account of the conditional must give content to the idea of the assertibility of the antecedent *leading* to the assertibility of the consequent. It is this notion which was employed in our account of negation. To treat A→B as equivalent to ¬(A∧¬B) would only be possible by reneging on our account of negation and not allowing ourselves to treat the negation operator on that conjunction as an experienceable negation such that (A∧¬B)→⊥.

However, keeping within the confines of a falsificationist seman-tics, we can give content to the thought that in conditional assertions we are saying something to the effect that the assertibility of the antecedent *leads* to the assertibility of the consequent and, what is more, analogous to the intuitionist; we do this by invoking the

[3] The idea of using proofs upon proofs, or constructions on proofs is distinctive of intuitionist logic; cf. G. Sundholm, 'Constructions, proofs and the meaning of the logical constants', *Journal of Philosophical Logic* 1983, for a discussion of the relevants notions of construction.

falsification of operations upon falsifications, just as the intuitionist invokes the notion of proofs, or constructions, upon proofs. We can distinguish A→B as a stronger claim than ¬(A∧¬B) by considering the following question: For any pair of sentences A and B, when ¬(A∧¬B) holds why is this so? The thought suggested by this question is that when, and only when, the holding of this conjunction is due to the following relation between the falsifiers of A and B are we then justified in making the conditional assertion A→B. The relevant relation between the classes of falsifiers is that $f_B \subseteq f_A$. The intuitiveness of the proposal is apparent. Taking, as I have argued, the assertibility of an utterance to depend on its undefeat, providing this places effectively recognisable constraints on experience, then clearly, if the above relation holds between the defeating sets for A and B, if A is assertible B will be assertible too. B's assertibility will be a consequence of A's in a manner that is stronger than observing only that it is not the case that A∧¬B holds. That is to say, A→B is falsified if and only if $f_B \not\subseteq f_A$ or .

$$f_{A \to B} = f_{f_B \subseteq f_A}.$$

Thus

(3) $f_{A \to B} = \{f_B \not\subseteq f_A\}$

It is to be noted that with the conditional the set of falsifiers with which we are concerned is the single member set comprising the meta-report that the set of falsifiers of the consequent is not a subset of the set of falsifiers of the antecedent. This statement, the falsifier for the conditional, call 'c' and the set we are interested in I shall designate, for the conditional A→B, as the set $\{c_{AB}\}$. With such an account of the falsifier of the conditional the account of the constant can be completed with negation such that

(4) $f_{\neg A} = f_{f_\perp \subseteq f_A}.$

That is, A is falsified if and only if $f_\perp \not\subseteq f_A$. Now, if we take '⊥' as the directly recognisable contradiction of the form

(5) My present total state of information is represented by the

set $\{e_1 \ldots e_n\}$ and by the set $\{\neg e_1 \ldots \neg e_n\}$ where $e_1 \ldots e_n$ are all the effectively decidable sentences at any one time,

then we capture the intuitive idea that '\perp' is a contradiction ruling out the possibility of any experience. Clearly, for most sentences, the directly recognisable contradiction involved will be particular to that sentence. By defining '\perp' structurally, as above, in terms of the two *complete* characterisations of experience neither of which can be true at the same time, we can treat '\perp' as uniform. This in the ploy achieved in intuitionist mathematics by taking '\perp' as '$1=0$'. Taking '\perp' as a contradiction that rules out the possibility of any experience, '\perp' will be falsified by the assertibility of any one effectively decidable sentence p and we may take as f_\perp the set, $\{p\}$, where 'p' is such a sentence. We now have

(6) $f_{\neg A} = \{ \{p\} \nsubseteq f_A \}$

or

$f_{\neg A} = c_{A\perp}$

which is to say that $\neg A$ is falsified if the set $\{p\}$ is not a subset of the set of falsifiers of A; that is, no effectively decidable truth appears in the set of falsifiers of A. And that is surely right. What then of double negation?

Now clearly

(7) $f_{\neg\neg A} = f_{\neg A \rightarrow \perp}$

but then

(8) $f_{\neg\neg A} = \{f_\perp \nsubseteq f_{\neg A}\}$

and so

(9) $f_{\neg\neg A} = \{f_\perp \nsubseteq f_{A \rightarrow \perp}\}$

and from the above this comes to

(10) $f_{\neg\neg A} = \{ \{p\} \nsubseteq \{c_{A\perp}\} \}$

which is to say that the set containing any particular effectively decidable truth is not a subset of the set containing the meta-report $c_{A\perp}$; that is, no effectively decidable truth appears in the set of falsifiers of A. But then $c_{A\perp}$ is not effectively decidable, and just as ¬A is falsified if no effectively decidable truth appears in the set of falsifiers of A, so too is ¬¬A falsified if the falsifiers of ¬A, the set $\{c_{A\perp}\}$, contains no effectively decidable truth.

Now because the account of $f_{A\to B}$ is stronger than merely $f^{\neg}(_{A_{A}}\neg_B)$ we cannot simply capture entailment in the manner $A_1 \ldots A_n \vdash B$ iff $f_B \subseteq f_{A_1} \cup \ldots f_{A_n}$ for, although this would be satisfactory for sequents using only '∧' or 'v', with the others it fails. With the sequent

A, A→B⊢B

the union of the sets of falsifiers of the left-hand side give us only $f_A \cup \{c_{AB}\}$. As with the conditional, we have to give a slightly stronger account. I shall say that

$A_1 \ldots A_n \vdash B$

holds if, and only if, if B is falsified then one of $A_1 \ldots A_n$ must be falsified as well either because

(i) $f_B \subseteq f_{A_1} \cup f_{A_2} \cup \ldots f_{A_n}$, or

(ii) If not (i) then either f_{A_1} or f_{A_2} or $\ldots f_{A_n}$ is the statement that $f_B \not\subseteq f_{A_1}$ or $f_B \not\subseteq f_{A_2}$ or $\ldots f_B \not\subseteq f_{A_n}$.

Clause (ii) captures the validity of sequents using the conditional. Given that negation is a derived constant, ¬A being defined as A→⊥, then all theorems of the logic will be conditional in form. This means that, given the strong account of the conditional, we cannot simply take ⊢B as obtaining just in case f_B = the null class, although this is intuitively what we want. We must define theoremhood a little more accurately with respect to ⊢A→B. Theorems will then be those conditionals which cannot be falsified (their set of falsifiers *will* be the null set) because either

(i) $f_B \subseteq f_A$ by, (a) $f_A = f_i \cup f_j \cup \ldots f_n$ and $f_B = f_{iv}f_{jv} \ldots f_n$, or

(b) $f_B = f_i \cap f_j \cap \ldots f_n$ and $f_A = f_{iA} f_{jA} \ldots f_n$, or

(c) $f_B = \neg A$, or

(ii) if $f_B \nsubseteq f_A$ then f_A includes the statement that $f_B \nsubseteq f_A$.

Sub-clauses (a) and (b) of (i) cover the cases of theoremhood where the compositionality which gives $f_B \subseteq f_A$ is due to '\wedge' and '\vee'; (c) covers the limiting case for theorems of the form $\vdash A \rightarrow \neg \neg A$ for from above we had

$$f \neg \neg A = \{ f_\perp \nsubseteq f \neg A \}$$

that is, $\neg \neg A$ is falsified just in case there is no effectively decidable sentence in $f \neg A$: that is, $\neg A$ holds. From this is it clear that

$$\vdash \neg \neg A \rightarrow A$$

fails, for unless A is antecedently acknowledged to be effectively decidable we have no guarantee that the set of defeaters for A, f_A, includes the sentence $A \rightarrow \perp$. This is just another way of putting the point made on several occasions above that for many sentences their defeating set and the defeating set of their negations do not place effective constraints on experience.

I said in Chapter 2 that the logic of experience would be experienceable truth preserving. We now take, as our only permissible notion of experienceable truth, the notion of *successful survival*, which is meant as a name for the idea that we came across in saying that for a sentence to be assertible it must make an effective constraint on experience and not be falsified. I shall simply speak of a sentence's survival to cover both these aspects. But now, from the logic sketched above, it is quite clear that the logic is survivability-preserving, and we may read $A_1 \ldots A_n \vdash B$ as saying that if $A_1 \ldots A_n$ survive then B survives too. It is clear also that not only does the natural deduction system for intuitionist logic capture the intended meanings of the constants but also, we might say, it is survival-preserving if we read the introduction and elimination rules as saying that, given the survival of the premises, the conclusion survives. The short point to the whole of the preceeding argument is that from the considerations about knowledge and experienceable truth originally raised in Chapter 2 we have now arrived at the

situation where we may say that in generalising a quasi-intuitionist semantics from mathematical to empirical discourse we have substituted, as analogue for the concept of *proof*, the concept of *survival*. And although in so doing we turn from a justificationist perspective to a falsificationist one, the concept of a sentence's survival carries just the same experienceable restrictions as does the notion of proof. This comes out in, and is due to, the account of negation.

To extend the above to cope with quantified sentences we need to add the following. Clearly, $\exists xA(x)$ is an assertion ruling out the possibility that for any term n of the relevant domain, $A(n)$ does not hold. Characterised in terms of sets of falsifiers this comes to

$$(11) \quad f_{\exists xA(x)} = f_{A(n_1)} \cap f_{A(n_2)} \cap \ldots f_{A(n_n)}$$

so that as long as some instance $A(n_i)$ makes an effective constraint on experience and survives we are entitled to say that $\exists xA(x)$ survives.

Universal quantification is not so obvious, and it is easier to approach the matter by first considering the following definition of the survival of a universally quantified sentence modelled on that of universal quantification in intuitionistic logic:[4]

$\forall xA(x)$ *survives* if we have a construction which appended to each object a (of the domain of discourse) the survival of $A(a)$ is thereby proven.

We can build on this as follows. We only consider universal quantification where the domain is specified so that we are not concerned with accounting for simply $\forall xA(x)$, but $\forall x(\phi x \rightarrow \psi x)$ where 'ϕ' is the predicate which defines the domain. Then, if for this domain $\forall x\psi(x)$ survives, this is because we can show that if a named object a is ψ we can show that an arbitrary object is ψ, i.e. $\psi(y)$. Thus, if $\psi(y)$ survives, $\forall x\psi(x)$ survives. What then is it to be able to show that if $\psi(a)$ survives then $\psi(y)$? The construction required is the construction which shows that $f_{\psi(y)} \subseteq f_{\psi(a)}$, and the construction which is required to show *this* for the domain defined by 'ϕ' is

$$(12) \quad f_{\psi(a)} \subseteq f_{\phi(a)}.$$

[4] Cf. Sundholm, op. cit.

For then, if the falsification conditions for a being ϕ include the falsifying conditions for its being ψ because of a relation between the concepts of 'ϕ' and 'ψ', then any arbitrary object y will also be such that its falsification conditions for $\psi(y)$ are a subset of the falsification conditions for $\phi(y)$. That is, considering $\forall x(\phi x \rightarrow \psi x)$ we have

(13) $\quad f_{\forall x(\phi x \rightarrow \psi x)} = f_{\cap \psi(a)} \subseteq f \phi(a)$

or

(14) $\quad f_{\forall x(\phi x \rightarrow \psi x)} = \{ f_{\psi(a)} \nsubseteq f_{\phi(a)} \}$

Of course (14) entails that if there is some object n such that $\phi(n)$ but not $\psi(n)$ then $\forall x(\phi x \rightarrow \psi x)$ is falsified, but it does not follow, taking 'ϕ' as specifying the domain, that $f_{\forall x \psi x} = \{ \exists x \neg \psi x \}$. For although $\forall x \psi x$ is an assertion ruling out the possibility that $\psi(\xi)$ is not satisfied, it is a stronger assertion than $\neg \exists x \neg \psi x$ just as $A \rightarrow B$ is stronger than $\neg(A \wedge \neg B)$ although in each case, if the latter sentence survives, the former do not.

Secondary Qualities

In Chapter 7 I claimed that colour properties were properties that represented the world as being a certain way and, as such, were capable of figuring in descriptions which are objectively true. Therefore there are certain truths about tomatoes that Martians will never discover and, if the Martian intrinsic property of 'redfeel' were available to a species, certain truths such that we will never discover that tomatoes are redfeel. We are as ineluctably incapable of grasping what it is for an object to be redfeel as the Martian is of grasping what it is for an object to be red. Nevertheless, it may be the case that some objects are red and redfeel. Such thoughts may run counter to many people's view of the primary/secondary quality distinction. I do not aim to establish, in this appendix, a defence of these claims, but merely to provide the conceptual map which makes me think that they are correct.[1]

An ancient tradition on the primary/secondary quality distinction has it that the distinction is between properties that figure in objective descriptions of the world and those that figure in subjective accounts of the world. There is a limited suggestion of this in Locke where he says that secondary qualities are 'nothing in the Objects themselves, but Powers to produce various Sensations in us by their *primary Qualities*',[2] where the 'nothing but' suggests a subjectivist error theory of secondary qualities. This is only a limited suggestion, though, for this follows only a page after Locke has defined qualities *in general* thus: 'the Power to produce any *Idea* in our mind, I call *Quality* of the subject wherein that power is.'[3] This is before he

[1] The following view of the distinction is implicit in Dummett's 'Common sense and physics' in *Perception and Identity*, ed. G. F. MacDonald (London 1979). I have heard McDowell say something very like the following, although he used a distinction between two uses of the adjective 'subjective' which, at best, is a confusing way of putting the matter.

[2] Locke, *Essay Concerning Human Understanding*, bk. 2, ch. 8, section 10.

[3] Op. cit., bk. 2, ch. 8, section 8. I am indebted to John Campbell for some of the thoughts here; cf. his 'Locke on primary and secondary qualities', *Canadian Journal of Philosophy* 1980.

makes the primary/secondary distinction. However, the 'nothing but' can be explained by acknowledging that to say of an object that it is red is *only* to say that it has a power to produce a certain sort of Idea in us; it says nothing about what other powers the object has with regard to other objects, whether material objects or minds. On the other hand, to say that an object is square is to say that it has the power to produce Ideas of squareness in us *and* to say that it has the power to interact with other objects in certain ways; for example, it has a capacity to get stuck in round holes. Or, to take another example, to say that object *n* has a certain fine surface structure is to say something about its capacity to interact with other objects in certain physical ways and is a way of describing that surface structure which is neutral with regard to whether or not some sentient creature experiences *n* as red or others experience it as redfeel. But then the 'nothing but' is nothing but an indication that descriptions of objects using secondary qualities are descriptions that are *limited*, or *relative*, to the perceptual apparatus and concomitant capacities of a particular kind of creature. It is only to say how *we* experience the object. The primary quality description of the object's fine surface structure is a description that prescinds from such relative descriptions and describes the object's surface in a way of which there is good reason to suppose that any creature, whatever its perceptual apparatus, could come to have knowledge. This then is just to say that the primary/secondary quality distinction is a distinction between properties that figure in an *absolute* description as opposed to those that figure in a relative description of an object.

The relativity of secondary quality descriptions is clear. To say that an object is red is just to say that

(1) *n* is disposed under appropriate conditions to produce certain qualitative experiences in creatures of a certain physiological kind.

However, the absolute/relative distinction does not cut at the same point as an objective/subjective distinction, for if *n* is red then it is objectively true that it is red, for then (1) is objectively true. And if the account of Chapter 7 is correct, it is the object that is red not my experience brought about by my having my eyes open when, under normal lighting, a ripe tomato is before me. Regardless of

whether or not a description of an object is an absolute or relative description, primary/secondary quality description, it is as much liable to objective truth and falsehood. For all we know, it is an objective fact that tomatoes are redfeel; that is, they are disposed under appropriate conditions to produce certain qualitative experiences (tactile ones) in creatures of a certain physiological kind. Of course, saying 'for all we know' is to make a very large disclaimer, for we do not know and could not know what it would be like to have an experience as of an object being redfeel. Given the sort of perceptual apparatus that we possess we have no grasp of the content of that concept.

What then is the point of seeking absolute descriptions of an object in terms of its primary qualities? First, it must be noted that when I speak of absolute descriptions of an object I mean only descriptions employing properties which could, in principle, be recognised to be satisfied by the object by any creature no matter what its sensory system may be like. There are two confusions that have be kept in mind in keeping the absolute/relative and the objective/subjective distinctions apart. The first is the confusion of absolute with objective conceptions of reality. This seems to infect Williams' discussion of the absolute conception of reality in his book on Descartes, where I take him to be discussing a particular conception of what an *objective* conception of the world would be like, namely a realist one.[4] On the other hand, there is the danger of failing to separate the notions of relative and subjective descriptions, and here McGinn's treatment of secondary qualities and indexicals seems to suffer in this respect.[5] In the present case I wish to record no more than a semantic quibble with these writers; I wish they had used different terminologies to avoid confusion, although I would be prepared to defend, in each case, a stronger claim of confusion.

What then does an absolute description give us? It gives a description which prescinds from our particular perspective to produce a description in the lowest common denominator of experience—the sort of description on which we, Martians, bats and the rest of the universe could agree. However, in doing this it does not give us descriptions which are any more objective or real! Such a project also gives us more determinate ways of describing the objects of our

[4] B. Williams, *Descartes* (London 1978), especially ch. 2.
[5] C. McGinn, *The Subjective View* (Oxford 1983).

world in so far as we take absolute descriptions to explain our capacity to recognise the objective truth of the applicability of those relative descriptions of objects that come naturally to us. This, and this alone, is a respectable enough reason for science to pursue absolute descriptions (cf. Chapter 9).

Bibliography

Baker, G. P., 'Criteria: a new foundation for semantics', *Ratio* 1974
Baker, G. & Hacker, P., *Language, Sense and Nonsense*, Oxford 1984
Blackburn, S., *Spreading the Word*, Oxford 1984
—— 'The Individual Strikes Back', *Synthese 58* 1984
Block, N. & Fodor, J., 'What psychological states are not', *Philosophical Review* 1972
Boyd, R., 'Realism, Underdetermination and the causal theory of evidence', *Nous* 1973
Brouwer, L. E. J., 'Consciousness, philosophy and mathematics' in *Collected Papers 1*, ed. A. Heyting, Amsterdam 1975
Campbell, J., 'Locke on primary and secondary qualities', *Canadian Journal of Philosophy* 1980
—— 'Knowledge and understanding', *Philosophical Quarterly* 1982
—— 'Possession of concepts', *Proceedings of the Aristotelian Society 85*, 1985
—— 'Conceptual structure' in *Meaning and Interpretation*, ed. C. Travis, Oxford 1986
Camus, A., *The Myth of Sisyphus*
Craig, E. J., 'Meaning, use and privacy', *Mind* 1982
Guttenplan, S. D., 'Meaning and metaphysics' in *Meaning and Interpretation*, ed. C. Travis, Oxford 1986.
Davidson, D., 'Reality without reference', *Dialectica* 1977 reprinted in his *Inquiries into Truth and Interpretation*
—— *Inquiries into Truth and Interpretation*, Oxford 1984
Davies, M., 'Tacit knowledge and the structure of thought and language' in *Meaning and Interpretation*, ed. C. Travis, Oxford 1986
Dennett D., *Content and Consciousness*, London 1969
Devitt, M., 'Dummett's anti-realism', *Journal of Philosophy* 1983
—— *Realism and Truth* Oxford 1984
Dodwell, P. C., *Visual Pattern Recognition*, New York 1970
Donnellan, D., 'Reference and definite descriptions', *Philosophical Review* 1966
Dummett, M. A. E., 'Truth', *Proceedings of the Aristotelian Society* 1959 reprinted in *Truth and Other Enigmas*
—— 'The philosophical basis of intuitionistic logic', in *Logic Colloquium*, eds. H. Rose & J. Shepherdson, Oxford 1975, reprinted ibid
—— 'The justification of deduction', *Proceedings of the British Academy* 1975 reprinted ibid

272 *Language, Logic & Experience*

—— 'What is a theory of meaning?' in *Mind and Language*, ed. S. Guttenplan, Oxford 1975

—— 'What is a theory of meaning? II' in *Truth and Meaning*, eds. J. McDowell & G. Evans, Oxford 1976

—— 'Frege's distinction between sense and reference' in *Truth and Other Enigmas*

—— *Truth and Other Enigmas*, London 1978

—— 'What do I know when I know a language?' Lecture given at the centenary celebrations of Stockholm University, 24 May 1978

—— 'Common sense and physics' in *Perception and Identity*, ed. G. F. MacDonald, London 1979

—— *Frege: Philosophy of Language*, London 2nd ed. 1981

—— *The Interpretation of Frege's Philosophy*, London 1981

Edginton, D., 'Meaning and bivalence and realism', *Proceedings of the Aristotelian Society* 1981

Evans, G. & McDowell, J. eds., *Truth and Meaning*, Oxford 1976

Evans, G., *The Varieties of Reference*, Oxford 1982

Field, H., 'Mental Representation', *Erkenntnis* 1977 reprinted in *Readings in the Philosophy of Psychology*, ed. N. Block, Oxford 1985

Fodor, J., 'Semantics Wisconsin style', *Synthese* 1984

Frege, G., 'On sense and reference' in *The Philosophical Writings of Gottlob Frege*, ed. P. Geach & M. Black, Oxford 1953

—— *Philosophical and Mathematical Correspondence*, ed. B. McGuinness & trans H. Kaal, Oxford 1980

Grayling, A. C., *The Refutation of Scepticism*, London 1985

Haack, S., 'Dummett's justification of deduction', *Mind* 1982

Hertz, H., *The Principles of Mechanics*, New York 1965

Horwich, P., 'Three forms of realism', *Synthese* 1982

Jackson, F., *Perception*, Cambridge 1977

Kaplan, D., 'Quantifying in', *Synthese* 1968

Kim, J., 'Perception and reference without causality', *Journal of Philosophy* 1977

Kripke, S., 'Naming and necessity' in *Semantics of Natural Language*, eds. G. Harman & D. Davidson, Dordrecht & Boston 1972, reprinted in book form, Oxford 1980

—— *Wittgenstein on Rules and Private Language*, Oxford 1982

Lear, J., 'Ethics, mathematics and relativism', *Mind* 1983

Locke, D., *Perception and Our Knowledge of the External World*, London 1966

Luntley, M., 'Verification, perception and theoretical entities', *Philosophical Quarterly* 1982

—— 'Understanding anthropologists', *Inquiry* 1982

—— 'The sense of a name', *Philosophical Quarterly* 1984, reprinted in *Frege, Tradition and Influence*, ed. C. Wright, Oxford 1984

—— 'Social science or dialogues of the deaf?', *Inquiry* 1985

—— 'The real anti-realism and other bare truths', *Erkenntnis* 1985

—— 'Dummett and Quine: meaning and behaviour' in *Reading Dummett*, ed. A. Grayling, London, forthcoming

McDowell, J., 'Truth conditions, bivalence and verificationism' in *Truth and Meaning*, eds. J. McDowell & G. Evans, Oxford 1976
—— 'On the sense and reference of a proper name', *Mind* 1977
—— 'On "the reality of the past" ' in *Action and Interpretation*, eds. C. Hookway & P. Pettit, Cambridge 1978
—— 'Anti-realism and the epistemology of understanding' in *Meaning and Understanding*, eds. H. Parret & B. Bouveresse, Berlin & New York 1981
—— 'Criteria, defeasibility and knowledge', Henrietta Hertz lecture to the British Academy, *Proceedings of the British Academy* 1982
—— 'Virtue and reason', *Monist* 1979
—— 'De re senses', *Philosophical Quarterly* 1984, reprinted in *Frege, tradition and influence*, ed. C. Wright, Oxford 1984
—— 'Values and secondary qualities' in *Morality and Objectivity: A Tribute to J. L. Mackie*, ed. T. Honderich, London 1985
—— 'Singular thought and the extent of inner space', in *Subject, Thought and Context*, eds. P. Pettit & J. McDowell, Oxford 1986
—— 'In defence of modesty' in *Michael Dummett* ed. B. Taylor, Dortrecht 1987
McGinn, C., 'Truth and use' in *Reference, Truth and Reality*, ed. M. Platts, London 1980
—— *The Subjective View*, Oxford 1983
Marks, L. E., *The Unity of the Sense*, London 1978
Nagel, T., 'What is it like to be a bat?' in his *Mortal Questions*, Cambridge 1979
—— 'The limits of objectivity' in *The Tanner Lectures on Human Values*, vol. 1, Oxford 1980
—— *The View from Nowhere*, Oxford 1986
Parfit, D. 'Personal identity', *Philosophical Review* 1971
Peacocke, C., *Sense and Content*, Oxford 1983
—— *Thoughts: An Essay on Content*, Oxford 1986
—— 'The Limits of intelligibility: a postverificationist proposal', inaugural lecture at the University of London, forthcoming
—— 'Understanding logical constants: a realist account', Henrietta Hertz lecture to the British Academy 1987, to be published in the Academy's proceedings
Philips, D. Z., *Faith and Philosophical Enquiry*, London 1970
Pitcher, G., *A Theory of Perception*, Princeton 1971
Platts, M. *Ways of Meaning*, London 1979
—— ed., *Reference, Truth and Reality*, London 1980
Prawitz, D.,'On the idea of a general proof theory', *Synthese* 1974
—— 'Proofs and the meanings and completeness of the logical constants' in *Essays on Mathematical and Philosophical Logic*, ed. K. J. J. Hintikka et al., Dordrecht 1978
Putnam, H., 'Analyticity and apriority: beyond Wittgenstein and Quine' in *Midwest Studies in Philosophy* vol. 4, ed. P. A. French et al., Minnesota 1979
Rock, I., *The Logic of Perception*, Cambridge, Mass. 1983

Rorty, R., 'Mind-body identity, privacy and categories', *Review of Metaphysics* 1965
—— *Philosophy and the Mirror of Nature*, Oxford 1980
Russell, B., *The Principles of Mathematics*, London 1903
—— *Problems of Philosophy*, London 1912
—— 'Knowledge by acquaintance and knowledge by description' in *Mysticism and Knowledge*, London 1918, reissued by Penguin, London 1953
Ryle, G., 'Sensations', in *Perceiving, Sensing and Knowing*, ed. R. Swartz, New York 1965
Salmon, N., *Frege's Puzzle*, New York 1987
Sainsbury, M., *Russell*, London 1979
Searle, J., *Intentionality*, Cambridge 1983
Schiffer, S., 'Intention-based semantics', *Notre Dame Journal of Formal Logic* 1982
Shoemaker, S., 'Functionalism and qualia', *Philosophical Studies* 1975
Stalnaker, R., *Inquiry*, Cambridge, Mass. 1984
Strawson, P. F., 'Perception and its objects', in *Perception and Identity*, ed. G. F. MacDonald, London 1979
Sundholm, G., 'Constructions, proofs and the meaning of the logical constants', *Journal of Philosophical Logic* 1983
Swinburne, R., *The Coherence of Theism*, Oxford 1977
—— *The Existence of God*, Oxford 1979
Tennant, N., 'Is this a proof I see before me?', *Analysis* 1981
—— 'Were those disproofs I saw before me?', *Analysis* 1984
—— 'Weir and those 'disproofs' I saw before me', *Analysis* 1985
—— *Anti-realism and Logic*, Oxford 1987
Weir, A., 'Truth conditions and truth values', *Analysis* 1983
—— 'Rejoinder to Tennant', *Analysis* 1985
—— 'Dummett on meaning and classical logic', *Mind* 1986
Wiggins, D., 'What would be a substantial theory of truth?', *Philosophical Subjects*, ed. Zak van Straaten, Oxford 1980
—— 'Truth, invention and the meaning of life', *Proceedings of the British Academy*, London 1976
—— *Needs, Values, Truth: Essays in the Philosophy of Value*, Oxford 1987
Williams, B., *Descartes: the project of pure enquiry*, London 1978
Wittgenstein, L., *Philosophical Investigations*, Oxford 1953
—— *The Remarks on the Foundations of Mathematics* Oxford, 3rd ed. 1978
Wodehouse, P. G., *Ring for Jeeves*, London repr. 1971
Woodfield, A. ed., *Thought and Object*, Oxford 1982
Wright, C., 'Truth-conditions and criteria', *Proceedings of the Aristotelian Society*, supplementary volume 1976
—— 'Anti-realist semantics: the role of criteria' in *Idealism: Past and Present*, ed. G. Vesey, Cambridge 1982
—— 'Realism, truth value links, other minds and the past', *Ratio* 1980
—— 'Critical notice of *Truth and Other Enigmas*', *Philosophical Quarterly* 1981
—— 'Strict finitism', *Synthese 1* 1982
—— 'Second thoughts about criteria', *Synthese 58* 1984

—— 'Does *Philosophical Investigations* l. 258–60 suggest a cogent argument against private language?' in *Subject, Thought and Context*, eds. J. McDowell & P. Pettit, Oxford 1986

—— *Realism, Meaning and Truth*, Oxford 1987

Yolton, J. W., 'Ideas and knowledge in seventeenth-century philosophy', *Journal of the History of Philosophy* 1975

—— *Perceptual Acquaintance*, Oxford 1984

Index